3D Game Textures

3D Game Textures
Create Professional Game Art Using Photoshop
Luke Ahearn

Second Edition

AMSTERDAM • BOSTON • HEIDELBERG • LONDON
NEW YORK • OXFORD • PARIS • SAN DIEGO
SAN FRANCISCO • SINGAPORE • SYDNEY • TOKYO

Focal Press is an imprint of Elsevier

Focal Press is an imprint of Elsevier
30 Corporate Drive, Suite 400, Burlington, MA 01803, USA
Linacre House, Jordan Hill, Oxford OX2 8DP, UK

Recognizing the importance of preserving what has been written, Elsevier prints its
books on acid-free paper whenever possible.

Library of Congress Cataloging-in-Publication Data
Ahearn, Luke.
 3D game textures : create professional game art using Photoshop / Luke Ahearn.
 p. cm.
 Includes index.
 ISBN 978-0-240-81148-2 (pbk. : alk. paper) 1. Computer games—Programming.
2. Computer graphics. 3. Adobe Photoshop. I. Title.
 QA76.76.C672A42154 2009
 794.8'16693—dc22

 2008055833

British Library Cataloguing-in-Publication Data
A catalogue record for this book is available from the British Library.

ISBN: 978-0-240-81148-2

For information on all Focal Press publications
visit our website at www.books.elsevier.com

09 10 11 12 13 5 4 3 2 1

Printed in China

Julie, Ellen, and Cooper.

Contents

Acknowledgments

Brian Grabinski, Mark Birge-Anderson, and Jose Vazquez—the concept artists.

Ann Sidenblad, a great friend and one of the best digital artists I know, for providing her invaluable feedback.

Jeffrey C. Huff, Assistant Professor of Computer Graphics at Missouri State University, for technical editing on this version of the book.

Nick Marks, for his initial input on this book many years ago.

NVIDIA—Doug Rogers, Kevin Bjorke, Gary King, Sébastien Dominé, Carrie Cowan, and Derek Perez, for information and help developing the shader section.

Maggie Quale at Smith Micro Inc.

Alkis "Atlas" Roufas, for the Genetica3 demo on the desk.

Michael S. Elliott, for the use of the Tengwar-Gandalf font.

The Focal Press people, who are too numerous to name. Specifically, I worked with Laura Lewin, Amanda Guest, Katy Spencer, and Chris Simpson. In addition, Becky Golden-Harrell, who was at Focal Press for the first edition of this book.

Introduction

Welcome to the second edition of this book. Game development is still booming! Many more books have been written, even more information is available on the Internet, and many more colleges are offering courses, or even degrees, in game development—and many use this book. Thanks to all the students and instructors who emailed me with suggestions and corrections. I loved the praise, but really appreciate the feedback and corrections the most. You have made this a better book. Yet still I find that of all the numerous topics that fall under the large umbrella of game development, texture creation is still not getting thorough treatment. People still trumpet the virtues of the Offset Filter in Photoshop—hence the need for this second edition.

I wrote this book after having held many positions on various game projects from president and art director to in-the-trenches artist working through crunch times. I worked with many artists on numerous projects, and no matter what their education or background, their knowledge of game development came largely from actually doing it. No one school or book can adequately train you for an industry that changes so fast and requires a rather large set of skills to function in. Even an experienced game developer must face a learning curve quite frequently. The reality is that most game projects are one-time, unique ventures that are never to be done the same way twice. Things change too fast: the technology, the processes, the marketplace. And the industry is still a bit transitory, so you may find yourself in a new town, at a new company, at work on a new genre of game, with tools that you have never used before. You would think that writing a book about something that is so constantly changing and affected by so many variables would be impossible. But given all the change and evolution in our industry, there are some core skills and practices that don't change from year to year. My goal with this book is not only to show you how to create textures, but also to give you a basis for understanding the larger picture of game development as it pertains to texture creation. The difference between a good artist and a good artist who can function as a member of a high-performance game development team is the ability to do good work fast and efficiently—and to contribute to the forward momentum of the project. I approached each of the projects in the book with all of this mind and tried to give you a feel for the various situations in which you may find yourself as a game artist.

Note: Remember that although specific game tools are not the focus of this book, in the job hunt you will want to master at least one set of commercially useful game development tools—at the expert level, if possible.

I also developed the exercises in this book to rely heavily on Photoshop. I did this for several reasons:

- The only way to really get to know Photoshop well is to use it a lot and to use it with real-world examples, not just a limited three-step tutorial on the Offset Filter.
- When you get to know your way around Photoshop, you will be more impressed by it. Every day I learn some new trick or feature that saves precious time.
- When you are truly proficient in Photoshop, you will develop a *feeling* for the best way to accomplish a task. When you develop this feeling, you know that you have left the learning curve far behind you. You can then focus on getting better and faster at Photoshop until it becomes an extension of you. You will be less hindered in creating what you are envisioning.
- When you get to know the capabilities of Photoshop, you will be able to create anything you want and will be less dependent on resources that may not be available everywhere you go, such as premade texture sets, digital cameras, and other software.

When you are able to use other resources to create your textures, they will be much better—and not only visually. Your source files will be more flexible, better organized, and much easier to work with. This is very important, because creating game art is a balancing act. You are always making decisions that involve not only aesthetics, but also efficiency and technological limits. Having files that are easy to find and that can be quickly altered is as important as how good they look. The best-looking texture in the world is useless if you can't find it or it won't run in a game engine. And on a development team, you will most likely not be the only person using a file. If your layers are not named, grouped, and organized, the next person's job will be much, much harder. One of the biggest challenges in game development is not breaking any of the fragile connections between the thousands of parts of a typical game. A poorly organized file is one of the things that will threaten to break those connections; many poorly organized files will almost assuredly cause a break. These connections are called *dependencies*. The development team must function smoothly and efficiently as a whole, because usually certain tasks and goals must be reached by one group, or individual, in order for the other team members to move forward with their work. A good number of poorly organized or missing files will cause the guilty party to take longer to complete his work and cause the dependent party to wait before starting her work. There is a snowball effect, delays cause more delays, and the schedule starts to slip dramatically. The project may even grind to a standstill. What's worse is having no schedule and not knowing (until it's way too late) that the game you had hoped (or are contractually obligated) to develop is an impossibility given the lack of time and resources that you have so late in development.

The worst case is that this will cause the project to get cancelled. At best, this is where most of the infamous *crunch time* is created. Crunch time includes those last few months where the development team lives in the office day and night to finish a game. One day developers are going to realize that the reason they are crunching is because the project wasn't planned properly. Someone at a higher level didn't do his job a year or two earlier, and the developers end up paying for it.

So, beyond creating a wood or metal texture, the greater goal is to learn to create assets in an efficient, organized, and flexible way. To work on a game development team, speed, accuracy, and flexibility are critical. The process in which you handle assets is called the *pipeline*. From concept to creation to in-game asset, tens of thousands of files pass through the pipeline. So where you save your files; what you name them; and how you name, group, and organize the layers in a Photoshop file are all important details. You don't want to be the person responsible for losing or overwriting a file that took someone else hours or days to create. Not only will you create the loss of precious hours of work, but potentially you could be responsible for delaying the entire project.

I hope you enjoy the book.

What This Book Is Not

There is much confusion when it comes to the vocabulary of game development. This book does not cover careers, characters, animation, lighting, modeling, NURBS, shader programming, or character skinning and is not a vague overview of all game art. This book *is* focused on creating 2D textures for various 3D game environments.

Whom This Book Is For

This book is for game developers, architects, simulation developers, web designers, and anyone who needs to create 2D imagery for a 3D computer application. I have come across two general types of individuals in the art departments of game development teams: the artistically challenged technical person and the technically challenged artistic person. Most people are trained and/or simply more proficient at thinking in one of those ways. There's no shame in being a great programmer who can't draw a bloody talon or in being a great artist who can't do all that complex code stuff. This book will help the beginner get started in game texturing, but it will also help the technically oriented professionals who are artistically challenged create textures (in a way they can relate to), and it will teach the technically challenged artists to create their art in a fashion that will allow them to set up their work with an eye toward the important aspects of game development. There is no shame in being an artist who has focused solely on creating beautiful art, and not on the technical issues of game development, but it is limiting.

The good news is that the creation of beautiful art is the hard part. All you have to do now is set up your art in a way that allows you to quickly find, alter, and output your textures for use in a game.

Overview

Chapter 1: A Basic (Game) Art Education

The basis of computer art is art itself, so in Chapter 1, I discuss the most basic and important aspects of visual art. Although teaching you traditional fine-art skills is beyond the scope of this book, it is critical to have an understanding of some basic aspects of visual art in order to create game textures. The basic aspects of visual art we will focus on are shape and form, light and shadow, texture, color, and perspective.

Chapter 2: A Brief Orientation to Computer Graphic Technology

We will talk technology very briefly. You will eventually need to learn a good deal about the technical side of computer art to decide on the various issues that technology will present to you, but a brief orientation of technology is all you will need to start painting textures. Although creating art on a computer can be limiting, frustrating, and confusing for many people, once you understand the limits placed on you and learn to work within them, you are much more likely to create impressive work. The aspects of technology that we will look at are common features of graphic file formats, the power of two and the grid, UV mapping, and shader technology for artists.

Chapter 3: Shaders and Materials

Shaders allow for a level of realism in games that is stunning and getting better all the time. Simply put, a shader is a mini-program that processes graphic effects in real time. For example, the reflections on a surface can move in real time instead of being "baked" or permanently painted into a surface. Shader effects are very powerful visually, even if viewers are unaware of what they are seeing. That is, the average player would have a hard time specifying why the game looks so good. It may be the real-time reflections, normal mapping, or the specular mapping being processed in real time.

Chapter 4: Prepping for Texture Creation

In this chapter we will look at the various sources of digital resources for texture creation and each of the steps in the process of gathering, preparing, and storing your assets. The focus of this

book is the creation of textures using Photoshop, so that you develop strong Photoshop skills, but in reality it is more common, easier, and more effective to use photo reference in texture creation. We will be using photo reference later in the book, and the CD contains a good collection of photo reference for you to use in your work. We also look at the use of overlays or overlay textures in this chapter.

Chapter 5: The Sci-Fi Setting

This is the first tutorial chapter. A sci-fi scene looks complex due to the geometry and effects presenting use, but in actuality the texture set is very simple. We will start by taking from the concept sketch ideas for the base materials that we will create for the scene and from that base build a simple and versatile set of textures. This method produces textures that can be used in various ways and that are designed to be used with the newer technology coming out (shaders like bump and normal mapping and so on).

Chapter 6: The Urban Setting

In this chapter you will learn to work more faithfully to the detail in a concept sketch or any reference material that may be given to you. When you create textures for a game environment, you are usually creating them for a world that has been thought out, detailed, and developed to the point that showcasing your creativity is not the primary goal of your work. You are showcasing your talent and ability to recreate what you see in the materials in front of you. We will build a set of textures as they were traditionally created, in sets: base, wall, floor, and ceiling. This chapter focuses on breaking out not only the base materials that need to be created for a scene, but also the detail textures as well. Even though this approach is falling by the wayside due to technological advances, it is still an applicable skill to many games and applications and a good skill to have when you are required to work with more advanced technology. We always start with the basics to build a material (shape, color, texture) and then build detail on top of that.
What you end up with is a full texture set that is easily altered and built on. By the end of the chapter, you will have created all the textures needed for the urban environment as seen in the concept sketch.

Chapter 7: The Outdoor Setting

In this chapter we will create a set of textures for a forest that can be altered to look spooky, friendly, or fanciful. Using the basic approach presented here to break out the elements of an outdoor scene, you can also create a similar set of textures for any outdoor environment; jungle, desert, and so on. I will also introduce the use of photo source in texture creation. I mentioned in the very beginning of the book that the use of photo source to create

textures is not only common but preferred. It makes your job faster and easier and gives your textures an extra layer of richness that can take a lot of time to achieve otherwise. Although working with overlays may take the most time and tweaking, they are generally added later in the creation process, after a good foundation is laid. Using digital imagery will greatly enhance and speed up your work, but you don't want it to be a crutch that you will always have to lean on. We will also look at the ways that the sky is typically handled in a game. We will also look at terrain painting, clouds, and water.

Chapter 8: Game Effects

Games are full of visual effects—probably even more so than you realize. These effects are important, not just as eye candy, but for giving the player clues and information on what is happening in the game world. These effects also add a great deal to the level of immersion that a player will experience in a game. Typically, if you shoot at any surface in a game—wood, metal, concrete, and their variations—you will see and hear a different effect for each surface. Effects also include the glow around a candle, light shafts from a window, even raindrops. The assets for these effects are fairly easy to create. Actually, asset creation is the easy part of creating effects in a relative sense. It does take work to create the art and it must look good, but the systems that run the effects can be complex and challenging to work with. Generally, you will often create three types of effects: Static, Animated, and Particle.

Chapter 9: Normal Maps and Multi-Pass Shaders

This chapter focuses on normal mapping; specifically, creating them in Photoshop with a look at creating them using a 3D program. We will also create the supporting maps for a typical environment: bump, normal, specular, illumination, and opacity. I will explain how 3D applications are used to do this, but of course we won't be doing this in this book.

Bonus Chapter (on the DVD): The Fantasy Setting

This is a long chapter, so pace yourself. This chapter combines the creation of many high-detail textures that are used in a high-polygon-count scene. We will use the Path Tool in Photoshop to create the fancy curves that you see in the scene, and we will do some basic hand painting that will produce great results. Finally, we will look at the process of creating the textures used in a shader.

Have fun!

The Concept Artists

The Urban Setting
Jose Vazquez

Jose was born in Mexico and raised in Chicago, Illinois, from the age of three. He still keeps a close connection with his Mexican heritage. Jose has a B.A. in Illustration from Columbia College and a B.A. in Media Arts and Animation from the Illinois Institute of Art. Jose has more than 15 years of professional experience that began with graffiti and then grew into contracted large-scale murals. Dabbling in airbrush art, portraits, and paintings of all media, Jose has a strong traditional art background, but due to his animation education, all of his current works are digital. Jose currently develops characters in the video gaming industry. You can contact Jose at www.sephseer.com.

The Sci-Fi Setting
Brian Grabinski

Brian Grabinski was born and raised in Illinois. He graduated from the Chicago-based American Academy of Art in 1997. Upon graduation, he started working freelance and has worked as a full-time illustrator/graphic designer for 8 years now. Brian has also worked as a full-time concept artist for the video game company Rainbow Studios/THQ, based out of Phoenix, Arizona, and for the Chicago-area Animation Studio, Dreamation/Cineme. Brian continues to work freelance for various clients and is employed full-time at the Hoffman Estates, Illinois–based videogame company High Voltage Studios as a full-time concept artist. You can contact Brian via email at briangrabinski@ aol.com or brian.grabinski@high-voltage. com.

The Fantasy Setting
Mark Birge-Anderson

Mark Birge-Anderson attended the Layton School of Art and Design in Milwaukee, Wisconsin, and the Art Academy of Cincinnati. He works in advertising in Chicago, coming up with original concepts and designs. He has also done concept art for an animation studio in Chicago and plans to pursue work in that exciting field. Mark does freelance illustration as well and can be reached at mark@matrix1.com.

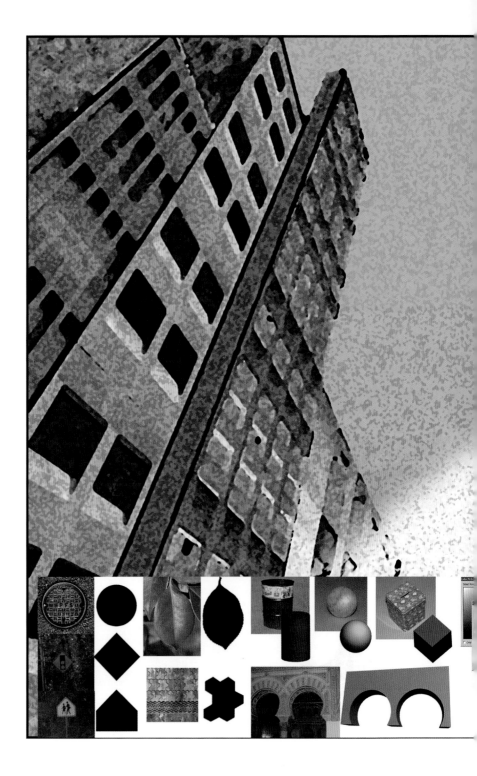

Chapter 1

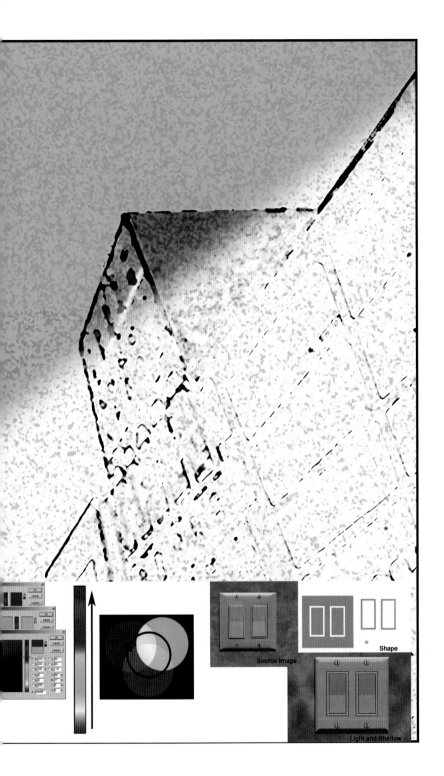

A Basic (Game) Art Education

Art is born of the observation and investigation of nature.

Cicero (Roman author, orator, and politician, 106 BC–43 BC)

Introduction

The basis of computer art is art itself, so before we dive into any technical issues, we must first discuss the most basic — but important aspects of visual art. Though teaching you traditional fine art skills is beyond the scope of this book, it is critical to have an understanding of some basic aspects of visual art in order to create game textures. Fortunately, these basic aspects of art are fairly easy to present in book form. By studying these basics of art, you will learn to see the world as an artist does and to understand what you see, and then to be better able to create a texture set for a game world.

The basic aspects of visual art that we will focus on are:

• Shape and form
• Light and shadow
• Texture
• Color
• Perspective

Learning to observe the basic visual aspects of the world around you is a strong beginning in the process of seeing the world like an artist, communicating with other artists, and creating great game textures. Technology is, of course, critical to the larger picture of game textures, but the actual basics of art is where great textures begin. Too often, would-be game artists are thrown into a discussion on tiling, or even game engine technology, when the skills that are most important for the creation of game textures are the ability to understand what you are seeing in the real world and the ability to recreate it in the computer. Often a texture artist is required to break a scene down to its core materials and build a texture set based on those materials, so learning this ability is essential. Although you don't need to have an advanced degree in art to create great textures, let's face it: almost anyone can learn what buttons to push in Photoshop, but the person who understands and skillfully applies the basics of art can make a texture that stands out above the rest.

There are many types of art and aspects of visual art that you should further explore in order to develop as a game artist. Some of the things you can study and/or practice are

• Figure drawing
• Still-life drawing
• Photography
• Painting (oil, water color, etc.)
• Lighting (for film, still photography, the stage, or CG)
• Color theory and application

- Sculpture
- Drafting and architectural rendering
- Anatomy
- Set design
- Technical illustration

It is even worth the time to study other areas of interest beyond art, such as the sciences, particularly the behavior of the physical world. Light, for example, is becoming processed more and more in real time and not painted into the texture to the extent it was just a few years ago. The more you understand and are able to reproduce effects such as reflection, refraction, blowing smoke, and so on, the more success you will find as a game artist. We presently have emerging technologies that reproduce the real world to a much greater extent than ever before, but it still takes an artist to create the input and adjust the output for these effects to look their best. The areas of study that will help you when dealing with real-world behaviors are endless. You can start by simply observing the world. Watch how water drips or flows, the variations of light and shadow on different surfaces at different times of the day, how a tree grows from the ground—straight like a young pine or flared at the base like an old oak—and you will soon be staring at the cracks in the pavement and photographing the side of a dumpster while the world stares at you. An excellent book for this type activity is *Digital Texturing & Painting* by Owen Demers (New Riders, 2001). You can also take tours of museums, architectural tours, nature walks; join a photography club; join a figure drawing class—there is no end to the classes, clubs, disciplines, and other situations that will open up your mind to new inspirations and teach you new tools and techniques for texture creation. And, of course, playing games, watching movies, and reading graphic novels are food to the game artist.

Chapter Overview

Shape (2D) and Form (3D)
Light and Shadow
Texture: Tactile vs. Visual
Color
Perspective

There are many elements of traditional art, but we will narrow our focus to those elements that are most pertinent to texture creation. We will start with shape and form.

Shape (2D) and Form (3D)

A **shape** (height and width) is simply a two-dimensional (flat) outline of a form. Circles, squares, rectangles, and triangles are all examples of shape. Shape is what we first use to draw a picture with before we understand such concepts as light, shadow, and depth. As children we draw what we see in a crude way. Look at the

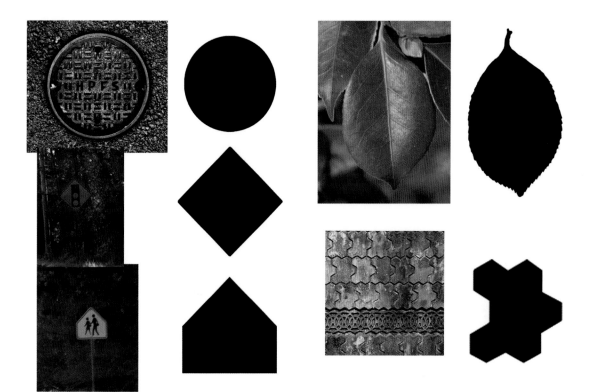

Figure 1-1
Here are some examples of shapes that compose everyday objects. These shapes range from simple to complex.

drawings of very young children and you will see that they are almost always composed of pure basic shapes: triangular roof, square door, circular sun. Even as adults, when we understand shadows and perspective, we have trouble drawing what we see before us and instead rely on a whole series of mental notes and assumptions as to what we think we are seeing. There are exercises to help develop the ability to draw what we actually see. Most notably, the book *The New Drawing on the Right Side of the Brain*, by Betty Edwards (Tarcher, 1999), offers many such exercises. And one of the most famous of these involves the drawing of a human face from a photo. After you have done this, you then turn the photo upside down and draw it again. The upside-down results are often far better than the right-side up, first try. This is because once you turn the image upside down, your brain is no longer able to make any mental assumptions about what you think you are seeing; you can see only what's really there. Your brain hasn't yet developed a set of rules and assumptions about the uncommon sight of an upside-down human face. One of the first skills that you can practice as an artist is trying to see the shapes that make up the objects that surround you. Figure 1-1 has some examples of this shape training, ranging from the simple to the complex. This is a very important skill to acquire. As a texture artist, you will often need to see an object's fundamental shape amidst all the clutter and confusion in a scene so that you can create the 2D art that goes over the 3D objects of the world.

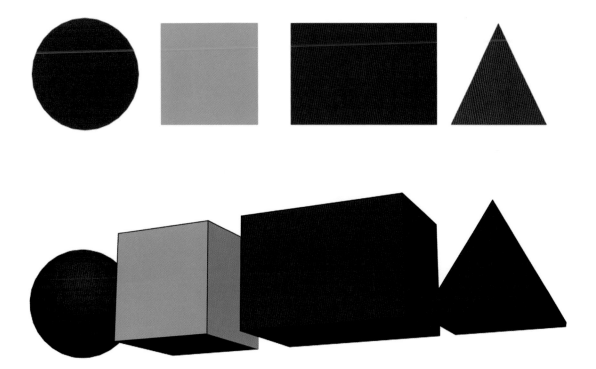

Form is three-dimensional (height, width, and depth) and includes simple objects like spheres, cubes, and pyramids. See Figure 1-2 for examples and visual comparisons. You will see later that as a texture artist, you are creating art on flat shapes (essentially squares and rectangles) that are later placed on the surfaces of forms. An example can be seen in Figure 1-3, as a cube is turned into a crate (a common prop in many computer games). When a shape is cut into a base material in Photoshop and some highlights and shadows are added, the illusion of form is created. A texture can be created rather quickly using this method. See Figure 1-4 for a very simple example of a space door created using an image of rust, some basic shapes, and some standard Photoshop Layer Effects.

Of course, mapping those textures to more complex shapes like weapons, vehicles, and characters gets more complex, and the textures themselves reflect this complexity. Paradoxically, as the speed, quality, and the complexity of game technology increase, artists are actually producing more simplified textures in some cases. The complexity comes in the understanding and implementation of the technology. Don't worry—you will gradually be introduced to this complexity, culminating with some sections on shader technology.

As with shapes, you can practice looking for the forms that make up the objects around you. In Figure 1-5 you can see some examples of this.

Figure 1-2
Here are examples of shapes and forms. Notice how it is shadow that turns a circle into a sphere.

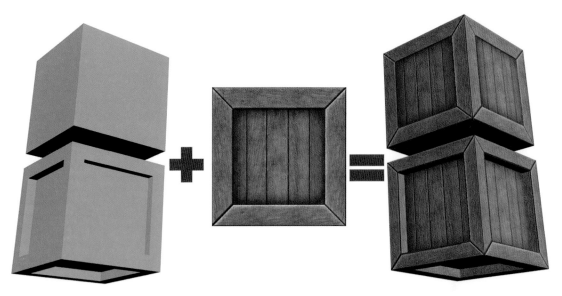

Figure 1-3
A game texture is basically a 2D image applied, or mapped, to a 3D shape to add visual detail. In this example, a cube is turned into a crate using texture. And a more complex 3D shape makes a more interesting crate using the same 2D image.

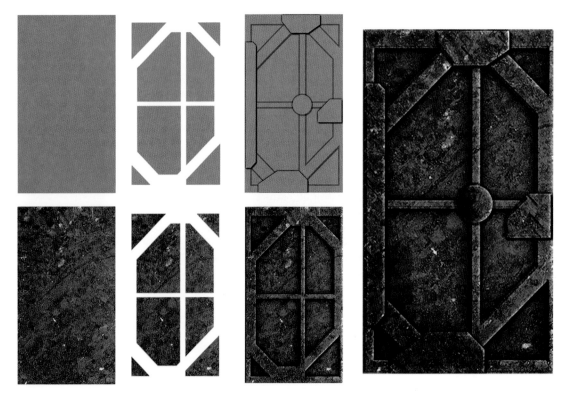

Figure 1-4
Here is an example of how shapes can be cut into an image and with some simple layer effects can be turned into a texture in Photoshop.

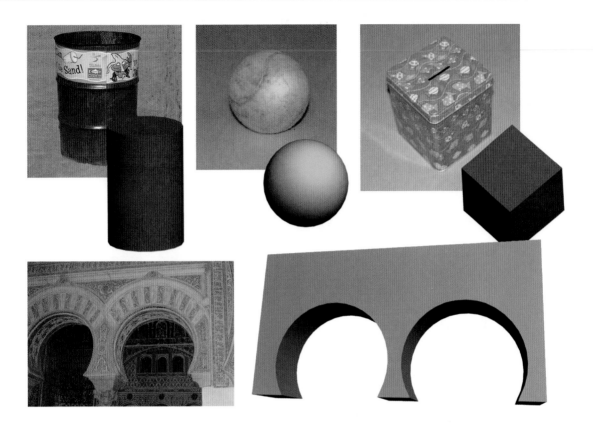

Light and Shadow

Of all the topics in traditional art, this is arguably the most important, due to its difficulty to master and importance to the final work. Light and shadow give depth to and—as a result—define what we see. At its simplest, light and shadow are easy to see and understand. Most of us are familiar with shadow; our own shadow cast by the sun, making animal silhouettes with our hands on the wall, or a single light source shining on a sphere and the round shadow that it casts. That's where this book will start. Light and shadow quickly get more complicated, and the examples in this book will get more complex as well. The book will start with the ability to see and analyze light and shadow in this chapter, move up to creating and tweaking light and shadow in Photoshop using Layer Styles for the most part, and finally look at some basic hand tweaking of light and shadow. If you want to master the ability to hand-paint light and shadow on complex and organic surfaces, then you are advised to take traditional art classes in illustration, sketching, and painting.

We all know that the absence of light is darkness, and in total darkness we can obviously see nothing at all, but the presence of too much light will also make it difficult to see. Too much light blows away shadow and removes depth and desaturates color. In the previous section, we looked at how shape and form differ. We see that difference primarily as light and shadow as in the example

Figure 1-5
Here are some examples of the forms that make up the objects around you.

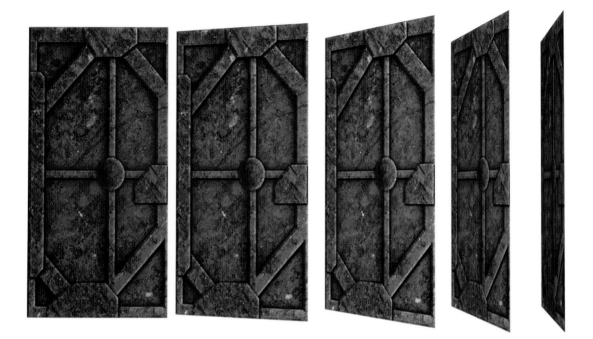

Figure 1-6
Here is the same door texture from the previous section. Notice the complete lack of depth as we look at it from angles other than straight on. The illusion of depth is shattered.

of the circle and a sphere. But even if the sphere were lit evenly with no shadows and looked just like the circle, the difference would become apparent when rotated. The sphere would always look round if rotated, whereas once you began to rotate the circle it would begin to look like an oval until it eventually disappeared when completely sideways. In Figure 1-4, in which a shape was cut into an image of rusted metal and made to look like a metal space door using Photoshop Layer Effects, the highlights and shadows were faked using the various tools and their settings. In Figure 1-6 you can see the same door texture rotated from front to side. Notice the complete lack of depth in the image on the far right. The illusion is shattered.

Understanding light and shadow is very important in the process of creating quality textures. We will go into more depth on this topic as we work through this book. One of the main reasons for dwelling on the topic is the importance of light and shadow visually, but in addition, you will see that many necessary decisions are based on whether light and shadow should be represented using texture, geometry, or technology. To make this decision intelligently in a serious game production involves the input and expertise of many people. Although what looks best is ideally the first priority, what runs best on the target computer is usually what the decision boils down to. So keep in mind that in game development you don't want to make any assumptions about light and shadows—ask questions. I cover different scenarios of how light and shadow may be handled in a game in this book. It can be challenging to make shadows look good in any one of the situations. Too little and you lack depth; too much and the texture starts to look flat. Making shadows too long

or intense is an easy mistake. And unless the game level specifically calls for that on some rare occasion, don't do it. Technology sometimes handles the highlights and shadows. This feature is challenging, because it is a new way of thinking that baffles many people who are unfamiliar with computer graphics. It can also be a bit overwhelming, because you go from creating one texture for a surface to creating three or more textures that all work together on one surface. Naming and storing those textures can get confusing if you let it get away from you.

Overall, you want your textures to be as versatile as possible, and to a great extent, that includes the ability to use those textures under various lighting conditions. See Figure 1-7 for an example of a texture in which the shadows and highlights have been improperly implemented and another one that has been correctly created. For this reason we will purposely use highlight and shadow to a minimal amount. You will find that if your texture needs more depth than a modest amount of highlight and/or shadow, then you most likely need to create geometry or use a shader—or consider removing the source of shadow! If there is no need for a large electrical box on a wall, then don't paint it in if it draws attention to itself and looks flat. If there is a need and you are creating deep and harsh shadows because of it, you may need to create the geometry for the protruding element. You will find that as game development technology accelerates, things like pipes, doorknobs, and ledges are easily created with the larger polygon budgets, or by using the advanced shaders at our disposal. Many texture surface properties are no longer painted on. Reflections, specular highlights, bump mapping, and other aspects of highlight and shadow are now processed in real time.

In the rest of this book I will take various approaches to light and shadow using Photoshop's Layer Effects to automate this process and other tools to hand paint highlights and shadows. One of the main benefits of creating your own highlights and shadows in your textures is that you can control them and make them more interesting, as well as consistent. Nothing is worse than a texture with shadows from conflicting light sources: harsh, short shadows on some elements of the texture and longer, more diffuse shadows on others. See Figure 1-8 for an example of this. The human eye can detect these types of errors even if the human seeing it can't quite understand why the image looks wrong. One of the artist's greatest abilities is not only being able to create art, but also being able to consciously know and verbalize what he is seeing. In Figure 1-9, you can see the various types of shadows created as the light source changes. This is a simple demonstration. If you ever have the opportunity to light a 3D scene or movie set, you will discover that the range of variables for light and shadow can be quite large.

Highlights also tell us a good bit about the light source as well as the object itself. In Figure 1-10, you can see another simple illustration of how different materials will have different highlight patterns and intensities. These materials lack any texture or color

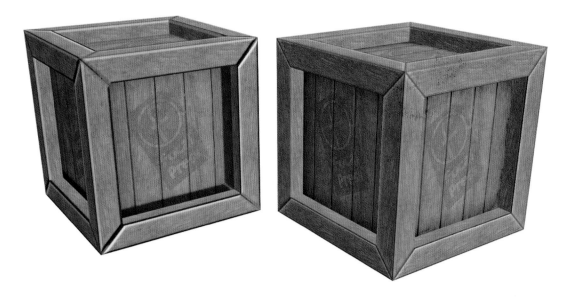

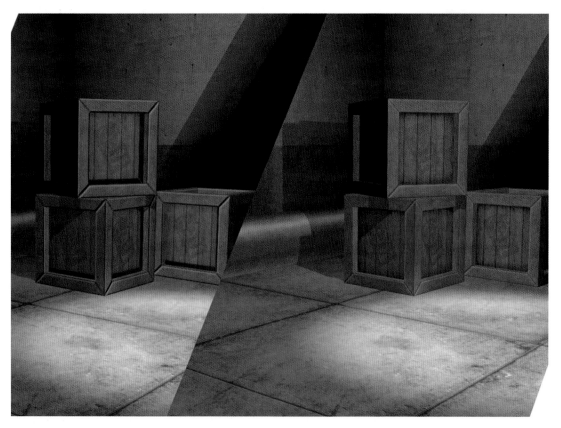

Figure 1-7
The crate on the left has conflicting light sources. The shadow from the edge of the crate is coming up from the bottom, is too dark, is too long, and even has a gap in it. The highlights on the edges are in conflict with the shadow cast on the inner panel of the crate, and they are too hot, or bright. The crate on the right has a more subtle, low-contrast, and diffuse highlight and shadow scheme and will work better in more diverse situations.

Figure 1-8
Here is a *really bad* texture
created from two sources.
Notice the difference in the
shadows and highlights. The
human eye can detect these
errors, even if the human
seeing it can't understand
why the image looks wrong.

and simply show the highlights and shadows created on the surface
by one consistent light source.

For a more advanced and in-depth discussion on the subject of light
and shadow for 3D scenes, I recommend *Essential CG Lighting
Techniques with 3ds Max* by Darren Brooker (Focal, 2006).

Texture

In the bulk of this book, as in the game industry, we will be using
the term *texture* to mean a 2D static image. What we refer to as
textures in this book are also sometimes called *materials,* or even
tile sets (from older games), but we will stick to the term *texture.*
The one exception in this book is that in this section we will talk
about the word *texture* as it is used in traditional art: painting,
sculpture, and so on. A side note on vocabulary: keep in mind that
vocabulary is very important and can be a confusing aspect of
working in the game industry. There is much room for
miscommunication. Different words can often mean the same thing,
and the same words can often mean many different things.
Acronyms can be especially confusing; RAM, POV, MMO, and RPG
all mean different things in different industries. *POV* means "point-

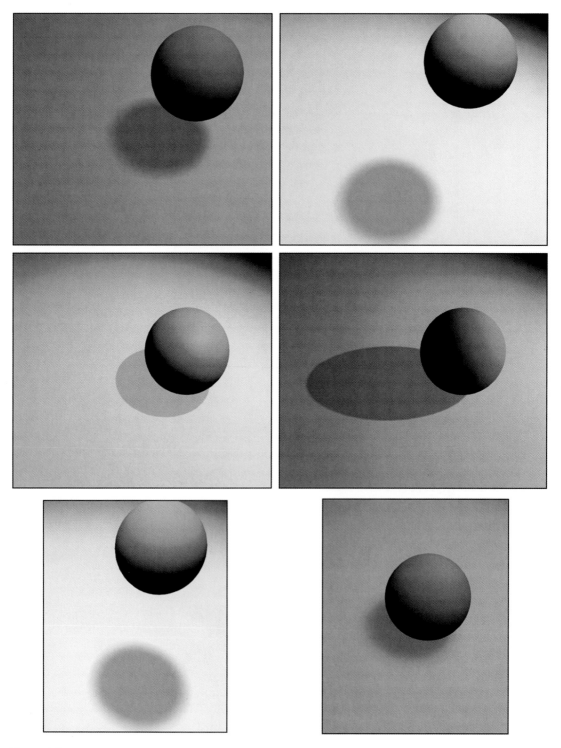

Figure 1-9
With one light source and a simple object, you can see the range of shadows we can create. Each shadow tells us information about the object and the light source, such as location, intensity, and so on.

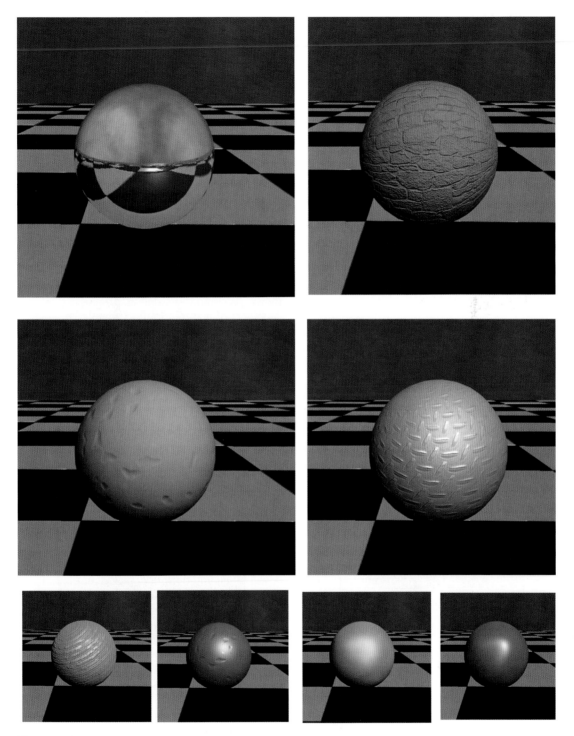

Figure 1-10
With one light source and a simple object with various highlights on it, you can see that the object appears to be created of various materials. Keep in mind that what you are seeing is only highlight and shadow. How much does only this aspect of an image tell you about the material?

of-view" in the game industry, "personally owned vehicle" in government, and also stands for "persistence of vision." So to clarify, the term *texture*—usually meaning a 2D image applied to a polygon (the face of a 3D object)—in this section of this chapter refers to an aspect of an image and not the image itself. We draw this distinction for the following conversation on traditional art.

In traditional art, there are two types of textures: tactile and visual.

Tactile texture is when you are able to actually touch the physical texture of the art or object. Smooth and cold (marble, polished metal, glass) is as much a texture as coarse and rough. In art this term applies to sculptures and the like, but many paintings have thick and very pronounced brush or palette knife strokes. Vincent Van Gogh was famous for doing this. Some painters even add materials such as sand to their paint to bring more physical or tactile texture to their work.

Visual texture is the illusion of what the surface's texture might feel like if we could touch it. Visual texture is composed of fine highlights and shadows. As computer game texture artists, we deal solely with this aspect of texture. So, for example, an image on your monitor may look like rough stone, smooth metal, or even a beautiful woman … and if you try and kiss that beautiful woman, she is still just a monitor—not that I ever tried that, mind you.

There are many ways to convey texture in a 2D piece of art. In computer games we are combining 2D and 3D elements and must often decide which to use. With 2D we are almost always forced to use strictly 2D imagery for fine visual texture. And though the faster processors, larger quantities of RAM, and the latest crop of 3D graphic cards allow us to use larger and more detailed textures and more geometry, a great deal of visual texture is still static; noticeably so, to a trained artist. This limitation is starting to melt away as complex shader systems are coming into the mainstream of real-time games. The real-time processing of bump maps, specular highlights, and a long list of other, more complex effects adds to our game worlds a depth of realism not even dreamed of in the recent past. This book will teach you both the current method of building texture sets and the increasingly common method of building material sets that use textures and shader effects together. I will discuss this more at length later in the book, but for now you can see some visual examples of these effects. In Figure 1-11 you can see how in the 2D strip the object rotates but the effects stay static on the surface, while on the 3D strip the object rotates and the effect moves realistically across the surface.

The game artist's job is often to consider what tools and techniques we have at our disposal and determine which best accomplishes the job. We must often make a trade-off between what looks good and what runs well. As you begin to paint textures, you will find that some of the techniques of traditional art don't work in the context of game texturing. As traditional artists, we usually do a painting that represents one static viewpoint, and we can paint into it strong

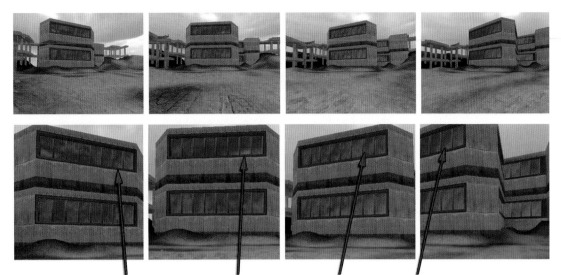

WINDOWS HAVE A REFLECTION OF THE SKY IN THEM
THAT REFLECTION MOVES AS THE PLAYERS DOES.

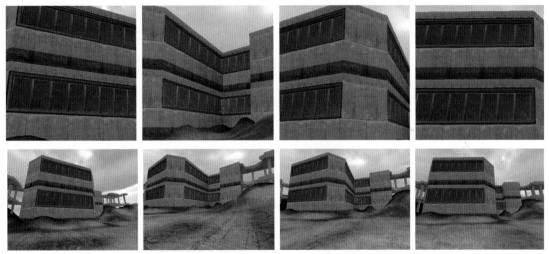

THESE WINDOWS ARE PAINTED TEXTURES
AND STAY THE SAME NO MATTER WHERE THE PLAYER WALKS

Figure 1-11
Visual texture is composed of fine highlights and shadows. A shader allows for the real-time processing of visual texture, among other effects, and adds much more realism to a scene as the surface reacts with the world around it. In this example I used a specular map. These effects are best seen in 3D, but you can see here that the windows in the building on the top row have a reflection of the sky in them and that that reflection moves as the player does. The windows in the building on the lower row are painted textures and stay the same no matter where the player walks. The bottom two rows are close-ups to help you see the effect. If you pick one window in the close-up images and look closely, you will see that the cloud reflections are in different places in each frame.

light sources and a great deal of depth, but that amount of depth representation goes beyond tactile texture and becomes faked geometry and looks flat in a dynamic, real-time 3D world. As mentioned earlier in this chapter, this approach will not work in a 3D game in which a player can move about and examine the texture. Once again, we must choose what to represent using a static 2D image, what can be processed in real time using a shader, and what must be represented using actual geometry. There are many solutions for this problem; among them are restricting the players' ability to move around the texture, removing the element of overt depth representation, or adding actual geometry for the parts of the texture represented by the overt depth representation (see Figure 1-12).

Color

We all know what color is in an everyday fashion: "Get me those pliers. No, the ones with black handles." "I said to paint the house green. I didn't mean neon green!" That's all fine for civilian discussions of color, but when you begin to speak with artists about color, you need to learn to speak of color intelligently, and that takes a little more education and some practice. You will also learn to choose and combine color. In games, as in movies, interior design, and other visual disciplines, color is very important. Color tells us much about the world and situation we are in.
At one game company we developed a massively multiplayer game that started in the town—saturated green grass, blue water, butterflies—you get the picture: this was a nice, safe place. As you moved away from town, the colors darkened and lost saturation. The grass went from a brighter green to a less-saturated brownish-green. There were other visual clues as well. Most people can look at grass and tell whether it is healthy, dying, kept up, or growing wild. Away from town, the grass was also long and clumpy, dying, and growing over the path. But even before we changed any other aspect of the game—still using the same grass texture from town that was well trimmed—we simply lowered the saturation of the colors on the fly and you could feel the life drain from the world as you walked away from town. As you create textures, you will probably have some form of direction on color choice—or maybe not. You might need to know what colors to choose to convey what is presented in the design document and what colors will work well together.

This section lays out a simple introduction to the vocabulary of color, color mixing (on the computer), and color choices and their commonly accepted meanings. I decided to skip the complex science of color and stick to the practical and immediately useful aspects of color. Color can get very complex and esoteric, but you would benefit from taking your education further and learning how color works on a scientific basis. Although this chapter will be a strong starting point, you will eventually move on from working with only the colors contained in the texture that you are creating to how those colors interact with

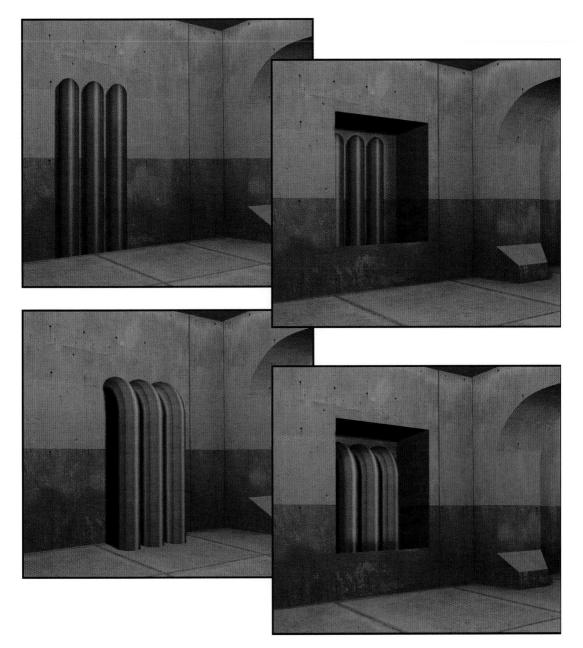

Figure 1-12
There are several possibilities when dealing with overt depth representation. **Upper left:** the pipes are painted into the texture and totally lack any depth; notice how they dead-end into the floor. **Upper right:** restricting the players' ability to move around the texture can alleviate some of the problem. **Lower left:** adding actual geometry for the parts of the texture that cause the overt depth is the best solution if possible (this method uses less texture memory but more polygons). Finally, **lower right:** adding the actual geometry into the recess is an option that looks pretty interesting and actually allows for a reduction of geometry. The removal of polygons from the back sides of the pipes more than offsets the added faces of the recess.

other elements in the world, such as lighting. To start with, however, a game texture artist needs the ability to communicate, create, and choose colors.

First, I will discuss the way in which we discuss color. There are many color models, or ways of looking at and communicating color verbally. There are models that concern printing, physics, pigment, and light. They each have their own vocabulary, concepts, and tools for breaking out color. As digital artists, we use the models that describe light, because we are working with colored pixels that emit light. A little later we will take a closer look at those color systems from the standpoint of color mixing, but for now we will look at the vocabulary of color. In game development you will almost always use the RGB color model to mix color and the HSB color model (both explained next) to discuss color. You will see that Photoshop allows for the numeric input and visual selection of color in various ways. When you discuss color choices and changes and then go to enact them, you are often translating between two or more models. Don't worry; this is not difficult, and most people don't even realize that they are doing it.

Figure 1-13
In this image you can see a representation of HSB—Hue, Saturation, and Brightness.

First, we will look at the **HSB** model, which stands for **Hue, Saturation,** and **Brightness,** as this is the most common way for digital artists to communicate concerning color. In Figure 1-13 you can see examples of these aspects of color. These three properties

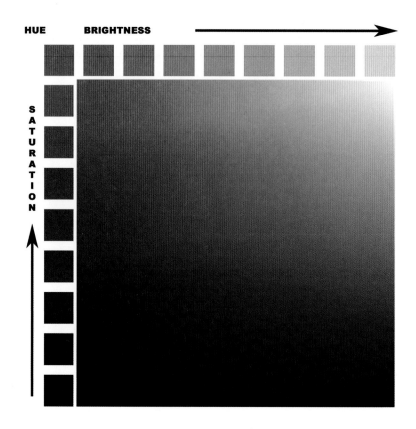

of color are the main aspects of color that we need to be concerned with when discussing color:

- Hue is the name of the color (red, yellow, green).
- Saturation (or Chroma) is the strength or purity of the color.
- Brightness is the lightness or darkness of the color.

Hue

Most people use the word *color* when referring to hue. Although there are many, many colors, there are far fewer hues. Variations of saturation and brightness create the nearly unlimited colors we see in the world. Scarlet, maroon, pink, and crimson are all colors, but the base hue is red.

Understanding color and its various properties is best done with visual examples. The most often used method is the Color Wheel, developed by Johannes Itten. We will look at the Color Wheel a little later. In Photoshop you will recognize the Color Picker, which allows for various methods for choosing and controlling color, both numerically and visually. The Color Picker has various ways to choose color, but the most commonly used is RGB (Red, Green, Blue)—Figure 1-14.

Saturation

Saturation quite simply is the amount of white in the color. In Figure 1-15 you can see the saturation of a color being decreased as white is added. If you have access to a software package like Photoshop

Figure 1-14
Here are Color Pickers from various applications.

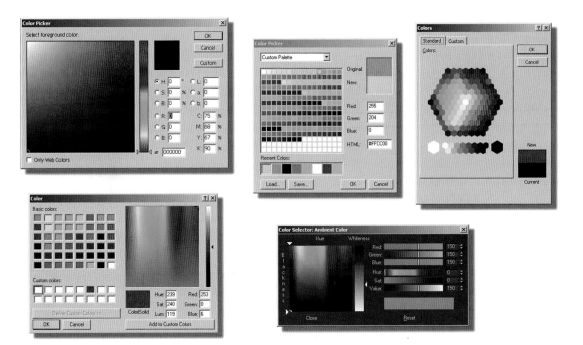

100% saturation **0% saturation**

Figure 1-15
The saturation of the color red at 100% and decreasing to 0% by adding white.

100% brightness **0% brightness**

Figure 1-16
The brightness of the color red at 100% and decreasing to 0% by adding black.

and open the color picker, you can slide the picker from the pure hue to a less saturated hue and watch the saturation numbers in the HSB slots go down as the color gets less saturated. Notice how the brightness doesn't change unless you start dragging down and adding black to the color. Also, you may want to look down at the RGB numbers and notice how the red in RGB doesn't change, but the green and blue do.

Brightness

Brightness is the amount of black in the color. In Figure 1-16 you can see the brightness of a color being decreased. As in the previous discussion of saturation, you can open the Color Picker in Photoshop and this time, instead of decreasing the saturation, you can decrease the brightness by dragging down. You can look at the HSB and the RGB slots and see the brightness numbers decreasing. Also notice that this time in the RGB slots the red numbers decrease, but the blue and green are already at zero and stay there.

Like most other aspects of color, brightness is affected by other factors. What colors are next to each other? What are the properties of the lights in the world? Another job of the texture artist is making sure the textures in the world are consistent. That involves balancing the hues, saturation, and brightness of the color, in most cases. Figure 1-17 depicts an example of a texture that may have looked okay in Photoshop, but needed to be corrected to fit the scene. You can see that a great deal of contrast and intensity of color makes tiling the image a greater challenge.

Color Systems: Additive and Subtractive

There are two types of color systems: additive and subtractive. Subtractive color is the physical mixing of paints, or pigments, to

PATCH OF EXPOSED STONE IN THE CONCRETE

create a color. It is called *subtractive* because light waves are absorbed (or subtracted from the spectrum) by the paint and only the reflected waves are seen. A red pigment, therefore, is reflecting only red light and absorbing all the others. In the subtractive system, you get black by mixing all the colors together—theoretically. It is a challenge to mix pigments that result in a true black or a vibrant color. That is one of the reasons art supply stores have so many choices when it comes to paint. One of our advantages of working in the additive system is that we can get consistent and vibrant results with light. We won't dwell on the subtractive system, as we won't be using it.

The additive system is when light is added together (like on a computer screen) to create a color, so naturally we deal with the additive system as computer artists, because we are working with light. In Figure 1-18 you can see how the additive system works. I simply went into 3ds Max and created three spotlights that were pure red, green, and blue and created my own Additive Color Wheel,

Figure 1-17
Here is an example of a texture that may have looked okay in Photoshop, but needed to be corrected to fit in the scene correctly. This is a subtle example. Notice the patch of exposed stone in the concrete on the building that repeats?

Figure 1-18
The additive system works by adding lights. Black is the absence of light (the area outside of the spotlights), and White is all light (the center area where all three lights overlap each other): the combination of red, green, and blue is the additive system.

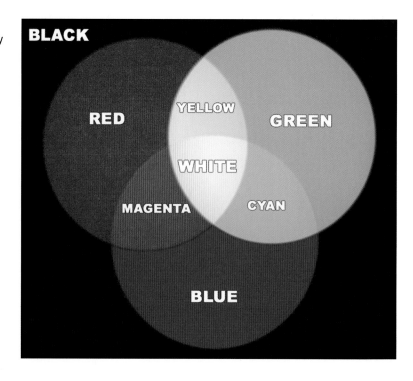

or a visual representation of how the colors interact. Black is the absence of light (the area outside of the spotlights), and White is all light (the center area where all three lights overlap each other): the combination of red, green, and blue is the additive system. If you look at the Color Picker in Photoshop (Figure 1-19), you will see a vertical rectangle of color graduating from red through the colors and back to red. This allows you to select a hue and use the Color Picker Palette to change the value and intensity.

Primary Colors

The three primary colors in the additive color system are red, green, and blue (RGB). They are referred to as primary colors because you can mix them and make all the other colors, but you can't create the primary colors by mixing any other color. Many projection televisions use a system where you can see the red, green, and blue lens that project the three colors (RGB) to create the image you see using the additive method.

Secondary Colors

The secondary colors are yellow, magenta, and cyan. When you mix equal amounts of two primary colors together, you get a secondary color. You can see that these colors are located between the primary colors on the color wheel and on the Photoshop Color Picker vertical strip.

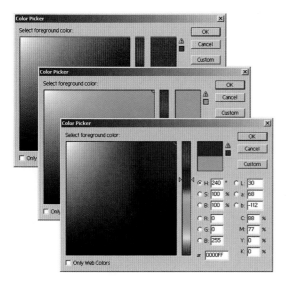

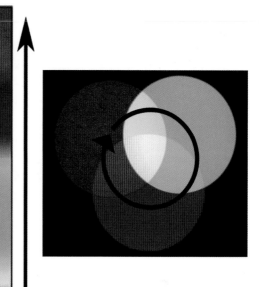

Color Emphasis

Color is often used for emphasis. Look at Figure 1-20. All things being equal, the larger shapes dominate, but the small shapes demand your attention once color is added. Of course, there are many other forms of emphasis that you can use in creating art, but color can be the most powerful—and overused. Ever come across a web page that has a busy background and every font, color, and mode of emphasis devised by man splashed across it? There is almost no actual emphasis, as all the elements cancel each other out. Often, less is more.

In another example using a photograph, Figure 1-21, you can see that in the first black-and-white photo, your eye would most likely be drawn to the dark opening of the doghouse and you would most likely assume that the subject of this picture is the doghouse. In the second version, the colorful flower draws the primary interest; it still competes with the doghouse door for attention, but you would probably make the assumption that the focus of this picture was the flower.

In a game scene, you can see the use of color drawing the attention of a player to an important item. Look at Figure 1-22. In the first version of the scene, you are drawn to the fire and then to all the items in the shadows. In the second version, the red crate draws your attention and clearly means something. Depending on the world logic of the game you are playing, that could simply mean that you can interact with the object, or it could mean that the item is dangerous. That decision brings to our next topic: color expression.

Figure 1-19
The Color Picker in Photoshop has a vertical rectangle of color graduating from red through the colors and back to red. This allows you to select a hue and use the Color Picker Palette to change the value and intensity.

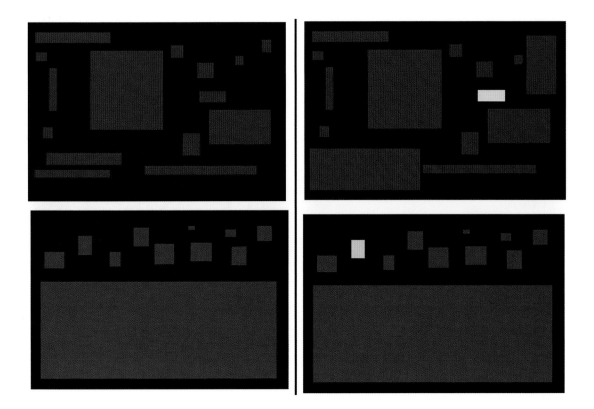

Figure 1-20
All things being equal, the larger shapes dominate, but the small shapes demand your attention once color is added.

Color Expression or Warm and Cool Colors

When you start painting textures and choosing colors, you will want to know how they interact in terms of contrast, harmony, and even message. There is a lot of information on this topic, and once again, Johannes Itten enters the picture (the guy who did the Color Wheel). Johannes Itten provided artists with a great deal of information on how color works and how they work together. Itten was among the first people to look at color not just from a scientific point of view, but from an artistic and emotional point of view. He was very interested in how colors made people feel. From his research we get the vocabulary of warm and cool colors.

We all are familiar with this convention, as it is mostly based on the natural world. When asked to draw a flame, we reach for the red or orange crayon; ice is blue; the sun yellow. Each warm and cool color has commonly associated feelings for it, both positive and negative. The brighter or purer the color, the more positive the association. Darker and duller colors tend to have the negative connotations associated with them.

The warm colors are red and yellow, and the cool colors are blue and green. Children will color the sun yellow and ice blue and use the black crayon to scratch out things they don't like. Traffic lights are hot when you should stop or be cautious (red and yellow) and cool when it is okay to go (green). Red and orange are hot and

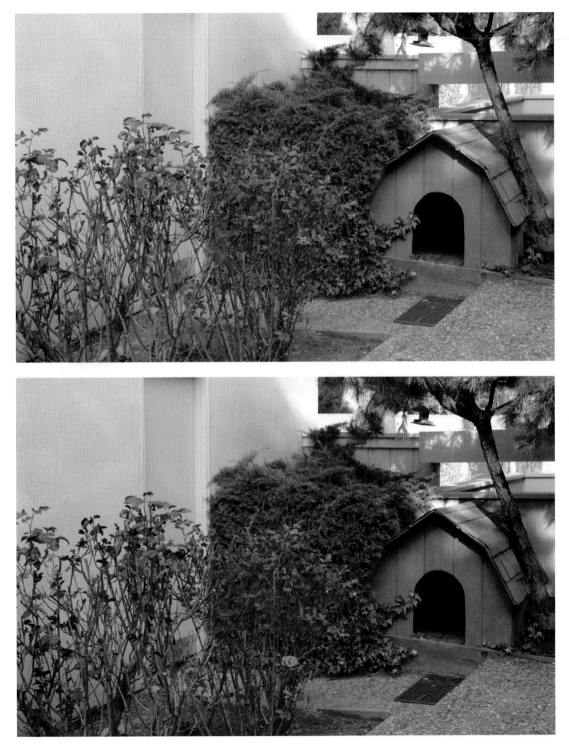

Figure 1-21
Your eye is most likely drawn to the opening of the doghouse in the black and white photo, but add color, and the flower draws the primary interest.

Figure 1-22
In a room full of normal objects, the players' eyes will be drawn to the fire and then equally to the objects. In a room full of normal objects, a red crate draws attention, especially given the fact that there are other normal crates around it.

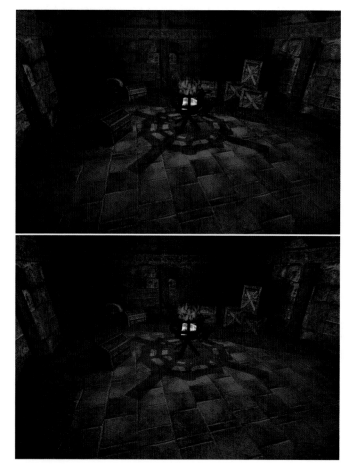

usually associated with fire, lava, and coals. How many red and black shirts do you see at the mall? Red and black together generally symbolize demonic obsession. Red by itself can mean royalty and strength as well as demonism. Deep red can be erotic. Yellow is a hot color like the sun, a light giver. Yellow is rich like gold as a pure color. A deep yellow (amber) window in the dark of a cold night can mean fire and warmth. But washed out or pale yellow can mean envy or betrayal. Calling a person yellow is an insult, meaning that he is a coward. Judas is portrayed as wearing yellow garments in many paintings. During the Inquisition, people who were considered guilty of heresy were made to wear yellow. For green, we think of lush jungles teaming with life. As green washes out, we get a sense of dread and decay (zombie and orc skin). Vibrant green in a certain context can be toxic waste and radioactive slime. Blue in its saturated state is cold like ice; fresh like water and the sky. Darker blues indicate misery. Purple is mysterious and royal.

Keep in mind that color is context-sensitive. Water is generally blue; would you drink dark-green water? But not just any blue will do. In

the real world, if we come across water that is a saturated blue that we can't see through, we get suspicious. Was this water dyed? Are there weird chemicals in there? If anything lives in that, then what could it be?! Blood is generally red, but what if an enemy bled green? What if the game you are playing is about an alien race taking over earth and one of your companions bleeds green from an injury during combat? In a fantasy game, you might come across coins. Which coin do you take: the bright yellowish metal or gray-green metal? With no previous information on the color of coins in this world, most people would pick the brighter yellow. Look at Figure 1-23. What are some of the assumptions you might make about these three scenes?

Looking at color in this way may make it seem a bit mechanical, but it still takes a talented artist to make the right color choices. You can memorize all the information in the world, but it usually comes down to having a good eye and being able to convey that vision in your work and to your coworkers.

Perspective

We discussed earlier in this chapter that dramatic perspective (Figure 1-24) is usually not used in the creation of a game texture, although sometimes perspective is present and needs to be understood. In addition, understanding perspective is not only a valuable artistic tool to have available, but will also help you when you are taking digital reference images and when you are cleaning and straightening those images. We will look at the artistic aspects of perspective now; later, in the chapter on cleaning and storing your assets, we will talk about fixing those images.

Quite simply, *perspective* is the illusion that something far away from us is smaller. This effect can be naturally occurring, as in a photo, or a mechanically created illusion in a painting. You can see samples of this illusion in Figure 1-25. In 2D artwork, perspective is a technique used to recreate that illusion and give the artwork a 3D depth. Perspective uses overlapping objects, horizon lines, and vanishing points to create a feeling of depth. You can see in Figure 1-26 an image and the same image with the major lines of perspective as they converge on one point, called the *vanishing point*. Several types of perspectives are used to achieve different effects.

One-Point Perspective

One-point perspective is when all the major lines of an image converge on one point. This effect is best illustrated when looking down a set of straight railroad tracks or a long road. The lines of the road and track, although we know they are the same distance apart, seem to meet and join together at some point in the far distance— the vanishing point. In one-point perspective, all the lines move away from you (the *z*-axis) and converge at the vanishing point.

Figure 1-23
These three scenes are the same, except for the ax. What questions and/or assumptions run through your mind looking at each version?

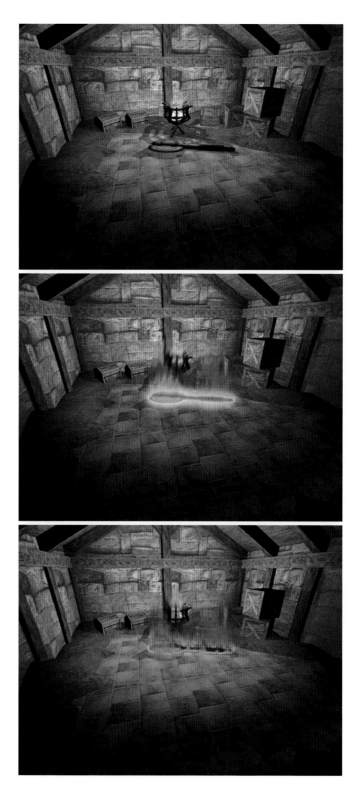

Vertical and horizontal or up and down and right and left lines (the x- and y-axes) remain straight, as seen in Figure 1-27.

Two-Point Perspective

One-point perspective works fine if you happen to be looking directly at the front of something or standing in the middle of some railroad tracks, but what if the scene is viewed from the side? Then you shift into two-point perspective. Two-point perspective has two vanishing points on the horizon line. All lines, except the vertical, will converge onto one of the two vanishing points. See Figure 1-28.

Three-Point Perspective

Three-point perspective is probably the most challenging of all. In three-point perspective every line will eventually converge on one of three points. Three-point perspective is the most dramatic of all and can often be seen in comic books when the hero is flying over buildings or kicking butt in the alley below as the buildings tower above. Figure 1-29 shows three-point perspective.

Figure 1-24
Although dramatic perspective is used in traditional art, it is not used in a game texture. But there is some notion of perspective, so it is best to understand the concept.

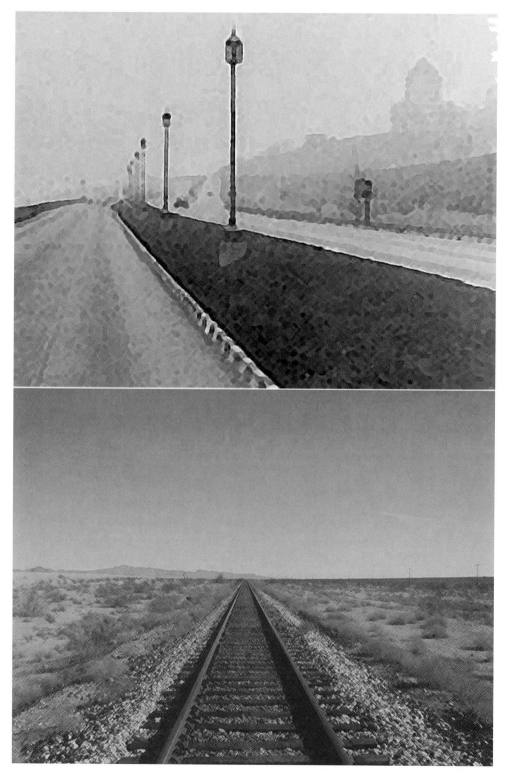

Figure 1-25
Perspective is the illusion that something far away from us is smaller. Are the street lights actually getting smaller in this image? Are the train tracks really getting closer together?

Perspective, from the texture artist's point of view while photographing surfaces for game art, can be the enemy. We will look at that in a coming chapter when I talk about collecting and cleaning your images. From the art education point of view, knowing what perspective is and what it looks like is enough.

Figure 1-26
In 2D artwork, perspective is a technique used to recreate that illusion and give the artwork a 3D depth.

Quick Studies of the World Around You

The following pages display some quick studies that I did of random objects. I tried to work through each of them as a game artist might to give you some quick and general examples of how a game artist might break them down. We will do this type of exercise in more

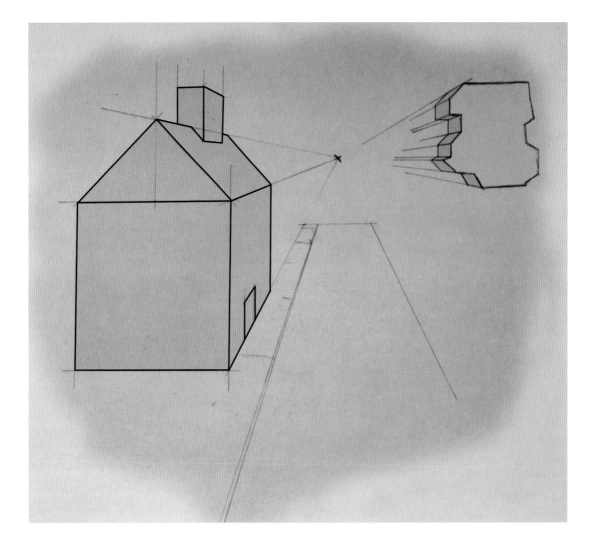

Figure 1-27
In one-point perspective, all the lines that move away from the viewer seem to meet at a far point on the horizon. This point is called the *vanishing point*.

depth throughout the book, but in the tutorial portions of the book, those breakouts will be more specific and focused to the goal at hand. This is a general look and introduction to the thought process of recreating surfaces and materials in a digital environment. I covered all that was introduced in this chapter: shape and form, light and shadow, texture, color, as well as considering other aspects of the object or material. I didn't touch on perspective in these exercises, because I wanted to limit the exercise to recreating 2D surfaces (textures), and perspective is not as critical as the other concepts in this chapter. In the following pages, Figures 1-30 to 1-35 each have a caption that discuss the particulars of each study.

Conclusion

This chapter was an overview of the most basic, yet critical, aspects of traditional art. Understanding the concepts in this chapter, and

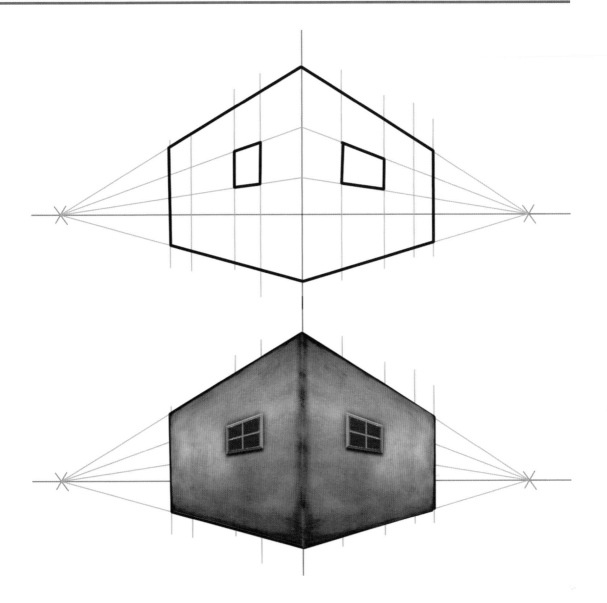

further exploring them on your own, will make you a much better texture artist. We are now ready to get more technical and look at the mechanical issues of creating game textures.

Chapter Exercises

1. Examine and sketch your own series of basics shapes from world objects. Start with a ball, cereal box, and other simple objects, and work up to more complex items (what basic shapes is a car made from?). Pick three different objects and sketch each using only basic shapes. Compare the accuracy of your drawing by holding it at arm's length next to the object in the background. If you are having trouble with this, it may help to use a picture so

Figure 1-28
Two-point perspective has two vanishing points on the horizon line. All lines, except the vertical, will converge onto one of the two vanishing points.

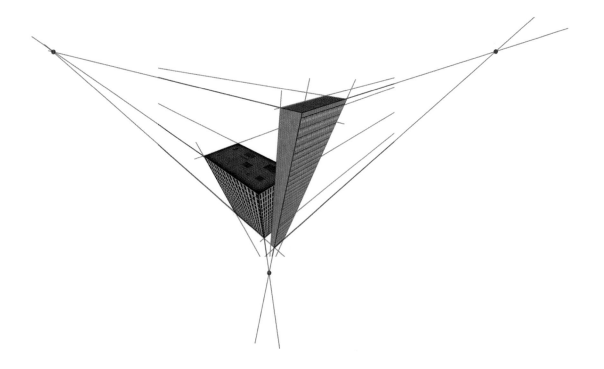

Figure 1-29
In three-point perspective, every line will eventually converge on one of three vanishing points.

that you can work side by side and compare the two images—yours and the original.

2. Train your eye to see light and shadow. Start with a flashlight or one light source in a dark room and shine it at an object on a bare table top. The shadow should be pretty easy to identify. Move the light back and at different angles and watch the shadow move. Now turn on another light source. Is it brighter than the light you are holding? Is it a different color? See how the dual shadows interact with each other. What happens to the shadow when the object is moved instead of the light? Also study how light and shadow affect color. Notice the various shades of color across a surface that may at first seem to be one solid color. Better yet, take an image into Photoshop and sample the various parts of the surface from darkest to lightest and take note of the range of shades the surface holds.

3. Focus on visual texture. Pick any object and look at it closely. A common mistake new artists make is to create a base texture and stop. Well, a perfectly colored, shiny, and cleaner-than-clean plastic-looking object is going to look fake. In real life, even a new object has some texture—if not an actual texture like a leather grain, then a notion of the imperfection of the real world. Sometimes a subtle noise or cloud overlay is enough to create the almost indistinguishable texture that creates a more believable surface. Any object in the real world will have scratches from wear and tear and other signs of use will develop pretty quickly. Study the texture of common objects and see what has created this object's texture. Is a wooden step smooth from use or rough due to weather and decay?

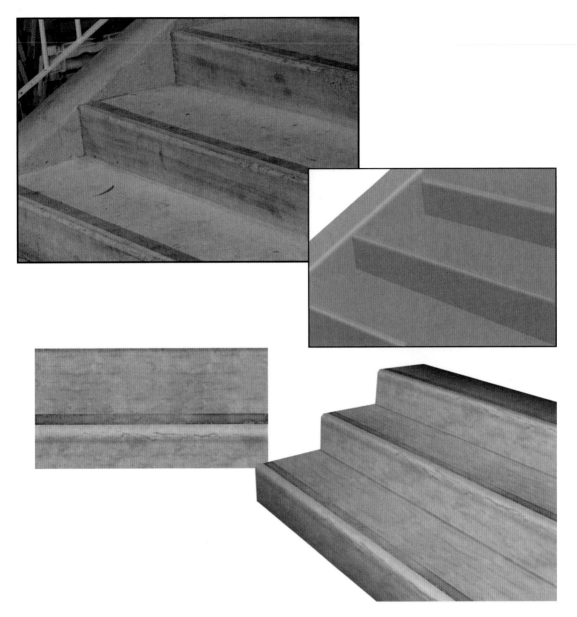

Figure 1-30
The upper-lefthand image is a digital photo of some simple concrete stairs. You might have an art lead email you an image like this and tell you that she wants a texture based on these stairs. Fortunately, this is a rather simple form, not a lot of color or detail to distract us. Look at the simple recreation of the stairs to the right showing the basic light and shadow patterns on the stairs. The lower-left image shows the 2D texture created in Photoshop to be applied to a 3D model of the stairs. If you look at the yellow stripe on the stairs and compare it to the stripe on the texture, you can see the highlights painted in the texture where the edge of the step is and the shadow under the lip of the edge. If you were able to examine the original digital image of the stairs closely, you would see an almost infinite amount of detail. Part of the texture artist's job is to know when to draw the line. Here I didn't include every scuff and mark from the original stair image, because that approach wouldn't work. You will learn in coming chapters that such details usually stand out and draw attention to the repeating pattern of a texture, or in the case of fabrics and fine meshes can create noise or static in the texture. I created this texture pretty quickly; given more time, I would experiment with the chips and wear on the edge of the steps to add more character.

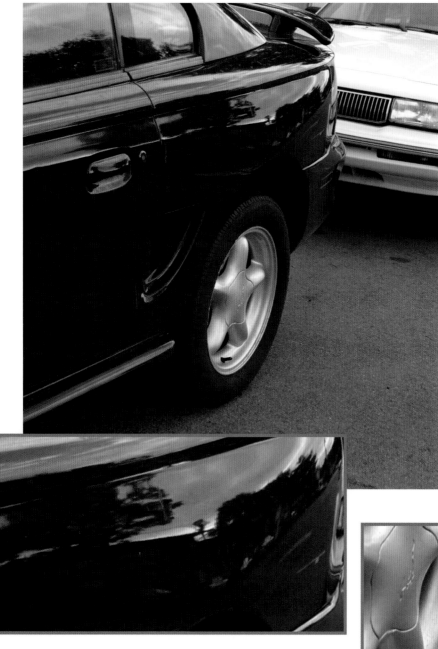

Figure 1-31
This image simply shows the world that I need to wash my car. Seriously, look at the various parts of complex objects and you will see a variety of surface behaviors. Notice how the paint is highly reflective and mirrors the world around the car. The metal is not flat like a mirror, so notice the distortion of the reflected image. The windows, while reflecting the surrounding world as well, are translucent, so you can see what's behind the window and on the other side of the car. The window also has a patina of dirt and spots on it. If you needed to recreate this as realistically as possible, you would have to take all those aspects into consideration and determine the best way to achieve the effect. Look at the close-up of the rim. You can see that the highlights are not mirror-like in their accuracy, but rather are a diffuse notion of highlight. Looks simple to paint, but wheels rotate and will instantly look bad if not painted properly. Using a real-time process for highlights eliminates this problem. Though the tires are flat black and reveal only a faint notion of highlight, depending on the detail level, you may be dealing with complex mapping and shader effects here, too. All of this seems obvious, but taking the time to examine the object you are recreating and understanding what you are seeing and how to verbalize it helps when turning the object into game art. If you were to make materials or textures for this vehicle, you would need to know many things about the technology and how the car will be used in the game. Can we have real-time environmental reflections? Can we fake them using a shader? Do we have to carefully paint in a vague notion of metallic highlights that work in all situations the car may be in? And the windows: can we do a translucent/reflective surface with an alpha channel for dirt? If the car is used in a driving game in which the vehicle is the focus of the game and the player gets to interact up close and personal with the car, then I am sure a lot of attention will be given to these questions. But, if this car is a static prop sitting on a street that the player blazes past, then over-the-top effects may only be a waste of development time and computer resources.

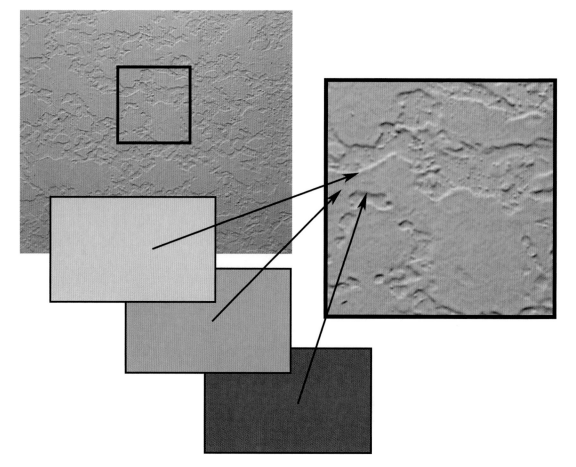

Figure 1-32
This is a straight-on photo of an interior plaster wall. I included this obviously unexciting image to demonstrate that even in such a simple surface, there can be complex highlight and shadow going on. Look at the color swatches of the highlight, shadow, and mid-tone. Notice that the colors are not simple black, white, and gray. The highlight is not pure white or light gray, but a very pale green. Look at the close-up of the image. You can clearly see the consistent behavior of light as it highlights the upper ridges of the plaster and shadow falls from the lower edges. Once you start studying such seemingly commonplace things, like a wall that you walk by a hundred times a day, you will start to notice, understand, and remember how various lights, materials, and other factors affect a surface. Do you convey that simple raised pattern in the texture, using geometry, or a shader? Of course, that depends on many factors, and hopefully by the end of this book you will know what questions to ask to determine the answers.

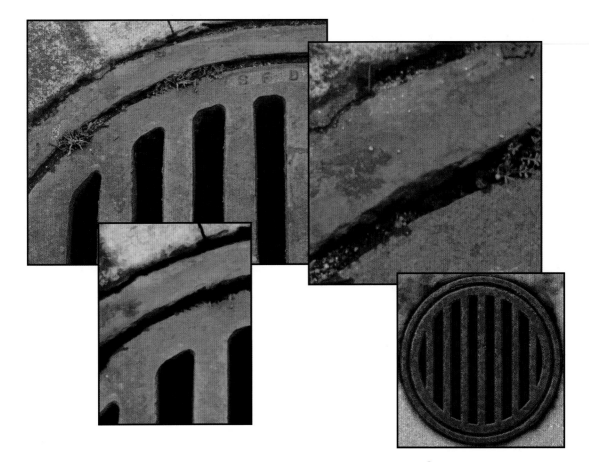

Figure 1-33

This sewer intrigued me: a simple shape of a common item that many might overlook as not worthy of serious attention. Some may have the attitude that it is only a sewer grate, so make it and move on. But a shiny new sewer grate with clean edges would stand out in a grungy urban setting. Look at this sewer grate. It is made of iron and looks solid and heavy. It was probably laid down decades ago and has had thousands of cars drive over it, people walk over it, millions of gallons of rain water pour through it. On the image at the upper left you can look at the iron and see how it is rusted, but so well worn that the rust is polished off in most places. Dirt has built up in the cracks between the grate, the rim, and the concrete. Even little plants have managed to grow. Look at the close-up at the upper right and you can see just how beat up this iron is and how discolored it has become. At the lower left, I desaturated and cleaned up a portion of the image to see just how the light and shadow are hitting it and to get a feel for the quality of the surface. In this image, you can more clearly see the roughness of the cement and the metal, and although the circular grate looks round from a distance, up close there are no straight edges and smooth curves. All this detail can't be depicted 100% in a game texture, but knowing it's there and understanding what you are seeing will allow you to convey a richer version of the grate as you learn to focus on those details that add realism and character. On the lower right is a texture I did, and you can see that I was able to quickly achieve a mottled and grungy look for the metal and the edges. There are a few places at the top where I started the process of eating away at the concrete and the metal a bit.

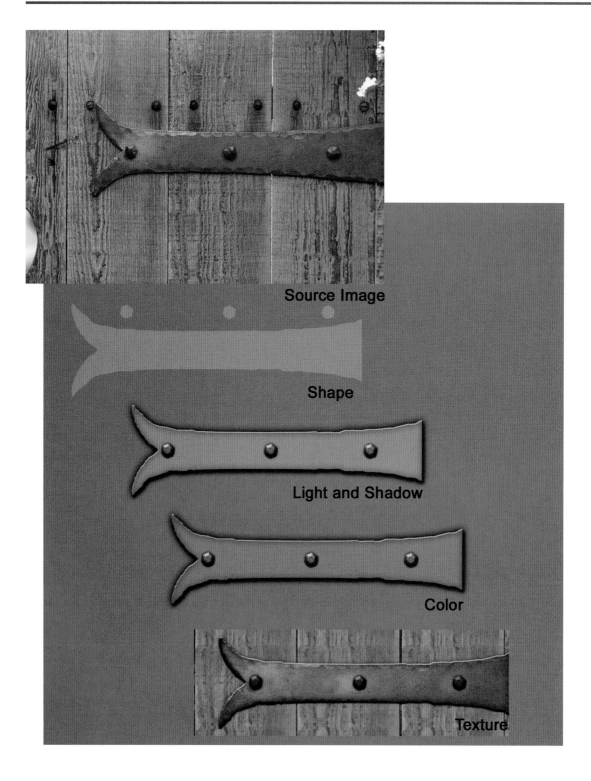

Source Image

Shape

Light and Shadow

Color

Texture

Figure 1-34
This image is similar to the sewer in approach. Here I wanted to point out how a simple shape can be turned into an ornate hinge with little effort. The top image is the original digital photo of the hinge. I drew the shape of the hinge in Photoshop. You may notice that I drew the screws separately. This is because you need the shapes separately to work with them in Photoshop—you will see why later in the book. In Photoshop I applied and adjusted the Layer Effects and then colored the hinge close to the overall color of the original. After that it was a matter of applying the right filters and doing some hand work to get the edges looking right. We will be doing this type of work throughout the book. And I will remind you from time to time that although the best approach may be to use a photo source, or any one of the other methods available, the focus of this book is to help you develop a set of Photoshop skills that will allow you to not depend on any one method. These skills will improve your abilities when working in any of the other methods.

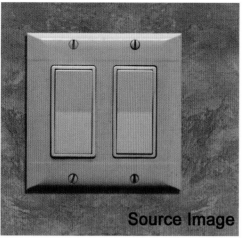

Source Image

Shape

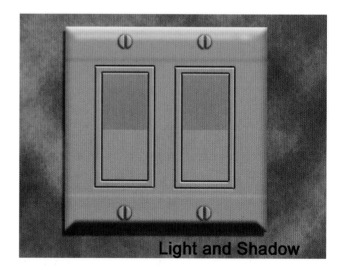

Light and Shadow

Figure 1-35
This light switch is a common object that you might need to create. Instead of taking the time to clean up and manipulate a photo, you can just make one quicker from scratch. The switch is composed of simple shapes with the Layer Effects applied. The wall behind the switch was a quick series of filters run to add a base for this exercise.

4. Look closely at what color you are "really" seeing. As noted in this chapter, we mentally fill in a lot of blanks when it comes to trying to determine what we are seeing. Color is no exception. Look at images from the Internet, or better yet, take digital images with your own camera and load them into Photoshop or similar image program. Sample the colors of various spots and see that almost no color is going to be pure, perfectly even, or at all where you might think it would be on the color selector. A red mug is not going to be a pure red mug; it will most likely be a shade darker or lighter or contain other colors.

5. Color Expression. Can you make a puppy look evil? Try painting its eyes red. Take an image of a garden and desaturate it. What other images can you take and simply change the colors (all of them across the image or only one color) and create various moods and messages. A house with rich amber windows at night might seem inviting. How does a window with a red tint or green cast make you feel? Try combining colors, too. An amber window with a predominantly black surrounding may feel like a lonely sight in the void as opposed to the fanciful and richer blue surrounding.

6. Quick Studies. Do your own quick studies of the world. Take pictures or just examine a surface or object and determine every bit of information you can based on what you learned in this chapter. Define the basic shape, note how light and shadow play on the object and how the object affects the light and shadow of the world around it, and sample and determine the colors of the object and the amount of variation of the color along the surface of the object. How would you begin to create the surface of this object in Photoshop? Don't try yet, but think about it. Later, you will learn the tools necessary to create surfaces, but for now you need to be able to dissect a surface and determine what colors, shapes, and other qualities the surface contains.

Chapter 2

A Brief Orientation to Computer Graphic Technology

Everything should be made as simple as possible, but not simpler.

Albert Einstein (1879–1955)

Introduction

Now it's time to talk technology, but very briefly. You will eventually need to learn a good deal about the technical side of computer art to make the various decisions that technology will present to you, but a brief orientation of technology is all you need to start painting textures. I could have gotten away without including this chapter at all and instead launched directly into painting textures, but I believe that this small bit of information is critical to your long-term success as a texture artist. Learning to button-push from a tutorial may get you good results, but it won't give you the tools to eventually attack your own unique problems when asked to create a texture that will be used in a certain context: genre, platform, and so on. Understanding why textures are constructed the way they are, and why there are certain limits and restrictions placed on the game artist, will help you avoid a lot of wasted time. Later, as you are exposed to more information, complexity, and unique development situations, you will more easily assimilate that information and be able to use it more creatively.

Although creating art on a computer can be limiting, frustrating, and confusing for many people, once you understand the limits placed on you and learn to work within them, you are much more likely to create impressive work. One of the first issues that you will run into is file formats. There are many graphic file formats, and each has many options and features. Each is designed for different purposes, and their complexity and range of options reflect that. We will look not at the formats themselves as much as the options and features most often used by the texture artist. I find that starting with the gross oversimplification that I am just dealing with colored dots somehow helps me keep my mind wrapped around concepts and techniques that can get very complex in their implementation. Keep in mind that at the core, as a game artist you are always working with pixels—colored dots—and a file format is simply the way in which those pixels are stored, even in the case of the PSD file format, which we will look at later. The PSD, or Photoshop file format, saves a great deal of information, but mainly it stores information about pixels and how they interact with each other. I am not trying to oversimplify a very complex subject and application such as Photoshop, but I am trying to tell you that you should not be intimidated with all of the complexity. You can start very simply and assimilate a little at a time, rather than be overwhelmed all at once. Just remember that there is always more to learn, there is always a better and faster way to do something, and you should be having fun. Photoshop, with all of its powerful tools and options, is simply giving you an almost unlimited number of ways to adjust the hue, saturation, brightness, and transparency of the pixels in an image to achieve many different results. One concept, which we will look at in more detail in Chapter 4, is layer blending modes. In

addition to being able to layer images on top of each other in Photoshop, you can control how the pixels in each layer blend with each other. Blending modes are very useful and used often in building textures. Quite simply, when you choose a blending mode, you are changing the way in which a pixel reacts with the pixels below it, thus affecting its hue, saturation, brightness, and/or transparency. The end result on screen is one pixel of a specific hue, saturation, and brightness.

We will look at image size, too. This topic is pretty straightforward, as we will talk about height and width, but knowing how big to make your images involves a bit of knowledge about the technology used, the method in which the world is being built, and how the texture will be used in the world. A texture that is huge, but on a small sign that the player will never go near, is a waste of texture memory. Likewise, a texture that covers 80% of the walls of your level, which the player will spend most of his time running past, probably warrants a much larger image.

And we will talk about the grid. The grid is a bit of a throwback to games that required ridged geometry placement for various technical reasons. Nowadays, in most cases, we can literally build levels any way we like with no regard to right angles and grids, but if we do things that way, we run into problems. The grid is still very important for many reasons and makes building easier. Laying out textures on a grid makes them fit perfectly together, not just one texture tiling with itself, but a set of textures that will fit together when combined in the game world. When you are using a set of many textures you've built on the grid, in a game world built on the same grid, things will match up perfectly and look solid. When the textures and world elements are both built on the same grid, we can also more easily keep track of relative proportions of objects in the world as we work.

We will look at UV mapping. Even though we won't be doing any UV mapping in the book, it makes texture creation a little easier, and the process will make more sense, if you understand how your textures will be applied to the surfaces of the 3D game world. You will see how the textures you create in this book are applied to the 3D scenes they are decorating.

Finally, we will look at shaders at the end of this chapter. Shaders allow a level of realism in games that is stunning and getting better all the time. Very simply, a shader is a mini-program that processes graphic effects in real time. Shaders are used for image effects like hair, fire, shadows, water, reflections, and so on. Although shaders play a huge role in game development, you still need to know basic texture creation to get the best results. Later in the book we actually build the assets for a shader.

Even though this book is focused on creating game textures, it is important to introduce some technical concepts. But looking at every conceivable graphic file format or aspect of technology would be counterproductive, so I will keep it brief.

Common Features of Graphic File Formats

I will discuss graphic formats from a functional point of view rather than list every graphic file format available. Knowing the most common options typically available and used by the game artist is really what you need to know.

Vector and Bitmapped Files

There are basically two types of graphic files: vector and bitmapped. A *bitmapped* file is the native format for the Windows environment and contains pixels (or colored dots). When you zoom in to a bitmapped image, you can see the pixels. Though bitmap is a type of image, a bitmapped image can be one of many different formats. Game developers deal almost exclusively with bitmapped images and the options associated with them, so they will naturally be our focus. There has been some gradual adoption of vector-based images in UI (user interface) and menu construction in the form of fancy menu and UI systems, but these are very much like Flash-based sites on the Internet and are built in the same manner. Game content in a 3D game is still almost exclusively bitmapped.

Source and Output Files: Distinctions

There is a distinction between the format of the output file (game-ready art) and the format of the original (source) file. The source file is what the game artists create in Photoshop using large image sizes and many image options. They will then output a copy of that image and resize, convert, and optimize it. In actual production you will almost certainly work in Photoshop's proprietary file format (PSD) as the source file; these files get very large. Your source image will always be larger and of higher detail than the output file. The PSD file format is very flexible and saves a large amount of information. The output file—the game-ready art—is much smaller.

This book is focused on the creation of the flexible source file in the PSD format. When the time comes to output any of these images for use as a texture in a game, you will determine the size, format, and other details about the final image. The image you see in a game may only be 256×256 pixels (you can often see the pixels if you look) but is most certainly a smaller and more optimized copy of the original PSD file. Although the smaller compressed game image may be 43K in file size, the original PSD file may easily be 40 megabytes or larger. Photoshop saves lots of other data specific to the PSD format and useful in image creation such as layers, levels, alpha channels, adjustment layers, layer effects, text layers, layer sets—and a great deal more, even audio files and attached notes. Don't let all this confuse you; you will be introduced to the PSD file later.

Warning: One mistake that many new artists make is to work in Photoshop on a source image, forget they are editing the source, and then resize and convert the original and save it. Once you do that and close the file, you can't go back. When you are later asked to alter that image, you have only the small, low-detail version to work with. You will see exactly what I am talking about later in this chapter with the introduction of layers.

Choosing a File Format

I use (and recommend) the following four criteria to choose a file format for output:

- **What looks best.** This is the most important consideration from the artist's point of view but often changes as a result of the other, equally important criteria.
- **What the development technology requires.** Quite simply, if you don't generate assets to the specifications the game engine requires, it may not run at all. Some game engines require that a list of specifications be met in terms of size, ratio, color depth, format, and so on. Some technologies may require the use of an exporter or converter to generate textures in a proprietary format. Still other technologies will take whatever you throw at them without complaining and then simply squish, resize, compress, and otherwise alter the texture to suit its needs.
- **What the target user system requires/will support.** Making a game that will run only on the most powerful computer that money can buy will severely limit your audience. If you are id Software (the creators of DOOM, Quake, and so on; I don't have to tell you that, do I?), you can pull this off, as people will actually upgrade their systems to play your game—I literally just spent $1,600 building a new computer so that I could play a $50 game. But that case is of course the exception and not the rule. Most developers must determine what computers their audience will most likely be using when their game is released. Console developers know almost exactly what they are developing for in terms of hardware configuration, but PC developers have to make complex decisions that always leave someone unhappy. Due to the vast variations in power, configuration, and compatibility of all the PCs in the world, it often requires developing significant amounts of technology and additional assets to deal with these differences by offering the user many configuration options. Or you develop to the least common denominator, knowing that you are not creating the best game you can because you are not developing for cutting-edge hardware. But game play is king, so often a low-tech game will break out on the sales charts.
- **What your boss tells you to use.** I am not trying to be flip with this fourth one. There may be circumstances when a superior tells you what format an asset needs to be, and usually the reason is

logical. You can ask why or simply obey, but I don't advise ignoring the instructions.

Format Options

Here are some of the most commonly used and critical features of graphic formats that game artists use most. As you work on different teams using different development technologies, you will learn about the numerous file formats available and the options specific to each format. But the core functionality of these files will be fundamentally the same. So understanding the basic information presented here will make the adoption of those varying formats and their options much easier.

Note to Second Lifers and other virtual world creators: Keep in mind that in most computer games, the final form of the texture you create is what is used by the engine, but in many online worlds no matter what the texture is when it leaves your computer, it is common that it will be resized, converted, and compressed on the server to make things work smoothly in the virtual world. So, if the texture that you created looks terrible in the world, it may be that it has been heavily processed on the server side.

Compression

Compression is simply making a file smaller in size. It's easier said than done for a programmer. Creating compression routines that don't ruin visual quality is of course a complex programming task, but as artists we deal with compression primarily on a visual basis, judging whether we like the quality of the compressed image. We will make sure that our file meets the technical requirements and then press "Save As" and we are done. Most game artists will learn more about the various compression schemes and their options so they can create the smallest file size with maximum image quality.

Some image formats use absolutely no compression, preserving the image in its original state and losing no data. These are called *lossless*, whereas a *lossy* format will allow compression that strips out and reorganizes data in various ways and results in data loss for a smaller file size at the cost of visual quality to varying degrees. Compression is almost exclusively used on the output file and not used on the source asset, because it degrades quality. In Figure 2-1 you can see some examples of what image compression can do to an image.

Alpha Channels

Alpha channels are simply black-and-white or grayscale images. These images can be used in different ways, but typically they are used for transparency or masking. In other words, an alpha channel can make a portion of an image completely transparent or

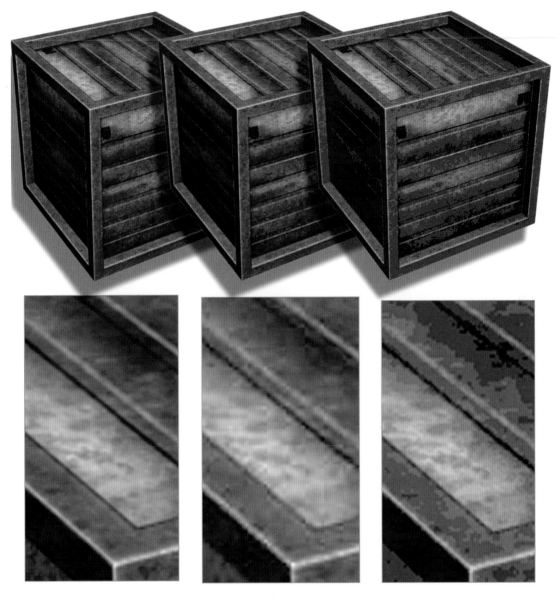

Figure 2-1
Here are some examples of what compression can do to an image. On the **upper left** is the original uncompressed image, in the **middle** is a moderately compressed image, and on the **right** is a highly compressed image. **Below** are close-ups of the three images. Notice how the middle image appears to have a pattern of squares over it. This is due to the compression scheme. The image on the right has had many colors stripped out, so the image is very small, but lacking many colors looks blotchy. You need to know how close the player will get to this image to determine how small and compressed you can make it.

(depending on the quality of the alpha channel) semitransparent. In Figure 2-2 you can see a very common use for the alpha channel: foliage. The use of the alpha channel extends to other objects as well, objects that have details that would be better created using the alpha channel method rather than modeling the detail. Wire fences,

Alpha in use in scene

Figure 2-2
An alpha channel is typically used to make parts of an image transparent. Here you can see how a few polygons and one image can make these ferns look complex and organic, because we can make parts of this image transparent.

tree branches, and other real-world objects are often created using alpha channels and so are effects like muzzle blasts and scorch marks. Because alpha channels can give a semitransparent property to a model, they have been used on ghosts, water, fire, and other ethereal effects. Look at the ferns in the previous example. The use of alpha channels allows for much more complex and realistic shapes than can be efficiently created in 3D in some cases. If you modeled each fern in 3D, there would need to be so many polygons as to be impractical, the other option being terribly "geometric"-looking ferns if modeled using a low number of polygons.

When "Saving As" or "Exporting" an image from Photoshop, you need to make sure that the format you are saving to supports alpha channels; otherwise, that information may be lost. Typically, alpha channels are preserved in many formats, but not all formats. Keep in mind the distinction between exporting to a format, which typically means that you are creating another version of that file, and saving a file. As mentioned previously, if you resize and degrade your source asset and save the file, you will lose the ability to easily alter and re-export the asset. Usually the "Save As" or "Exporting" function will warn you about the potential for loss, or tell you the options available to you in that format. In Figure 2-3 you can see on the "Save As" window that this file being saved as a JPG is warning the user that layers and alpha channels will not be preserved.

Sometimes the alpha channel or mask is part of the file format, and sometimes it is a separate image. In low-quality transparency schemes, it is sometimes only a certain color in the image itself that determines what part of the image is see-through, and there is no separate mask or alpha channel. You can see examples of these types of alpha in the very next section on DDS format and DXTC.

DDS Format and DXTC (Output Format)

This is a common file format that game developers output. DDS stands for Microsoft DirectDraw® Surface file format. This format stores textures as well as a lot of other information that is used in-game for various reasons that are both technical and visual in nature. DDS is the file extension, and the compression scheme is referred to as Direct X Texture Compression (DXTC). Several tools allow you to save in the DDS format using DXTC. Douglas H. Rogers, in the Developer Relations group at NVIDIA, develops Texture Tools that support DXTC and stores textures in the DDS format. The developer pages on the NVIDIA web site contain many useful texture manipulation tools and a mountain of information for programmers and content creators:

http://developer.nvidia.com/ (NVIDIA's developer web site)
http://developer.nvidia.com/object/nv_texture_tools.html (Texture
 tools)

Figure 2-4 shows the NVIDIA DDS tools interface. This is an easy-to-install plug-in that allows the exporting of the DDS file format from Photoshop. After you select "Save As" in Photoshop and select the DDS format, the NVIDIA tool activates. On the Texture Tool interface, you will see a lot of options available for the output format of the image and tools to view the choices you make. There are options for compression, MIP map filtering, sharpening, fading, normal map creation, and more. We will discuss only the compression options here, because the other options are out of the scope of this book. Suffice it to say that you have a lot of control with this tool. Among the various options, the two you will be most concerned with are compression and the alpha channel. You can decide to compress an image a great deal (8:1) if you can get away with it visually, or use

Figure 2-3
Typically, "Saving As" or "Exporting" in Photoshop will warn you about information that may be lost, such as this file being saved as a JPG. The warning is that layers and alpha channels will not be preserved.

no compression if you want the highest possible quality. There is also a 3D preview window so that you can see various versions of the texture before you save the image to disk. You can zoom, rotate, and move the image in the window, and you can even assign a background color or background image to the preview window. By choosing the background, you can see your textures in context. It only makes sense that if you are developing a texture with an alpha channel—the bars of a cage, for example, that sits in front of another texture, maybe a dark stucco wall or bright canvas tent—it helps to see the two textures together. This method makes

Figure 2-4
This is the NVIDIA DDS tools interface, an easy-to-install (and very useful) plug-in that allows the exporting of the DDS file format from Photoshop. After you select "Save As" in Photoshop, there are many options and tools to view various versions of the file before committing to the version of the file you want to export.

workflow much faster, as you can see what you are getting before you commit to exporting the file, checking the results, exporting again, and guessing each time as to whether you made the proper adjustments to the image.

The DXT compression scheme can reduce texture size eightfold (fourfold if there is an alpha channel). In my experience, they still look really good, especially considering the reduction in file size. You must examine both the visual and technical results of any file you output, and that's where the NVIDIA tools really come in handy. In general, the DDS format allows for the highest quality and most efficient output of assets and gives you the tools to make that balancing act much easier. There are many options, but most likely you will use four main compression options: DXT1 (with no alpha), DXT1 (with alpha), DXT3, and DXT5 (both have alpha).

DXT1 with no transparency is the most compressed of the choices and results in the smallest file size.

DXT1 with alpha transparency offers a simple version of alpha with an on/off alpha transparency scheme (which is not supported by some game engines). In this scheme the pixel is either completely transparent or completely opaque and results in jagged edges in the image. Consequently, this compression scheme has limited uses.

DXT3 and DXT5 have more refined alpha channels, and both result in a larger file size. You can see in the previous figure of the DDS Viewer that the file size and compression scheme used are displayed below the image. These image sizes are larger, because this format saves the alpha channel as a separate image inside itself. In case there is any confusion, you are effectively doubling your image file size because of the alpha but not the pixel dimensions of the image. Both these schemes result in the same file size. Then why the two choices? Though each has the same color compression scheme, they have different compression schemes for the alpha channel. They will each generate good or bad results depending on the texture. You should visually compare how the alpha looks in each format to choose the right one, but when given the choice it is safe to say that you will be using DXT5 the most. The tool makes this visual comparison very easy. The example in Figure 2-5 shows a window with fine granularity in the alpha channel so it requires DXT3 or DXT5. You can see that the less-refined alpha scheme of DXT1 simply will not work on the window. But if you were doing a texture, such as a grate or vent, where a very exact edge between opaque and clear exists, then DXT1 will do the trick. These formats are still lossy compression schemes, meaning some data are lost from the original image.

In general, when using the NVIDIA texture tools, you should always try to compress your textures as much as possible. Use the tool and compare the various images side by side. You will find that DXT1 compression is very good for a lot of images and can save a ton of your texture memory budget, thus allowing you to possibly use

Figure 2-5
DXT1 uses a more compressed and simplified scheme for transparency that does not always work well in every situation. If you were doing an object where a very exact edge between opaque and clear is needed, then DXT1 would work. The grate in the upper lefthand corner works using DXT1, but the window, which requires a much finer alpha channel, needs DXT5. The file sizes of the two window images are displayed below them. It may be hard to read in the printed version, but they are **left** 87K and **right** 174K.

more textures in the game. Of course, if you need an alpha channel, use DXT5 or DXT3.

Explore the options in the texture tools if you like; you will find a lot of them. Don't let yourself get overwhelmed, though. You know what you need for now and 80% of what you will most likely need to know in the near future.

PSD Format (Photoshop/Production Format)

PSD, as mentioned earlier, is the native file format for Photoshop and usually the production format of choice for game developers. This format's file size can get quite large, as it retains a lot of information in a very flexible way so that the artist can easily go back and tweak, or even drastically change, the art and re-output a new file quickly. One of the features of the PSD format that makes it so large and flexible a format is layers. We will use layers quite extensively throughout the book, as well as many of the other numerous tools and features available in Photoshop. This section provides a quick introduction to the concept.

The functionality of layers is one of the first options you will come across in Photoshop. This is an option increasingly available in other formats used by high-end 2D paint programs. Storing an image in layers means that you can effectively store many images on top of each other and control how each layer affects the one under it. Imagine one image being a megabyte in size and storing a stack of those images on top of each other. That is one reason that this file size can get so large. In Figure 2-6 you can see the Layers window as it appears in Photoshop. This is the window that lets you move and manipulate layers and is not the actual image. The stack of layers on the right is an illustration of the concept of layers and doesn't actually appear in Photoshop that way. What you see in the Photoshop image window, the actual image you are editing, is what the final image will look like, whether it is in layers or flattened.

Flattened means what it sounds like. When all the layers are reduced to one layer, the image becomes one layer—one image. When this happens (if you save your file and can't undo the Flatten operation), you lose all flexibility. Notice that in the Layers window the layer named "Dark Stucco" is turned off (there is no eye icon next to it like the others), so this layer, while actually in the file, is not visible and not part of the final texture as a result. Also notice that the layer "Horizontal Beams" is on top of the layer "Vertical Beams" and these beams have that relationship in the final texture. I output the final texture, which you can see at the lower left of the figure. Layers are critical in texture creation, because they allow you to build textures in an easy and effective way and to keep the layers separate so the texture can be adjusted and modified and quickly output again. In Figure 2-7 you can see several examples of how layers are used in Photoshop. Imagine if this layer were flattened and I wanted to remove an element that is part of the final image such as the horizontal or vertical beams, or the cracks. It would be tough: I would essentially have to rebuild the texture instead of clicking a layer on and off.

The Power of Two and the Grid

Now we will speak a bit about working with 2D images that are meant to be used in a 3D space, like a game world. Most game art

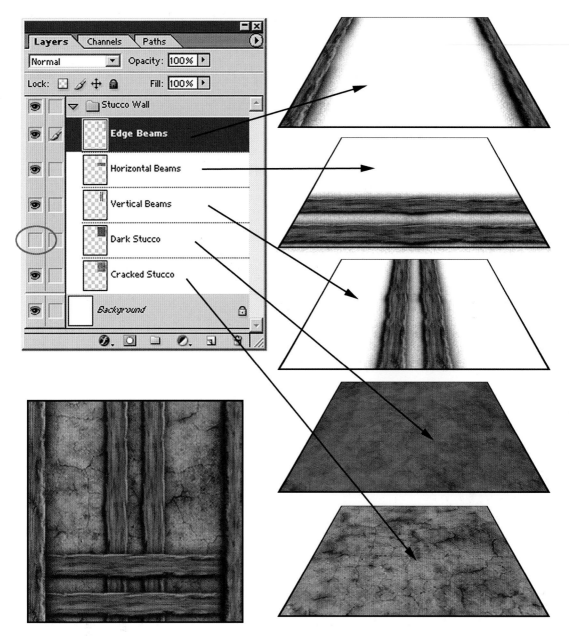

Figure 2-6
At the **upper left** is the Layers window as it appears in Photoshop. This tool allows you to move and manipulate layers. The stack of layers on the **right** is an illustration of the concept of layers and doesn't actually appear in Photoshop that way.

books talk a lot about image resolution, and that is an important topic, but for now all you need to know is that you are restricted in most games to a certain image size. When you create a 2D image for a game, you will always have parameters, restrictions, and rules that you must follow, and they can range in number from a few to many. Where you are working, what technology you are using, and

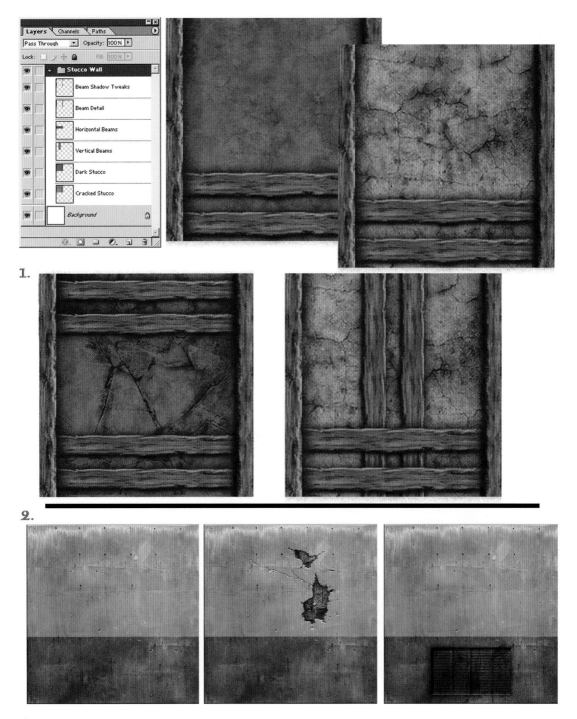

Figure 2-7
Here you can see two examples of how various textures were built up using layers in one file and, furthermore, how layer control allows for the modification and quick output of a texture.

even what type of game you are making all contribute to
determining those specific parameters and guidelines. The most
basic and general requirement for game art is that you must make
your textures a power of two in size, which means that the images
must be a specific number of pixels in height and width. These sizes
are typically as follows:

- 16×16
- 32×32
- 64×64
- 128×128
- 256×256
- 512×512
- 1024×1024

Next-generation games now under development are commonly
using 2048×2048 maps.

Note that a 512×512 image is four times as large as a 256×256
image, just as a 256×256 image is four times larger than a 128×128
image. Sometimes the fact that the power of two numbers are twice
as big as the previous number throws some people off. The fact that
$256 \times 2 = 512$ makes it seem logical on the surface. But look at
Figure 2-8 for a visual representation of this concept. Understanding
that concept, you can see that a 512×512 has four times the pixels
of a 256×256 image. Not long ago, a 512×512 image was
considered a large texture. We are already using 1024×1024 images
as a standard size and frequently go up to 2048×2048. Add to that
hardware and software advances and the jump in visual quality of a
game is simply incredible. Maybe more so to those of us who have
watched game technology creep along at first, explode, and then
keep growing exponentially. The advances are across the board and
most contribute directly to the visual quality of a game: rag doll
physics, more complex and refined animation tools, improved AI,
more complex yet easier to use particle systems—the list is very
long.

Back to the power of two and the first question that most people
ask: "Why must we make our textures a power of two?" The
simplified answer is that most computer game engines and 3D cards
require a texture to fit certain criteria because they can process and
display them faster. Most game engines do not restrict texture size
to a perfect square. Rectangular sizes like 256×512 and 128×1024
are usually acceptable. I started the list of sizes at 16×16, but most
game engines today don't even use textures smaller than 32×32,
and that's usually for particles and small decals. Plugging in an
asset with the wrong parameters can cause an error message, the
asset will be ignored, and some engines will even crash. Some
engines/game tools might even take the asset and alter it so that it
will work: changing size, format, color depth, and so on.

The "power of two" limit actually doesn't exist in the code of many
3D graphics engines but is still commonly imposed on game
developers for various reasons. I believe that you can already use

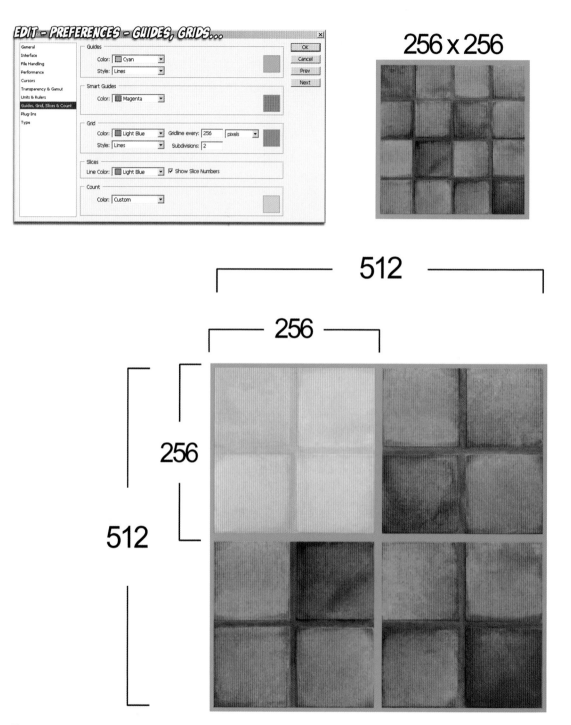

Figure 2-8
A 512×512 image is four times as large as a 256×256 image, not twice as large. The fact that the number 512 is twice as big as 256 sometimes throws people off. I used an image of some tiles so you can see the relationship. The 256 image overlaid takes up one-fourth of the area of the 512 image.

non–power of two textures in certain engines, but I would still stick to the grid for most of the work unless in an uncommon situation where I need to use a non–power of two texture. Maybe I am biased and simply used to working on the grid, but I believe that it makes building a game easier for everyone involved from the texture artist to the level designer. That takes us to the next point about the grid. Aside from technical reasons to use the power of two and a grid, there are productivity issues.

So your images need to be certain pixel dimensions for technical reasons (currently, they won't work in most game engines if they aren't exact), but it also helps in production to work with these standard sizes. Most major game world editors (the software tool that you use to build the game world) use a grid system based on the same power of two dimensions. If you lay out a hall with a floor that is 256 units wide in the world and place a 256-pixel image on that floor, you are going to get a perfect fit. You can also make the texture 512 and scale the UV mapping down by exactly 50%, and once again, you will get a perfect fit. You can use an image of a tile that is only 128 pixels and UV that across the floor in a repeating pattern and get a perfect fit, too. This makes everyone's life easier, because you are not guessing, eyeballing, and trying to calculate how to make various-sized images fit in odd-sized spaces.

When working in Photoshop, you can use the grid tool to lay a grid over your workspace to subdivide a power of two texture into smaller power of two units. We will talk about how to do that later on in the book, but for now just know that Photoshop allows for the placing of grids and guidelines over your image that are not part of the art, but are tools that help you keep things straight. For a game developer this functionality is very useful—you just have to remember to set your grid spaces to the power of two. In the commonly used 3D packages like 3ds Max and Maya, you can also set up a custom grid to these dimensions. The result is that the models, textures, and world space are all built on a standard grid, giving the developer consistent units and sizes. A simple example would be the creation of an object for a game decoration, such as a doorway arch. If the texture artist creates a texture for the arch that is 512×1024 and the modeler makes the model of the arch on a grid and creates the arch model 512×1024, the image will fit perfectly over it. I left out the third dimension of depth in the model for this example to keep things simple. That textured model will then fit perfectly in a 512×1024 doorway that was built on the grid in the game world. Figure 2-9 shows the visual for this example.

Another reason for creating visual elements within a texture on the grid is so that they line up with each other even if they are on different textures. For example, in many first-person shooters, the height of a stair is 16 units (a power of two). Therefore, if you make a wall texture with a floor molding 16 units high, it will look much neater when the wall molding runs into the stairs. Even though the real world is often put together in a way that defies these guidelines, that is no excuse to allow those mistakes in a game. In a game those are mistakes and they are noticeable and not looked

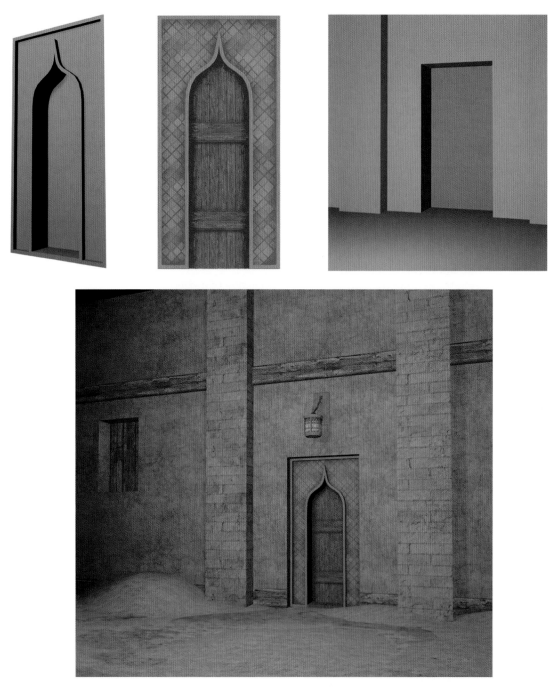

Figure 2-9
A texture created on a grid will fit perfectly on a model created on the same grid, which in turn will fit perfectly into a game world built on the same grid. In this case, the arch model (**left**) is 512×1024, the texture (**middle**) is also 512×1024, and the boring doorway (**right**) that we are trying to fill in the game world is of the same dimensions. You can see all the elements together in the image at the bottom.

upon as a faithful recreation of reality. In the real world, you will see wallpaper that wasn't hung correctly with seams that don't meet up with each other, or a brick wall that was repaired with bricks that don't match in color, grass that has been laid down in squares by a landscaper and are visually tiled, and other messy real-world examples. In Figure 2-10 you can see a simple texture set applied to a game setting and see how all the various textures fit with each other on the various surfaces of the room.

Although some artists view the grid as a limit, others appreciate it as a tool. And given the fact that we are not bound to it nearly as much as we were just a few years ago, it is more of a tool now than a restraint. Working on the grid helps the world stay consistent and look better, and frankly, you can work much faster. This is called modular design. Modular design is very important when you work on a computer game. A computer game requires efficiency and organization. No matter how powerful computers get, you always want to squeeze out every ounce of performance you can. The best way to do that is to use only the textures you need, no more and no less.

Modular Design

In the context of texture creation, *modular design* is the art of designing and creating your textures so that they will all fit together. This starts with simple tiling and moves into the next realm of advanced tiling, which we will, of course, cover in Chapter 4, "Prepping for Texture Creation." In the real world, a great example of modular design is office furniture. You can buy the core desk and add hutches, lighted cabinets, extensions, and on and on. All these parts are designed to fit together, allowing you to create hundreds of combinations, thus ending up with a desk very unique and fit for you. Add to that the ability to swap textures—I mean, select the color and finish you want—and you end up a huge variety of options.

Earlier, you saw an example of *texture modularity* with the set of textures based on a brick and tile with variations that all fit together. The base brick wall covers most of the surface of the game world. To make that space interesting, I added trim, cracks, a baseboard, a vent, and other details. As we progress, you will become very familiar with the concept of modularity. Modularity extends to all aspects of game design, and 3D modelers often create modular chunks of a game world that can be copied and arranged. Typically, modelers start with the large common and repetitive chunks like floor panels, wall panels, ceiling panels, and other repetitive large world geometry, and then move into decorations such as columns, lamps, and special case meshes. They may even create versions of the large modular chunks with damage like cracks or holes in them. The power of two and the grid are both limits and tools for creating clean, solid levels. In Figure 2-11 you can see the base 3D parts of simple level set, in Figure 2-12 the parts are assembled into a room and hall, and in Figure 2-13 the room and

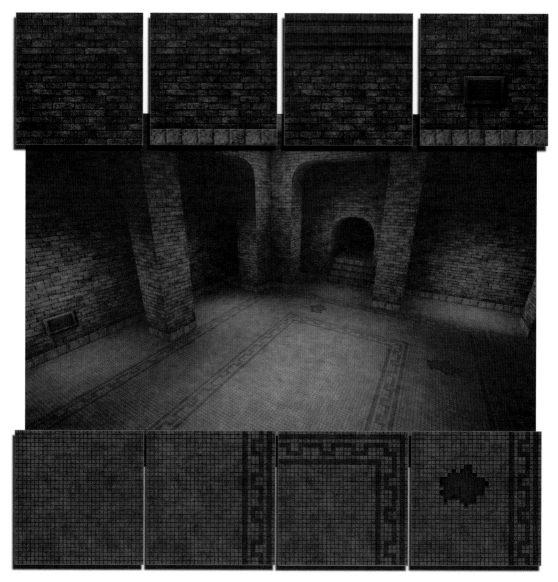

Figure 2-10
This texture set of eight textures was built off two base textures: tiles and bricks. Building everything on the grid in Photoshop and 3ds Max allowed for the seamless tiling of the entire set. Notice the pattern that runs through the floor and how it meets at every turn. I was able to rotate the tile with the corner pattern on it and have it still match up to the others. It is pretty easy to tile tiles, I admit, but by making sure they met up properly in Photoshop, I was able to use one corner pattern tile instead of four.

hall are textured. In Figure 2-14 you can see an additional example of modular design. The castle wall is actually two pieces: one undamaged and one damaged.

As you create textures on a specific project, you will find that in most instances there are many other parameters to consider besides the grid, but these concern the final output file more than

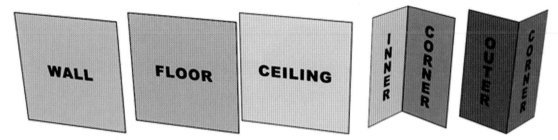

Figure 2-11
These are the basic 3D pieces of geometry for building a modular level.

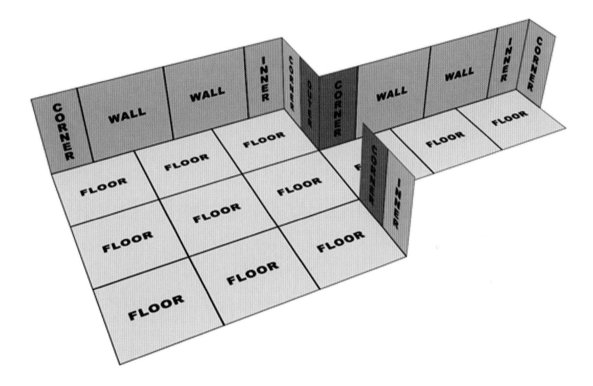

the source file. Although the grid must be considered as you build, things like the largest and smallest file size that the engine can handle, the total texture memory you are allotted, and other technical details are pretty much reserved for after the texture is created and pertain to the output file.

As a side note on technical limits, just because there is a maximum texture size a game engine can handle doesn't mean that you should use a lot of textures at the maximum size. A large image on a small object, or one that a player never sees close up, is just a waste of resources. In fact, though some game engines demand very specific input parameters, others allow for multiple color depths, variable file sizes and resolutions, and even differing

Figure 2-12
Here the base pieces are assembled into a simple room and hall.

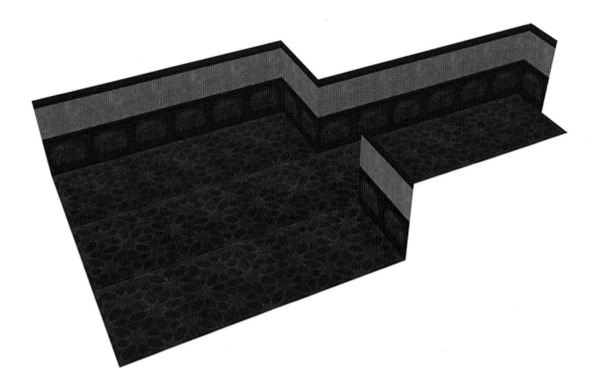

Figure 2-13
The simple room and hall,
textured.

formats. Knowing your engine is important, because you can cut file sizes significantly with little to no loss of visual quality simply by knowing what options you have.

There are always going to be limits imposed on you by development technology, game design, target audience, or even genre. Certain texture size is currently just one of those limits. Most importantly, knowing those limits and what you can do to work around them makes you more valuable than just a great artist. If you are able to experiment with file size, compression, color depth, and so on and are able to get twice the number of textures into the game, you will not only free yourself up to do more as an artist, but you will also be much more valuable as a developer.

UV Mapping

All the textures that you create will end up being mapped onto a 3D object. *UV mapping* at its simplest is the process of placing a 2D texture on a 3D mesh. We will look at the various ways textures can be placed on a 3D object.

Note that there is a distinction between a texture and a skin. A skin is the art that goes on a more complex model such as a character, monster, or weapon. Skins are generally not tileable and are created for a specific mesh. A texture is generally the art that covers the game world surfaces: grass, floor tiles, walls, and so on, and UVing these surfaces is much simpler than skinning an organic model. You

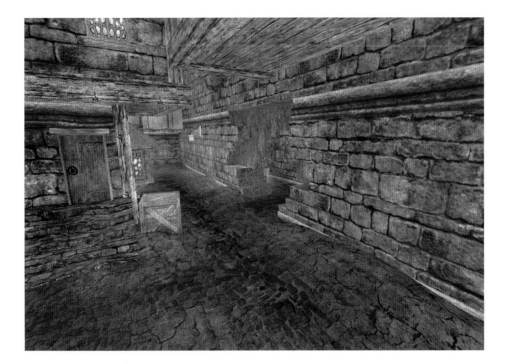

will not be applying your textures to any 3D meshes in this book, but you should understand the various UV mapping types since it can affect how you create your textures in some cases.

Mapping Types

Planar

Planar mapping works like a projector. The texture is projected onto the 3D surface from one direction. This method can be used on walls and other flat planar surfaces but is limited and can't be used on complex objects, as the process of projecting the texture in one

Figure 2-14
Here is an example of a modular piece of geometry. There are two sections of castle wall: one is undamaged and one has a gaping hole in it. They were built on the grid, so they meet up perfectly. The wall here is several normal wall sections lined up with a damaged section in the middle.

direction also creates smearing on the sides of the 3D model that don't face the planar projection directly. See Figure 2-15 for an illustration of the planar UV mapping type.

Box

Box mapping projects the texture onto the model from six sides. This method works great on boxes! This mapping scheme can be useful in some varying situations if you plan for it. Obviously, you can use it on more complex boxes, and if you design on the grid you can make things work to your benefit. In Figure 2-16 you can see how the box mapping type works in the upper lefthand corner of the image. At the top right is a rusted box texture and a close-up of the edge of the texture. I made the edge of the box exactly 16 units wide in the texture. Now look at the box model below that. It has an edge that is exactly 16 units wide as well. I can use box mapping here, and the fact that the texture is projected straight through the model causes that 16-unit edge of the texture to map perfectly on all the edges of the outer and inner rims of the box. The lower righthand corner has a close-up of the box and you can see how the highlights and all the edges meet cleanly.

Spherical

Spherical mapping surrounds the object and projects the map from all sides in a spherical pattern. You will see where the texture meets along the edge unless you have created a texture that tiles correctly. Also, the texture gets gathered up, or pinched, at the top and bottom of the sphere. Spherical mapping is obviously great for planets and other spherical things. See Figure 2-17.

Cylindrical

Cylindrical mapping projects the map by wrapping it around in a cylindrical shape. Seams will show if you have not tiled the texture properly. Cylindrical mapping can be used on tree trunks, columns, and the like. See Figure 2-18 for some examples of cylindrical mapping.

Those are the most basic UV mapping types and are the most common ways that world textures will be applied. Actually, world textures are mostly planar or box mapped onto the faces of the world. Applying these standard UV mapping types is pretty straightforward and usually automatic in the game editor and can be easily changed by the level builder.

Game Optimizations

A computer game must look good and run well. This is a game artist's mantra. Until you have tried to accomplish this goal, you have no idea how much at odds these objectives are. Although the

Figure 2-15
Planar mapping projects the texture onto the 3D mesh from one direction. This can be used on walls and other flat planar surfaces. However, it is limited and can't be used on complex objects. Projecting the texture in one direction creates smearing on the sides of a 3D model that don't face the planar projection directly.

16

Figure 2-16
Upper left, how the box mapping type works. **Top right,** a rusted box texture and a close-up of the edge of the texture. The edge of the box in the texture is exactly 16 units wide. The box model below has an edge that is exactly 16 units wide as well.

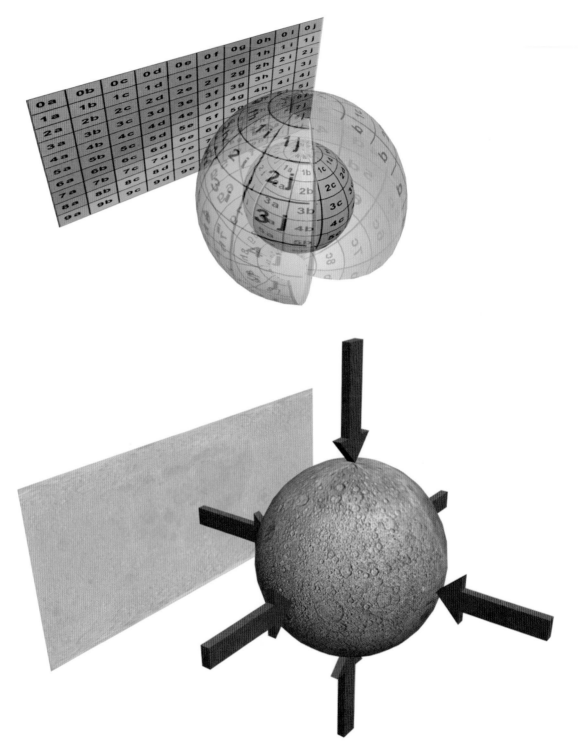

Figure 2-17
Spherical mapping surrounds the object and projects the map from all sides in a spherical pattern. You will see where the texture meets along the edge unless you have created a texture that tiles correctly. Spherical mapping is great for planets.

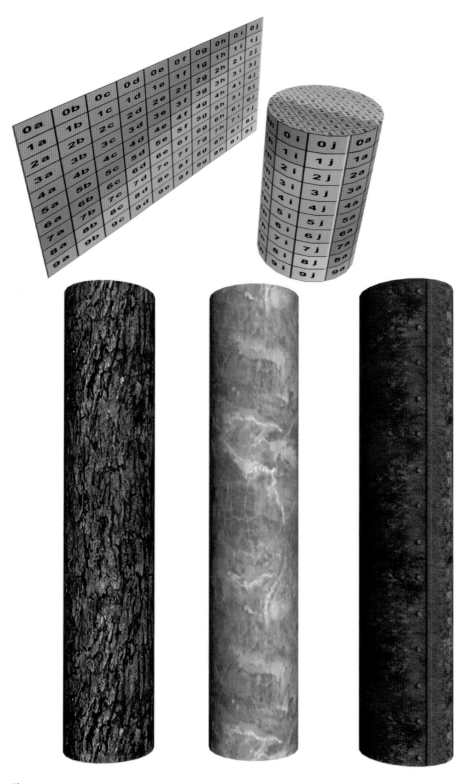

Figure 2-18
Cylindrical mapping projects the map by wrapping it around in a cylindrical shape.

primary focus of this book is the generation of art assets for computer game environments, we can't escape the fact that creating art for a game is more than just making a pretty picture. When you create art for a game, you need to create art that will accomplish several goals, the least of which is that your art must work technically in the game environment and work as efficiently as possible in that environment. This goal requires planning and creating your art to very specific guidelines. Those guidelines may change depending on many variables (I will discuss these later), but they are all essentially the same variables. In any case, you need to be very well aware of what those variables are and build accordingly.

Making a game run at its very best is called *optimization*. It is a common belief that this is solely the domain of the programmer— but nothing could be farther from the truth. It is, in fact, everyone's job to optimize from day one. The artists have a huge impact on how well a game runs, so we need to know every trick possible to achieve this. It cannot be stressed enough that you have to be familiar with the most common methods of game world optimization, because much of what can be done to optimize a game is under your control and takes place during asset creation or the implementation of the asset into the world.

There are many things that can or need to be done during the actual assembly of the game world—tasks that might fall to you. Because the computer game must not only look good, but run well too, you will have to use every trick available to you. If you don't, the game world will not run well enough to use or will not look as good as it can. If you fail to make the game look as good as possible due to a lack of optimization, you are wasting an opportunity as valuable as gold in game development.

Performance is usually expressed as frames per second (FPS) in a game, and there is a definite limit to what you can do as an artist, programmer, or designer based on this—no matter what system specs you are working with. If frame rate is inefficiently used in one place and goes undetected, then it is by definition diminishing the available frame rate in other areas of the game. One of my pet peeves is the last-minute gutting of a game to make it run. I have seen entire levels that have taken weeks and months to perfect be gutted at the last minute. Trade-offs are unavoidable, but if you don't look at your game in its totality and track your frame rate (among other resources), you are going to get caught unaware at the end of development as the game comes together and doesn't run as you had hoped (Figure 2-19).

Let me repeat (because this drives me absolutely nuts): you have to track your resources. Just because you can run through your level at 120 frames a second doesn't mean that performance is assured. You have to consider several things first before celebrating the blistering frame rate. Are you using the target machine, or are you using a high-end machine typical of most development studios? What is left to implement in the game? Are the collision detection

RADIUS CALCULATING ACTUAL VISIBILITY TO CAMERA

OBJECT NOT VISIBLE TO PLAYER

CONE OF CAMERA VIEW

Figure 2-19
You can't see it, but is the game engine drawing it and wasting resources?

and physics in place? What about running artificial intelligence (AI) and game logic? Sometimes the addition of a heads-up display or interface slows things down. As soon as you fire a weapon, you are potentially triggering collision detection, creating hundreds of assets (particles) triggering sound events, displaying decals on walls, and so on. Think about the addition of other players and characters, and their weapons. Suddenly you have thousands more polygons on the screen, a few more large textures loading, and other assets and events. In short, can you think of every possible thing the final game will have running and guess what your frame rate target should *actually* be? You probably can't get a dead-on correct answer early in development, but an educated guess (have lunch with the programmers and question them—they'll love you for it) and the awareness that your actual frame rate will be cut in half when the game is up and running in full will help you hit a more realistic target and prevent the total destruction of a game level at the last minute.

This section looks at some of the most common tools and techniques (accessible to the artist) used for optimizing a game world. I present them from the artist's point of view, meaning how the tool or technique works and what control the artist generally has over it. Usually you will see that most of these tools and techniques are explored or presented from the programmer's point of view (they are very involved programmatically, to put it mildly), but artists really need to understand these devices, as they are critical to making a level look good and run well.

I personally break optimization down into three major areas: asset-, collision-, and occlusion-based, and in this book we will look only at the asset-based optimizations, as they are in the domain of the texture artist. The other two take place in the modeling and world-

building phase. Aside from the things we as artists can do to optimize the game, there are of course many other areas that also need to be optimized. Most of these optimizations are found in the program code. Things like memory management, CPU and GPU code, AI, collision code, networking, sound, and the game play itself all eat up resources and need to be optimized by the programmers.

Asset-based optimizations are simply those optimizations that you can implement and effect during asset production. Assets are the art we create, and they present the first opportunity that we have to apply any optimizations. Technically, there are always opportunities from day one to keep optimizations in mind and apply them during the design phase, but often the artist is not present during this time. Our first opportunity is usually when we start to create the assets for the game. Some optimizations are possible in the design and planning of the assets; for example, the design of how a texture is laid out affects how the UV maps are laid out and that in turn can affect performance.

Note: YOU! Yes, you! You the artist are responsible for a great deal of the optimization in a game. In every phase, from planning to create the assets, to producing the assets, to introducing those assets into the game world, there are opportunities to optimize.

The most common asset-based optimizations are:

- MIP mapping
- Texture pages
- Unlit textures
- Multiple UV channels
- Lightmaps
- Masking and transparency
- Texture size and compression

MIP Mapping

MIP mapping, sometimes called *texture LOD* (level of detail), is usually a programmer-controlled function, but sometimes the artist is given control of this too. The explanation is pretty simple. A large texture seen at a far distance in a game world looks the same as a smaller texture due to the fact that both are being displayed using the same number of pixels on screen; it is therefore a waste of resources to use a large texture on an object that is far away in the game world. In addition, using a larger texture on a small, faraway object usually doesn't look as good as the smaller texture would, due to the fact that the larger texture is being resized on the fly by the game engine. To solve both these problems, programmers usually implement some form of MIP mapping. MIP stands for the Latin phrase *multum in parvo*, which means "many things in a small place." MIP mapping is the creation of multiple sizes of a texture for display at various distances in the game (Figure 2-20). Sometimes you can see the MIP maps pop as they change from larger to

Figure 2-20
A texture that has MIP maps associated with it. (Sample image from "Glory of the Roman Empire," courtesy of Haemimont Games.)

smaller, especially in older games. MIP mapping allows the texture to be viewed close up and in detail as well as render faster (and look better) from a distance. Figure 2-21 shows the MIP-mapped texture of some jungle vines. Notice that the alpha channel is MIP mapped as well. Fortunately, NVIDIA created several tools to make all of this easier for the artist (Figure 2-22). The DXT Compression Plug-in is one of the most useful tools, and I discuss that later in this chapter in the section on texture size and compression. With this tool you can control many variables that affect the visual quality of the image.

Note: Texture LOD and LOD pertaining to a 3D model in the game engine are both the same concept, but one applies to the use of gradually smaller 2D assets and the other 3D.

Texture Pages (or T-Pages, Atlas Textures, or Texture Packing)

This section starts with a bit of a disclaimer. It seems that the industry is now moving away from texture atlases. Although atlases will continue to be an effective solution for some hardware, things are shifting over (due to technical reasons beyond me) to individual

Figure 2-21
A texture that has MIP maps associated with it and an alpha channel. Notice that the alpha channel is MIP mapped as well. (Sample image from "Glory of the Roman Empire," courtesy of Haemimont Games.)

Figure 2-22
This figure shows the interface and examples of the NVIDIA MIP-mapping tool.

textures. That's great news for me—I find that texture atlases slow things down in the typical artist's workflow.

As you build a game world, you create many textures to cover the many 3D objects in the world. When the game world is loaded and run in the game engine, the game engine has to access (call) each of those textures for each frame it renders. These calls slow everything down, so it is desirable to reduce the number of calls. There is a technique you can use called *texture packing* or creating a *texture atlas* that can accomplish this. Basically it involves taking a large group of textures that are related in some way (usually geographically close to one another in the game world) and putting them together to create one large texture. You can see a texture atlas of foliage created for a jungle level in Figure 2-23. You can create an atlas by hand or with a tool. Of course, NVIDIA makes such a tool (Figure 2-24). The primary benefit of a tool like this for the artist is the speed at which atlases can be built and altered. This tool creates the one large texture and with it a file that tells the game engine where each image is placed on the master image.

Unlit Textures

An unlit texture is a texture that is unaffected by lighting and displays at 100% brightness—sometimes called a *full bright* or *self-illuminated* texture. Note that this not the same as a texture that uses an illumination map. When an illumination map is used, it

must calculate lighting for a texture and take into account the grayscale illumination map. Because calculating the lighting for a texture can be one of the biggest resource hogs in a game, it can be much more practical to use an unlit texture, which renders much faster. Using unlit textures is a way to boost performance. This technique is easy with some materials such as water or certain signs, and in some game types or genres you can get away with using large numbers of unlit textures. Large forested outdoor areas can benefit from the use of unlit textures on the foliage. Figure 2-25 shows an example of a texture that is lit in one scene and then unlit in the next. Notice how the sign is at full brightness and remains unchanged by the lighting affecting the walls. Particle systems typically look better unlit and run faster as well (Figure 2-26).

Figure 2-23
An example of an atlas texture.

atlas0002 - 11.dds

tiger.diff.tga

atlas0002 - 11.xml

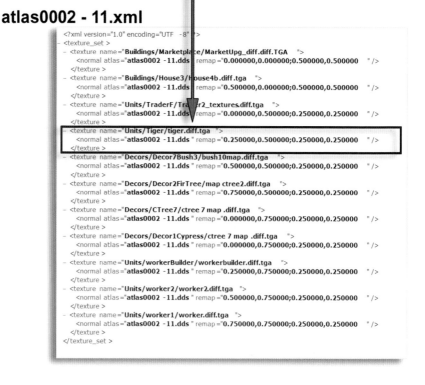

Figure 2-24
The texture atlas and
accompanying index file.

Multitexturing or Multiple UV Channels

Increasingly often, in today's game engines you are not limited to
one UV channel. Thus you are allowed to combine textures on a
surface in real time. That in turn allows a great degree of variety
from a relatively smaller set of assets. A grayscale image may

simply define the dark and light areas of a surface, another map may define color, and another some unique detail. You can see an example of this method in Figure 2-27. The building mesh has a base-colored material applied; on a separate channel I applied dirt, and on another I added details such as posters and cracks. Multiple UV channels are also used to apply bump mapping and other shader effects.

Figure 2-25
An example of a texture that is lit in one scene and unlit in the next.

Lightmaps

Lightmaps are prerendered images that define the light and shadow on the surfaces of your world. Lightmaps are created before the

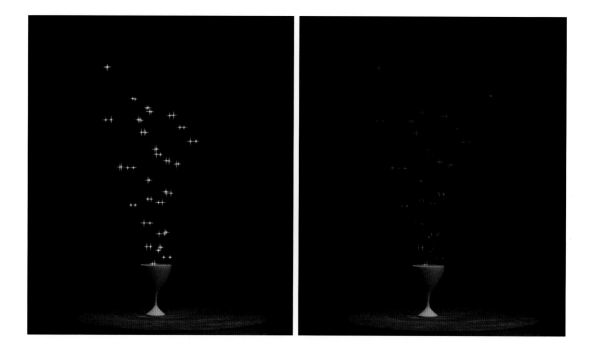

Figure 2-26
Particles lit and unlit.

game runs and are saved as part of a file, which means that the size of that file is increased. There are two things you can do to optimize lightmaps: lower their resolution or compress them. A smaller lightmap will result in a faster loading and running level, but lowering the resolution also lowers the quality (Figure 2-28).

Note: For a great article on compressing lightmaps, go to Gamasutra.com and look up "Making Quality Game Textures" by Riccard Linde.

Usually you can opt out of using a lightmap or can determine at what size the lightmap will be created. This step allows you to increase the resolution of the lightmap in those areas where the player can go and lower the resolution for less accessible but visible areas.

Masking and Transparency

When possible, it is preferable to use masking instead of transparency because masking renders more quickly. Take a look at Figure 2-29, as these concepts are much easier to grasp pictorially.

Masking typically uses a specific color that is designated the "clear" color, and this creates hard jagged edges (although newer hardware can handle larger-resolution textures and can post-process the images and smooth the edges).

Transparency uses a separate, additional channel, a grayscale image called the *alpha channel*, to determine the opacity of a pixel.

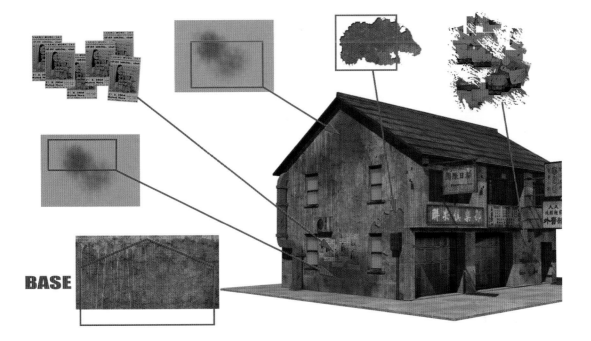

BASE

The trade-off is that transparency looks better, but it also requires more file space and more processing power, because although masking simply either draws the pixel or not, transparency must look at two pixels (the source image pixel and the on-screen pixel behind it), consider the grayscale pixel of the alpha channel, and calculate the color of the final on-screen pixel. Technically, what you are seeing isn't real-world transparency, but rather a new image composed of a blending of two images that gives the illusion of transparency.

Of course, NVIDIA makes a tool that allows for the rapid adjusting and viewing of textures before outputting them (Figure 2-30).

Figure 2-27
Multitexturing allows you to combine a relatively small set of assets in creating a large variety of surfaces.

Texture Size and Compression

Make sure to consider the size of each texture you create. A texture that covers most of the walls and/or floors in your world and has to tile well while still holding up visually, needs to be larger than a texture that is displayed infrequently and is not subject to direct examination by the player. The other factor is compression. A compressed texture file can be significantly smaller than an uncompressed one yet still maintain visual integrity using the right combination of compression options. NVIDIA makes a plug-in (http://developer.nvidia.com) for Photoshop that allows for the rapid and easy iteration through many compression schemes before final output of the file (Figure 2-31).

Remember that there are many factors to consider when determining texture size and compression. How close will the player

SHADOW MAP LARGE

SHADOW MAP SMALL

Figure 2-28
Lightmaps both large and small on the same area.

get to the asset? How often will the asset appear in the world, and how many times is it expected to tile or repeat? Can you achieve the same effect with a more efficient solution? Can you use three small textures on multiple UV channels as opposed to one enormous texture? How much can you compress or reduce the resolution of an image and still maintain visual integrity? One of the most valuable but underappreciated skills a game artist can acquire is knowing not only the various ways of implementing game art solutions, but what methods and combination of those methods comprise the best solution.

Figure 2-29
How the three methods discussed here work with examples.

Chapter Exercises

1. Photoshop, with all of its powerful tools and options, simply gives you an almost unlimited number of ways to do what?
2. Why is working on the grid useful?
3. Explain the difference between a source and output file.
4. What are the four criteria for choosing a graphic file format?
5. What are the DDS and DXT formats? Explain the features and options of these formats.

Figure 2-30
The interface and various windows of the NVIDIA tool as applied to masking and alpha.

6. What is the PSD format? List and define at least three of the features of a PSD file.
7. What is the grid? Explain.
8. A 512×512 image is how many times as large as a 256×256 image? Explain your answer.
9. What is modular design?
10. What is UV mapping? List and define the most common UV mapping types.
11. What is the mantra of a computer game artist?
12. What is optimization and why is it important?
13. Why is it important to track the performance of your game as a whole entity?
14. What are the seven optimizations looked at in this book and how do they speed things up?

Conclusion

That was a quick overview of some vast and complex topics. But the level of coverage of these concepts is enough to help you create textures that will work in a game world. Learning and mastering any one of these concepts will take time, but fear not: good basic knowledge will allow you to work up to mastering these topics quickly and more easily.

Figure 2-31
The interface and various windows of the NVIDIA tool as applied to the compression options.

grayscale

blank

color

norr

Chapter 3

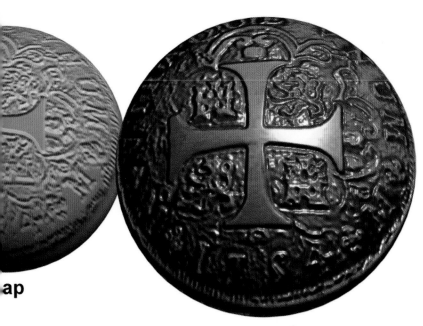

ap

normal
map
implemented

Shaders and Materials

Introduction

Figure 3-1
A few of the absolutely
awesome images that can be
rendered on an NVIDIA
graphics card.

Shaders allow for a level of realism in games that is stunning—and getting better all the time. In Figure 3-1 there are some screenshots provided by NVIDIA. As I write this, the latest crop of DirectX 10 cards is out, DirectX 11 is right on the horizon, and the quality of the graphics is amazing. Simply put, a *shader* is a mini-program that

processes graphic effects in real time. For example, the reflections on a surface can move in real time instead of being "baked" or permanently painted onto a surface. Shader effects are very powerful visually, even if viewers are unaware of what they are seeing—the average player would have a hard time defining why the game that he or she is playing looks so good. It may be the real-time reflections, normal mapping, or the specular mapping being processed in real time.

Ever since these technologies started rapidly advancing, there has been talk that procedural textures and advanced technologies would one day replace the artist. This will never happen. As amazing as the technology is, it still takes an artist to make these technologies produce the best visual results. In fact, the artist has become more important than ever, as technology has become more complex. Although programmers give us incredible new technologies, the artist is still needed to create and control the input and output of those systems.

There are two main types of shaders on modern graphics processors (GPUs):

- *Vertex shaders* manipulate geometry (vertices and their attributes) in real time.
- *Pixel shaders* manipulate rendered pixels in real time.

The ability to manipulate an individual pixel or vertex in real time is what makes shaders so powerful, and also what makes them so processor-intensive. On one hand, we can simulate virtually any condition using shaders; on the other hand, they devour resources. For each frame displayed, all the shader effects for that frame must be processed (or rendered), which takes time. Although the time required is minuscule, it adds up, as millions of individual pixels and vertices are being processed. Shaders can be used for many complex material appearances and image effects: hair, fire, shadows, water, reflections, and so forth. Shaders are so flexible that the list of possible effects is almost endless—a shader programmer can write almost any imaginable effect. Interestingly, though only very recently has consumer-level hardware been able to handle the intense demand that real-time shaders puts on a system, the knowledge of these processes has been around for decades. In fact, many of the techniques that you will read about here are based on algorithms named for well-known mathematical geniuses; for instance, Phong and Blinn are recognizable names if you are a 3D artist.

Remember that the ability to manipulate an individual pixel or vertex in real time is what makes shaders so powerful. Very recently, real-time lighting began being calculated per vertex, not per pixel—that is, lighting is now often calculated for an entire face of a polygon, not for every pixel. This ability is significant, because it not only adds a great degree of detail and smoothness, but also allows for shaders such as normal maps to function. But how does all this work? That brings me to the large fuzzy overlap between

TEXTURE MAPS

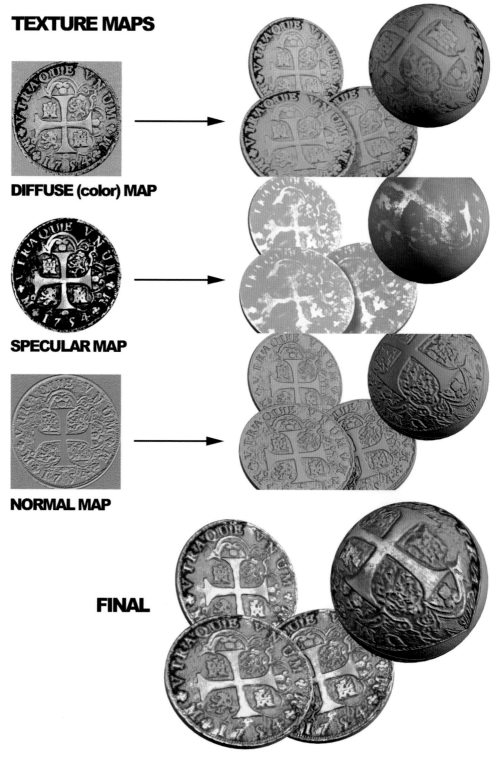

DIFFUSE (color) MAP

SPECULAR MAP

NORMAL MAP

FINAL

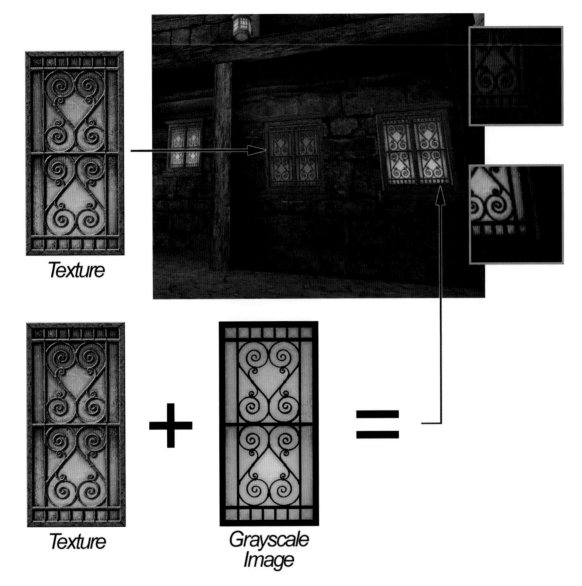

Texture

Texture + *Grayscale Image* =

Figure 3-2
Here is a simple flow showing how two shaders works for the artist. The illumination map is applied to the texture of the window to make the proper parts of the window glow with light while leaving the frame dark. The coin, a simple cylinder, is mapped with a diffuse or color map, a specular map, and a normal bump map. You can see the final result at the bottom where the effects of all three maps are combined.

programming and art. Granted, these are two very different activities, and there is a line between how much art a programmer needs to understand and how much technology an artist needs to understand. Exactly where that line is, no one can say precisely, but when it comes to shaders, you should understand the basics of how the technology works. Wait! Don't fling the book across the room just yet. You don't need to know the math behind it all, just a simple explanation of how it works.

Shader Basics

Shaders, from the artist's point of view, are often a bit of a black box. Our involvement usually requires that we generate input for a preexisting shader—set parameters and/or assign textures, and then look at the end result. Because the artist's role is mostly confined to creating input and judging the output of the shader, we often have nothing to do with the code. In some cases, shader code is written or edited by an artist, but most newer shader-creation tools are more like the material systems in Max and Maya, requiring no programming knowledge. Figure 3-2 shows a couple of examples of how a material shader works from the artist's point of view.

Shaders often require the use of 2D assets as input, and the artist is usually the one tasked with not only creating those assets, but also understanding, creating, and implementing the shader to some degree. So, although shaders can perform much of the work that an artist would do on an asset, they may also increase our workload. Already there are effects in games where the artist is no longer painting a texture as an isolated entity but is creating a series of textures that must all work together for a desired effect. Using shaders requires more planning, a different way of thinking about creating the art, and more organization. The artist needs to learn the shader tool, organize more assets (assets that may be linked to one another and are therefore more rigid in their mobility after a shader is in place), and learn the mental discipline of creating assets that are not the end result but component parts of a final result.

We have to get accustomed to painting textures devoid of certain properties that will later be processed in real time. One reason we need to understand the fundamentals of light and shadow, or to develop the skill to see the base material of a scene behind all the dirt, reflections, and other surface properties, is that we may soon be building textures starting with a very plain surface (even a pattern) and building a complex organizational tree of maps and effects to create a final surface—much like we already do in 3D programs and how some texture generators work. For example, the highlights on the armor in Figure 3-3 are controlled by a shader. With no specular highlight, a surface can look flat and dull. With a generic specular highlight applied evenly to the surface, things will often look plastic and fake. Using a map to control the specular highlight, we can make a surface look much more realistic. Although

shaders can make our lives easier in some respects, and can
definitely make our games look better, they can also be a bit
complex to understand at first and require a greater degree of
organization.

Some of the most common shaders today require images
easily created and manipulated in Photoshop. The most common
of these are the color map (or diffuse channel), the bump and
normal maps, specularity maps, illumination maps, and opacity
maps. In general, a game artist creates textures meant to be tiled
over an area or mapped to an object. When the texture is to be
mapped to an object, the artist starts the creation of the texture
with a template. Whether a complex character skin or a simple
prop, this template is generated from the UV coordinates that have
been mapped out onto the 3D model. After the basic color
information has been put into place, the other shader maps are
often created from the initial color map, the 3D model itself, and
even some hand painting. The UV map represents the exact way in
which the 2D art will be mapped, or wrapped around, the 3D model.
In Figure 3-4 you can see how the template was created from the
actual face model and the simple prop and then used as a guide to
paint the textures. We will be working with templates later in the
book.

Common Shader Effects

Like most issues related to computer game technology, shaders are
a vast and complex topic riddled with new vocabulary, concepts,
and technological requirements. In addition, each game engine and
each game project will have its own vocabulary, process, and subtle
nuances in dealing with shaders. But you will always deal with some
basic shader effects, and here are some samples of them. You may
notice that these shader effects are very similar to filter effects in
Photoshop, materials in Max or Maya, and many post-video effects.
Post-video effects are effects inserted into a film or video during the
editing process, after the footage is shot.

In this chapter we look at not only what these shaders can do in a
cursory sense, but also some of the ways you can get various
effects with these shaders. The following is a list of basic shaders
and material types that you will most likely work with in game
development:

- Diffuse (color maps or textures)
- Blend
- Detail mapping
- Depth of field
- Heat haze
- Specularity
- Bloom (glow or halo)
- Masking and opacity
- Illumination (emissive)
- Reflection/cube mapping

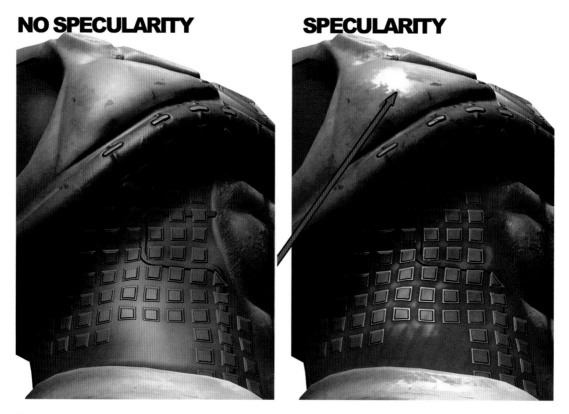

Figure 3-3
Instead of painting a highlight onto a surface in Photoshop, you can now leave it out and assign a shader.

Figure 3-4
From right to left: The UV template, the diffuse map created from the template, and the model wrapped with the texture. The left side of the face was left unmapped so that you can see the original mesh.

- Pan/rotate/scale
- Normal, bump, and parallax mapping

Diffuse (Color Maps or Textures)

The term *diffuse map* has many meanings, depending on what software you use and what your educational background might be. I will spare you the technical and scientific definition and simply tell you that the diffuse map in the game industry generally means that the color map or texture is an image containing only the color information of a surface. This is not to say it is devoid of all detail. Because game engines still don't reproduce the visual world 100% accurately, we still need to fill in the gaps. We can do this with subtle detail in the color map that is supported by the other maps. Areas in the texture where light would be noticeably brighter or darker can be defined to some degree. The spaces between metal panels and wood planks are examples of where some darkness could be painted in with good effect. In Figure 3-5 you can see the diffuse map for an old pirate. There is probably a bit too much light and shadow information in the texture. The prominent highlights and shadows on the veins and wrinkles are especially noticeable, and I would take them down and replace them with a normal map if this were to be used in real time. There is a normal map on this mesh, but I relied on the color map a bit more, as I created this mesh for a specific use at a fixed angle and the normal map didn't need to behave perfectly.

Cracks and seams are places where dirt is most likely to collect, which would further add to the darkness of such parts of the texture. Technically, you can handle these cracks with the normal map and other effects, but I find that relying too heavily on one map type often results in plastic-looking materials.

Originally, game artists had only the diffuse channel to work with, and essentially what you created in Photoshop was what you saw in the game—all shadows, highlights, and details were contained on the color map and were static (or "baked in"). This image was typically of low resolution and color depth and was wrapped around a low-polygon model—presto, you had a game model. This process has changed quite a bit in the past few years. With the advent of new technologies that require a slightly complex separation of visual components into a series of separate assets that are processed together to create the final effect, the color map has become much simpler and subtler. That is, it's simple and subtle in terms of other information aside from the color itself, but richer in color detail because we can now use images that have much larger resolutions. In some ways, this method of asset creation is harder to grasp and execute, but in other ways it is actually easier—especially for a trained artist who already understands how the visual world works.

The color map in Figure 3-6 contains the base color of a character's skin. In addition to the skin tone, however, the color map also must

Figure 3-5
The diffuse color map can contain much information, but presently the use of per-pixel lighting makes this unnecessary and often undesirable.

convey subtle details that either can't be depicted by the technology or are simply so subtle it may be quicker to paint them into the color map than to try to reproduce them technically. Human skin is so subtle yet complex that often the qualities of skin (such as age and condition) and the details of skin (such as small veins, creases, spots, freckles, and pores) are best portrayed on the color map. Human skin is not one smooth color, but rather is composed of many colors and interacts with light in a most unique way. Such a map can take a long time to produce, as it requires a balance between subtle but clear detail. Too much contrast, saturation, or other attribute, and the character starts to look diseased; not enough, and the character looks like a mannequin.

Blend

The blend shader blends two textures together; depending on what software or game engine you use, it may blend in a default fashion or offer various modes very similar to the blending modes in Photoshop. The blending usually occurs between a base texture and one or more textures on top of this. Each layer has its own set of UV coordinates, so you can have one small tileable texture that repeats as your base and blend other textures on top, such as stains, cracks, and other details. This method not only takes up less texture memory, but it also allows for a great deal of variety as there are so many options when blending numerous textures together. The basic blending modes follow and are displayed in Figure 3-7:

- Average
- Additive
- Subtractive

Figure 3-6
The diffuse color map of human facial skin. Even with complex shaders, the skin on a human face is so full of subtlety and detail that we still need to have some detail in the color map.

Figure 3-7
Various blending effects using the blend shader.

Average

Average blends the colors of the base map and the new map evenly. If you don't want either texture overpowering the other in any way, use the average mode. This mode is appropriate for creating an entirely new texture from two separate textures or, in conjunction with grayscale base maps, for coloring the base map.

Additive

The additive color model brightens the base map. Black becomes completely transparent.

Subtractive

The subtractive color model darkens the base map with the new image. White becomes completely transparent.

Detail Mapping

A detail texture is a layer laid on top of a low-detail color texture. Players can see the detail texture from their point of view, but the detail texture is fading in as they move. This allows the texture (the ground, for instance) to look very detailed. Detail textures are usually grayscale images that add detail to the color map below it, using one of the blending modes discussed previously. Detail textures can be used to add detail to stone, metal, wood—any surface in the world (Figure 3-8).

Depth of Field

Depth of field in photography is the distance in front of and beyond the subject being focused on and photographed. A shader can create the illusion that objects in the background are far off by blurring them, thus causing a depth of field effect. You can adjust the depth of field, just as you can in photography, so that the area in focus can range from infinite to very narrow or shallow. A shallow depth of field means that objects are in focus only in a very small area. Depth of field can be so shallow that a very close-up picture of a coin can have one side of the coin in focus and the other totally blurry. Figure 3-9 shows an example of depth of field.

Figure 3-8
Players can see the detail texture from their point of view, but the detail texture is fading in as they move.

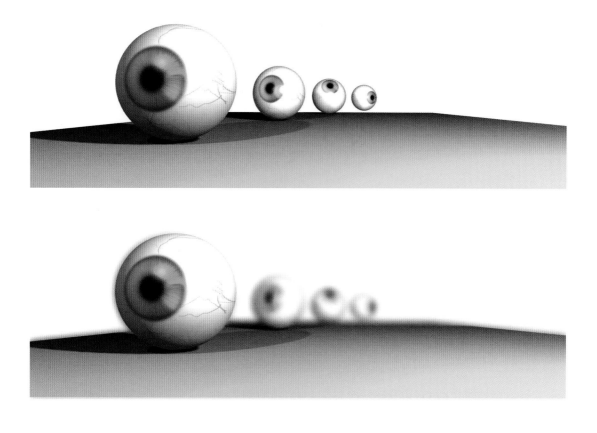

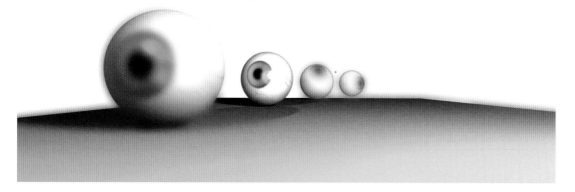

Figure 3-9
This shader creates the illusion that objects in the background are far off by blurring them, thus causing a depth of field effect.

Heat Haze

Heat haze creates the shimmering effect you can see emanating from very hot objects, or the ground, on hot days. Figure 3-10 shows the effect applied to the exhaust pipe of a vehicle.

Specular Highlights and Glossiness

A specular highlight is that bright spot that appears on most surfaces when light hits it. That spot can be small and bright or

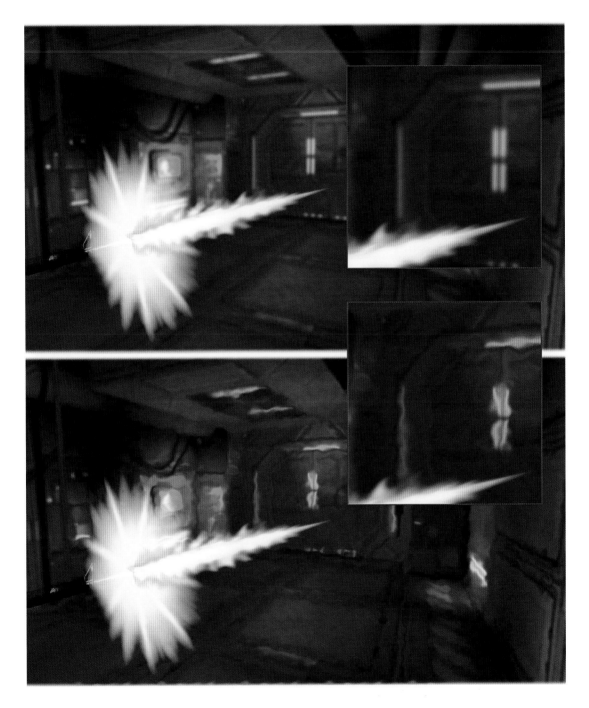

large and barely noticeable, depending on the quality of the material the light is hitting. A *specularity* map allows you to control this effect, and you can even use a mask to control how various parts of the same surface display the specular light differently. A good example is beat-up metal armor. You may have a layer of old paint and dirt that will not be highly reflective and areas where this has been worn away to reveal reflective metal, which is metal that

Figure 3-10
The bottom muzzle blast has the heat effect present.

Figure 3-11
Specularity map and examples of specular basics.

has been polished by constant wear and tear (Figure 3-11). Sometimes glossiness is separated from the specular highlight; the distinction is that glossiness determines the size of the specular highlight, and specularity controls the intensity of the highlight.

A specularity map controls what parts of the surface are shiny or dull based on the grayscale value of the specularity map. You can see that the armor has no specular control on the left, and the middle and right have two different specularity maps. Specularity maps are generally created from the color map. In Photoshop you simply desaturate a copy of the color map and adjust from there. You can see the exact spot where the grayscale image is affecting the specularity on the model (Figure 3-12).

Bloom (Glow or Halo)

Blooming makes a light source appear brighter than it really is by taking the light source and spreading it out over the edges of the object it is on. A bright light will appear to bleed over onto objects around it, both in front of and behind the object. Usually this effect is achieved by creating a glow around the light source that is blended with its surroundings, but sometimes the engine actually processes the entire screen. Using several render passes, it will multiply the frame (like the Photoshop blending mode, this lightens the lighter areas and darkens the darker areas), blurs the image, and then draws it on top of the original screen. Blooming helps create the illusion that a light source is brighter than it can actually be displayed by the monitor. See Figure 3-13.

Masking and Opacity

Masking typically uses a specific color that is designated as the "clear" color and is more efficient than transparency. Transparency

NO SPECULARITY **SPECULARITY** **SPECULARITY with MASK**

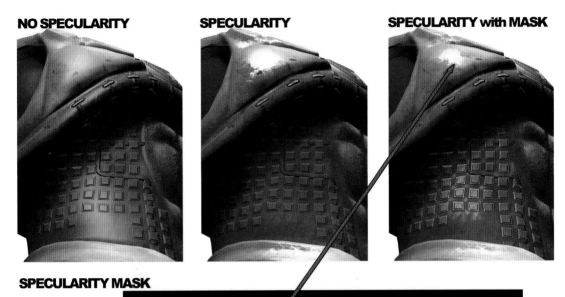

SPECULARITY MASK

Figure 3-12
Specularity map.

uses a separate channel or grayscale image to determine the opacity of a pixel. The trade-off is that transparency looks better, but it requires more file space and more processing power. Masking can significantly speed up a huge scene with tons of overlapping elements with transparency on them, such as a forest or jungle. In Figure 3-14 you can see examples of masking and transparency. In Figure 3-15 you can see the interface of the NVIDIA tool that allows for the rapid adjusting and viewing of textures before outputting them.

Opacity maps determine whether an image is solid or transparent, or somewhere in between. Opacity is generally best used when there is a need for transparency, as on windows, and/or subtle ranges in opacity, such as we see in smoke and fire. Although masking can do the job for tree leaves, fences, and grates, opacity is better for in-game effects such as explosions, fire, bullet holes, smoke, and particles like rain and magic sparks. In Figure 3-16 you can see various examples of such effects.

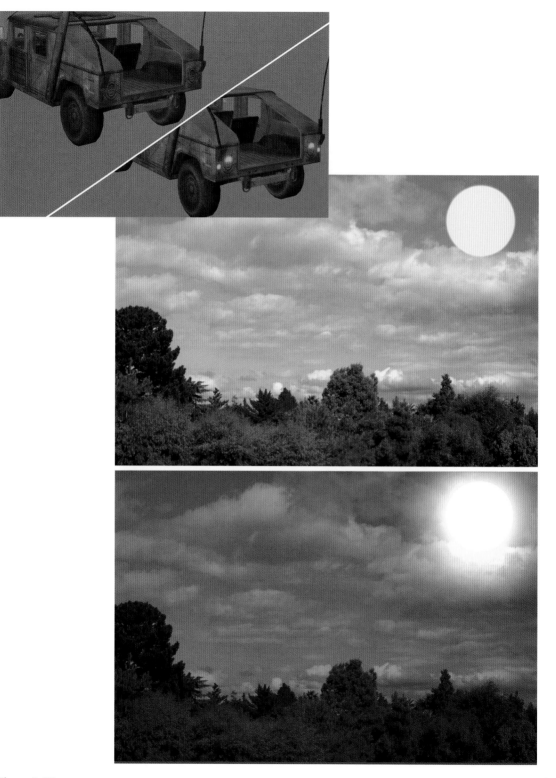

Figure 3-13
Bloom shots. Light glow, with full-frame processing.

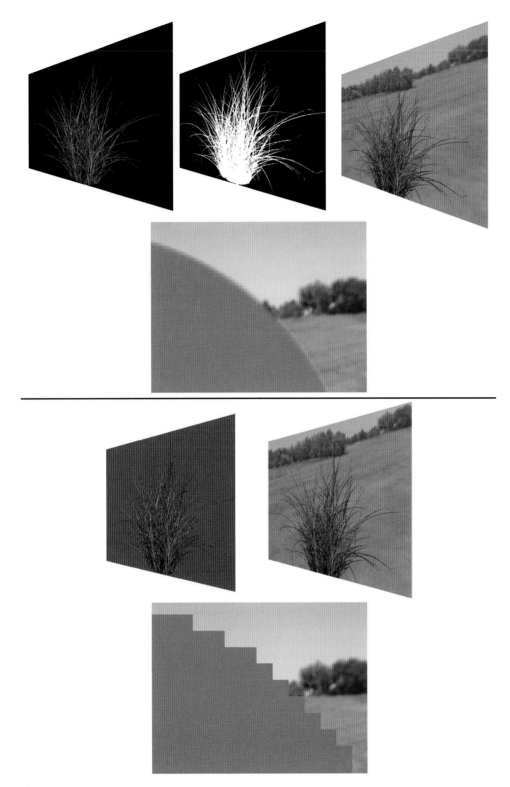

Figure 3-14
The **upper portion** of this figure shows an image of some grass with an alpha channel and the **lower** a color mask. Notice that the images look virtually identical from afar; it isn't until we are very close that we can see the jagged edge.

Figure 3-15
The interface of the NVIDIA tool. The three most common masking and alpha formats have been highlighted.

Illumination and Unlit Textures

An unlit texture and a texture with an illumination map applied are two different things. An unlit texture is simply a texture that is unaffected by lighting and displays at 100 percent brightness under all conditions; an unlit texture can also be known by other names such as a full bright or self-illuminated texture (Figure 3-17). In Figure 3-18 you can see an example of an unlit texture on a particle that looks better unlit and also runs faster. An illumination mapped texture, sometimes known as an emissive texture, uses an additional image (typically a grayscale image) to control what portions of the texture are lit and to what degree. When you use an illumination map additional calculations must be done and additional resources used for controlling the lighting on a texture this way. So while the fully bright texture can make thing run faster the addition of the illumination map to a texture creates more processing demands and requires more memory to hold the additional map and can therefore slow things down.

Reflection

The reflective nature of a surface can be like a mirror (100% reflective) or completely matte—a rough wood may have no reflection at all. Real-time reflections can be very draining on the computer, so there are ways to fake reflections using environment or cube mapping.

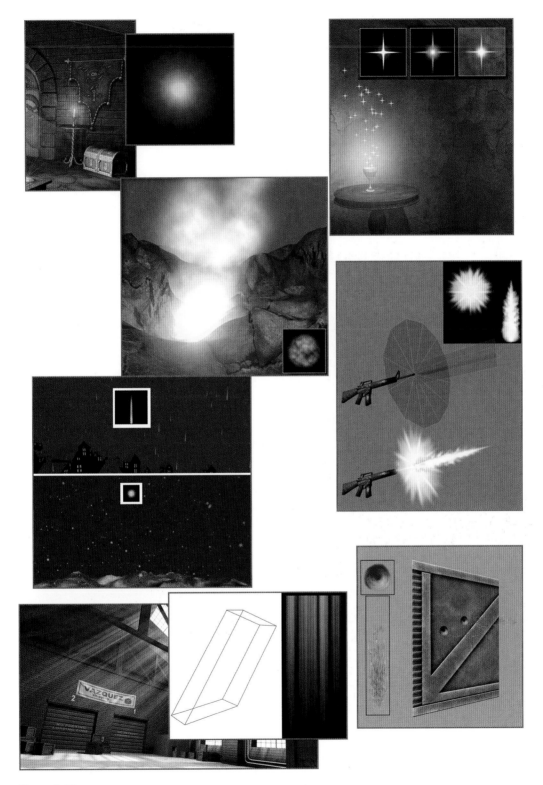

Figure 3-16
Particle examples.

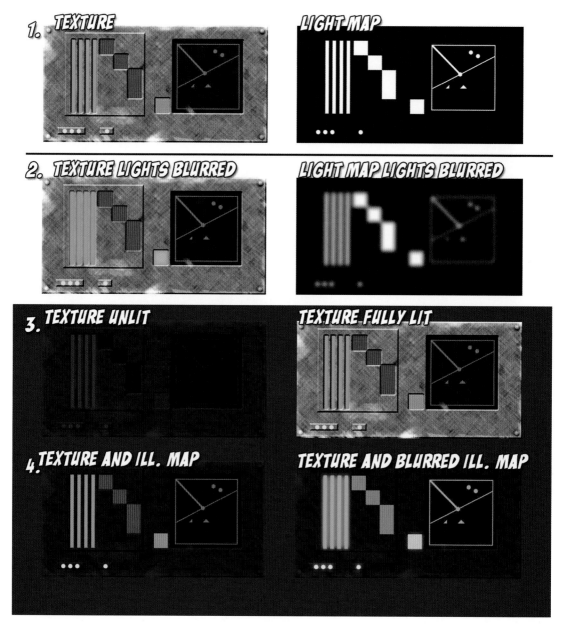

Figure 3-17
1 is the control panel texture, and to the **right** its illumination map; **2** is a version of the control panel where the lit parts are slightly blurred and the corresponding bright parts on the illumination map are as well. In **3** you can see the control panel in a darkened setting and the control panel unlit (or full bright), and in **4** the illumination-mapped versions. By blurring the portion to be lit in the color map and the illumination map, a glow effect is simulated.

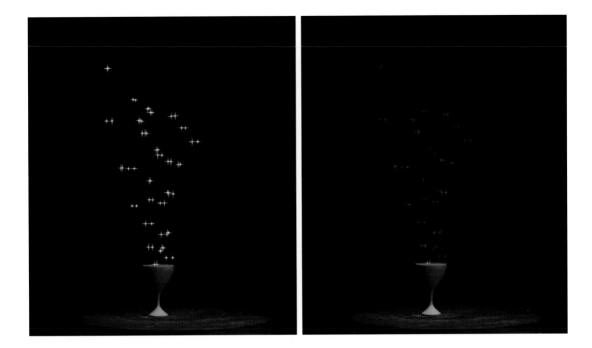

Figure 3-18
Magic particle unlit and lit.

There are many ways to generate reflections in a game, but the most common and easiest to implement is the cube map. A *cube map* is a series of images that the environment map uses to fake the reflection on the surface of an object. Cube maps are so named because the reflections you see are actually six images arranged in a cube and projected back onto the reflective object. These images are rendered from the location of the reflective object so the cube map reflects the objects' surroundings accurately. These six images cover all directions: up, down, front, back, left, and right. Ideally, they all line up, meaning that the images meet at the edges so the reflection is seamless. The images of the cube map are most commonly static, meaning that they are always the same. If you are looking into a reflection created by a static cube map, you won't see yourself (or your in-game character). This is the most efficient way to handle cube mapping, but there are also other techniques for generating real-time reflections. One of those techniques is called *dynamic cube mapping*. This method redraws the six images in the cube map every frame. If the object mapped with the environment map moves, or something in the environment around it moves, the cube maps are updated to render an accurate reflection in real time.

Figure 3-19 shows how the (static) cube map was created for the pitcher. Notice the maps arranged as if the cube were folded open like a box. The six images that form the cube map were rendered from the location of the pitcher, so the metal looks as if it is reflecting its surroundings from the proper position. You can even use a simple cloud image as a cube map and get some great results (Figure 3-20). I did nothing more than use cloud images for each face of the cube map, and the armor looks like it is made of silver. The neat thing is that in a game, those reflections would move with

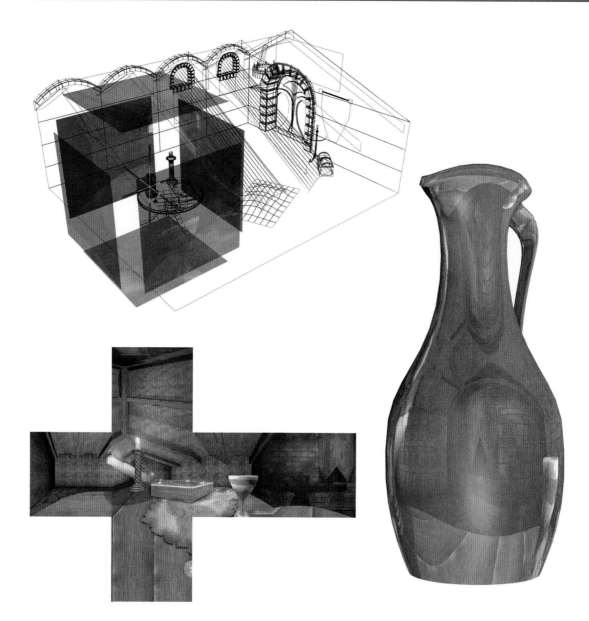

Figure 3-19
This cube map was created for the pitcher. The metal looks as if it is reflecting its surroundings from the proper position.

the armor and look so much more convincing than a static image of a reflection.

Pan/Rotate/Scale

Often shader systems give the artist the ability to pan, rotate, scale, and otherwise move a texture in real time, which can be useful to convey the movement of elements on a computer screen, fluid through pipes, or to create a moving walkway. It has been used to animate waterfalls and rotating fans. In Figure 3-21 you can see the simple concepts of *panning* (moving vertically or horizontally), *rotating* (turning), and *scaling* (larger or smaller). You can also see

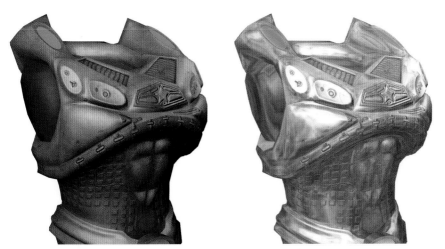

that to make a wheel look like it is turning, we must pan and rotate the texture. You should be aware that although this illustrates the concept, chances are that in a 3D game the mesh the texture is on would turn and move, and not the texture itself. I have used a scrolling and panning smoke texture over a simple laser light texture with a great "dust in the laser beams" effect (Figure 3-22).

Figure 3-20
With a simple cloud image as a cube map, this armor looks as if it were made of silver.

Bump, Normal, and Parallax Occlusion Mapping

These shaders add 3D depth to an otherwise flat surface. Bump maps are grayscale and display the most limited 3D effect; the others add depth using a color map with lighting information encoded in it. These shaders are all similar in what they accomplish, but depending on the exact code of the shader and the supporting hardware, the effect can range from really cool to absolutely awesome. A basic normal map adds a level of depth deeper than the bump map, but more advanced forms of these shaders add details and behaviors such as self-occlusion, silhouetting, and self-shadowing. Figure 3-23 is a simple visual demonstration of how the shader operates. Because we can calculate the light of the surface for every pixel, we don't need to include geometry to create shadows and highlights as we did when we lit per polygon.
We can now tell the 3D application to treat each and every pixel as if it were reacting to light, as it did when it was on the high-polygon model.

Have you ever seen a mural or painting that looked real, but when you changed your viewing angle, you could suddenly see that it was fake—a flat, 2D image? The light and shadow didn't move. The artist painted it to be viewed from that one angle, so it only looks good from that one angle. Imagine if you could create a painting that quickly repainted itself every time you moved, so it looked as if you were seeing a real three-dimensional scene. That is essentially what a normal map is doing as it calculates light and shadow in real time.

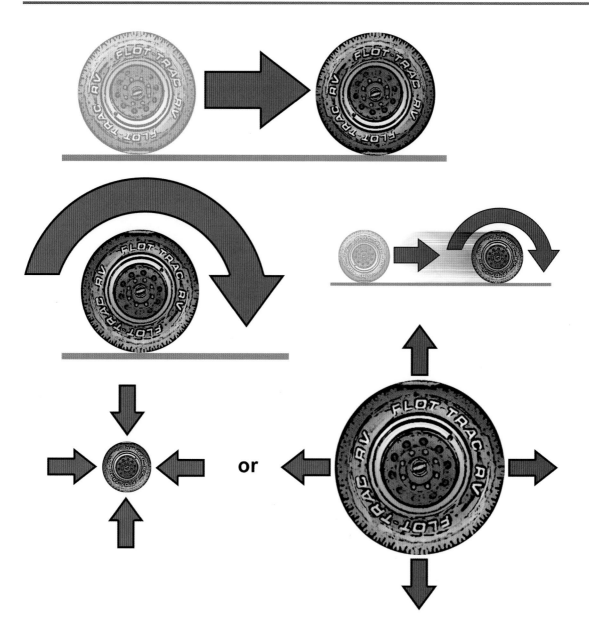

Figure 3-21
Pan (moving vertically or horizontally), rotating (turning), and scaling (larger or smaller).

In short, a normal map is an RGB image that records all of the light and shadow detail from a high-polygon model. When this map is applied to a low-resolution model, the light and shadows are calculated as if the light were hitting the high-resolution version of the model. The idea is actually simple to understand. (Of course, my standard disclaimer of how tricky this is for a programmer goes here, but seriously, we have the fun part of all of this.)

We still need to maintain the silhouette of the model as best we can. Using a present-day vanilla normal map allows us to focus more polygons on the silhouette of the model, which is a benefit. But there is also a drawback to this: it means that the normal map

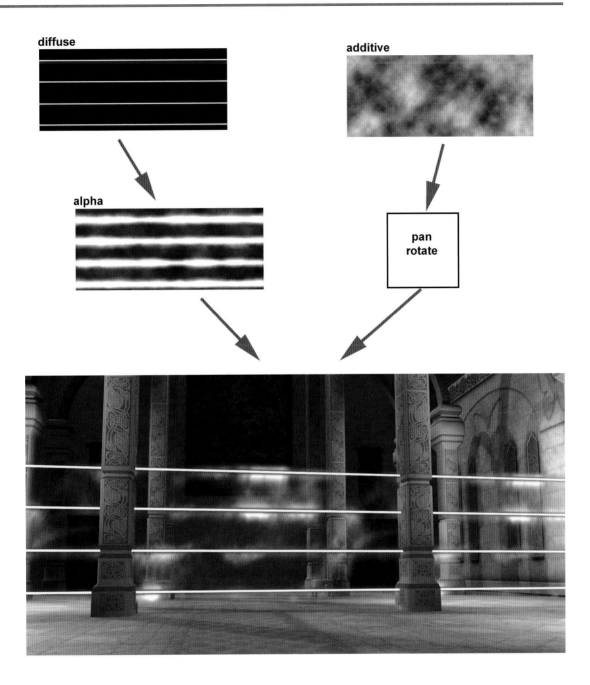

diffuse

additive

alpha

pan
rotate

cannot change the silhouette. Back to the painting analogy. Even if a painting can be repainted so quickly it looks real, there is a limit to the effect. When you move too far off on an angle, you will see that it is just a flat 2D painting that is updating in real time. That is how a basic normal map works. But there are more complex versions of normal maps that can actually move the pixels in real time and change the silhouette when viewed from the side; this would be like the canvas of the painting actually pushing out to form the detail painted on it.

Figure 3-22
Scrolling and panning smoke texture over a simple laser light texture for a "dust in the laser beams" effect.

Figure 3-23
A simple visual
demonstration of how the
shader operates.

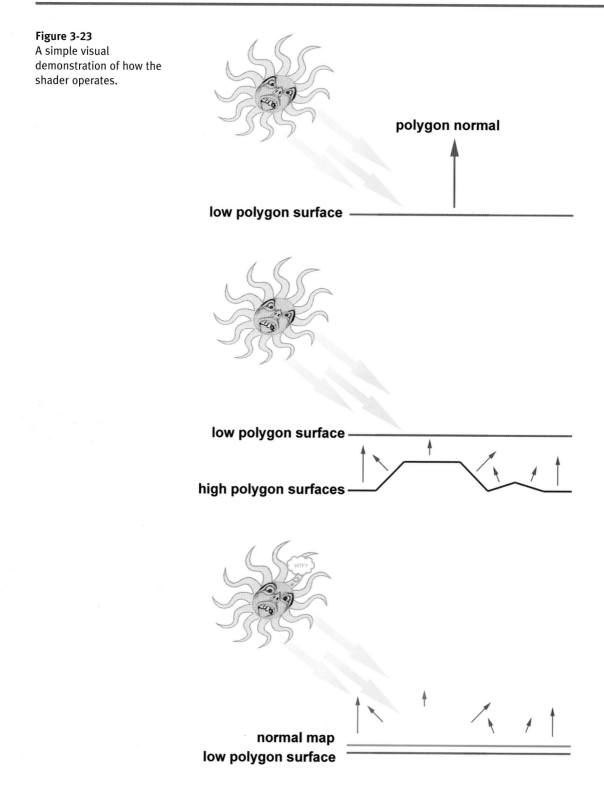

polygon normal

low polygon surface

low polygon surface

high polygon surfaces

WTF?

normal map
low polygon surface

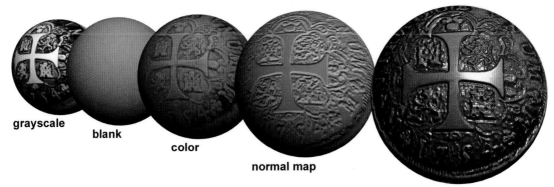

grayscale

blank

color

normal map

normal
map
implemented

Although the best normal maps are typically generated from very highly detailed 3D models, you can get a free Photoshop plug-in from NVIDIA (http://developer.nvidia.com) that will generate a normal map for you from a 2D image. There are many other tricks for creating normal maps entirely in Photoshop, and we will use them later in the book. This method is especially easy when creating environmental art, as the surfaces we work with tend to be much simpler than the surface of a character. In Figure 3-24 the surface was built up using images created in Photoshop; even the normal map was created as a black-and-white map and exported as a normal map. You can see the grayscale image used to create the normal map and the surface with nothing applied to it. Then you see the color map only, and the normal map only, and finally the surface with all the maps applied. We look at normal mapping in much greater depth later in the book and actually create normal maps using a few different methods.

Figure 3-24
A surface built up using images created in Photoshop.

Node-Based Shader Systems

Node-based shader systems are fairly common and well worth the effort to understand. They are powerful and, I find, easier to work with. They are very visual by nature and are literally movable nodes that you can connect to each other. You can create new nodes, delete, cut, copy, and paste them. They contain all the functions that we've discussed and more. You can connect nodes to each other in many combinations and see the results in real time. The most basic feature of a node is the input and output of data. By linking nodes, you can exercise almost infinite control over the final behavior of the material. Each node will have different options based on what the node does. The node-based material system from Poser 7 can be seen in Figure 3-25.

Note: Although there is no theoretical limit to the number of nodes, or connections, in a material, there is a practical limit; this is an area where you can optimize your work. Make sure that you are not

Figure 3-25
The node-based material system from Poser 7.

creating a material too complex for where it will be used and don't create a material with ten nodes when three may do.

Basic Node Operations

Basic node operations are the process of moving and connecting the nodes. Figure 3-26 shows a basic node tree. You can see that nodes can be created, selected, connected, moved as well as cut, copied, and pasted. You usually can expand and collapse both the node itself and the node tree branches. Most nodes will have many fields for the input of data variables from numbers, files, colors, and more. These values are dictated by what the node does and should be looked at on a case-by-case basis. An example is that a 2D image node will simply contain a place to input the image and other variables pertaining to 2D images such as UV information, and so on. This node can then be plugged into a node requiring the input of an image map such as a specular map. It all starts with the root node.

Root Node

The *root node* is a complete shader that contains the most common inputs for a material. You can plug into this a complex combination of nodes that will allow you to achieve almost any effect imaginable.

ROOT NODE

DIFFUSE COLOR

SPECULAR

HIGHLIGHT SIZE

ILLUMINATION (AMBIENT COLOR)

TRANSPARENCY

TRANSLUCENCE

REFLECTION

REFRACTION

BUMP/NORMAL

DISPLACEMENT

MATERIAL VIEW

Poser has a very robust node-based material system. The root node usually contains the following fields, at the very least:

Figure 3-26
A basic root node.

- Diffuse Color
- Specular
- Highlight Size
- Illumination
- Pan Rotate Scale
- Ambient Color
- Transparency
- Translucence
- Reflection
- Refraction
- Bump/Normal
- Displacement

Common Node Setups

Figure 3-27
Diffuse material.

Figure 3-28
Material with specular highlights.

Figure 3-29
Material with an illumination map.

Figure 3-30
A complex node system used to create an animated fire.

SIMPLE NODE SYSTEMS CAN CREATE BEAUTIFUL MATERIALS

Figure 3-31
Even a simple one-node material system can create this beautiful hammered metal.

Conclusion

That was a quick look at what shaders can do. We will implement all of them in the coming exercises to create various effects. Our implementation will be generic, meaning that we will create the assets for the shader based on the most basic parameters. If you are using Max, Maya, Blender, or any other shader system, these basics will translate easily into those systems.

Chapter Exercises

1. Give a simple explanation of what a shader is.
2. Give an example of a common shader.
3. Diagram and explain the workflow of a simple shader.
4. Explain how shaders can both increase and decrease the workload of the texture artist.
5. List and explain the common shaders discussed in this book.
6. What is a node-based shader system? Sketch a simple material using the material from this chapter in node form.

Chapter 4

Prepping for Texture Creation

Do, or do not. There is no "try."

<div align="right">Yoda (Jedi Master)</div>

Introduction

I love quoting Yoda.

In this chapter we will take the next step in creating the best game textures possible, which is to have the best texture resources possible. We will look at the various sources of digital resources for texture creation and each of the steps in the process of gathering, preparing, and storing your assets.

Although the focus of this book is the creation of textures using Photoshop so that you develop strong Photoshop skills, in reality it is more common, easier, and more effective to use photo reference in texture creation. We will be using a little photo reference in the book, and the DVD contains a good collection of the kinds of images that I find to be the hardest to create in Photoshop without actually hand-painting them. Cracks, splats, drips, wood grains, and other organic random stuff, though they can be created in Photoshop, simply look more genuine when taken from a good source photo. Typically, a texture is built with layers containing various sources of imagery, and photo reference plays a big part in this process. Layers are "composited" together using the various tools in Photoshop, such as layer blending modes. If you are unfamiliar with the concept of layers and layer blending modes, see Chapter 2. For additional information see the appendix on Photoshop. We will be using compositing throughout the book. Even if all the elements of a texture are created entirely in Photoshop, we will still be using layers and blending modes to composite the various parts together. No matter what source you get the image from, you always end up in Photoshop combining and manipulating the various sources to create the imagery that fits your needs. You will almost always use Photoshop in the creation and final output of the texture.

A *resource*, in the context of this book, is any digital image from any source that helps you create your art. Therefore, a small checkered pattern made in Photoshop that can be tiled across a canvas in Photoshop and used as the base of a tiled floor is a resource. A high-resolution digital photograph of a dirty surface that you might overlay to make the tiled pattern look dirty is a resource. And so is any other image that can be used in order to get the desired effect (Figure 4-1).

The examples are as endless as your imagination and limited only to the number of digital images you can collect. There are no cut-and-dried rules here. A resource that may seem useless to some may be just what you need. In general, you will want to avoid wasting space and dealing with the clutter of low-resolution, poor-quality, and just plain bad images. But if you come across an image that you have a specific use for, keep it! Keep in mind that although

it is easy to make a texture like the above-mentioned plain-and-simple checkered texture, it takes time to create. Why not have one on hand that you can drop into an image when needed?

If possible, save everything you can. You never know when you will need a high-resolution image of a penny, a close-up of rotting meat, or 101 highway signs from South America. Naturally, my first recommendation to you as a game artist is to buy a very large hard drive—the biggest you can afford. This makes the process of sharing, backing up, and switching to a new computer much easier. And in the event of a natural disaster you will be saved. "Honey, you grab the kids, pets, silverware, and family pictures. I have to burn my 40 gigs of textures onto 67 CDs! Meet you outside!" In addition to a large external hard drive, I also have a RAID array in my system that mirrors several hard drives so that if one crashes I don't lose any work—even my most recent work. It has also provided me with peace of mind, in that when I'm out of town I can leave my external drive in a safe location away from my house. If my computer got stolen, the house burned down, or my system got damaged in any way, I would still have my external drive. I could more easily replace the system than the data.

It is also a good idea to crop, resize, and otherwise manipulate your images to make them as size-efficient and user-ready as possible without degrading their quality. An image that tiles nicely and is already a power of two will not slow your inspired work flow, as you can simply drop it into your work and not stop to crop, clean, tile, and otherwise make it useful.

Figure 4-1
A resource is any image that can be used to create art. Here, a simple checked pattern was used to create a tile floor by combining it with other images.

In the process of greedily obtaining and hoarding digital images, you will discover that whatever time you spend up front to make them easier to find and use in the long run will be worth every second. You need to categorize your assets by type (terrain, liquid, doors) as well as keep track of where you got them. Some texture collections have copyrights and "use restrictions" attached to them. Therefore, you might not be able to store all your images in one neat structure, instead having them in various folders according to many criteria. We will look at that process later in this chapter in some detail.

First, let's look at the process of gathering the raw images for your collection. There are many ways to collect images for your collection; all have their pros and cons.

Gathering Textures

There are many sources for textures and digital imagery, including creating them in Photoshop, taking digital photographs, scanning them in, buying texture collections, surfing the Internet for useful images, and using 3D applications to model and render images.

Creating Textures in Photoshop

Although there are many ways to create a texture, I wanted to focus on using pure Photoshop as much as possible for this book. I believe that if you are able to create anything you want in Photoshop, then when you have the other resources at your disposal, you will be much better and faster at creating textures. I will briefly introduce this method here and we will spend the rest of the book creating textures using Photoshop. Technically, every game texture you create will pass through Photoshop and become a Photoshopped image to some degree.

Many people get intimidated by the prospect of a blank slate in Photoshop when creating a texture, or they may be critical of this method based on low-quality work that they have seen. Creating basic materials and even objects in Photoshop is not that hard and does not require special painting skills. In fact, you can create materials and objects with a greater degree of control, and thus create an image that may be better than a digital image of the same thing in some cases; see Figure 4-2.

In the end, no matter what source you obtain your raw assets from, you will always use Photoshop (or a similar 2D image editor) to manipulate and assemble your textures in their final state. For example, you may create a frame for a window in Photoshop based on a photograph, create the glass panes from scratch, and use an actual image of a wood grain to add detail to the window frame and overlay a grime layer, too (see Figure 4-3).

Figure 4-2
The image on the **left** is a digital photograph and the one on the **right** was created entirely in Photoshop.

There are some cons to this method. It does take some time to start from a blank slate and use all the proper filters and tools to create a realistic texture or material from scratch. If you are not patient and understand the methods, then textures will look "Photoshopped," which is not a negative term pertaining to Photoshop, but is a comment on a lack of quality in the image itself. Not adjusting any Photoshop default values or taking the time to tweak and test the texture will result in substandard work. One positive is that this method allows you to create an image that is uniquely yours. You will never be stuck without the texture you need. If you can imagine it, you can create it in Photoshop. Just because you can't find a picture to manipulate, you don't have to stop working.

Even if you don't need to create from a blank slate in Photoshop, you will still need to use Photoshop to manipulate your images to make them useful to you. The better you know Photoshop and its many tools, the better your work will be—no matter what method you use.

Finally, there is consistency. Knowing how to use Photoshop to its fullest will allow you to achieve consistency with your texture sets, and that is very important. No matter how great your textures look, if they don't visually mesh together in a game world, all the good you have accomplished in your texture work is diminished.

Figure 4-3
This window was created in
Photoshop using a mixture of
photographic and Photoshop
elements.

Digital Cameras

Using a digital camera to collect images is very common
and becoming easier as the prices of digital cameras drop
and their quality increases. The only real cons of this method are
that people don't like it when you take pictures of their front
doors and they will often call the police (true story). Art gallery
owners don't like it when you take pictures of the paintings
hanging on their walls (true again). And the government hates it
when you take pictures of their secret alien storage facilities and
will try to take your camera away from you (can't talk about this
one).

In all seriousness, there are no drawbacks to this method
other than the cost of the camera. Depending on what camera you
purchase, you may be stuck with limited storage and resolution,
odd formats, and slow data transfer times. But this should not be a
problem with a fairly recent purchase. As of this writing, $300 will
buy you a digital camera that should do the job well and make data
transfer easy via memory cards or a direct connection to the
computer from the camera. With a decent digital camera, you can
take pictures of anything and everything. The images will be yours
(unless you are taking pictures of copyrighted artwork, people, and
so on) and you can set up shoots for specific items. I have taken
pictures of dirty dishes and fake blood smears on paper, and
I have stood in the highway for the right angle on a sign—all
for the sake of textures. Be warned that since 9/11, taking pictures
of most places will be noticed and you need to be more careful.
Before 9/11, no one would think much of you if you were taking a
picture of the rusted door of a power station or warehouse,
but now you may be watched or even reported. I have been pulled
over and questioned by the police after taking pictures around a
warehouse. Someone thought it suspicious and wrote my plate
number down.

Digital images are versatile, too. Don't be limited to the original
context or scale of the asset. Use the texture where it works. A rock
can be the side of a mountain, a small crack in a sidewalk can be a
large crack in a wall, the vent opening on a hairdryer can be a large
sewer grate, and so on (Figure 4-4). This applies not just to scale,
but to context as well. A really great source for some of the most
disgusting textures I have ever seen were simply close-ups of the
pots and pans in the kitchen after dinner. Grease drippings from a
roast, congealed butter after the vegetables have been removed,
and dried ketchup can make for some great imagery. We have
included some on the DVD, of course. In Figure 4-5 are some of the
sick images in my collection.

The possibilities are as endless as your imagination with a digital
camera. Another benefit is the ease and extremely low cost of
experimentation with a digital camera. You are not limited by factors
such as the number of prints on a roll or the cost of film and
developing. You can shoot and delete a thousand images for the
price of ten.

Figure 4-4
Don't be limited to the original context or scale of an asset. Use the texture where it works. A rock can be the side of a mountain, a small crack in a sidewalk can be a large crack in a wall, and in this case the vent opening on a hairdryer is a large sewer grate.

Tips on Taking Digital Photographs

Taking digital photographs for use as texture resource takes a different mindset than traditional photography. Most likely, the first images you take will have aspects that will make them hard to use in a texture. You won't be able to see these problems right off; in fact, you will have to go home and look at the images up close on your computer and try to work on them before the problems pop up. But there is no substitute for this process, and going through it a few times is the only way to develop an eye for spotting potential problems before taking the picture. Even so, here are some general tips for using a digital camera for capturing texture resources that will help speed up that process.

Image Resolution

This first tip is an obvious one. The higher you set the resolution on your camera, the higher the detail will be in the image. It also eats up memory, but makes for a better resource.

Diminish Image Tilt

This is a rather simple tip. When you take a picture, look closely in the viewfinder. You will see some marks (Figure 4-6); whether they

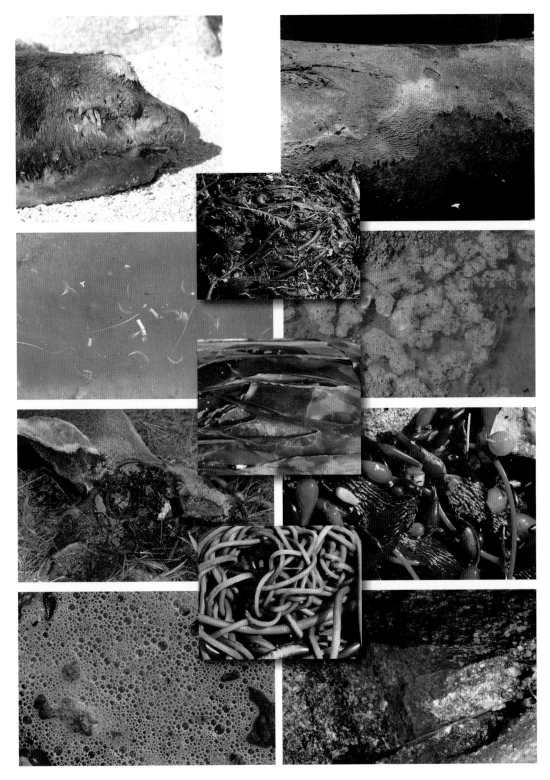

Figure 4-5
Guess what these are.

Figure 4-6
Save yourself some work; use the marks in the viewfinder to line up your shot. These are very useful and easy to use when you are taking a picture of a surface with straight lines such as a brick wall or the frame of a window.

are lines, squares, or circles doesn't matter. These marks may be there for a number of reasons, but primarily they are there to help you line up your shot. These are very useful and easy to use when you are taking a picture of a surface with straight lines such as a brick wall or the frame of a window. Unfortunately, many newer cameras don't have view finders anymore; rather they have a small screen on the back of the camera. This screen may or may not have any marks at all. If you have such a camera and want to line up your shots you can carefully draw a set of your own lines using a very fine-point water-soluble marker. If you do this be very careful not to scratch the screen, don't use a permanent marker unless you want the marks to be permanent, and do this at your own risk. Take your time measuring out the lines so they are perfectly straight across the screen horizontally, vertically, and centered.

Watch the Auto Settings

Many digital cameras come with preprogrammed image control modes. These are various presets for the camera for taking various types of pictures: close-ups, portraits, sports, and nighttime pictures, to name a few. The danger here is that some of the presets have a shallow depth of field and other settings that can distort or affect the image in an undesirable way. Depth of field is the area of the image that is in focus from the camera lens to infinity. You can have a shallow depth of field, so that items that are only within a few feet or inches are in focus, and objects that are closer or farther from the camera are blurry. In Figure 4-7, you can see a few examples of depth of field.

A shallow depth of field can be bad when it is so shallow that when you are photographing a surface, parts of the surface are out of focus and blurry and other parts are crisp. This can happen easily if you are taking a picture at an angle, looking up at a window, for example, and using a shallow depth of field. The part of the window closest to you will be in focus and the farthest parts will be blurry.

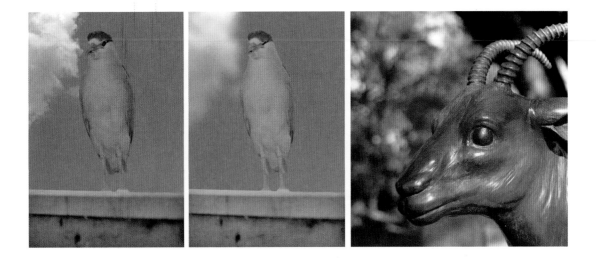

Diminish Lens Distortion (Fisheye)

When purchasing a digital camera, make sure that you get a decent lens. Cheaper lenses tend to give you a fisheye effect (Figure 4-8), spherically distorting the image, which can make it much harder to clean up your images for use. You can get a 5-megapixel camera the size of a pack of cigarettes, yet the lens is the size of a drop of water, which will give you bad distortion. There are cheaper cameras with lower pixel resolution and better lenses, and those are the ones I would buy over the ones with poor lenses.

If you have a camera with a lens prone to fisheye, you can counter the effect by getting as far back from the surface you are photographing and zooming in. See Figure 4-9 for an example of a surface that was photographed close up and zoomed all the way out and then farther away and zoomed in as far as possible. The effect is not very pronounced, but the bulge in the lines of the bricks would be very noticeable if you tried to tile this image.

Diminish Angle Distortion (Position)

Distortion also comes from the position of the camera in relation to the subject. This relates to perspective, which we discussed in Chapter 1. When you take a picture standing above, below, or to the left or right of whatever you are photographing, you are creating perspective in the image. You will not have straight lines and therefore have to make corrections in Photoshop. The Photoshop work is not too time-consuming when correcting straight lines that are at an angle using the Free Transform or Crop Tool (we look at that later in this chapter). Correcting a bulged out image may be harder, but what's bad about skewed angles as opposed to the bulge is that dramatically changing the perspective and angles in an image will cause it to fall apart visually. Even if the lines are perfectly straight, an object with any kind of depth, such as

Figure 4-7
Many digital cameras come with preprogrammed image control modes. Be careful of the presets that have a shallow depth of field and other settings that can affect the image in an undesirable way. Depth of field is the area of the image that is in focus from the camera lens to infinity. You can have a shallow depth of field, so that items that are only within a few feet or inches are in focus, and objects that are closer are farther from the camera are blurry. To the **left** you can see that the bird and the background are both in focus; in the **middle** the bird is in focus, but the sky is not; and on the **right** is an image where the foreground object is in focus, but the background is not.

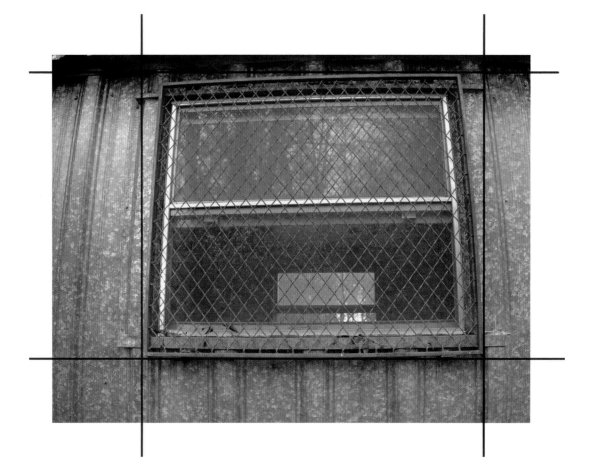

Figure 4-8
When buying a digital camera, try to get a decent lens. Even high-megapixel cameras often have cheap lenses that distort the image, creating a fisheye, or spherical, effect. This makes using the image as a texture more difficult, as it takes more time to correct such errors and does more damage to the image when doing so. This image is very distorted due to the cheap lens on the camera and would be very hard to correct (not even worth it, in my opinion). Notice the blue lines that are straight compared to the edges of the window frame.

windows and doors that have protruding frames around them, retains visual information about the angle at which the object was captured (this relates to Chapter 1, too—particularly light and shadow). The human eye will detect those differences and the image will look off. There are ways to correct those errors, but they are time-consuming, as you are basically rebuilding the image—best to avoid if possible. So, even if you get all the lines in the image straight in Photoshop, the shadows will just not look right. Things that are flat like signs can be more easily compensated for in Photoshop. You can see some examples of this in Figure 4-10 and an illustration on how to position yourself in Figure 4-11.

Diminish Lighting Problems

Lighting is a big concern, too. If you have studied photography or film, you may be familiar with the term "golden hour." For photographers, the best light for photography occurs 1 hour after sunrise and 1 hour before sunset. During this time, the light is diffuse. For a texture hunter, this is not always the best time to take pictures, because the light tends to be saturated with blues and oranges and is changing rapidly.

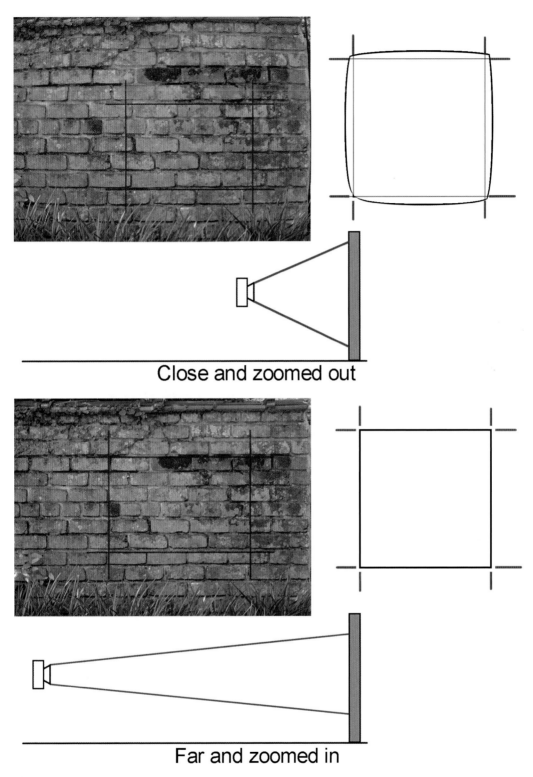

Close and zoomed out

Far and zoomed in

Figure 4-9
Distortion from a cheap lens can be countered somewhat by getting as far back from the surface you are photographing and zooming in. This is an example of a surface that was photographed close up and zoomed all the way out and then farther away and zoomed in as much as possible. The effect may not look that pronounced, but later, when you try to use this image to tile across a wall surface, it will be very noticeable.

But during the day, light is of very high contrast and harsh when the sun is overhead. When the sun is low in the sky, the shadows can be equally as harsh, but are longer. During these hours, when the sun is low in the sky, you are also faced with the problem that anything you are trying to photograph might be facing away from the sun and therefore silhouetted. These images generally come out really dark. This is not a good time to take texture source images either.

So what does that leave? If possible, wait for a cloudy or overcast day. Although many photographers don't go out on overcast days, it is the best time for us to go out and shoot. Light is plentiful, it is just diffused by the clouds. There are no harsh shadows, as the light is more evenly distributed. On overcast days, plants and trees in particular are more saturated. Although we have a lot of control over our image in Photoshop, harsh shadows are almost impossible to remove. Figure 4-12 shows two wooden shutters, one shot on an overcast day and one on a sunny day.

Don't Use the Flash If at All Possible

Another problem is flash burn. Avoid the flash if possible. A professional photographer knows how to use a flash so that it casts just the right amount of controlled light, and maybe you can learn that, too, but in general if you take a picture using the flash, you will get harsh light and shadow and a large flash burn in the image. Even surfaces that don't seem highly reflective will be burned by a flash. In fact, even if you are photographing a very matte (nonreflective) surface, you will still get a large overlit area in the middle of the image and the edges will recede into darkness. This is just as bad as a burn for texture work. You can remove a mild flash burn in Photoshop, but usually doing so requires you to clone and paint the flashed part of the image to remove it. I would opt to take another path if possible. Figure 4-13 shows a flash burned image and how poorly it tiles.

Plan for Alpha Channels

We talked about alpha channels in Chapter 2 (making parts of the image transparent) and later we will look at various ways to create alpha channels. Many of the techniques for removing backgrounds

Figure 4-10
Distortion also comes from the position of the camera in relation to the subject. When you take a picture standing above, below, or to the left or right of whatever you are photographing, you are creating perspective angles in the image that will have to be corrected in Photoshop. The windows on the **upper left** are okay, but the windows on the **upper right** are at too dramatic an angle. The **second row** shows some windows all taken at a good straight on angle. The **third row** shows a sign that was taken at a skewed angle but easily fixed as it is flat and lacks a lot of depth. These windows on the **bottom left** are at a very extreme angle. **Bottom right**, even after straightening the lines, the protruding frame retains visual information about the angle at which the window was captured and the image doesn't work.

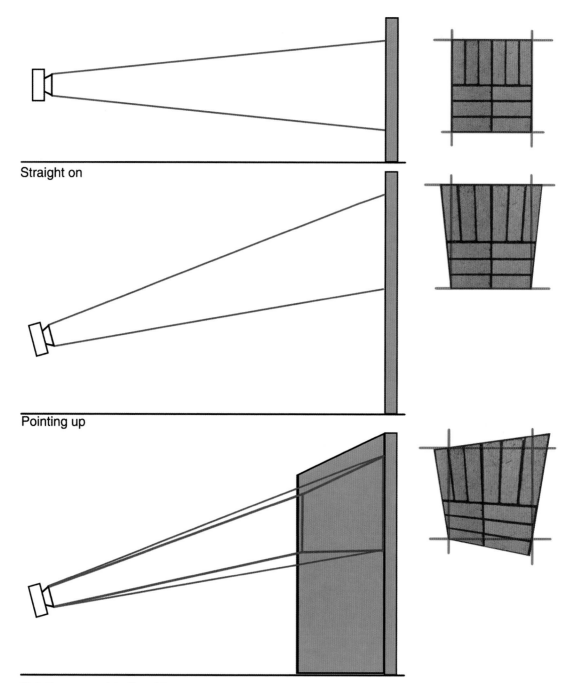

Straight on

Pointing up

Pointing up and to the side

Figure 4-11
Ideally, you want to take a picture straight on to minimize angle distortion, but even if you can't get into an optimal position, you can still minimize angle distortion by positioning yourself as straight vertically or horizontally as you can. **Top,** ideally the camera should be pointing straight at the subject. If this is possible, the image will be mostly square and easier to fix in Photoshop. The illustration in the **middle** is of the camera looking up, like at a window or sign high on a wall. In this scenario the image will come out wider at the top than the bottom. At the **bottom** you can see that taking a picture from an angle that is both horizontally and vertically off will create a very distorted image.

to create alpha channels rely on the separation and deletion of the background colors from the foreground objects. Knowing this, if it is at all possible, try to make sure that the objects you are capturing have a contrasting color behind them. Figure 4-14 depicts a plant that was photographed so the background could easily be removed and an alpha channel created. There is also an example of an image of grass that is too full of grass; there is no clear delineation between grass and background.

Figure 4-12
Although we have a lot of control over our image in Photoshop, harsh shadows are almost impossible to remove. Here are two wooden shutters, one shot on an overcast day and one on a sunny day.

Plan for Tiling

If you know that you will be tiling the surface you are photographing, then try to capture all the edges and boundaries you will need to make the tiling easier. If you clip off part of the image, the tiling of that surface will be much harder. If you are photographing a surface, such as a brick or stone wall that you intend to tile, try to pick a section of the wall that has as few repeatable aspects if at all possible.

Scanners

Scanners are another way to capture digital images. Not only can you scan documents, but you can also scan small 3D objects like knives, leaves, or feathers (Figure 4-15). Just be careful not to scratch the glass or spill liquids into your scanner. Keep in mind

Figure 4-13
Avoid the flash if possible. In general, if you take a picture using the flash, you will get harsh light and shadow and a large flash burn in the image. Even surfaces that don't seem highly reflective will be burned by a flash. The **top** image shows a flash burn and the **bottom** shows how poorly it tiles.

that even though scanners have dropped in price and increased in quality, it is often easier to just take a picture of an object with a digital camera rather than scan it. Also keep in mind that most images you would like to scan may be copyrighted.

Scanners are great for artists who actually do their work on paper, but once again a digital camera would be better, considering the fact that artwork can easily be too big for a scanner and the paint or ink may rub off on the scanner glass.

Texture Collections

There are some terrific texture collections for sale that anyone can buy, and they fall into three general categories:

- The finished game texture
- The digital photograph collection
- The digital image of a surface or thing

The problem with the finished game texture is that anyone and everyone will recognize those purchased textures. They can almost never be used "as is" and will need to be modified, so it is generally

Figure 4-14
When digitally capturing anything with the intent to create an alpha channel if it is at all possible position the camera so that the objects you are capturing have a solid contrasting color behind them. This will make it much easier to remove the background.

Figure 4-15
You can scan small 3D objects like knives, leaves, or feathers. Just be careful not to scratch the glass or spill damaging liquids into your scanner.

Figure 4-16
Left, an image of a digital photograph from a clip art–type collection and, **right,** a digital image of—ugh, that's sick. Which image would you prefer in your collection (by the way, it's ketchup and bacon fat)?

better to get a good set of base images and build your own textures. But if you can get your hands on these texture collections, they are very useful for learning. You can also use these "as is" in certain circumstances. If you are prototyping or building a walkthrough that will not be sold on artistic merits, then these sets can be very useful and time-saving.

The digital photograph collection is the sort that features a kid holding balloons, a shot of the Chrysler building, the Statue of Liberty, and a sunset. These are artsy shots and though they may have their uses, they aren't generally as useful to the texture artist. Give me a good image of a rusted dumpster panel, cracked stucco, or a wall of wooden planks. The digital photograph is sold mostly as clip art for web sites and newsletters. Only a texture artist would love a high-resolution image of a pile of rotten meat swarming with maggots. Most people would prefer the kid holding the balloons.

Finally, we have the digital image of the rusted dumpster panel, the side of the dead seal, the close-up of pork drippings, and dried vomit (see Figure 4-16). These are the images the texture artist lives for, the ones we find most useful. These are the images you will composite over other images in Photoshop using the layer blending modes to create some incredible textures. These images are best when you take them and swap them with your fellow artists. There is a good set of digital images on the CD/DVD to help get you started or to add to your collection.

The Internet

The Internet is a great source of images. Of course, you will run into copyright restrictions and low-resolution images, among other problems, but quite often the images you will find by going to the

image search on Google will be surprisingly good (Figure 4-17). Even just for a source of reference, the Internet can be invaluable. Type in a few keywords and you can see pirate gold, maps, Persian rugs, almost anything you can imagine that someone took a picture of and uploaded somewhere on the Internet.

Figure 4-17
Searching Google for the word *rust* netted 178,000 images. *Google image search screen used with permission.*

Using 3D Applications

Another method used for creating 2D textures is to model them in 3D. This method is great for modeling things that you can't get a picture of and that would lack the depth you need in Photoshop. This method also allows you to create a surface using all the lights, materials, and shaders the 3D package has to offer. You can render an image from a 3D application, process it in Photoshop, and then apply it to a lower-poly-count game model. The big drawback to this method is that it relies on the facts that you (1) are a 3D modeler and (2) own the necessary software. That is a major drawback, because you need to know how to 3D model, texture, and light—as well as own the software. This method can also be time-consuming and must be weighed against other options.

Figure 4-18
Cropping chops the image down to the size of the crop box and removes what's outside it.

Cleaning Your Textures

The process of cleaning up your textures is an important one. Time spent at this stage will save you much time later on. When an image is cropped, it saves space; when it is named and saved appropriately, it is much easier to find when you need it; and when an image tiles nicely, it can be used "as is"; you won't have to stop your creativity to clean up the image. Also, the process of working for a few minutes with each texture helps you become familiar with what images you have on your hard drive. This will speed you up and allow you to create better textures, as you will be aware of the many options you have when building your texture. Of all the things you can do to manipulate an image when cleaning it up, the first thing you will most likely do is crop it.

Cropping

Cropping an image is simply the process of cutting off portions of an image. Cropping literally chops away the portions of the image outside the crop box (see Figure 4-18). The Crop Tool in Photoshop, however, can do much more than just cut your image down to size. Some of the features of the Crop Tool can be very useful and time-saving.

As you are cropping your images, keep in mind that while power of two textures (discussed in Chapter 2) are often your final goal, a perfect square of any size will be fine as long as you remember to start your texture work in the power of two, resizing the source to fit. Some resource images defy the perfect square rule, so don't stress. If the image is a panoramic scene of the horizon or to be used as an overlay for stains and weathering, then leave it as complete as you like.

Cropping an image can save file space, as well as resizing it, but I don't resize and I crop as little as possible. I like to keep the entire image, and I always use a copy of the image and never alter the original. Increasing the image size doesn't buy you anything but a larger file size and sizing it down or cropping it only degrades quality and/or removes portions of the image you can't get back later if you need it. I do crop a lot when I am working on windows, doors, and things like that as I straighten them, especially if all there is around it is a boring wall that looks like all the others I have.

Warning: Cropping is permanent unless you change the **Delete** option to **Hide** in the Option Bar in Photoshop. Once you do that the canvas size will be scaled down, but the image will still be the same size and is just hidden as it is outside the canvas area. If you use the Delete option and save and close your file, you can never get the cropped portion back. You cannot use the Hide option on an image that only has a background layer. You need to either convert the background to a layer, duplicate it, or create a new layer.

Note: You can make the canvas size larger using the Crop Tool. You can drag the crop box handles outside the canvas.

Here are some helpful tips when cropping an image in Photoshop. When using the Crop Tool you can:

• Hold down Shift, and it will make the selection perfectly square.
• Hold down Alt, and the crop box will drag and size from the center point of the crop box.
• Hold down the Shift and Alt keys and make the selection perfectly square as well as drag and size from the center point of the crop box.
• Press the Caps Lock key and your cursor will change to the small crosshairs instead of the thick Crop Icon that can get in the way of the image you are trying to crop.
• Enter a height and width in the options bar. After you drag out the crop box and hit Enter, the image crops and resizes. You will notice that you can size the crop box but not change the proportions. The height and width stay proportional to the values you entered.
• You can also hold down the Ctrl and Alt keys **after** you start dragging out the crop box to make the crop box selection the exact size of the dimensions you entered, so the image will not resize after you press Enter.
• You can rotate the crop box and it will crop and rotate the image to match the selection. See Figure 4-19.

Fixing Perspective (Bad Angles) with the Crop Tool

Using the Crop Tool in Photoshop, you are also able to instantly fix perspective problems. I find this feature particularly useful. All you have to do is drag out a crop box on your canvas (doesn't matter how big it is as you adjust it later) and make sure that the

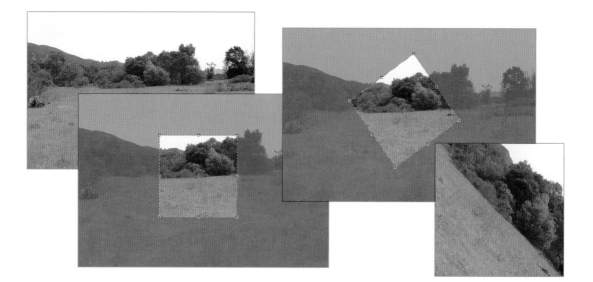

Figure 4-19
You can rotate the crop box and it will crop and rotate the image to match the selection. From **left** to **right**: the original image, the crop box dragged out, the crop box rotated, and the final result after pressing Enter.

Perspective box is checked in the Options bar; then you can drag each individual handle to the corners of the thing you want to crop and fix. When you press Enter, BAM! The image is cropped and the perspective fixed. See Figure 4-20 for a visual of the Crop Tool fixing perspective in an image. This works best on images with straight lines. I mentioned earlier that a bulged-out image is harder to work with than one with straight lines. This is one of the reasons. The lines connecting the crop box handles are straight, but if the area of the image you are trying to crop is bulged, the lines will be curved and you won't get a clean result when you crop.

Resampling an Image Using Crop

Resampling means to resize your image, to change the pixel height and width of the image. The Crop Tool allows you to crop your image based on the dimensions and resolution of another image. You must first open the image you want to take the information from and then select the Crop Tool. Click Front Image in the Options bar and then click on the image you want to crop. Drag the crop box out (it will maintain the proportions of the sampled image), and when you crop your image it will also resize it.

You can also change the color and opacity of the shading shield and turn it off and on (see Figure 4-21). The shading shield is the area outside the crop box that will be cropped.

Crop Using the Trim Command

The Trim command (Image > Trim) crops an image by cropping away the parts of the image that has transparent pixels; therefore, Trim will have no effect on a full layer (Figure 4-22).

The Free Transform Tool

The Free Transform Tool allows you to size and distort the layer or selection in many ways. This tool is particularly useful in cleaning up textures and in texture creation. The Free Transform Tool allows you to scale, rotate, skew, distort, and change the perspective of an image as well as other options for quickly rotating or flipping the image (see Figure 4-23). You can choose to flip the image horizontally or vertically or rotate the image exactly 90 degrees clockwise or counterclockwise as well as 180 degrees. All of this manipulation of an image is really useful when creating textures. Manipulating one visual element to fit convincingly into another is a good deal of what you will be doing during texture creation. Not all digital resources will come to you at the same resolution, angle, and so on. You may want to overlay a crack from one image on a wall texture and may need to scale, rotate, or even distort it to make it look the way you want it to.

Figure 4-20
The Crop Tool allows you to instantly fix perspective problems. The image at the **upper left** is the source. The **upper right** shows the extent of the perspective problem with red lines. The lower **left image** is the crop box on the canvas after each handle has been dragged to the corners of the part of the image I want to retain and fix. **Lower right,** after you press Enter, the image is cropped and the perspective fixed.

Figure 4-21
You can change the color and opacity of the shading shield and turn it off and on. The shield is the area outside the crop box. Here you can see various settings applied to the shield.

Figure 4-22
The Trim command crops an image by cropping away the parts of the image that has transparent pixels.

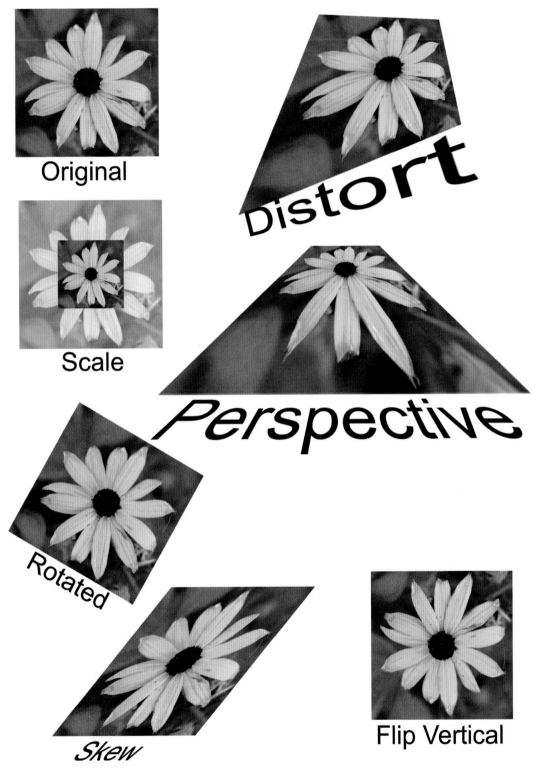

Figure 4-23
The Free Transform Tool allows you to scale, rotate, skew, distort, and change the perspective of an image as well as other options for quickly rotating or flipping the image.

You will use the Free Transform Tool frequently in texture creation. As you are creating a texture, you will be bringing images together from various sources and they will be of various sizes. You may be working on an image that is one size, say 1024×1024, and paste in an image to use in the texture as an overlay or detail that is larger or smaller and will need to be fit into the texture.

Note: Once an image is in the computer, the maximum detail is set and cannot be increased. The Free Transform Tool is one way to make an image larger, but the amount of detail doesn't increase; only the number of pixels is increased by a mathematical process called *interpolation*. This process does not increase the detail; it simply adds extra pixels to smooth the transition between the original pixels.

Warning: Be careful when doing any severe manipulation to an image, as you may degrade the image quality. Resizing, for example, does a lot of damage to an image. If you reduce a large image and later re-enlarge it, you will seriously degrade it. Once you shrink an image and save it, you lose the resolution of the original image.

Texture Tiling

A tiling texture is an image that can repeat over a surface and still look good. Although it is easy to remove the seams in an image in most cases, it is more art than science to create a texture that can tile across a large surface, not have a pattern to it, and still look good (not being a blurry mess in order to tile). I purposely didn't discuss how to tile a texture until *after* I discussed the best way to collect and prepare your resources because some images are just not worth working with if you can help it. If the lighting is so bad, the resolution so low, or the image so distorted that you are looking at some serious reworking of the image, I would wager that it would probably be quicker to get a new base image than try to rebuild a bad one. There are so many sources of digital imagery it just doesn't make sense to perform major surgery on a bad base image. Some images are literally tiles—like floor tiles—and are easy to make repeat across a surface, but others can be complex artificial or organic patterns that are more challenging to work with. With these types of images the challenge is not only to make them tile, but also to create an interesting texture without high contrast or unique details that make the tiling noticeable (Figure 4-24). These errors are often called *banding* and *hot spots*.

Tiling a texture is arguably the most discussed aspect of texture creation, but there is more to tiling than just using the Offset Filter and cloning away the seams. That method doesn't always work when tiling various surfaces. What approach you use to tile an image will depend on the image you start with, where the texture will be used, and even the technology used.

Figure 4-24
On the **top** are examples of organic and inorganic images that do not tile well. The organic water image has severe banding: you can see harsh dark stripes running vertically in the tiled image. The inorganic white bricks have a very severe hot spot; there is a clearly identifiable spot on the texture that you can see repeating. The **bottom** two examples are a set of organic and inorganic images that tile much more nicely.

The Base Image

The condition of the base image and what the final outcome must be will determine what you will have to do to the image to make it usable. At this point in the chapter, you are well aware of the things you can do: cropping, fixing angles, smoothing the lighting, and others. If you are starting with an image that was shot dead on straight, you may not need to fix the angles. If it was perfectly lit, you will not need to spend time adjusting the lighting—you get the idea.

The Context of the Texture

Where will this texture be used? The answer to this question has a lot to do with the tiling techniques discussed shortly. But context also has to do with how close the player gets to the image, and how many times it will tile across a surface. You need to know this information, because you can spend a lot of time making a texture tile a thousand times across a large terrain and find out that the image will be used in a place where it will only tile four times or that you took too much detail out trying to make it work where it was not intended to.

The Technology Used

If you are developing for a platform or technology that is limited to low-color 128×128 images or a cutting-edge game engine using a high-end system that allows for high-color 1024×1024 images, you will obviously approach the processing and creation of the image differently. A larger image will allow for more detail and be a bit easier to tile due to the larger area covered. But image size is not the only technological consideration when determining the final appearance of your texture. What you can do with those textures in the game engine makes a huge difference in the final form that your texture will take.

Some game engines allow combining of multiple layers of textures on terrain (just like Photoshop layers), and this allows the texture artist to make a number of textures that are predominantly one material. Textures composed of one material are much simpler to tile. It used to be that terrain was covered in one texture and if you wanted something like a road or dirt patch, you had to create various versions of that one texture to place on the terrain polygons on which you wanted the road to run or the dirt patch to appear. This was limiting to say the least: roads ran in straight lines and right angles, and you had to create a separate texture for any unique terrain detail. Now we can create a few versions of the terrain textures: packed dirt, grassy dirt, dried dirt, grass, dead grass, and other single-themed textures and paint them onto the terrain. We can make our base layer grass and paint on darker grass, dirt patches, or a dirt road with a dirt-to-grass border. This is easier, and the results are far more pleasing. This approach also

makes dealing with texture tiling much easier. See Figure 4-25 for an example of a terrain built using the layer system.

Some engines allow for random swapping of textures across a surface. You can create a texture and various versions of it and apply the main image to a surface and the game engine will randomly assign the textures to various polygons. This method usually relies on a naming convention so that the engine will know that when **Wall_Texture_001_a** is present and there is also present **Wall_Texture_001_b** and more in the sequence, to use those other textures in the random tile.

These random tiles are usually subtler in their differences than the textures in a texture set as shown in Chapter 2. In a texture set, you may have a very noticeable detail in the various textures: vents, large cracks, and so on, but a random tile is meant to break up the pattern produced by a tiling texture and not add specific detail (Figure 4-26). Four vents showing up at random spots on a wall would look weird, whereas subtle variances in the pattern of a brick—and even gradual light shifts, in this case—may work well. This is another technology that would allow for smaller textures. Four 128×128 versions of a texture randomly tiled would look better than one 256×256 texture tiled and would take up the same texture memory (if this doesn't make sense, look at Chapter 2, in which I discussed the power of two).

But even this newer approach is being supplanted by an even newer technology. With shaders and projected textures, or decals, you can make the wall texture simple and add detail in other ways. Figure 4-27 shows an example of how a projected texture works. Shaders (discussed at length in Chapter 2 as well, with visual examples) can use even simpler textures and process varied detail in real time.

Fixing Light Variations Across an Image

You will notice that when you are tiling a digital image (right after you run the Offset Filter for the first time), there are often variations in the lighting across the surface. This is almost unavoidable and why I spent some time earlier saying, "Diffuse light good, flash bad." Probably the first thing you should correct in an image you plan to tile is the lighting. There are several ways to do this. Most commonly you can use the High Pass Filter or use the image itself to manually adjust the lighting (or a bit of both).

The High Pass Filter basically "reduces brightness differences; it also reduces the contrast of the image, paling the colors." The use of the High Pass Filter is detailed in an excellent article on Gamasutra, "The Power of the High Pass Filter," by Peter Hajba (**www.gamasutra.com/features/20010523/hajba_01.htm**).

I try many things in conjunction with the High Pass Filter. For one, I copy the image I am repairing on a new layer (Ctrl+A, Ctrl+C, Ctrl+N,

Figure 4-25
Not too long ago (**top**) terrain was textured by covering the terrain in one texture. Roads, dirt patches, and any unique area had to be created as a separate version of the base texture and placed on the terrain polygon where the detail appeared. Roads ran in straight lines and right angles. Nowadays (**bottom**) most commercial game engines allow for the layering of textures on terrain, like Photoshop layers. These textures can be composed of predominantly one material. Using a base dirt, grass, and other single-type textures, you can paint them onto the terrain. This method allows for a much more organic terrain with more variety using the same number of textures. Not only are the results far more pleasing, but this approach also makes dealing with texture tiling much easier.

Figure 4-26
Some engines allow for random swapping of various textures across a surface. This method usually relies on a naming convention so that the engine will know to include all textures of a certain naming pattern in the process. These random tiles are usually more subtle in their differences than the textures in a texture set. In a texture set you have noticeable detail, but a random tile is meant to be subtle to break up the pattern produced by a tiling texture and not add specific detail. In the **left** image, you can see a repeating pattern. On the **right**, three versions of the tile have been randomly applied to the surface. Some of the bricks are actually more pronounced, lighter or darker, but still work because of the random tiling.

and Ctrl+V), blur the copy using the highest setting of Gaussian Blur (this makes the layer a solid color), or just use an adjustment layer (explained in the last chapter) and fill it with a desired color, and then I use the High Pass Filter on the original layer. Tweaking the High Pass Filter is a balancing act between the smaller radius (gray and flat) and a higher radius (little to no effect on the image) to even out the lighting. Then I play with the blending modes (also explained in the last chapter) and levels and other settings on the color layer. Sometimes I even use a copy of the high-pass layer, invert it, blur it a little, and play with the blending modes and opacity to further adjust the lighting.

New to Photoshop CS is the Shadow/Highlights command (Image > Adjustments > Shadow/Highlights). This tool allows you to control the shadows and highlights in an image, especially silhouetted and flash burned images. The Shadow/Highlights command goes beyond levels and does not just darken or lighten the image. It treats the shadow and highlight areas separately from each other and enables independent control of the shadows and the highlights. Because the default settings are designed for images that have bad backlighting, you will have to play with the adjustments if your image doesn't look just right when you first open the tool.

Figure 4-27
A projected texture works like it sounds. You can project a texture onto a surface in the game world. Here you can see the image of a crack with an alpha channel projected onto a wall texture, and the result is a wall with a crack in it.

Each image you process will be different from the last. There is no one perfect way to fix the lighting in an image. At first you may have to experiment with several ways, but after a while, you will begin to have a sense for what the best approach may be more immediately for each particular image.

One-Way Tiling (Horizontal and Vertical)

Making an image tile on only one axis, horizontal or vertical, is much easier than making an image that must tile across a larger surface in all four directions. See Figure 4-29 for a visual of one-way tiling. One-way tiling is usually used on a wall where the texture only needs to tile across the wall, and not up and down it.

Three- and Four-Way Tiling

Three-way tiling is used in the case of a wall set where the sides of the texture are designed to tile with each other and the top edge

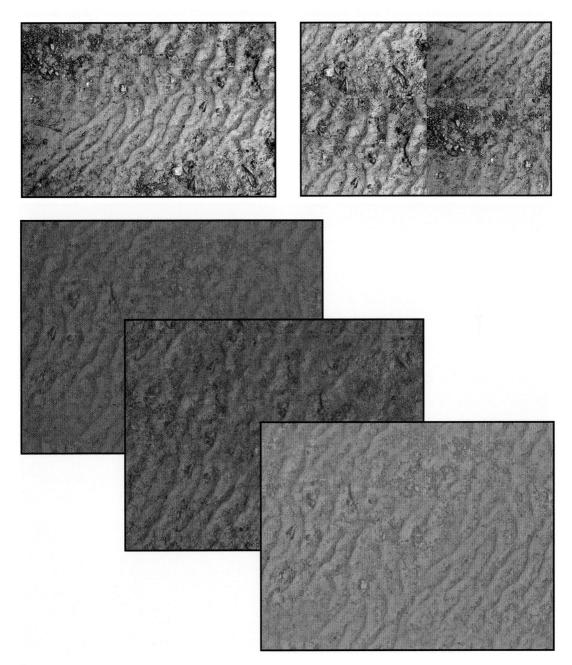

Figure 4-28
On the **top left** is an image of dirt and to the **right** the image offset, so you can see the lighting variance. **Below** are three versions of the image from the same PSD file. Playing with the blending modes and other variables will give you various results.

with another texture; the bottom edge doesn't tile at all. The top of the wall texture will tile with itself side to side and with another texture on the bottom (see Figures 4-30 and 4-31). The center tile must tile in all four directions (with itself) and the top of the bottom texture and the bottom of the top texture. This is easy to

Figure 4-29
Upper left, the wall texture was designed to tile only one way, horizontally. **Right,** the vertically stacked textures show how the texture was not designed to tile and **below,** the texture horizontally tiled. At the **bottom,** the texture used in a scene where it is horizontally tiled.

Figure 4-30
Three- and four-way tiling is used in this wall texture set. The **top** texture tiles only in three directions; with itself, side to side, and with the base wall texture below it. The base wall texture in the **center** tiles in all four directions, and the **bottom** texture tiles in three directions, side to side and with the base above it.

understand when presented visually. Four-way can be easy if you are working with clean and simple textures like clean blocks and bricks. In the figures, the center of the brick wall tiles with itself, is clean, and is not a huge challenge. It gets a bit more challenging when you are working with stone walls and odd-sized bricks with dirt and weathering thrown in.

Figure 4-31
Here are the three- and four-way tiling texture sets used in a scene.

Organic vs. Inorganic Tiling

Inorganic surfaces are artificial and generally more easily tiled along seams. Things like walls, bricks, cut wooden planks, metal plates, windows, and so on are pretty easy to tile. Organic surfaces can be easy, too. Things like grass and dirt are fairly easy to tweak and blend into a seamless tile. The challenge comes when you try to tile things with obvious and complex patterns like cobblestones and other assembled stone surfaces that aren't on a grid. Organic surfaces with pronounced segments like pine bark, dirt, or rock with striations, or even certain grasses can be challenging to tile. Because of the randomness at which the objects or materials are laid out, they don't tile in the real world and are harder to capture and tile in the computer. This leads us into the next section on the various tiling techniques.

Texture Tiling in Practice

There are several ways to tile a texture, and like most other aspects of computer art, you will most likely use a bit of each technique to get the job done. Of course, most texture tiling starts with the classic Offset Filter. All together now:

• Copy the layer you want to tile.
• Run the Offset Filter.

- Enter half the height and width of your image (or with CS, you can use the slider bars to move the image in real time).
- Erase the hard line in the texture that appears in the vertical and horizontal centers of the offset image with a soft brush.

And you have removed the seams.

This is the first technique you will learn. If you are new to texture creation and have tried to find any information on the topic, you most likely didn't find much beyond the use of the Offset Filter. In four lines or less, you can be taught to tile anything, right? Or maybe you need the deluxe version of the tutorial that tells you to use the Clone Tool to remove conspicuous detail that may be noticeable when the texture tiles. Unfortunately, making a texture tile usually involves more work than this. Even if the texture looks flawless by itself, when it is repeated over a surface several times, it may be painfully obvious that your texture is tiling (Figure 4-32).

Edge Copy

Other than using the Offset Filter, you can also use a different technique. This method involves starting with an image larger than you intend the final texture to be and copying some of the outer portions of the image from one side and moving it over to the other side. You don't flip or rotate this piece. By selecting a piece of the image outside the portion of the image you want to tile and moving it over, you are creating a seamless transition between the left and right sides of the image. The seam you need to deal with now exists on the inside edge of the pasted portion and is easier to work with than an offset image. This process is detailed in this section.

You will still need to clean and clone, but I prefer this method when trying to tile an image with large irregular elements like stones. With this method, you are working with one edge, whereas with the Offset Filter you are trying to blend two edges at once.

Project: Tiling Stones Using Edge Copy

One problem with tiling stonework is that often there are wide variations of color, contrast, size, and even the positions of the stones. Unlike bricks, wooden planks, and other artificial materials, stones are not uniform in length and width and as a result don't fit together in a perfect pattern. There is another, simpler, way than this to make stones in Photoshop that are more uniform and easier to tile. I prefer that method and use it in the chapter on fantasy textures. But you should know this method in the event that you need to tile a specific image that fits these criteria. The following project illustrates edge tiling as well as a few tricks to make natural stones more uniform.

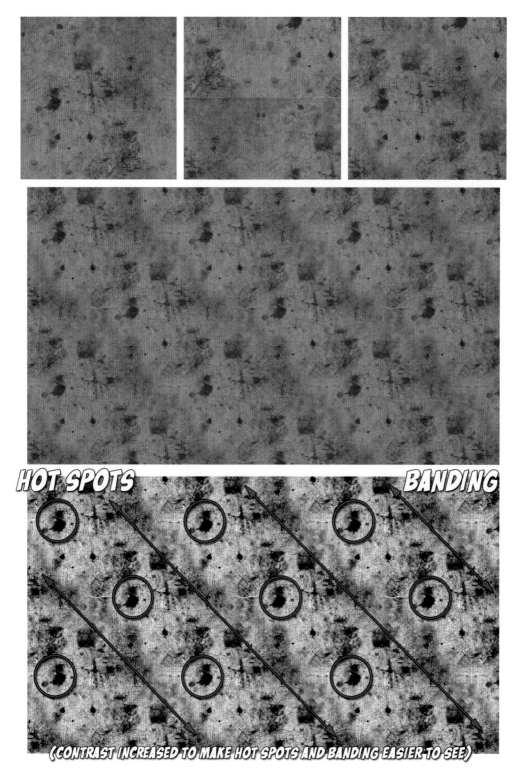

Figure 4-32
The Offset Filter is the first tiling technique you will learn, but making a texture tile usually involves more work than simply removing the noticeable seams. Even if the texture looks flawless by itself, when it is repeated over a surface several times, it may be painfully obvious that your texture is tiling. The **top left** image is the original, the **top middle** is the offset image, and the **top right** is the image with no seams. But the large image **below** is the seamless tile tiling, but not very well. Notice the very repetitive patterns and the diagonal banding, too.

Setting up the Image

1. Open the source image from the DVD for this project. Note that this image is larger than 1024 and not a power of two. That is preferred in this instance.
2. Set your grid to 128 (Edit > Preferences > Guides, Grid).
3. Choose a square portion of the image you want to tile. Use the grid and make sure your selection is a power of two. I selected the portion you can see in Figure 4-33 outlined in red. The square I chose is a 1024×1024 section with some of the image to the left and the bottom of the selection.
4. Drag out some guidelines to mark the four edges of your selection. These will help you later on. You may even want to zoom in and make sure your guides are snapped precisely on the edge of the selection.

Cleaning up the Image

The very first thing I do when working on an image like this is to make all the stones more uniform. I don't just mean adjusting the lighting, but actually resizing and moving stones just a bit to get them to be closer in size. I find it makes tiling easier later on. You can see the original image and the corrected image where the stones are more similar in Figure 4-34. I resized and moved stones by cloning some stones over others, using various parts of several stones to create, or fix, another. That technique is explained next. You can also play with the High Pass Filter, the Shadow/Highlights command, and other methods for adjusting the lighting and consistency at this point. In this case I simply used the High Pass Filter.

Copy and Crop Parts

1. Now select the left part of the image on the *outside* of your square selection. This is the 128×1024 column marked in blue in Figure 4-33 and you can see it in Figure 4-35.
2. Copy the selection and paste it, creating a new layer (Ctrl+C and Ctrl+V) and move the new layer with the copied part of the image over to the right side of your selected area. Make sure you have snap turned on, so it will snap in place and look like Figure 4-35. I turned off the grid so you could see the part of the image pasted over the right side and how obvious the inner seam is that needs to be cleaned up. You can also see that by moving the outer piece we just moved to where it is inside the image the edges will now tile. The small arrows point out a spot where it is easy to see how the two halves of the stone will line up.
3. Repeat these steps for the horizontal portion of the image below your selection. Don't worry if this piece is not exactly 1024×128. This image was not a power of two to begin with, so the part at the bottom will not be 128 pixels high. Just make sure that the top of your selection is aligned with the bottom of the selected portion of the image we are going to tile.
4. Copy and paste this horizontal section into its own layer and drag it up to the top of the image and hide the layer for later.

EDIT - PREFERENCES - GUIDES, GRID,...

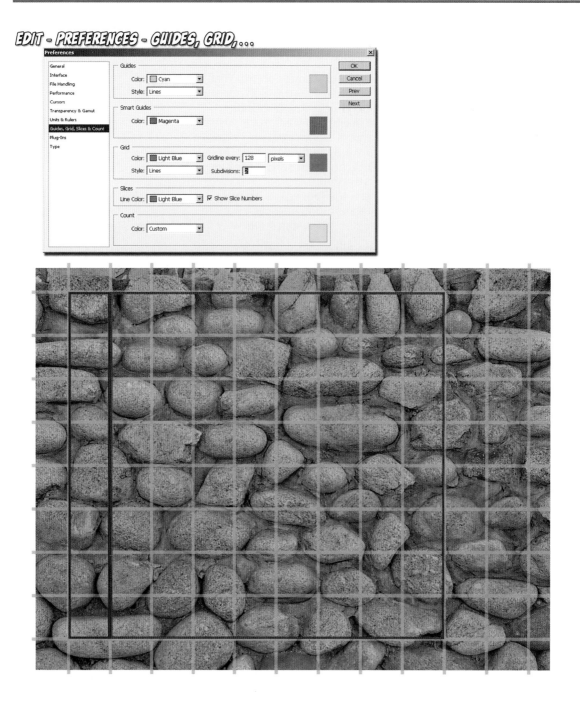

Figure 4-33
Setting the grid and choosing the portion of the source image you want to tile.

Removing the Seams

To remove the seams, I don't use the eraser. I find it so much easier, and faster, to create a layer mask and paint the edges away. If I make a mistake, I don't need to lose any work with the Undo command; I can just hit the "X" key and switch the brush color from black to white and paint back what I want.

1. Press the "D" key to set your colors to black and white.
2. Select the layer with the vertical portion of the image on it that we first created.
3. Create a layer mask for this layer by clicking the mask icon on the bottom of the layers palette.
4. Start painting away the seams. Use the "X" key to switch from black to white. You will find that some areas miraculously work and others simply will not. Just do your best on this first pass and don't try for perfection just yet. Figure 4-36 shows what I ended up with, good and bad.
5. Unhide the vertical layer and do the same.
6. Flatten the image.
7. Crop the image to a 1024×1024 image (Image > Crop). Use the grid to set your crop area precisely.
8. Filter > Other > Offset. Because this is a 1024×1024 image, the offset values in both directions should be 512. You will see that though there are no hard seams, we still have work to do.

Build/Rebuild Stones Using Clone

To get stones to tile involves a few tricks to make all the seams between the stones look good. Just copying the stones won't work, because they are not all the same size, shape, or at the same angle. Usually, you will never get a copy of a stone from one part of an image to fit with the other stones in different parts of the image.

Figure 4-34
Making all the stones more consistent before working on the image makes tiling easier later on. The original image is on the **left** and the corrected image on the **right**. By cloning some stones over others, using various parts of several stones to create or fix another, the stone can be made to look more uniform.

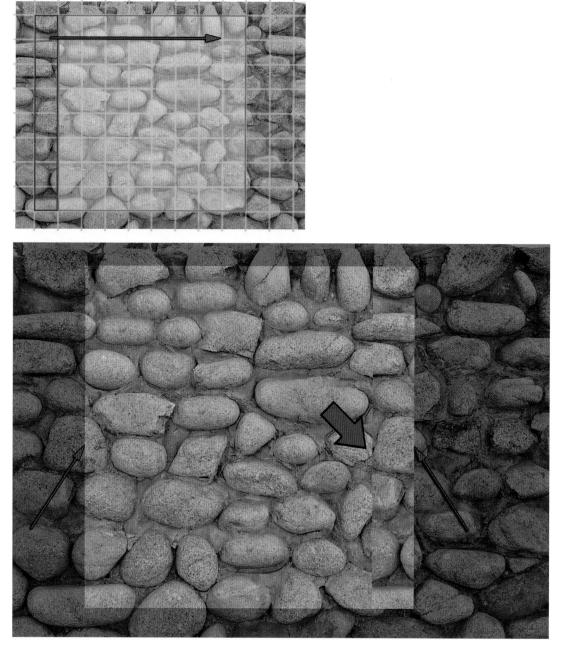

Figure 4-35
By selecting an area outside the part of the image you want to tile and moving it over, you are creating a seamless transition between the left and right sides of the image. The seam now exists on the inside edge of the pasted portion and is easier to work with than an offset image.

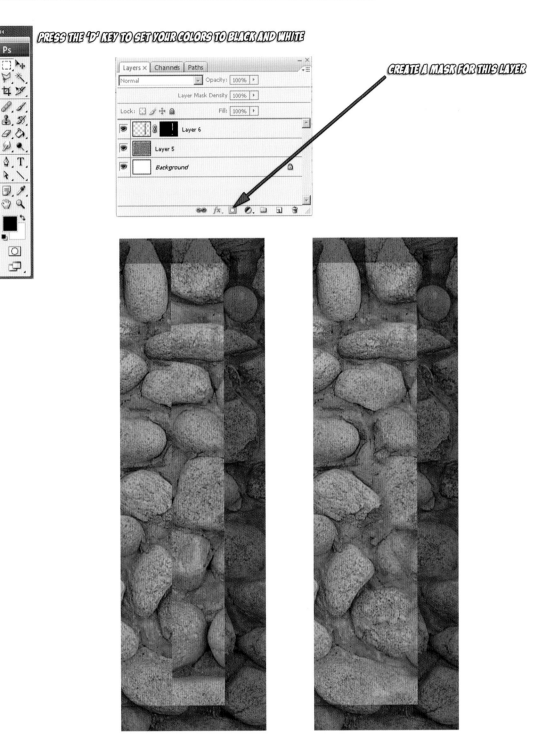

Figure 4-36
After you create a layer mask and paint away the seams, you will find that some areas work and others don't. Just do your best on this first pass and don't try for perfection just yet.

Plus you want the stones to all look different (just not too different), and many copies of the same stone would stand out. The answer is to build and rebuild stones using parts of each other.

Where two stones have blurred over each other, you can find edges and corners from other stones to clone over these stones. Figure 4-37 shows the few steps it took to restore the space between the stones. You will also need to use the Clone Tool lightly in some cases to retouch the main surface of the stone, as in Figure 4-37.

This process may take some time, so be patient and get those edges clean. I said earlier that you probably can't copy and paste a stone into your image and have it fit neatly, but you can copy small portions of a stone (a bottom edge or corner) and paste it in if it needs to be rotated to fit. You can also use parts from other images. If you took several pictures of the same stone wall, you can use stone parts from all the images to build one clean texture.

Testing a Tiling Texture

After you have rebuilt and repaired the stones to your liking, you can test the tiling of the texture. This is easy to do using the Define Pattern option in Photoshop. Note that there is a difference between *defining a pattern* and the *Pattern Maker*. We are defining a pattern to later fill in an area; this does not alter the image. Pattern Maker attempts to create a tiling pattern using a selection. Pattern Maker gives me mixed results, sometimes good and sometimes bad. Even the good results will require some touchup.

1. In order to get the best result, you may want to first look at your image size. If you are working on a large image (and you should be), you might want to create a copy of the image and reduce it to 256×256 so you can tile it across a larger canvas without creating a super huge image.
2. Select your entire image (Ctrl+A). You can select an unflattened Photoshop file, and this method will create a pattern using all layers that are visible.
3. Go to Edit > Define Pattern. These steps are illustrated in Figure 4-38.
4. The Pattern Name dialog box will appear and you will see a small thumbnail image of your pattern and have the option to name it.
5. Select OK. Nothing will seem to happen, but your pattern is now in the Pattern Preset Library.
6. Create a new image (Ctrl+N) and make it at least four times the size of your texture. If your image is 256×256, then make the new image at least 1024×1024.
7. Select the entire surface of the new image (Ctrl+A).
8. Right mouse click inside the selection and choose Fill.
9. When the Fill dialog box comes up, you will be able to choose what to use to fill the selection with. You can also drop down

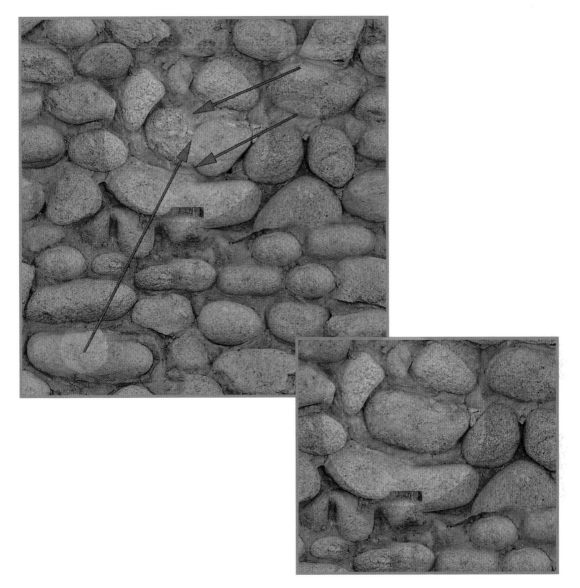

Figure 4-37
You can use edges and corners from other stones to restore or build the space between stones. You will also need to use the clone tool lightly in some cases to retouch the main surface of the stone. On the **upper left** are the blurred stone and the three places I determined I could take detail from using the clone tool. The **lower right** is the result of the repair.

the Custom Pattern list below that and your new pattern will be at the end of the list.

10. After you select the pattern, click OK and the image will be filled with the pattern.

You can now get a much better idea of how your image will tile over a large surface. It is still preferable to put the image into the game

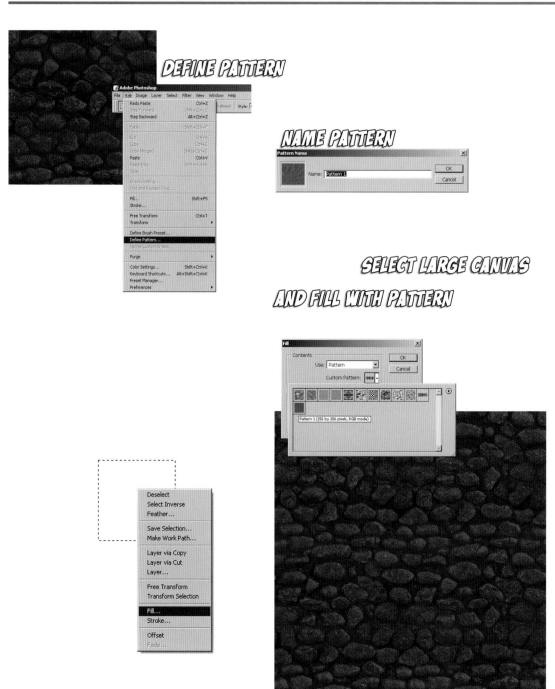

Figure 4-38
The basic steps to define a pattern to test the tiling of your image. The **upper left** is the beginning image and the **lower right** the tiled result.

engine it will be used in and see it tile there. The size of the pattern you create and the size of the test image you create to tile it in also depend on the final use of the texture. If you are creating a horizontally tiling wall texture, then you can make the pattern larger like 512×512 and make the new fill image 512 pixels high but 1024 pixels or more wide.

After a few times of doing this, your Pattern Preset Library will begin to get pretty full. You can delete patterns by going back to step 9 in the previous list, and when you have access to the pattern library, simply right-click and select Delete, or hold down Alt and the cursor turns into a cute little pair of scissors and you can left-click to delete the pattern.

Note: You can't undo or cancel the deletion of a pattern from the preset library!

Storing Your Textures

How you store your textures is important. The names you give your images, where you save them, the resolution and file format you save them as, and other decisions will directly affect how well you can work with them. As mentioned earlier in this chapter, you may need to store image assets according to several criteria in your personal collection such as ownership, image size, and usefulness. Here we will discuss how you name those images and save them in a directory structure so that you can find and use them later on.

If you buy a texture set and want to save all those files on your hard drive so you have easy access to them, you should simply name a folder after the company and copy all the files into it. If you are surfing the Internet and you download a hundred images from various sources on a theme, name a folder "Internet Images of Dogs" or whatever you were researching and save them there so you know where they came from. When you start snapping your own digital images and creating your own textures, you will want to have a folder for raw assets and finished work or for each project.

When you name a folder or individual file, choose a naming convention and use it. A naming convention is a set of rules for naming the files in an organized fashion. Keep in mind that it is simple to create a naming convention and far harder to stick with it. One key to this is to create a text file or document with the legend to your naming convention and folder structure in it and place it in your art drive. Print it out and keep it nearby until you get used to the convention. Although we can use long file names now, it is always advisable to keep file names as short and consistent as possible. This makes it easier to skim them and sort them. In some cases, computer applications still don't like long file names.

Tips for Good Naming Conventions

Use underscores "_" and not dashes "-" because the computer will see the dash as a minus sign and that affects the sorting of file names.

Underscores are good separators for data: they make content easier to read. Consider "grndrtrghv2.tga" versus "grn_drt_rgh_v2.tga". Using this example, here is a sample naming convention for a set of images.

grn_drt_rgh_v2.tga

This might mean

Grn = Ground
Drt = Dirt
Rgh = Rough
V2 = Version 2

That convention might be for finished textures. For 150 raw images of pine cones, you may want to use numbering at the end, like so:

fol_pine_con_001.tga
fol_pine_con_002.tga

and so on.

The naming convention for this raw asset is

fol = foliage
pine = pine trees
con = cone
= the number being the many images you took of pine
 cones

Some artists like to include the size in the naming convention like "lrg" or "sml" for large or small, or even the resolution, like 256 or 512. Naming conventions, like so many other aspects of game development, are often dictated by the project, technology, and company you are working for. A certain company might have strict naming conventions or they may leave you in charge of creating your own. A certain game technology may need certain naming conventions such as "_a" appearing at the end of a texture that uses an alpha channel. A large outdoor game might have a complex naming convention for foliage, and an indoor game with a few trees might simply have the trees stored as decorations or props.

No matter what, you need to be consistent and persistent with naming and organization. Writing the naming convention down and making sure that everyone understands and uses it are good ideas.

Conclusion

This chapter looked at the important aspects of collecting, preparing, and storing your textures and resources. Next we will start creating textures—and we will start with the Sci-Fi setting.

Chapter Exercises

1. What are some good sources for gathering textures?
2. List at least five tips for taking digital photographs.
3. What are the basic types of texture collections?
4. What are the most common functions used to clean up a texture?
5. What is tiling? Are there different types of tiling?

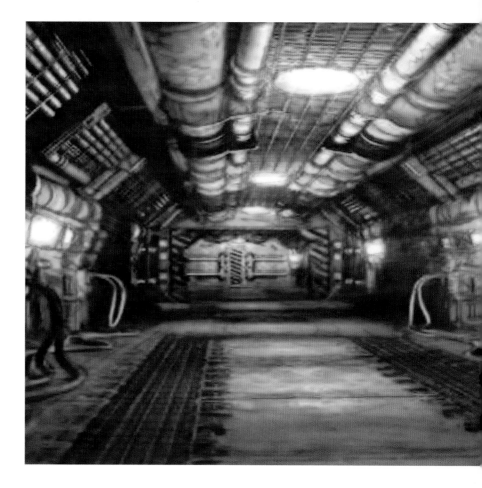

Chapter 5

Sci-Fi Hall Concept 2005 by Brian Grabinski

The Sci-Fi Setting

Introduction

For this first tutorial chapter, I chose a scene that looks complex due to the geometry and effects, but in actuality involves a very simple texture set. In this particular example, shown in Figure 5-1, we have some leeway to create a close approximation of the scene, because although this concept art is beautiful, it lacks close-up hard detail that would dictate what we need to create for the scene. Some game companies will dump a load of concept art and textual descriptions on you, but others might give you a loose image like this and let you fill in the gaps (because you are that good!).

We will start by taking from the concept sketch ideas for the materials that we want to create for this scene. As texture artists, we need to create a simple and versatile set of textures for the 3D modeler to use as they create/make up the finer details in the scene using geometry. In a real-life situation, you would ask several questions about this, or any, scene before creating textures for it. How old is this structure? What is it made of? What is it used for? What is the atmosphere like here? For this exercise, we will make assumptions about the exact materials the hall is made of and their condition.

Concept art and production issues aside, the method for creating these textures relies on a few smaller and simpler textures, so it is a good place to start. It also requires some fudging on the specific details present in the concept art, due to the limited set of textures we are working with, which is perfect for this example. Although some texture creation demands a focus on high detail, those textures tend to have limited uses. This method produces textures that can be used in various ways and are designed to be used with shader technology (like bump and normal mapping and so on).

Figure 5-1
This concept art is beautiful, but lacks hard detail that would dictate exactly what textures we should create for the scene.

These textures can be mapped in various ways, but because this method is designed for a more advanced game technology, we can also use lighting and other effects to help further contribute to the visual diversity of the scene.

This type of setting lends itself to general approach to texture creation. A structure such as this, which is industrial or military in nature, would actually be built in such a logical and modular fashion. This method can also be used in more traditional settings where shaders will be adding more detail and the artist needs mostly to apply base materials and few detailed textures. I have built Gothic settings using this method, and rather than corroded metal, created various wood and iron trims and fills.

The Concept Sketch

The front plate shows the concept art for the space hallway. Like warehouses full of crates, the space station hallway full of pipes is a game staple. I figured I would stick to the archetypes of game environments so that (after you master these base settings) you can expand outward to more unique and complex settings that stem from these roots.

Determining Texture Needs

Looking past the colored lights, glow effects, and the light suggestion of dirt and wear, we see metal – and lots of it. In fact, this place looks like it is composed entirely of the same type of metal with some specific detail in only few places. The only textures that needs to be created that are not a metal variant are the black and yellow caution stripes and a few minor detail textures.

We will start with the base metal texture and build our set from that. Even the caution stripes are painted over this metal, so it is part of that texture as well. The trick to this method, in which a few textures are used in many ways in a scene, is to build a set of textures that contain a selection of common parts that the environmental modeler will repeatedly use on high-poly-count geometry: things like a grate with an alpha channel, a larger wall piece, a metal fill, and some textures with parts that can be used as trim that will all add rich detail to complex geometry.

Our set will contain the following elements, as described in the next few sections:

- Base Metal
- Metal Fill
- Wall Panel
- Floor Panel with (alpha channeled) Grate
- Detail Texture: Vent/Panel/Bracket/Hose
- Pipe
- Caution Stripes

Base Metal

The metal in this scene appears to be an industrial-type metal used for mass fabrication. It wasn't created to look pretty. I am sure the bureaucrats who had to handle this large job wanted something durable that met their specs and was cheap. No money wasted on fancy finishes or fresh lemon scent. This metal might have been loaded and unloaded many times before it reached its final destination. Then it was manhandled (or robot-handled) in the construction of this outpost. So we will start by creating a flat, mottled, and less-than-perfect tiling sheet of metal (with no lemon scent).

Note: Throughout this book I use a simple convention to tell you what to do in Photoshop; it is all centered around the menu commands for clarity's sake. I do suggest using the hotkeys if at all possible.

1. Open Photoshop and create a new file: File > New…. We work from big to small, so make this image 1024×1024 pixels. Name this image **sci_fi_metal_base** and save it.
2. Create a new layer (Layer > New > Layer).
3. Press the "D" key to reset your colors to black and white.
4. Press the "G" key to activate the Paint Bucket (make sure the Paint Bucket is selected in the tool bar and not the Gradient Fill) and fill this layer.
5. Filter > Render > Clouds.
6. Filter > Render > Difference Clouds. Use Ctrl+F and run this filter five times. I chose five times because the difference (although subtle) just looks right to me after five applications of the filter.
7. Filter > Noise > Add Noise > 7.5%. Change your noise settings in the dialog to Monochromatic and Gaussian.
8. Image > Adjustments > Brightness/Contrast > Contrast –70. In newer versions of Photoshop, check the "Use Legacy" box.
9. Filter > Artistic > Colored Pencil – Pencil Width 6, Stroke Pressure 8, Paper Brightness 20.
10. Filter > Artistic > Fresco – Brush Size 2, Brush Detail 8, Texture 1.
11. Fade Fresco (Ctrl+Shift+F) 50% > Blending Mode – Multiply.
12. Filter > Render > Lighting Effects. Match the following settings:
 Light Type – Spotlight
 Intensity – 18
 Focus – 63
 Gloss – 68
 Material – 25
 Exposure – –16
 Ambience – 32
 Texture Channel – Blue
 Height – 71
13. Filter > Artistic > Plastic Wrap > Highlight Strength 4, Detail 7, Smoothness 3.
14. Filter > Sketch > Chrome > Detail 5, Smoothness 5.
15. Fade Chrome 50% > Blending Mode – Exclusion.
16. Image > Adjustments > Brightness 10, Contrast –20.

17. Filter > Brush Strokes > Accent Edges > Edge Width 2, Edge Brightness 18, Smoothness 7.
18. Fade Accent Edges 60%.
19. Filter > Render > Lighting Effects. Use the same settings as before. They should still be set the same, but double-check. Also, there seems to be a bug in the Render Lighting Effects filter. Move the light around a bit to reset it. If Photoshop crashes when you run this filter, you can find the solution on Google. I hesitate to tell you here because I don't want you messing up your install of Photoshop on my advice.
20. Fade Lightening Effects 40% > Blending Mode – Exclusion.
21. Tweak the contrast and resolution. I set the brightness to –18 and the contrast to 47.
22. Copy the layer and offset it and erase the seams so that you end up with a tileable image. Your image should look like the finished metal at the bottom right of Figure 5-2.

Metal Fill

The metal fill texture doesn't need to be as big as the base metal. The base metal is used to create the larger textures like wall and floor panels. The fill needs to be just a small texture created from the base that is much lower in contrast so that it can tile over surfaces you want filled with metal. It is small for memory efficiency, too. I simply copied a 256×256 portion of the base metal into a new image and lowered the contrast a lot. You can make lighter and darker versions of the fill based on your needs. I only needed a darker one. You can see the metal fill in Figure 5-3 and how it would be used.

Wall Panel

Now that we have a base metal, the rest is easy. Making this tiling wall panel will also be easy, because (1) they are supposed to be modular and logically we can get away with repeating parts, and (2) these wall panels can be pretty simple, as they are hidden behind all the pipes.

1. Open a copy of the base metal we created and save it as **sci_fi_metal_wall**.
2. You will be applying a layer style to this image and you can't apply layer effects and layer styles to a background, locked layer, or layer set. You need to duplicate the layer so you can apply effects to it. Name this layer **Base**.
3. Apply the Inner Glow layer style with the following settings:
 Structure
 Blend Mode – Vivid Light
 Opacity – 65%
 Noise – 19%
 Color – RBG 216,216,216
 Elements
 Size – 16 px

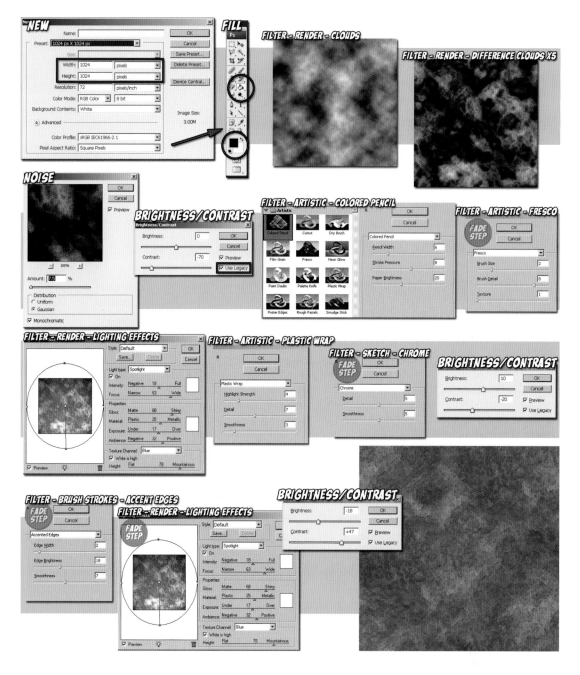

Figure 5-2
The steps to create the base metal for our scene.

Quality
Range – 50%
4. Apply the Bevel Emboss layer style with the following settings:
 Structure
 Style – Inner Bevel
 Technique – Chisel Hard
 Depth – 81%
 Direction – Up
 Size – 2

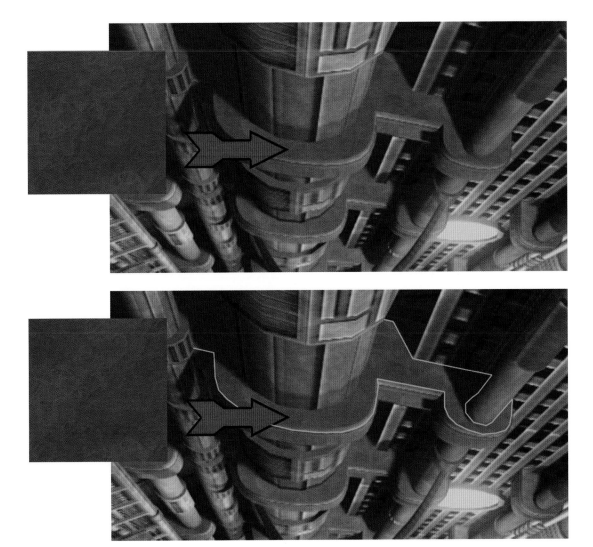

Shading
Highlight Mode – Screen
Opacity – 51%
Shadow Mode – Multiply
Opacity – 75%

Figure 5-3
Metal fill is used to fill in areas that don't need a lot of detail. Here is our metal fill in the scene.

5. Create a new Layer (Ctrl+Shift+N) and name it **Panel**.
6. Set your Grid to 32 units (Edit > Preferences > Guides Grid…).
7. Using the Polygonal Lasso, outline the shape shown in Figure 5-4. You can do whatever you like here, but the pattern I used was designed so that I could use it in a few places; specifically, the trimmed edges and crossbar.
8. Fill the selection with any color.
9. Set the Fill of this layer to 0.
10. Apply the Drop Shadow layer style with the following settings:
 Structure
 Blend Mode – Multiply
 Opacity – 23%

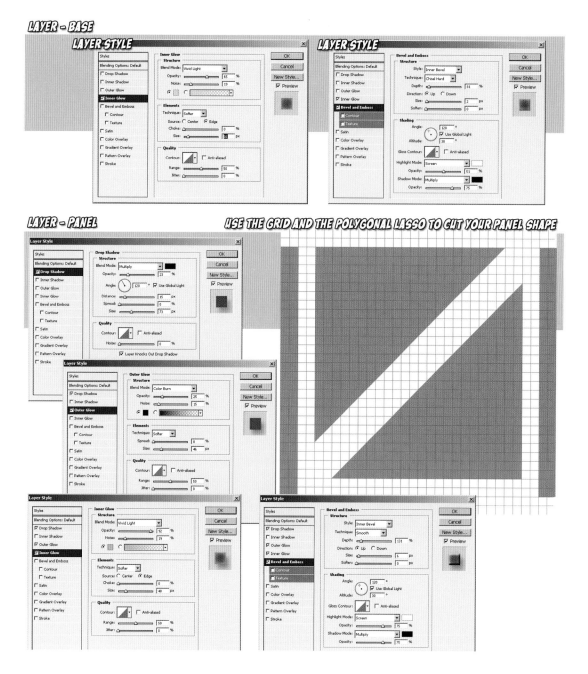

Figure 5-4
The pattern for the wall panel.

Distance – 15 px
Size – 73 px

11. Apply the **Outer Glow** layer style with the following settings:
Structure
Blend Mode – Color Burn
Opacity – 25%
Noise – 15%
Color – Black

Elements
Technique – Softer
Size – 46 px
Quality
Range – 50%

12. A white inner glow with some noise and the right blending mode can make the edges of the metal look scratched and worn. Apply the Inner Glow layer style with the following settings:

 Structure
 Blend Mode – Vivid Light
 Opacity – 92%
 Noise – 19%
 Color – RBG: 190,190,190
 Elements
 Size – 54 px
 Quality
 Range – 40%

13. Apply the Bevel Emboss layer style with the following settings:

 Structure
 Style – Inner Bevel
 Technique – Smooth
 Depth – 131%
 Direction – Up
 Size – 6
 Shading
 Highlight Mode – Screen
 Opacity – 75%
 Shadow Mode – Multiply
 Opacity – 75%

 At this point, I turned my grid back on and used a very hard, small brush (3 pixels) and erased a small gap in the panel horizontally across the canvas. Your image should look like Figure 5-5. Take note of where the gaps are.

14. Create another layer and paste the layer style from the panel layer into it. You will have to go into the layer style and make the Bevel and Emboss depth deeper. On this layer, you can add the little squares on the edges. They are 64 pixels wide and 22 pixels high. I offset the left and right columns of these shapes vertically by one shape so when the texture tiles the shapes look like they are interlocking.

To create another version of the wall panel reminiscent of sheet metal:

- Copy the Panel layer and delete the contents of the layer using Ctrl+A and Ctrl+X.
- You will be left with an empty layer that still has the same layer effects applied to it.
- Create new panels. I used the grid again and created those simple panels. I did tweak the Bevel and Emboss style.

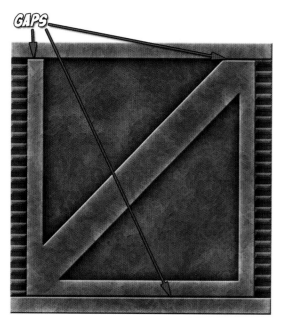

Figure 5-5
The wall panel with frame. Notice the gaps in the frames. This allows us to use this texture as trim in various places. The righthand image is a variation of the wall panel.

Floor Panel with Grate

The floor panel is very similar to the wall panel; in fact, you can use a copy of the wall panel to create it. Make sure that you are using a copy!

The floor is more complex and involves creating an alpha channel for the grate and creating a diamond plate pattern. We will also put a little wear and tear on the floor:

1. Name your new image **sci_fi_metal_floor**.
2. Go to the Panel layer and Select All (Ctrl+A) and press Delete. The layer is still there with the layer styles; it is just now empty. Fill the Layer with any color.
3. Select the layer the Base metal is on (it should be below the panel).
4. Filter > Brush Strokes > Crosshatch > Stroke Length 33, Sharpness 12, Strength 1.
5. Fade 50% > Blending Mode – Overlay. This makes the metal look duller and scratched.
6. Image > Adjustments > Brightness/Contrast > Brightness 5, Contrast 50.
7. Drag out a vertical guideline. Make sure you have "snap" on so this line will snap to the center of the image (View > Snap To > All).
8. Go back to the Panel layer and erase a line down the middle using a hard 9-pixel brush.
9. Select All and Select > Modify > Border – 8 pixels.
10. Press the Delete key to remove the very edges of the image. Deselect your image.
11. You can turn the Drop Shadow and Outer Glow effects off the Panel layer. Make sure the Fill is set to 0.

12. On the base metal you can use the Dodge Tool and a soft 45-pixel brush and subtly augment the Inner Glow, making the corners and a few random spots and giving a bit more wear to the metal than the rest.

13. Duplicate the Panel Layer and delete the contents. Turn off the Inner Glow effect and using the Polygonal Lasso make a shape for a frame on the left side of the image that is only two grid units wide (64 pixels) and is only on the two vertical sides of the image. The inside edges of this frame need to be straight. See Figure 5-6 for reference. I also made another layer that added some complexity to my frame. There are seams where parts fit tightly together on the frame; these are just another frame layer with fitting pieces. You could also accomplish this by using the eraser with a small hard brush on the same layer.

 1. Duplicate the Layer Style of the Frame layer.
 2. Copy the base metal layer and paste it, creating a new layer under the Frame Layer. Name this layer **Grid1**. We can't set the Fill to 0 for the grid, because the parts of the grid overlap each other, so we need to use some of the metal.
 3. Use the Marquee Selection Tool on the grid to create one-unit-wide vertical bars that are one unit apart and fit between the frame. Invert the selection and delete the metal outside the selection.
 4. Paste the layer style and make sure that the Inner Glow is not too big and that there is a subtle drop shadow and faint darkish Outer Glow. Even though we will be creating an alpha channel for the grid, you will still see the areas where the bars overlap and the shadows will be noticeable.
 5. Create a horizontal version of these bars on a layer underneath the vertical bars. Your image should look like Figure 5-7.

Now we will create diamond plate. You will recognize it when you see it if you aren't familiar with the term. It is a common texture, but like most things, if I can make it in Photoshop and have it tile perfectly and be totally flexible, then I will do it. Spending the time up front making an image or pattern that I can completely and quickly alter will considerably speed up my work in the long term.

Look at Figure 5-8. To make diamond plate, make the first diamond. This is nothing more than the space where two circles intersect. Fill a circular selection and move it over and invert it and use it to delete the portion of the circle outside the diamond. Creating the pattern for this can be accomplished in many ways and there are numerous patterns for diamond plate; you can even create your own.

Diamond plate is usually seen as a diagonal pattern, but I just tiled them straight up and down on a canvas larger than I needed, rotated it 45 degrees, and cropped the image down to 512 pixels. This pattern can be made into a diamond plate texture, or dropped into an image with Fill at 0 and Layer Styles applied. In this case the pattern was pasted into its own layer, the layer style copied from

HARD 9 PIXEL ERASER

FINAL FLOOR PANEL

FRAME SHAPES

SHAPES OF THE FLOOR PANEL

Figure 5-6
The floor panel, more beat up. The beginnings of the frame in place.

the Frame Layer, and the Fill set to 0. I also dropped the opacity down to 25%. See Figure 5-9.

To finish this texture, I pasted a copy of the base metal at the very top of the layer stack and set the opacity to 50%, the blending mode to Overlay, and Colorized (Ctrl+U) the layer to a desaturated orange-brown. This gives the metal a nice light swath of rust, like it has been in place a while and is used enough to keep the rust

Figure 5-7
The floor panel with the grid
in place.

worn away, but not cared for so much that it shines. This also
makes the entire texture look consistent and blends the elements
together visually.

Alpha Channel

Finally, we must make the alpha channel for the grate.

1. Create a new layer on the top of the stack (Ctrl+Shift+N).
2. Fill this layer with white: press "D" to reset your colors, press
 "X" to swap them, and press "G" to use the fill bucket.
3. Hold down the Ctrl+Shift keys and click on the icons for the
 grates and frames layers.
4. Hold Ctrl and press the "I" key to invert the white to black.
5. Select the white half of this image with the marquee tool and fill
 it with black.
6. The grate holes should be the only white that you see. Figure
 5-10 shows the alpha image for this texture.

Detail Texture: Vent/Panel/Bracket/Hose

Now we will create a texture that contains various areas of detail,
such as a vent, a panel, and two strips for a bracket and a hose that

Figure 5-8
The diamond plate pattern starts with one diamond duplicated and rotated on the grid. There are numerous patterns you can use to create diamond plate.

Figure 5-9
The floor panel with diamond plate added. Don't want our space marines to slip and fall.

are able to tile horizontally. These small detail pieces can be mapped in various places to add a lot of visual variety.

1. Open a copy of **sci_fi_metal_wall** and save it as **sci_fi_metal_details**.
2. Remove all but the Base and Panel layers.
3. Delete the contents of the Panel layer by selecting it all and pressing Delete.
4. Set the Fill to 100%.
5. Use guidelines to divide this texture evenly in half vertically and horizontally. Make sure that snap is on. The lines should be at the 512-pixel point on a 1024 image.
6. Create a New Layer Set and name it **Vent**.
7. Put the Panel layer in this new set and rename it **Vent Frame**.
8. Copy the base metal and paste it into the new Vent Frame layer.
9. Set the grid to 32.
10. Use the Marquee Selection Tool with the grid and delete the metal, leaving only a square in the upper righthand side of the image.
11. Use the Marquee and the grid again to delete the center of the square, leaving a 1-unit (32-pixel) frame.
12. Change the following settings in the layers styles:
 Drop Shadow
 Distance – 8
 Size – 10

1. CREATE A NEW LAYER ON THE TOP OF THE STACK (CTRL + SHIFT + N).

2. FILL THIS LAYER WITH WHITE, PRESS 'D' TO RESET YOUR COLORS, PRESS 'X' TO SWAP THEM, AND PRESS 'G' TO USE THE FILL BUCKET.

3. HOLD DOWN THE CTRL + SHIFT KEY AND CLICK ON THE ICONS FOR THE GRATES AND FRAMES LAYERS.

4. HOLD CTRL AND PRESS THE 'I' KEY. THIS WILL INVERT THE WHITE TO BLACK.

5. SELECT THE WHITE HALF OF THIS IMAGE WITH THE MARQUEE TOOL AND FILL IT WITH BLACK.

6. THE GRATE HOLES SHOULD BE THE ONLY WHITE YOU SEE.

Figure 5-10
The alpha image for the floor panel grate.

Inner Glow
Choke – 10
Size – 18
Bevel and Emboss
Highlight Mode – Soft Light

13. Duplicate the Vent Frame layer and place it below the Frame layer.
14. Name this new layer **Vent Louvers** and delete all the content from the layer.
15. Set the **Fill** to 0.

16. Use the marquee to select the empty space inside the vent frame and fill it with a color.
17. Use a small, hard eraser (3 pixels) and erase lines every 2 units on the grid.
18. On the Frame Layer, you can play with the Outer Glow size and opacity to get the vent to look dirtier around the louvers underneath. Your image should look like Figure 5-11.

You will notice that this next part of the texture is created in the same way as the previous part. Here you will create a simple panel with some detail on it.

1. Duplicate the vent layer set and name it **Panel.**
2. Delete the louver layer from the new layer set.
3. Delete the contents of the Vent Frame layer and rename it **Panel.**
4. Set the Fill to 0.
5. Fill this new layer with a color.
6. Use the Marquee Selection Tool and the grid and delete all but the upper-left square of this image. I erased some lines down the center of this panel to create a few smaller panels.
7. Duplicate the layer again and place it above the panel layer. Name it **Panel2.**
8. Change the Outer Glow settings. Take the Choke down to 0 and lower the size to 29 px.
9. Add a Gradient Overlay. Set the Blending Mode to Color Dodge and the Opacity to 20%.
10. Using the grid and selection Marquee, create a few random shapes and invert the selection and delete the metal around your shapes. Your image should look like Figure 5-12.

Note: At this point, you will notice that the layer styles from the various layer sets overlap each other. You can create a layer mask for an entire layer set and mask the section off.

1. Duplicate the panel layer set and name it **Bracket.**
2. Delete the Panel layer.
3. Delete the contents of the Panel2 layer and rename it **Bracket.**
4. Adjust your layer set mask so that it only reveals the 1024×256 rectangle below the middle of the image.
5. Open the Layer Styles and turn off the Gradient Overlay and apply a Color Overlay. Set the Opacity to 25% and the color to RGB 84,68,39.
6. Select the 1024×256 area of this layer and fill it with a color. Keep this region selected.
7. Because the Layer Fill is set to 0, we are seeing the layer style and effects of the bracket layer and the texture of metal is from the base layer. Go to the base layer.
8. Filter > Brush Strokes > Angled Strokes – Direction Balance 50, Stroke Length 23, Sharpness 4.
9. Set Fade Angled Strokes (Ctrl+Shift+F) to 70%.
10. Go back to the Bracket layer and delete some sections of the rectangle to look like Figure 5-13.

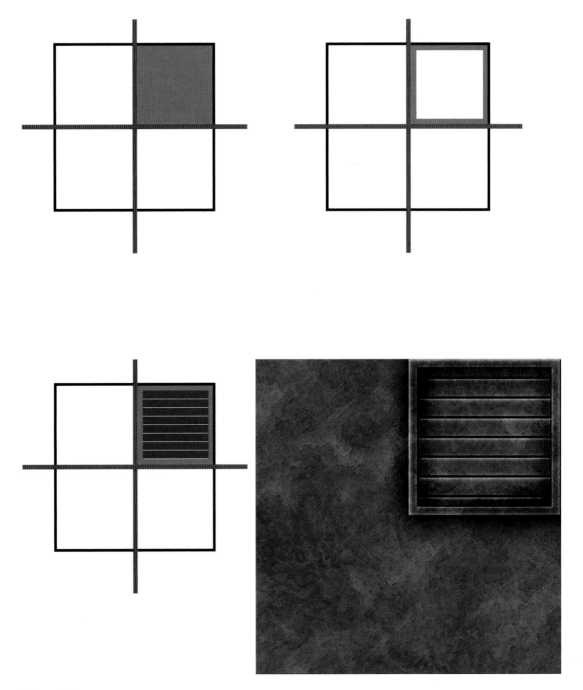

Figure 5-11
The vent on the detail texture.

11. To make this image useful, I selected the area and copied all layers (Ctrl+Shift+C).
12. Then I pasted this into a new top layer and offset it so that I could clean it up and make it tileable.
 1. Create a new layer set and name it **Hose**.
 2. Create a new layer and name it **Hose**.
 3. Adjust your layer set mask so that it reveals only the 1024×256 rectangle at the very bottom of the image.
 4. Copy a 1024×512 section of the base metal layer and paste it into the hose layer. Make sure that it is snapped in place along the bottom.
 5. Filter > Brush Strokes > Accent Edges – Edge Width 2, Edge Brightness 18, Smoothness 7.

Figure 5-12
The panel details. The layer effects of each layer set have been masked.

Figure 5-13
The horizontally tileable bracket.

6. Use the grid, the Dodge tool, and a soft 65-pixel brush, and put vertical highlights evenly spaced along the hose. Do this again with a smaller brush (27 pixels).

7. Create shadows between the highlights with the Burn Tool.

8. Create a new layer and name it **Ridges**. Set the Fill to 0.

9. Use a small, hard brush (13 pixels) and draw the vertical ridge lines on the light part of the hose. You can use the Offset Filter horizontally to make sure that the ridges are consistent across the hose.

10. Apply the following layer effects:
Drop shadow – Default settings.

Figure 5-14
The horizontally tileable hose and the final texture.

Outer Glow – Change the color to black, the Blending Mode to normal, and the size to 18.
Bevel and Emboss – Change the Technique to Chisel Soft and the Size to 3 pixels.
Your image should look like Figure 5-14.

Pipe

We need to make a tileable strip of shiny metal for the hydraulic pipes on the door and we can also use this to make a few of the pipes in the hall shiny, as if they were just installed or repaired.

1. Open a copy of the Metal Fill and save it as **sci_fi_metal_pipes**.
2. Crop this image down to a one-to-four ratio: 512×128 or 256×64, depending on the file size you are working with.
3. Lighten the metal using Levels (Ctrl+L).
4. Lower the contrast.
5. Run the Spatter filter on this.
6. Use the Burn and Dodge Tools to put horizontal highlights down the center of the pipe and shadows below and slightly on the top of the pipe. Figure 5-15 shows the pipe texture and the texture in use.

Figure 5-15
The pipe texture and the
texture in use.

Caution Stripes

The caution stripes start as nothing more than black and yellow
alternating strips. You can create them vertically, and the artists can
later rotate them 45 degrees on the model. The work is in making
the stripes look painted on the metal.

1. Open your base metal and save a copy as **sci_fi_caution**.
2. Create a new layer and name it **Stripes** and fill the layer with
 dark gray RGB 66,66,66.
3. Turn on the grid and make the yellow stripes 3 units (96 pixels)
 wide. Use a yellow RGB 234,219,111.
4. Filter > Noise > Add Noise 6%.
5. Filter > Artistic > Colored Pencil > Pencil Width 10, Stroke
 Pressure 6, Paper Brightness 21.
6. Filter > Blur > Gaussian Blur – 3 pixels.
7. Filter > Sketch > Torn Edges > Image Balance 25, Smoothness
 12, Contrast 12.
8. Set Layer Blending Mode – Soft Light, Opacity 75%.
9. Use various erasers and make some subtle worn spots and
 scratches in the paint.
10. You will have to offset the stripes and remove a hard edge. See
 Figure 5-16.

The Complete Scene

Here is the complete scene using the textures we just created
(Figure 5-17).

Building It up Using Overlays

In this exercise, I attempted to emulate the concept art as closely as
possible, but I also did a variation that took me only a few minutes.

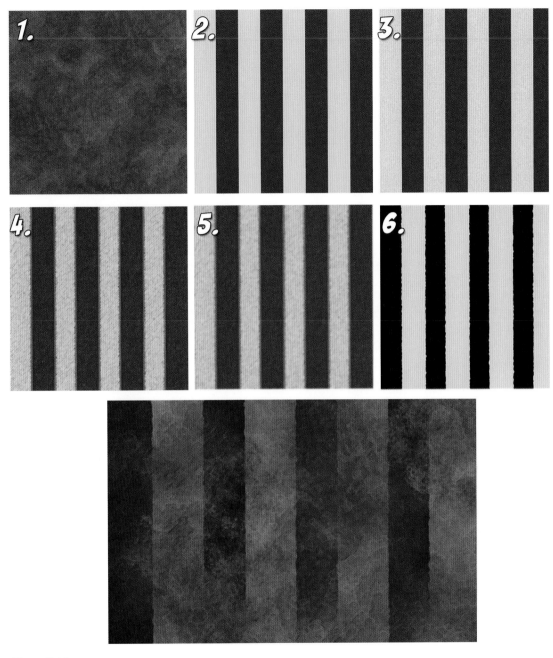

Figure 5-16
The caution stripes.

Figure 5-17
The final scene with the textures that we just created.

Figure 5-18
The texture set with a rusted overlay. A quick and simple step that changes the scene dramatically.

Figure 5-19
A variation with a simple rust overlay and lower lighting.

I put a rust overlay on the textures and changed the lighting in the scene. Because the lights are no longer glowing so brightly in this darker scene, I made a little yellowish dirty texture for the glass. See Figure 5-18 for the rusted texture set. In reality, you would use various types of assets to create a texture. Even if you do everything in Photoshop, nothing replaces the look of adding an overlay of a quality digital image. Several overlays are often used in texture creation. The overlay for this exercise is on the DVD. Try other overlays for various effects.

Tearing It Down for Shaders

There are a couple of shaders used in the final scene that add a great deal of visual richness to the scene: illumination, opacity, and bloom. Although bloom is often a shader assigned to a material that doesn't require any special work on the part of the texture artist, illumination maps can be created in several ways for various effects. The simplest way is to start with a solid black layer in the source file of your texture and paint in the areas you want lit with white. In the case of this scene, look at the texture set. We actually created an opacity mask for the grate, so let's make a quick and easy specularity map for the metal; the metal wall, specifically, because it has lots of edges for wear and tear and it is everywhere in the scene.

1. Open the file for the image that you created for the wall texture. You should have named it **sci_fi_metal_wall**.
2. You can create a copy of this image or create a new layer by selecting all (Ctrl+A) and the copying all layers (Ctrl+Shift+C) and pasting the result on the top of the stack of layers. Name this layer **Specularity**.
3. Use the brightness and contrast (Image > Adjust > Brightness/ Contrast > Use Legacy, Brightness –39, Contrast 77).
4. I ran the Crosshatch filter on this: Crosshatch > Stroke Length 7, Sharpness 3, Strength 1. This helps make the wear look scratchier. In Figure 5-20, you can see the texture with and without the specularity map applied.

Chapter Exercises

Go back through this chapter and create a texture set that is uniquely yours by altering the following:

1. The roughness of the base metal and/or the color of the base and fill.
2. The pattern used to cut the wall panel.
3. The pattern used to cut the floor panel. Try the floor without a grate or using all grate.
4. Change the pattern on the diamond plate.
5. Create your own details for the detail texture. Keep in mind how this texture is used in the scene in this instance.
6. Create a set of overlays to achieve a moldy look, a rusty look, a dusty look, and/or a cold look.

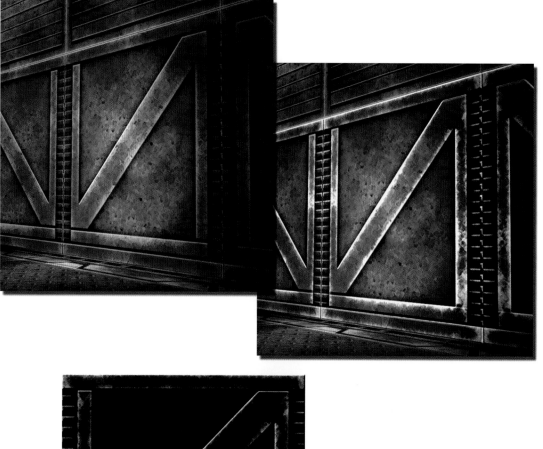

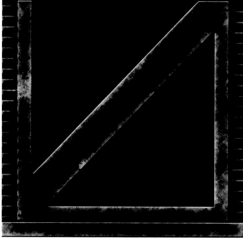

Figure 5-20
The wall texture with and without the specularity map applied.

Chapter 6

Warehouse Concept 2005 by Jose Vazquez.

The Urban Setting

Introduction

In this chapter, you will learn to work more faithfully to the detail in a concept sketch or any reference material that may be given to you. When you need to create textures for a game environment, you are usually creating them for a world that has been thought out, detailed, and developed to the point that showcasing your creativity is not the primary goal of your work. You are showcasing your talent and ability to recreate what you see in the materials in front of you.

As discussed earlier in the book, textures traditionally come in sets: base, wall, floor, and ceiling variants as well as fill, trim, and so on. This chapter focuses on breaking out the materials that need to be created for a scene and then the details that also need textures created for them. Even though this approach is changing somewhat with technological advances, it is still a skill that is applicable to many games and applications and a good skill to have when you are required to work with more advanced technology. We always start with the basics to build a material (shape, color, texture) and build detail on top of that. What you end up with is a full texture set that is easily altered and built on. By the end of the chapter, you will have created all the textures needed for the urban environment concept sketch on the facing page. We will use the standard urban environment so popular in many military, sci-fi, driving, and other game genres in this chapter, as it offers a good variety of materials and objects.

Unlike the last chapter, in which we used fewer and simpler textures on a high-polygon-count scene, here we will be putting more detail into the textures and using fewer polygons. In the last chapter, we mostly made simple variants of one texture, as opposed to the full texture set composed of materials and images for specific uses (like signs or a door). In the fantasy chapter we will go all out on polygon and texture usage to create a high-detail world.

The Concept Sketch

The front plate of the chapter shows the concept sketch for our urban area—a warehouse interior. In order to create a set of textures for a scene, you need information that is often not yet known to you or even anyone on the project. If you are in the early stages of development and are helping to test and prototype, you will be creating many variations of the assets needed for a scene. This is one reason to work large to small and in an organized/modular fashion. Even if all the specifications are in place, you will still most likely be producing many variations on the textures you are creating.

Technical questions aside (as these were addressed in the earlier chapters), you will also have to ask some questions pertaining to the fiction of the game world and the space you are creating textures for in particular. Some concept sketches are fuzzy in nature and often don't come with accompanying verbal descriptions. Usually, you will be given a thorough briefing on the game and the world space, but something that looks like one material to you in

the sketch might be something else. This scene is pretty straightforward. We can assume that the walls are bricks, the floor is concrete, and so on. But look at the windows (not the skylights). They don't look right for windows in a warehouse (I had the artists draw them that way on purpose and promised that I would say so in the book). The windows are also different from the skylight windows. As a texture artist, you may see the opportunity to save on texture space (memory) by making one texture that is applied to both surfaces. You should probably check this out with your boss, but he or she will either tell you to go for it or explain why the windows are the way they are—in any case, you can demonstrate that you are on the ball with this texture thing.

Breaking out the Materials in the Scene

Look at the concept sketch again and let's start identifying the materials in the scene. We have to look beyond the details, decorations, light and shadow, effects, and determine what basic materials compose this scene. Look at Figure 6-1 and the subtle clues that I left to help you identify the base materials.

Brick

Looking at the walls, you can see that the structure is obviously made of bricks. We will make our own bricks in Photoshop. Bricks are a common texture that you can easily get on the Internet or simply photograph in the real world. But making your own bricks is not only faster in many cases, but they also often look better in a game, as they are more visually consistent and easier to tile. Plus, if you build them up in layers, you have more control over the speed and variety of changes you can make to the texture.

Windows

I identify the windows next, only because my eye is drawn to them. Looking closer, I see that they will be easy to tile, as they are made in sections (panes) that can be easily tiled, but how do you get them to glow like that? And what about those shafts of light?

Wood

I then notice that the ceiling is made of dark wooden planks. There are also other places where wood is used: the crates and the wall of the little office. These are all variations of wood and can be made from a base wood grain material.

Concrete

The floor is made of concrete. There are subtle cracks and details on this floor, but it is mainly a big gray plane. We will experiment with

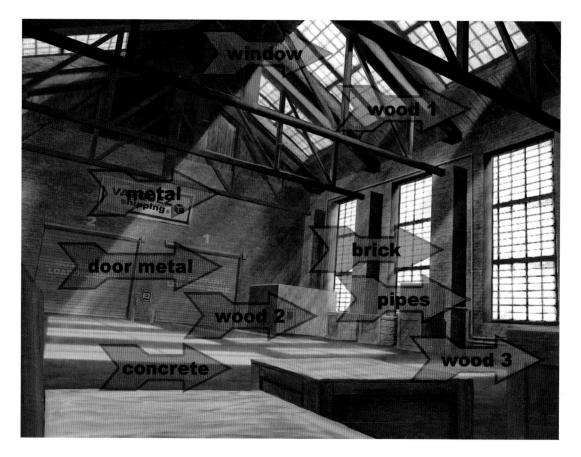

Figure 6-1
To determine what base materials compose a scene or environment, we have to look beyond the details, decorations, light and shadow, and effects.

two versions: a smoothly poured floor with no seams and a floor with seams that looks as if it had been poured in sections.

Metal

Finally, there is the metal. There are three types of metal in this scene that must tile. There are the beams, which are rusted, the grayish rolling garage doors, and the pipes on the wall. Unlike the wood, these textures are different enough that I will start with a different base texture to create two of them.

You will also notice that there are many other details for which art will need to be created—we will break those out after we create the base materials.

Creating Bricks

Creating bricks is easy. They are rectangles and are composed of two substances: bricks and mortar (mortar is the cement between the bricks). There are many styles of bricks and many types of mortar, too. There are also variations of the patterns in which the bricks are laid out, their length and width, the space between

them—even the mortar can be very different. An interior warehouse brick may have mortar that was put down sloppily and squishes from between the bricks, whereas the exterior of a house would have neat mortar that was scraped away to make the mortar indented and smooth.

Tiling bricks, when you first start doing it, can be a challenge. Bricks are various sizes and not always a neat fit for a power of two. In this exercise we will make our warehouse bricks—they're a standard red brick—and lay out the bricks using the grid so that they tile perfectly. After this, you will have a pretty flexible template for creating other types of bricks and even rough stones (as you will later in the fantasy chapter).

Way back in Chapter 1, we covered some of the basic elements of art. They were

- Shape (2D) and form (3D)
- Light and shadow
- Texture: tactile vs. visual
- Color
- Perspective

To create a texture from a blank slate in Photoshop, you start with shape, choose a color, start creating the visual texture, and work in the light and shadow toward the middle/end of things. You can approach the creation of a texture from many angles, but starting with shape seems to be the most logical progression to me. I like to lay the groundwork and make sure that things all tile and line up properly. It is a terrible thing to have worked on a texture for a long time only to find that it doesn't tile. Bricks are especially tricky if you don't do some math and consider brick and mortar heights and widths as they relate to the grid.

Then I choose a color that is at least close to the object or surface I am creating (the great thing about Photoshop is that you can recolor things fairly easily later on). I start to tackle the visual texture of the object immediately; this step takes the most time and experimentation. Although this is a linear exercise, meaning I take you through the creation of the bricks in steps from beginning to end; in reality, as you create your own textures, you will go back and forth, changing the color and light and shadow several times. You will need to tweak and change and even redo things until the texture is right.

Tiling Brick Pattern

Step one: shape. A brick is basically a rectangle. In order to make a brick pattern that tiles on the power of two, do the following:

1. Create a new image that is 1024×1024 and name it **brick_pattern**.
2. Set the grid to 32 and give it 2 subdivisions.

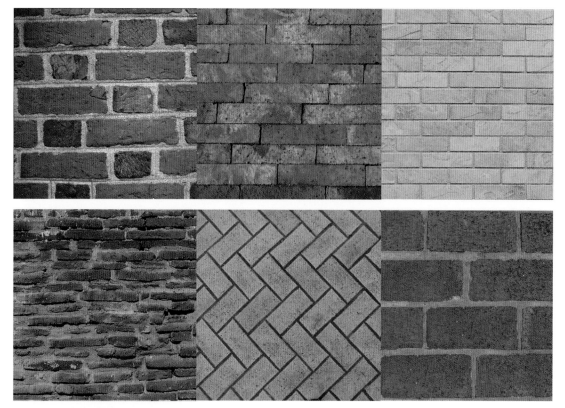

Figure 6-2
Bricks! There are many shapes and sizes. **Lower right**, the brick shape close up as it is built on the grid.

3. Create a new layer (Ctrl+Shift+N) and name it **Brick Shape**.
4. On this new layer, we will create our first brick shape. Look at Figure 6-2 to see the shape and size of the brick. Notice how the selection is one unit away from each major gridline. The units are 16 pixels and the bricks 496×112.
5. You can copy and paste the brick until it looks like Figure 6-3. You will have to push some of the bricks off the canvas edge to make them fill the half brick spaces. Double-check your mortar spacing! Copying and pasting creates a new layer each time you paste a brick, so alternatively you can choose Select All (Ctrl+A)

LAYOUT BRICKS AND CROP THOSE EDGES

1024 X 1024

CHECK THE TILING OF YOUR PATTERN

and hold down the Ctrl and Alt keys and click and drag a copy of the brick on the same layer. This is faster, but a little trickier. Every time you let up on the mouse the shape is pasted at that spot. You have to position exactly before placing a brick or you will be undoing a lot.

6. Crop the image. Make sure the Delete option is on and drag the Crop Tool over the canvas so that it will not change the canvas size, but crop off the half bricks hanging out of the canvas space.

7. Check the Image Size to make sure it is still 1024×1024. I am including all these little steps to begin with because they are

Figure 6-3
The brick pattern is the basis for the entire texture. Make sure it tiles right.

good habits to pick up. Checking things now and fixing them when you can still use Undo is much easier than discovering a mistake when the texture is complete.

8. Now use the Offset Filter and enter 512 for both the horizontal and vertical values. If you see any gaps or misalignments in the bricks, fix them now. Redo the exercise or, in the case of one brick being messed up, cut the brick out, copy another, and paste and position it in the empty spot. If you create a new layer, make sure that you merge the two layers together. You can simply link the two layers and use Ctrl+E to merge linked.

Note: Merging layers creates a new layer that inherits the name from the layer that is selected when you merge. If you have the named layer selected when you merge layers, it will save you typing the name again.

Save your file. You now have a tiling brick pattern. Before you make a texture out of this, you may want to save a copy in your image collection.

Brick Texture

We will create the texture for the bricks and mortar separately.

1. We will start by selecting a color for the bricks. I used RGB 131,85,67. There are many ways to change the colors of the bricks; I simply used the Paint Bucket and filled them in.
2. Noise > Add Noise 8%.
3. Brush Strokes > Sumi-e – Stroke Width 10, Stroke Pressure 4, Contrast 29.
4. Fade this filter (Ctrl+Shift+F) to about 10%.
5. Filter > Brush Strokes > Spatter – Spray Radius 20, Smoothness 5.
6. Filter > Artistic > Dry Brush – Brush Size 4, Brush Detail 10, Texture 2.
7. Filter > Artistic > Paint Daubs – Brush Size 12, Sharpness 5, Brush Type Simple.
8. Fade by 50% and change the Blending Mode to Lighten. Your image should look like Figure 6-4.
9. Here is where you have to do a little handiwork. The edges of the bricks are still too uniform. We need to chisel them down, so hit the "E" key to activate the Eraser.
10. Right-click and select a hard brush, size 13 (see Figure 6-5).
11. You might want to copy the layer and hide it in case you want to go back to this step later.
12. Start whittling down the edges and knocking some chips in the bricks. Take your time and be subtle. Remember that these bricks have to tile, and from far away subtlety doesn't pop, but when the player gets close, the subtle chips and imperfections will look good. Work at 100% zoom or even 125% so that you can control your brush. I rounded off the corners to help the bricks look older. When we put the mortar in, it will have the same interesting shape, as it will follow the space between the bricks.

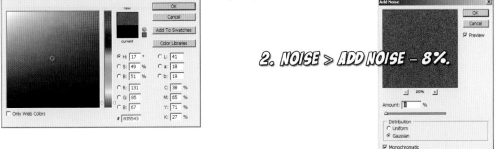

1. COLOR FOR THE BRICKS - RGB 131,85,67.

2. NOISE > ADD NOISE - 8%.

3. BRUSH STROKES > SUMI-E - WIDTH 10, PRESSURE 4, CONTRAST 29.

4. FADE ((CTRL + SHIFT + F) TO 10%.

5. FILTER > BRUSH STROKES > SPATTER - SPRAY RADIUS 20, SMOOTHNESS 5.

6. FILTER > ARTISTIC > DRY BRUSH - BRUSH SIZE 4, BRUSH DETAIL 10, TEXTURE 2.

7. FILTER > ARTISTIC > PAINT DAUBS - SIZE 12, SHARPNESS 5, TYPE SIMPLE.

8. FADE 50% BLENDING MODE - LIGHTEN.

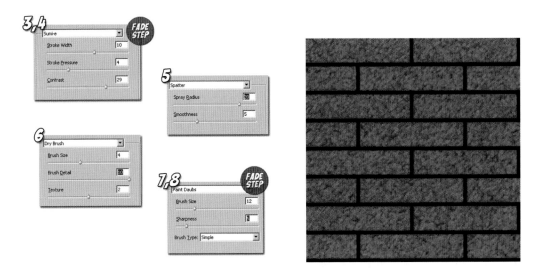

Figure 6-4
This is what the bricks should look like so far, after running a few filters.

Mortar Texture

Creating mortar is easy—it is simply the space between the bricks.

1. Create a new layer (Ctrl+Shift+N) and name it **Mortar.**
2. Select the layer with the bricks on it and use the Magic Wand Tool to select the empty space between the bricks.
3. Select the new Mortar layer and fill the selection with a very pale yellow. I used RGB 200,200,175.

Figure 6-5
Knocking the edges down slightly with the eraser helps make them look older and more natural.

4. Deselect the selection.
5. Filter > Noise > Add Noise 10%.
6. Filter > Artistic > Dry Brush – Brush Size 4, Brush Detail 7, Texture 1.

Your mortar should now look like Figure 6-6. The colors are still off, but we will fix that toward the end, after we add some depth and merge the two layers.

Figure 6-6
The bricks with the mortar added. The colors are off, but that will be fixed as we progress.

Brick and Mortar Depth

Giving the bricks depth simply requires the Bevel Emboss layer style with the following settings:

Structure
Style – Inner Bevel
Technique – Smooth
Depth – 61%
Direction – Up
Size – 13
Soften – 5
Shading
Highlight Mode – Linear Light
Opacity – 62%
Shadow Mode – Multiply
Opacity – 63%

Adding depth to the mortar begins with an inner shadow. Note that as you apply filters you may notice they affect the edges of the image. Don't worry about that: we will fix it later.

Change the following Inner Shadow settings:

Opacity – 57%
Distance – 13 px
Size – 13 px

Add an Inner Glow:

Structure
Blending Mode – Normal
Opacity – 60%
Noise – 20%
Color – Pure Black
Elements
Size – 22

Apply Bevel and Emboss:

Structure
Style – Inner Bevel
Technique – Chisel Soft
Depth – 101%
Direction – Up
Size – 10
Soften – 6
Shading
Highlight Mode – Screen
Opacity – 42%
Shadow Mode – Multiply
Opacity – 35%

If your background layer is white, or a light color, you may notice that the bricks and mortar have some of the bright color showing through. To fix this, simply fill the background layer with black or a very dark color. Your image should now look like Figure 6-7.

Brick Completion

We are going to merge the bricks, mortar, and background together, so make a copy of the unflattened Photoshop file so you can change things later if you like. You can also copy the layers and work in one file. Put the layers in their own layer set and hide the set.

1. Link the bricks, mortar, and background image together and merge them (Ctrl+E).
2. Filter > Artistic > Dry Brush – Brush Size 2, Brush Detail 10, Texture 2.
3. Fade this (Ctrl+Shift+F) and take the opacity down to 50%.
4. Filter > Brush Strokes > Spatter – Spray Radius 3, Smoothness 10.
5. Filter > Texture > Craquelure – Crack Spacing 52, Crack Depth 3, Crack Brightness 4.
6. Fade by 45% (Ctrl+Shift+F).
7. I found the bricks to be too saturated for the warehouse scene, so I made a copy of the layer and adjusted the brightness up +16 and the contrast down –29. I could have gone back and changed the steps of this exercise to end up with the results I wanted, but I had you do what I did, because that's how it really happens. Now we have two versions of the bricks instead of one.

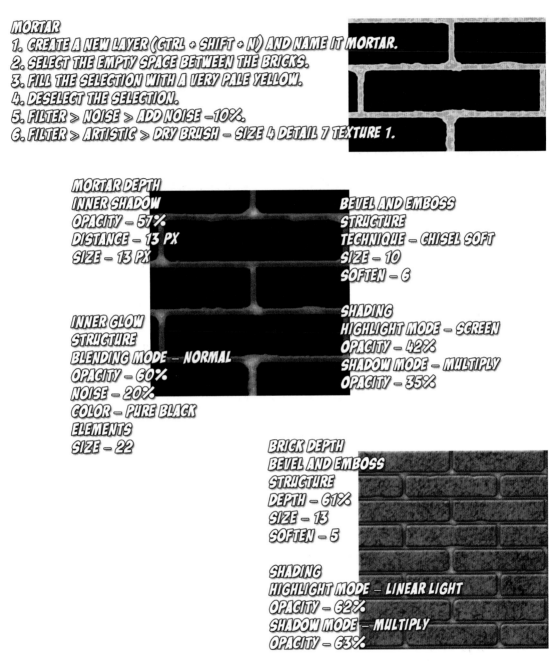

MORTAR
1. CREATE A NEW LAYER (CTRL + SHIFT + N) AND NAME IT MORTAR.
2. SELECT THE EMPTY SPACE BETWEEN THE BRICKS.
3. FILL THE SELECTION WITH A VERY PALE YELLOW.
4. DESELECT THE SELECTION.
5. FILTER > NOISE > ADD NOISE –10%.
6. FILTER > ARTISTIC > DRY BRUSH – SIZE 4 DETAIL 7 TEXTURE 1.

MORTAR DEPTH
INNER SHADOW
OPACITY – 57%
DISTANCE – 13 PX
SIZE – 13 PX

BEVEL AND EMBOSS
STRUCTURE
TECHNIQUE – CHISEL SOFT
SIZE – 10
SOFTEN – 6

INNER GLOW
STRUCTURE
BLENDING MODE – NORMAL
OPACITY – 60%
NOISE – 20%
COLOR – PURE BLACK
ELEMENTS
SIZE – 22

SHADING
HIGHLIGHT MODE – SCREEN
OPACITY – 42%
SHADOW MODE – MULTIPLY
OPACITY – 35%

BRICK DEPTH
BEVEL AND EMBOSS
STRUCTURE
DEPTH – 61%
SIZE – 13
SOFTEN – 5

SHADING
HIGHLIGHT MODE – LINEAR LIGHT
OPACITY – 62%
SHADOW MODE – MULTIPLY
OPACITY – 63%

8. Offset the image by 512×512 both ways and clone out the seams with a soft brush.

Figure 6-7
The bricks are starting to take shape as we add depth to them.

Top of the Wall

Having trim pieces, even subtle drip stains, around the top of a wall helps make the wall feel more real and the scene more solid. This is easy to do now that you have your base brick texture. You can experiment a lot, but always keep in mind these tips:

Figure 6-8

Now that we have a strong base that tiles well, we can make many variations of brick.

- Don't move or alter the base texture.
- Keep a sharp eye on the edges that are supposed to tile.

Remember that the base texture must still tile with itself. If this is confusing, flip back to Chapter 2 and look at the figure that explains three-way tiling using this very example. I usually completely clean the tiling edge of my texture, the edge that needs to seamlessly tile with itself, just to be sure. Even a slight change in brightness from a glow or airbrush stroke on the tiling edge of the texture (that your eye can't even detect) will look like a hard line running around the room when you put the texture in the world. Simply use a hard eraser, or even the Selection Tool, to make sure that no pixels are in the top few rows of your texture. You can even mask a few pixels at the top so that if there is a slight line, you can see it while you are still working on the texture.

We can add subtle drip stains, or we can add a general haze of dirt that may have accumulated in the corners in this old warehouse. Because we create drip stains on the windows in the next section, let's do the haze of dirt here.

1. Start by opening a copy of your base brick texture.
2. Our base brick texture has too few bricks on it to make a detailed tile set. I reduced the image to a 512×512 image and made the canvas size 1024×1024 and tiled it four times.
3. Name the new image **Brick_Warehouse_Base**. Now you have a base brick texture and a new base texture for your warehouse. I further darkened, desaturated, and lowered the contrast to get an old brick feel.
4. Make a new layer and name it **Dirt**.
5. Make Black your foreground color and use the Gradient Tool with the Foreground to Transparent preset selected.
6. Drag from the top to the bottom of your image about halfway. Hold Shift so the gradient is straight.
7. Filter > Noise > Add Noise 50%.
8. Filter > Blur > Motion Blur – Angle 90, Distance 100.
9. Filter > Artistic > Dry Brush – Brush Size 2, Brush Detail 10, Texture 2.

NEW LAYER NAMED DIRT
FOREGROUND COLOR BLACK
USE THE GRADIENT TOOL
FOREGROUND TRANSPARENT
DRAG FROM THE TOP TO THE BOTTOM
OF YOUR IMAGE ABOUT HALFWAY
HOLD SHIFT SO THE GRADIENT IS STRAIGHT

FILTER > NOISE > ADD NOISE – 50%
FILTER > BLUR > MOTION BLUR – ANGLE 90, DISTANCE 100.
FILTER > ARTISTIC > DRY BRUSH – SIZE 2, DETAIL 10, TEXTURE 2.
FILTER > ARTISTIC > FRESCO – SIZE 2, DETAIL 8, TEXTURE 1.
FILTER > BLUR > GAUSSIAN BLUR – 1.5 PIXELS.
LAYER BLENDING MODE TO MULTIPLY
OPACITY 67%

Figure 6-9
Trim pieces and subtle drip stains around the top of a wall help make the wall feel more real and the scene more solid. You may notice the trim at the top of the texture. After creating the bottom of the wall texture (which we will do after the top of the wall), I took that trim from the bottom of the wall and added it to this texture, scaling and darkening it.

10. Filter > Artistic > Fresco – Brush Size 2, Brush Detail 8, Texture 1.
11. Filter > Blur > Gaussian Blur – 1.5 pixels.
12. Set the layers Blending Mode to Multiply and the Opacity at 67%. Your image should look like Figure 6-9.

Bottom of the Wall

This is a warehouse, so we don't have to get too fancy with the trim that runs around the floor. Most likely it would just be a beat-up piece of wood or metal. We create wood and metal in more detail later in the chapter. Here we will make a plain and simple metal strip.

1. Create a new layer and name it **Metal Strip.**
2. Turn on the grid and set the grid size to 128 with 1 subdivision.
3. Drag out a selection that is 128 pixels high and 1024 wide.
4. Fill this selection with a dark gray, such as RGB 105,105,105.
5. Lock the layer transparency.
6. Filter > Noise > Add Noise 7%.
7. Filter > Blur > Gaussian Blur 1.5 pixels.
8. Set your foreground color to black and use the Gradient Tool (while holding Shift) and start from the bottom and go halfway up the strip. You could also use a large, soft brush to paint this black strip on.
9. Fade the gradient (Ctrl+Shift+F) to 25% and set the Blending Mode to Color Burn.
10. Filter > Artistic > Fresco – Brush Size 2, Brush Detail 8, Texture 1.
11. Fade to 24% and set the Blending Mode to Overlay.
12. Apply the following layer styles.

Outer Glow
Structure
Blending Mode – Normal
Opacity – 45%
Noise – 36%
Color – Pure Black
Elements
Spread – 9
Size – 174
Bevel and Emboss
Structure
Style – Inner Bevel
Technique – Smooth
Depth – 150%
Direction – Up
Size – 7
Soften – 0
Shading
Highlight Mode – Overlay
Opacity – 60%
Shadow Mode – Normal
Opacity – 50%

Your image should look like Figure 6-10. You can take a few extra steps to add some detail and interest. I copied the dirt from the top image and flipped it vertically using the Free Transform Tool and lowered the opacity of the dirt. I colorized the metal strip (Ctrl+U) a desaturated orange to make it look more rusted. Finally, I created a new layer, set the Fill to 0, and copied the Metal Strip layer style

Figure 6-10
Like the top, the bottom
looks better with trim and
some dirtying up.

and pasted it to the new layer. I added those little vertical strips
with a small, hard brush.

You are going to need to offset this image horizontally and fix the
edges. In order to do that, you will have to merge the layers so the
layer styles are not editable anymore. You will want to copy all the
layers in a layer set so you can change them later. Merge the copies
of the layers.

Windows

I mentioned earlier that the windows were purposely drawn wrong
in the concept sketch. They don't look like actual warehouse
windows. I went to a nearby warehouse and took the following
reference photo, Figure 6-11. You can see that these windows are
basically destroyed, but their construction can be seen in the
reference photo and their color and texture taken from the actual
concept sketch. In this section we will look at variations of these
window panes and create a version with an alpha channel.

The Frame

Windows are easy—just like bricks! They are a metal frame with
panes of glass in them. We start with the metal frame and work

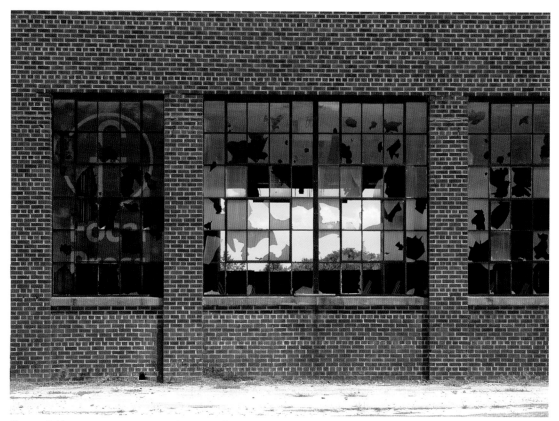

Figure 6-11
Warehouse window
reference.

down to the panes, similar to how we created bricks and the mortar around them. Then we can control the amount of weathering on the windows to our liking.

1. Open a new file, make it 1024×1024, and name it **Windows_ Warehouse_Base**. If your computer is having difficulties handling the larger files, you can work at 512×512 and simply adjust the effects and other parameters down by 50%.
2. Set your grid to 256 with one subdivision.
3. Create a new layer set and name it **Frame**.
4. Create a new layer in the set and name it **Outer Frame**.
5. Set your foreground color to a very dark brown. I used RGB 69,59,54.
6. Select the entire empty layer using Ctrl+A and right-click and select Stroke. Set the Width 18 pixels, Location inside.
7. I like to create the outer frame separate from the inner frame that holds the panes of glass, as it adds more depth to the texture. Create a new layer and name it **Inner Frame**. Make sure that this layer is underneath the outer frame layer.
8. Use the same color to draw lines along the grid. Use a hard 13-pixel brush.
9. Add the Layer Style Drop Shadow to the Outer Frame layer and change the following settings:
Blend Mode – Normal
Distance – 8 px
Size – 16 px

10. Add noise. Filter > Noise > Add Noise – Amount 0.75.
11. Copy and paste the layer style from the Outer Frame layer to the Inner Frame layer and change the size to 6.
12. Apply the noise filter again. Ctrl+F will reapply the last filter you ran using the same settings. Your frame should look like Figure 6-12.

Figure 6-12
The base window frame.

The Glass

Creating the glass panes is similar to how we created the brick mortar. We will make the glass and then delete the portions of the glass where the frame covers it. This gives us additional flexibility when using layer styles, because many of them operate on the edge of an image.

1. Create a new layer set and name it **Glass**. You can turn the Frame layer set off for this part of the exercise. It will be easier to see the canvas and speed up the computer's response time.
2. Select a muddy yellowish amber (I used RGB 127,106,48) and fill this layer using the paint bucket. Or Ctrl+A to select all, right-click > Fill > foreground color.

3. Add noise. Filter > Noise > Add Noise – Amount 7%.
4. Filter > Artistic > Dry Brush – Brush Size 10, Brush Detail 4, Texture 1.
5. Filter > Distort > Glass – Distortion 8, Smoothness 3, Texture Frosted, Scaling 166%.
6. Hit the "D" key so your foreground and background colors are black and white.
7. Filter > Render > Clouds – Fade this filter to 25% (Ctrl+Shift+F).
8. Filter > Blur > Gaussian Blur – 1.5 pixels.
9. Filter > Artistic > Fresco – Set all the settings to their max.
10. Fade the filter to 15% and set the Blending Mode to Multiply.
11. Cutting out the panes. Turn the Inner Frame layer on and select an empty pane. Right-click and Select Similar. Right-click again and Select Invert. Go to the Glass layer and press the Delete key to remove the portion of the glass behind the frame.
12. Do the same for the Outer Frame. Turn both frame layers off and your image should look like Figure 6-13.

Pane Variations

Creating multiple variations of the panes is easy and makes this texture very flexible (see Figure 6-13). Remember to create copies of the pane layer as you alter them. Some of the layer effects I applied to the panes that you might want to try are:

- Subtle Dirt: Inner Glow, Black—play with the size, opacity, noise, and blending modes.
- Subtle Dust: Change the Inner Glow color to a very light gray, Blending Mode: Dodge, Opacity 65%, Noise 16%, Size 40 pixels.
- Subtle Highlight: Bevel and Emboss; try changing the settings to a large, low depth; highlight and soften it. This can give nice even highlights to the panes; just be careful they don't look bulged out.
- Inside Light Source: For a large tiling texture, you want to keep things even, but in the case in which this window might be used in one instance with no tiling, you can add a subtle gradient using a layer style and experiment with the blending modes and gradient types to get the appearance that there is a stationary light source in the room beyond the window.

You can also play with colorization (Ctrl+U), desaturation, and other filters and effects for panes of various appearance. What you are trying to achieve may depend on the concept art, condition of the building around the window, and other environmental factors.

Weathering and Dirt

Various types of weathering and dirt can be applied to a surface, depending on the location and the material the surface is made of. The concept sketch shows indoor windows that do not need any dirt or weathering (maybe a bit of rust on the frames and a hint of dirt

on the glass). In fact, you may have noticed that the windows in the concept sketch are glowing a white-blue. That effect is a combination of making the texture the same color, using a shader to make the panes bright, and a special effect for the light beams. A more advanced shader called "bloom" can also be used for the glow to actually go outside the frames themselves. The light beams are easy, but we don't create them here. These types of effects were covered in Chapter 3.

But what if these windows were outside? The metal frame might be rusted. The panes might be streaked with rain and dirt. Depending on the location of the building and the condition it is in, this weathering could be mild to heavy. First, we can rust the frame.

Figure 6-13
The glass panes without the frame.

Figure 6-14
Window pane variations from **left** to **right** are subtle dirt, subtle dust, and subtle highlights/inner light source. They have also been colorized and the saturation and brightness adjusted.

Figure 6-15
Variations of the rusted pane, easily created because of the power of layers and blending modes.

1. Duplicate the layer set Frame and name it **Frame Overlay**.
2. Make sure the new Frame Overlay set is on top of the Frame set in the layer stack.
3. Open the new layers set and turn off the layer effects, link the two layers, and merge them together (Ctrl+E). You now have a solid copy of the entire frame.
4. Lock the Transparency on this layer.
5. Filter > Noise > Add Noise 10%.
6. Filter > Artistic > Dry Brush – Brush Size 2, Brush Detail 8, Texture 1.
7. Colorize. Ctrl+U, Hue 14, Saturation 30.
8. Change the Blending Mode to Darken and experiment with the opacity. Around 30% to 45% is light rust and 50% to 75% is heavy.
9. Changing the Blending Mode to Lighten will give you a brighter, drier-looking rust. Figure 6-15 shows a few variations of the rusted pane.

The panes can be weathered as well.

1. Start by duplicating the glass layer set and naming it **Outside Glass**.
2. Desaturate the glass layer (Ctrl+Shift+U).
3. Fade this by about 50% (Ctrl+Shift+F). Now the panes look faded, as if they have been outside a long time.
4. To create a general dirt layer, create a new layer on top of the stack and name it **Smog**.
5. Filter > Render > Clouds.
6. Change the Blending Mode to Multiply and set the Opacity to 50%.
7. Filter > Noise > Add Noise – 50%.
8. Filter > Blur > Motion Blur – 90 degrees and about 30 pixels of blur.

Rain Streaks
1. To create rain streaks, turn off the smog layer (you can turn it on later if you like) and create a new layer named **Rain Streaks**.
2. Select a medium gray as your foreground color (RGB 157,157,157).
3. Zoom way out so that your image is pretty small and the canvas fills most of the workspace (see Figure 6-16). This makes it easier to create various streak lengths.

Figure 6-16
The image small and canvas large. This makes it easier to vary the length of brush strokes on the canvas without having to change brushes because you can start drawing anywhere you want outside the canvas.

Figure 6-17
Rain streaks on the window.

4. Select a Brush of medium size and softness. Go to the Brushes Palette and under Shape Dynamic, change the control to Fade. Set the pixel fade to 128. This is the window to the right of the fade selection.
5. Now drag a few lines down your window. Hold Shift to keep the lines straight. Vary the length by starting to draw higher above the canvas and vary the width using the "[" and "]" keys. Be subtle.
6. Filter > Blur > Motion Blur 90 degrees and about 30 pixels of blur.
7. Set the Blending Mode of this layer to Overlay and set the Opacity between 50% and 75%. I ended up at 63% in Figure 6-16. You can, of course, experiment with the color of the streaks, the blending modes, and opacity. You can even add some noise and run the Motion Blur filter again with a lower pixel blur for streaks with a little more body.

Window Alpha

An alpha channel is a grayscale image used in various ways to achieve many effects on a texture in a game engine. For more information, see Chapter 2. We will make an alpha image for this window and use it in various ways.

1. Duplicate your window image. We will be merging layers and it is safer to work from a copy.

2. Duplicate the Frame layer set and name it **Alpha**. Make sure this new layer is on top of the layer stack.
3. Open the new set and turn off the layer effects, link the two layers, and merge them together (Ctrl+E). You now have a solid copy of the entire frame.
4. Use the D key to reset your colors.
5. Select an empty pane, right-click, and select Similar, and then Invert the selection and switch to the rectangular marquee and right-click and fill the selection with white. We want this frame solid white, because in the alpha channel white is solid and no light will pass through the frame or reflect off it.
6. Hide the new Frame Alpha layer set.
7. The windows should already be the way you want them in the texture. If not, go back and change them before making the alpha so they match. When you are ready, Merge Visible. The white frame should be a separate layer on top of your merged panes.
8. Desaturate the panes (Ctrl+Shift+U).
9. Using Levels drag the middle arrow a little to the right to darken this image.
10. Using Brightness/Contrast take the brightness down 20 and the contrast up 20.
11. Your image should look like Figure 6-18. If you keep the frame separate from the panes, you can adjust and alter the panes while keeping the frame solid white. With the panes this dark, they are almost completely transparent, so you will want to experiment with light/dark and contrast settings.

This alpha image can go into an alpha channel in Photoshop or an image format that supports alpha, or it can be used as a separate image. Some game engines use a separate grayscale image as the alpha, and others will recognize the alpha channel of an image. Some can do both, so you can use one grayscale image to define the opacity and illumination of the window and another to define the bump. In the case of a bump map for a window, you would want the panes smooth, unless there were mud splatters that would stand off the glass, and the frame would protrude. In Figure 6-19 you can see the window texture with various effects on it that use the alpha channel. Notice that in the image with opacity there are broken panes. This was easily done by making the broken and missing portions solid black with hard edges.

The size of the texture and the number of panes will fluctuate depending on your parameters. One approach is to make more panes in the same texture space; another is to make one pane, if the panes are all the same. This would allow a smaller image size, but more detail per pane. You can even have a polygon for every pane in the window and make an image with several pane variations; normal and several broken in various ways. Then the environmental artists can cover most of the panes with the normal pane and randomly place the broken ones.

Note: Some game engines and 3D applications use black as solid and white as transparent, and some may use the opposite. If this is

Figure 6-18

In most applications the white in an alpha channel is solid, so the frame is white and kept as a separate layer (it is red here only so that you can see it). It always stays solid white if you adjust the panes on their own layer.

TEXTURE

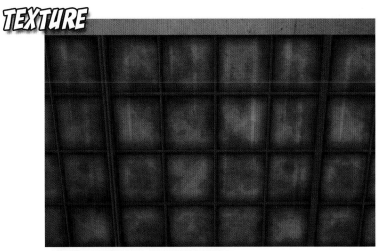

TEXTURE WITH ILLUMINATION MAP

TEXTURE WITH ALPHA CHANNEL

Figure 6-19
The **top** image is simply the texture as it is. The **middle** image has an illumination shader on it. It is hard to see in this image, but if you were on a dark street, these windows would be bright as if there were a light inside. The **bottom** image has an alpha channel used for opacity. White is solid, so black is clear. The broken panes are just solid black shapes on the alpha channel.

the case, you can simply invert your image using the invert command (Ctrl+I).

Wood

Our next material is wood. There are several places where wood is used in this warehouse, so we will start with a wood grain and create various versions of wood from there. One of the new features of Photoshop CS is the Fibers filter, and that comes in handy when making wood grain.

Basic Wood Fill

1. Open a new file and make it 512×512. Name it **Wood_Fill_001** (you may want to create more than one version, so a number helps).
2. Create a new layer and name it **Wood Grain**.
3. Fill the layer with a brownish color (RGB 85,80,70). I chose this washed out brown, as this is older wood. Normally, I would have made a more saturated version and simply copied it to a new layer and desaturated it. This way I would begin building up different versions of the wood grain.
4. Make sure your foreground color is the brownish color and the background color is just a darker version of it (RGB 61,58,50).
5. Filter > Render > Fibers – Variance 16, Strength 4.
6. This filter doesn't create a tiling image, so you need to copy this layer and offset it by 256 in both directions.
7. Use a big, soft brush and erase most of the top layer except for the edges. Keep an eye open for any hotspots you may want to remove.
8. Use the Offset Filter again (Ctrl+F) and look for any seams or corners you may have missed and hit them with the Clone Brush. You should have an image like Figure 6-20.

This is a basic wood fill. As you use it in various places, you may need to desaturate it, make it smaller and tile it, blur it—whatever works in the context where you are using the texture. Our first variation of this basic wood grain will be to create the wooden panels that compose the ceiling of the warehouse.

Wooden Planks

The ceiling of this warehouse is composed of dark wooden planks. The steps to create planks are easy.

1. Open a copy of the wood fill and name it **Wood_Planks_001**. Create a new layer and name it **seams**.
2. Set your grid to 128.
3. Use a small medium brush (5 pixels) and draw vertical lines along the gridlines using the darker background color from the

Figure 6-20
Basic wood fill. Subtle, understated, and oh-so-useful.

last exercise. Remember to get the edges of the image, too, or you will have one wide plank when you tile this image.

4. Use the Bevel and Emboss layer style with the following settings:
 Style – Outer Bevel
 Depth – 50%
 Size – 6 px
 Highlight Mode – Vivid Light
 Opacity – 100%
 Shadow Mode – Overlay
 Opacity – 87%

5. Make a copy of the Wood Grain layer and link it to the seams layer. Merge them (Ctrl+E).

6. When you merge these layers, the formerly adjustable layer styles are now permanent and the image is fixed. As a result, there are pixels outside the canvas area so you need to use the Crop Tool to remove them. Simply drag the tool completely across the image and press Enter. Check your image size and make sure it is still 512×512.

7. Now you can use the Offset Filter and offset the image by 256 both ways. If you haven't used the Offset Filter since the last section, you can use **Ctrl+F**. You might have some small edge imperfections so you can fix those now. Your image should look like Figure 6-21.

Figure 6-21
Basic wood planks. I can't
think of anything else to say,
but they're cool.

Wooden Planks, Office

The small office is also made of wooden planks. These are nothing
more than a copy of your current planks altered.

1. Copy and paste the plank layer and name the new resulting layer
 Office Planks.
2. Desaturate this layer.
3. Take both the Brightness/Contrast settings up +30.
4. Set your foreground color to RGB 120,118,131. This is the
 washed-out blue of the office boards.
5. Use Hue/Saturation (Ctrl+U) and check the colorize box. The
 saturation will be way too high, so take it all the way down to 3.

Wood, Crate

The crates are yet another variation, only this time we need to give
the wood grain more detail, add knotholes, build the frame around
the crate, and create seams.

1. Open and duplicate the Wood Grain image. Name it
 Crates_Wood_001.
2. We will first add knots and detail to the wood that would be
 undesirable for a tiling texture but that for the face of a crate
 will look great. Use the Liquify Tool (Ctrl+Shift+X).

3. Start with the Bloat Tool with a large brush between 100 and 200 pixels and drag it a little in a few places to create the knots.

4. Then use the Forward Nudge Tool with a 200 brush and subtly push the grain around. You don't have to do too much here. You can maybe make the grain contour to the knotholes. Your image should look similar to Figure 6-23.

5. Set the grid to 128. Before we start making planks, we are going to flip and rotate sections of the wood around so the planks look like they are cut from different boards. Turn on the grid, select the first and third columns of wood. Use the Free Transform Tool (Ctrl+T) and right-click and flip this selection vertically and horizontally. You can select and flip or rotate the boards more later as well.

6. Add seams just as you did for the wooden planks by creating a new layer named **seams** and drawing lines down the gridlines. This time use a 3-pixel brush and change the following settings in the Bevel and Emboss layer style:
 Style – Outer Bevel
 Depth – 97%
 Size – 1 px
 Highlight Mode – Vivid Light
 Opacity – 75%
 Shadow Mode – Overlay
 Opacity – 75%

7. The wood needs to be colorized as well to match the crates. Set your foreground color to RGB 167,140,82. Use the

Figure 6-22
Some quick adjustments, and our wood planks are ready for the office structure. Here they are on the office structure.

Figure 6-23
Wood grain made in minutes
with Liquify and the Bloat
Tools.

Hue/Saturation tool and Ctrl+U and move the saturation up to 37 and the brightness to 17.

8. Now we can make the frame. Set the grid to 64.

9. Use the Polygonal Lasso Tool and make a selection like the one in Figure 6-24. These sections are simply copied and pasted into their own layer and can be copied from any section of the wood grain. A vertical selection tends to work best.

10. Make four different sections and arrange them like a picture frame by flipping or rotating them.

11. Make sure that the frame layer is above the seams layer. Turn the background wood layer off so that you can see the four pieces. If there are small gaps, it's okay. Link the four layers and merge them together.

12. Zoom in with the grid on and use a 1-pixel brush to erase a small gap between the corners of the image and the inner corner where the boards meet. Remember that you can click once in the corner to start a line and hold Shift and click where you want the line to end. This will give a quick and perfectly straight line.

13. Add the layer style Outer Glow with the following settings:
Blend Mode – Normal
Opacity – 40%
Size – 35

14. Add the layer style Bevel and Emboss with the following settings:

Style – Inner Bevel
Technique – Chisel Soft
Depth – 90%
Size – 1 px

At this point your image should look like Figure 6-25.

You can add a lot of detail to crates in addition to variations of the wood (Figure 6-26). You can weather them and add decals and even a stencil, like in the concept sketch. The stenciled letters FRAGILE across some of the boxes are simply a text layer. Add a text layer, size and position it using the Free Transform tool, rasterize it (right-click), and add a little noise. Set your background color to black and run the Spatter filter. Zoom in and select the black splotches on the edge of the letters (then right-click and select Similar) and delete them. Set the Blending Mode to Color Burn and take the opacity down a bit. Now they look painted on.

These crate textures are the one texture in this scene that would benefit the most from the use of a reference photo of real wood either to build the texture with or use as an overlay. Here are the version of the crates I did using a real wood photo. The steps are the same as this exercise, only you don't spend your time making

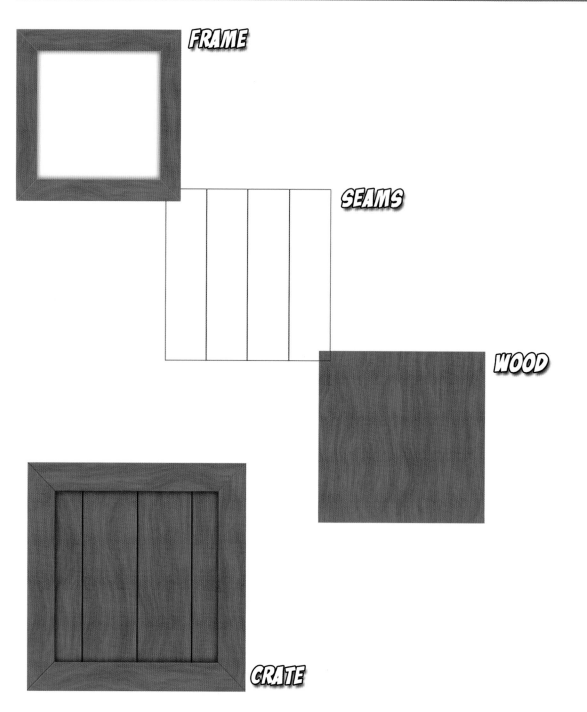

Figure 6-25
The crate base is a starting place for many variations.

Figure 6-26
These crate variations were made quickly from the base.

Figure 6-27
Sometimes there's nothing like the real thing. Wood-based textures like these crate textures often benefit the most from the use of a reference photo, either to build the texture with or to use as an overlay.

the wood grain; you spend your time cleaning and preparing the wood grain (using the techniques from Chapter 4).

Concrete

Concrete can be as simple as gray noise, but using a few tricks to make the concrete look splotchy and worn is worth the few extra

Figure 6-28
A basic concrete with subtle stains.

minutes they take. The concrete in our scene is simple, but I will take you a bit farther here so you are better able to create concrete for various uses. Subtle stains and weathering can be applied to the base concrete, but stronger details have to be added to a copy of the texture or created with an alpha channel so they can be projected.

Basic Concrete

1. Start with a new image – 1024×1024. Name it **Concrete_Base_001**.
2. Create a new layer and name it **Base**.
3. Foreground color RGB 140,140,140. Fill the layer.
4. Filter > Noise > Add Noise 3%.
5. Filter > Blur > Gaussian Blur 0.5 pixels.
6. Filter > Brush Strokes > Spatter – Spray Radius 15, Smoothness 8. Now we have a very basic and clean cement. The next step is to add subtle and varied stains.
7. Create a new layer and name it **Grime 1**.
8. Filter > Render > Clouds.
9. Brightness/Contrast – Brightness +10, Contrast +60.
10. Change the layer Blending Mode to Multiply and take the opacity down to 15%. Now you should have subtle dark stains on your concrete. Your image should look like Figure 6-28.

Figure 6-29
A rougher concrete made
from the base.

Rougher Concrete

To make the concrete a bit rougher, you can add some small pits, as
if the concrete was laid rough or just worn out.

1. Create a new layer and name it **Pits**.
2. Fill this new layer with black.
3. Filter > Noise > Add Noise 20%.
4. Filter > Artistic > Cutout – Number of Levels 8, Edge Simplicity 4,
 Edge Fidelity 3.
5. Take the contrast up +80 and the little clumps will pop out.
6. Select the black portion of the layer with the Magic Wand and
 delete it.
7. Change the Blending Mode to Multiply and the Fill to 0%.
8. Add the layer effect Bevel and Emboss and change the following
 settings:
 Depth – 1%
 Direction – Down
 Size – 1 px
 Soften – 2 px
 Highlight Mode Opacity – 36%
 Shadow Mode Opacity – 36%

Figure 6-30
Concrete with rust stains.

Stained Concrete

Not all stains are dark. Using orange as a base color, you can make rust stains similar to the way you make grime using black.

1. Create a new layer and name it **Rust Stains**.
2. Make your foreground color orange RGB 167,98,10 and your background color white.
3. Filter > Render > Clouds.
4. You may want to run the Difference Clouds filter to get more variation in the pattern, but if you do, run it twice, so the colors return to orange and white.
5. Take the opacity down to 10%. You can play with the brightness and contrast to get stronger or weaker rust stains.

Grooved Concrete

Another effect you can add is the subtle grooves that concrete retains from when it was smoothed out after it was poured.

1. Create a new layer and name it **Grooves**.
2. Render black and white clouds on the layer and lower the contrast, −70.
3. Add some noise: 9%.

Figure 6-31
Concrete with grooves in it from where it was smoothed after laying.

4. Filter > Texture > Grain – Intensity 50, Contrast 50, Grain Type Horizontal.
5. Lower the opacity of the layer to 10%.

Sectioned Concrete

Sometimes concrete floors are poured in sections with a seam or wooden divider between the sections. For seams, you can simply apply a Bevel Emboss filter to the base layer of concrete and you will get a neat seam around the concrete square. To make a wooden frame, do the following:

1. Create a new layer and call it **Frame**.
2. Fill the layer with a dark brown.
3. Use the grid set at 16 units and 1 subdivision and select all of the image except for a 16-pixel-wide strip on all four sides. Delete the selected color in the middle.
4. Add a small amount of noise to the frame.
5. Set the background color to black and run the Spatter filter.
6. Fade the filter by 50%.
7. Apply the Outer Glow layer style and make it black. This should be a faint outer glow.
8. Apply the Bevel and Emboss layer style and make the depth and size very small.

Figure 6-32
When putting a frame around the concrete, we split it in half so that we see half a frame where the texture hits a wall. It just looks neater.

9. Merge everything. Duplicate the layer and use the Free Transform Tool to make the image 8 pixels larger on all sides.
10. Crop the image and flatten it.
11. When you offset this image, the wooden frame should need little to no work on the seams.

By splitting the wood frame in half, we removed the problem of a double frame being on all sides. If we were to only put the frame on two sides, that would work until the texture hit a wall and the frame ended unnaturally. This way, the frame will tile perfectly and we will see half a frame where the texture hits a wall. It just looks neater. See Figure 6-32.

For the most part, creating concrete in Photoshop is a process of experimenting with various filters on clouds and noise and then choosing a blending mode. Building a concrete texture involves several very subtle layers, as concrete is generally covered in a variety of subtle stains and discolorations. Concrete is such a subtle texture that the best way to create concrete is to create a consistent base like we did here and overlay actual imagery of cracks and concrete textures. Figure 6-33 shows a few variations of concrete made from this base.

Details Using an Alpha Channel

You can add details like oils stains (where a vehicle may have been parked), signs, cracks, blast marks, and more either directly on the

texture or by creating an image with an alpha channel to be projected on the texture. The oil stains in this exercise are nothing more than various sized soft black brushes with the opacity set very low. To create the alpha:

1. Create a new layer named **Oil Stains** and paint some oil stains on it using various sized soft, black, round brushes with the opacity set very low.
2. Go to Select > Load Selection > Choose the layer name. In this case it will say "Oil Stain Transparency" and it will make a perfect selection of the oil stains on the layer.
3. Go to the Channels tab and add a new alpha layer. It should appear solid black with the lines of your selection on it.
4. Select the rectangular marquee and right-click in your selection and fill it with white.

Figure 6-33
With one simple concrete base, you can make many variations.

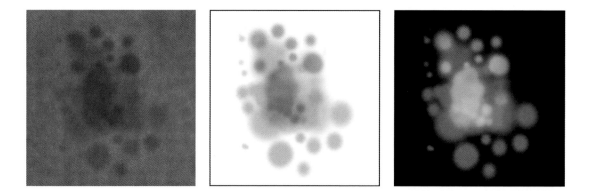

IMAGE

ALPHA

IMAGE OVER TEXTURE

Figure 6-34
Detail that would tile if it were part of a texture can be projected in a few places, so as to add interest. The detail texture can be masked with an alpha channel so that you can achieve subtle effects like these oil stains.

5. You can copy and paste this alpha channel into a separate image if you need to. Figure 6-34 shows you the texture with oil stains, the oil stains alone, and the alpha created for the stains.

We focused on concrete used as a floor here, but concrete is also used on walls. Concrete walls can have paint on them, a layer of dirt at the bottom, trim pieces, and even a wood grain. Concrete walls are poured into a wooden form that is removed when the concrete

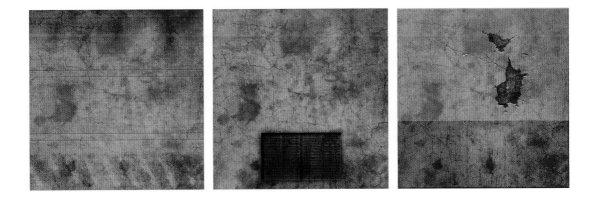

hardens. The concrete often retains the grain of the wood from the form.

Figure 6-35
Concrete wall variations made with one base.

Metal

Metal is similar to concrete with regard to how it is made in Photoshop, but we are of course going for a different look when we are creating metal. In this concept sketch, there are three types of metals, lightly rusted on the beams, a dull galvanized sheet metal on the garage doors, and the metal pipes on the wall. Technically we already made metal when we made the frames of the windows, and the techniques are similar.

Rusted Metal

Creating the rusted metal for the beams.

1. Create a new image 1024×1024 and name it **Metal_Rust_001**.
2. Create a new layer and name it **Base**. Fill the layer with a dark brown RGB 81,65,54.
3. Filter > Noise > Add Noise 40%.
4. Filter > Blur > Motion Blur – Angle 45, Distance 45.
5. Filter > Distort > Ocean Ripple – Size 10, Magnitude 10.

This is a base rust. I used levels to darken it a bit for this scene. I made the image really big so that it can be used in other places. For tiling on the beams, I reduced this image quite a bit. I cropped it so I could make a smaller texture without losing much detail (Figure 6-36).

Garage Door Metal

The garage door metal is very similar to the wood paneling in that there is the same type of seam running across the texture. The metal itself is a grayish mottled pattern.

Figure 6-36
Our base rusted metal.

1. Create a new image 512×512 and name it
 Metal_GarageDoor_001.
2. Create a new layer and name it **Base**.
3. Fill this layer with a medium gray.
4. Set Add Noise 5%.
5. Set Gaussian Blur 2 pixels.
6. Filter > Pixelate > Crystallize > Cell Size 33.
7. Set Add Noise 1%.
8. Create a new layer and name it **Seams**.
9. Set the Fill to 0%.
10. Use a hard, small brush and draw a line horizontally across the
 texture every 64 pixels.
11. Apply the following layer effects:
 Outer Glow
 Structure
 Blending Mode – Normal
 Opacity – 51%
 Noise – 13%
 Color – Pure black
 Elements
 Size – 32
 Bevel and Emboss
 Structure
 Style – Outer Bevel
 Depth – 111%

Direction – Down
Size – 27
Shading
Highlight Mode – Linear Dodge
Opacity – 46%
Shadow Mode – Multiply
Opacity – 68%

12. Make a new layer and name it **Hinge Pins**.
13. Select a dark gray color and use a 5-pixel hard brush to draw lines across the image on the inside of the bends in the metal. Use Shift to get them straight.
14. Apply the following layer effects:
Outer Glow
Structure
Blending Mode – Normal
Opacity – 75%
Noise – 8%
Color – Pure Black
Elements
Size – 10
Bevel and Emboss
Structure
Style – Inner Bevel
Depth – 100%
Direction – Up
Size – 5
Shading
Highlight Mode – Screen
Opacity – 42%
Shadow Mode – Multiply
Opacity – 75%
15. Copy the layers and flatten the image.
16. Offset the image by 256×256.
17. Check your tiling and clean up the seams (Figure 6-37).

Pipes

The pipes on the walls are made from one simple texture. In this context, we need to add the highlight, but in other cases, a shader is used.

1. Copy a vertical strip off the base metal of the garage door. Make this strip 128 wide and 512 high.
2. Paste it into a new file. Ctrl+N will create a new image the size of the image you copied. Name it **Metal_Pipes_001**.
3. Lighten the image a bit using levels.
4. Blur > Motion Blur – Angle 0, Distance 22.
5. Use the Dodge Tool and a soft 65-pixel brush and lighten the vertical center of the pipe (Figure 6-38).

If you want dirty pipes, you can go back and grab a copy of your rust texture and slap it on. Play with the opacity and blending modes.

Figure 6-37
Garage door metal with
hinge pins.

Figure 6-38
Pipe metal made from part of
the garage door metal and a
version with rust on it.

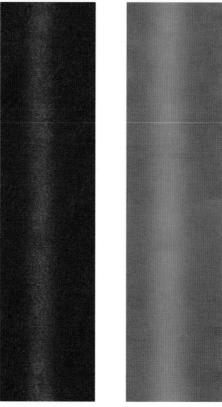

Like virtually every other surface, metal has a wide variety of appearances depending on the type of metal, the way in which the metal is used, and the environment it is in. Our window frames had a spattering of light dry rust on them, and the beams are evenly covered in a heavier rust. In other contexts, metal may have paint chipping and wearing off it or it may be shiny and new. The list is endless and we will tackle some of those other metal types and conditions in coming chapters.

Figure 6-39
Now that you have built the base materials of the scene you can start looking for the details that you will need to create using the base texture, or as a new image entirely.

Breaking out the Details

Now that you have built the base materials of the scene, you can start looking for the details you will need to create using the base texture or as a new image entirely. Look at the concept sketch again and let's start to identify the details. The numbers and the stenciled sign are the easiest; the small hanging sign requires a few more steps. The door is fairly complex and involves several steps. We will tackle that last.

Numbers

You will quickly learn that making signs, banners, and the like are easy with fonts, filters, and some patience. The numbers above the

two garage doors are nothing more than a font that is either laid onto a copy of the base brick texture or an image with alpha channeling. Because the alpha version of this is more challenging, we will take that approach.

1. Create a new image and name it **Detail_Number1_001.**
2. Fill the background with black.
3. Snap one guide at the horizontal center of the background and one at the vertical center.
4. Use the Text Tool and put a number 1 down; the Arial Black font seems to match the closest.
5. Use the Free Transform Tool and make the font fill most of the image. Keep it centered and proportional.
6. Right-click on the test layer and rasterize it.
7. Make sure your background color is black and run Filter > Brush Strokes > Spatter – Spray Radius 16, Smoothness – 8.
8. Use the Magic Wand Tool to select a black splotch on the edge and then right-click and choose Similar. Press the Delete key to remove the black parts of the number. You may want to turn the background layer off so you can see.
9. Noise > Add Noise – 9%.
10. Take the opacity of this layer down to 60%.
11. Blur > Gaussian Blur 0.5 pixels. If you want to see how the number will look in context, you can drop a copy of the brick texture on a layer behind the number.
12. To create the alpha for this, you do it just like we did the oil stains earlier. Go to Select > Load Selection > Choose the layer name. In this case it will say, "1 Transparency."
13. Go to the Channels tab and add a new alpha layer. It should appear solid black with the lines of your selection on it.
14. Select the rectangular marquee and right-click in your selection and fill it with white.
15. You can copy and paste this alpha channel into a separate image if you need to. Figure 6-40 shows you the texture with the number, the number alone, and the alpha created for the number.

Stencil Sign

The stenciled sign (Figure 6-41) is done in the exact same way as the numbers—just make the image size larger. In this case I made it 1024×256. I also took the opacity down further to 40%.

Small Sign

Between the garage doors is a small caution sign. Signs are easy to make and weather.

1. Start with an image that is 512×512 and name it **Signs_Caution_001.**
2. Create a new layer and name it **Base**.
3. Fill this layer with a safety sign yellow RGB 164,145,87.

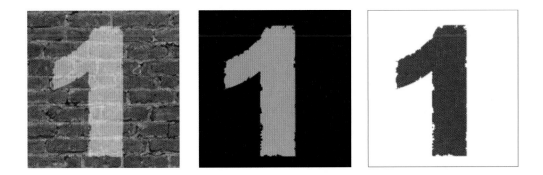

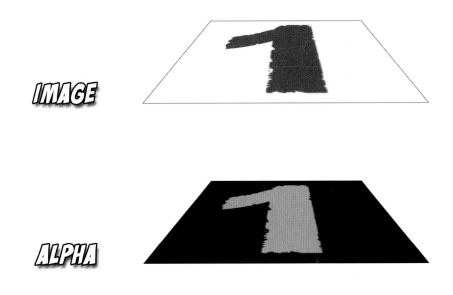

IMAGE

ALPHA

IMAGE OVER TEXTURE

Figure 6-40
Painted on numbers and signs are easy with fonts, filters, and patience. This number is using an alpha channel. **Left** is the number projected on a wall, **middle** is the number image, and **right** is the alpha channel for the number.

Figure 6-41
The stencil sign is done the same way as the numbers. **Top** is the sign projected on the garage door, **middle** is the image, and the alpha is at the **bottom.**

4. Add Noise 3.5%.
5. Blur > Gaussian Blur – 2 pixels.
6. The sign is not the same proportions as the square image that we have to work with (power of two), so we need to use the rectangular marquee to trim it down to the general size of the sign. In actual development we would find some other texture to fill in that dead space, because this doesn't need to tile, but for now we will leave it blank.
7. Now drag out a vertical and horizontal line to the center of the sign, *not* the image.
8. To make the red border, create a new layer and name it **Red Border.**
9. Set the foreground color to a dark red RGB 160,35,38.
10. Drag out the rectangular marquee on the red border layer until it is about the right size. Use the guidelines to center it vertically and horizontally.
11. Select the Rectangular Marquee Tool and right-click in the selection. Choose Stroke > Inside 16 pixels.
12. Create two text layers. One says "safety" and one says "zone"; the font is Arial Black and the color black.
13. The hard hat on the sign in the concept art is the one thing that if you can't draw it, you can replace by using the Custom Shape

Figure 6-42
Once you set up a template for a sign, you can crank out a wide assortment of variations quickly.

Figure 6-43
This banner was as easy to make as the little sign, and the folds in the cloth were just an extra simple step.

Tool or the Type Tool and the Wingdings font. Add a lightning bolt, exclamation point, a hand, and so on.

14. Figure 6-42 shows variations of the sign. Just a filter or two and it takes on a drastically different appearance.

Sign

The big banner over the garage doors is created the same way as the small sign. Start with an image that is 1024×256. Create a base layer. Fill this layer with a very light gray, add a small amount of noise, and Gaussian Blur it slightly. You can use the same settings as you did for the small sign. You make the red border the same way as well as the letters. There is even a Registration symbol under the Custom Shape Tool palette. You may have to load all your shapes to find it. I used the rectangular marquee on a new layer to make the box shape and used the eraser to make the lines on the box. The sign ends up being very bright and clean. I took the contrast, saturation, and brightness down and added a little more noise.

The last thing you can do that would add a lot to this banner would be to draw some folds on it. This is easier than it sounds. Select the Burn Tool and a large, soft brush. Drag out a few long lines that darken the banner where a fold shadow may be. Just drag from one of the upper corners diagonally to the center. Use the Dodge Tool and do the same, only do this on top of the darker parts (light and shadow). The effect is great-looking and easy to do. I did a few more areas and even zoomed in and made some tight folds at the corners of the banner (see Figure 6-43).

Door

The last detail we have to create is the office door. This is not hard, but it does have many steps.

1. Create a new image 512 wide by 1024 high. Name it **Door_Office_001**.
2. Create a new layer and name it **Material**.
3. Fill this layer with a light blue/gray RGB 155,158,164.
4. Filter > Noise > Add Noise 3%.
5. Filter > Blur > Gaussian Blur 0.5 pixels.
6. Set your grid to 64 with 1 subdivision and turn it on.
7. Duplicate the Material layer and name it **Frame**.
8. Use the rectangular marquee and select the space where the door will fit into the frame. This should be a 64-pixel frame on the top, right, and left with the bottom cut out.
9. Make sure the Material layer is turned off.
10. Press Delete on the Frame layer and you will see your doorframe.
11. Layer Style for frame: I am having you apply effects you won't see until after the door is more complete so you won't see much change as you enter the parameters. Apply the following layer styles:
Drop Shadow
Structure
Blending Mode – Multiply
Opacity – 24%
Distance – 5 px
Size – 7
Outer Glow
Structure
Blending Mode – Multiply
Opacity – 21%
Color – Pure Black
Elements
Technique – Softer
Size – 10
Bevel and Emboss
Structure
Size – 4
Shadow Mode Opacity – 50%
12. Make sure your background color is black and the Material layer is off.
13. On the Frame layer: Filter > Brush Strokes > Spatter – Spray Radius 12, Smoothness 8.
14. Fade this (Ctrl+F) to 25%.
15. Duplicate this layer and name it **Inner Frame**.
16. Turn on your grid and set the subdivisions to 6. Keep the grid at 64.
17. Use the rectangular marquee and select a 1-unit border around the inside of your frame.
18. On the Frame layer, press Delete.
19. Activate the Inner Frame layer and right-click to invert the selection. Press Delete.
20. Run the Spatter filter on the Frame layer again. If it was the last filter you used you can hit (Ctrl+F) to run it again with the same settings. I used the Burn Tool with a 5-pixel soft brush to put a subtle frame line at the top of the door. Your image should now look like Figure 6-44.

Figure 6-44
Your frame and inner frame
should look like this.

21. Now we will make the door itself. Select the empty space on the inside of the Inner Frame.
22. Duplicate the Material layer and name it **Door**.
23. Invert the selection and delete the portion of the door behind the frame.
24. Copy and Paste the layer style from the Frame layer. You need only to change the Bevel and Emboss style to Emboss.
25. Turn your 64 grid on and change the subdivisions to 3.
26. Look at Figure 6-45 for visual reference. Use the rectangular marquee and select the upper window and the three panel spaces in the door. Aside from good proportions, keeping the width of all the frames in the door the same is important. The bottom panel of the door can be a bit larger, like a real door. I made the thickness two units all the way around. Make sure that your panel spaces are the same size, too. I made the window 18 units high and each panel 5. Press Delete.
27. Run the Spatter Filter again and fade it to 25%.

Figure 6-45
Cutting out the window and
panels is easy, but pay
attention to the grid and the
placement of the elements.

28. You can use the Burn Tool with a very small, soft brush to put
 the seams on the door where the boards meet but were painted
 over.
29. Select the Magic Wand Tool and select one of the three empty
 panel spots in the door. Hold Shift and select the other two.
 Duplicate the Material layer and name it **Panels**. Paste the layer
 style and make the following changes:
 Outer Glow
 Turn it off.
 Inner Glow
 Opacity – 25%
 Noise – 12%
 Size – 38 px
 Bevel and Emboss
 Technique – Chisel Hard
 Direction – Down
 Size – 6 px
 Highlight Mode – Screen
 Opacity – 47%
 Shadow Mode – Multiply
 Opacity – 18%

30. Run the Spatter filter again (Ctrl+F) and fade it to 25% (Ctrl+Shift+F).
31. Select the empty place for the window and create a new layer and name it **Window**.
32. Fill the selection with black.
33. Filter > Noise > Add Noise 50%.
34. Filter > Artistic > Sponge – Brush Size 5, Definition 10, Smoothness 8. I took the brightness up 50 and the contrast down 10.
35. Add the following layer styles:
 Inner Shadow
 Blend – Multiply
 Opacity – 75%
 Distance – 2
 Size – 2
 Inner Glow
 Blend Mode – Screen
 Opacity – 38%
 Noise – 22%
 Color – RGB 194,212,235
 Size – 59 px
 Gradient Overlay
 Blend Mode – Lighten
 Opacity – 18%

Your image should now look like Figure 6-46.

Now we will add the details to the door like the knob, lock, and weather stripping at the bottom.

1. Create a new layer and name it **Knob_Plate_Lock**. Use the rectangular marquee and eyeball the knob plate. See Figure 6-47 for where I put it.
2. Fill the selection with a light brown RGB 74,67,62.
3. To create the lock above this plate, snap a vertical guideline to the center of the selection. Use the Circular Marquee and hold Shift to keep the circle perfect. Make the circle approximately the same width as the door plate, and then snap it to the guideline and place it above the plate roughly centered where the three boards of the door meet.
4. Fill the selection with light brown RGB 74,67,62.
5. Deselect all.
6. Filter > Noise > Add Noise 2%.
7. Filter > Artistic > Palette Knife – default settings.
8. Copy and paste the layer style from the Inner Frame layer and change the size in the Bevel and Emboss style to 3.
9. Key slot: Use a soft 5-pixel brush and the burn tool to paint a small black line through the lock plate to look like a key slot.
10. Copy the layer, merge it with an empty layer, and use Motion Blur to blur the layer vertically.
11. Make sure this new blurred layer is under the Knob_Plate_Lock. Move it down 10 pixels and changed the blending mode to Overlay and the opacity to 50%.
12. Use the Smudge brush to smear the pixels down so it looks like rust stains.

WHERE THE BOARDS MEET BUT WERE PAINTED OVER

THE DOOR SO FAR

PANELS WINDOW

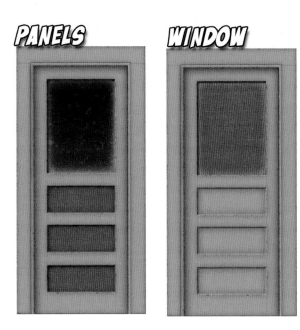

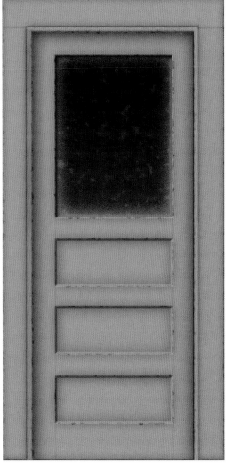

Figure 6-46
Your door with the window in it should look like this.

13. Create a new layer on top of the Knob_Plate_Lock layer and name it **Knob**.
14. Use the Circular Marquee and the same guideline that you used to create the lock and place a selection for the knob. Make the selection the same width as the plate, maybe even a pixel or two larger.
15. Fill that selection with a brassy color RGB 107,92,57.
16. Paste the layer style from the Knob_Plate_Lock layer and change the following settings (see Figure 6-48):
 Bevel and Emboss
 Depth – 101%
 Size – 6 px
 Soften – 3 px
 Highlight Mode – Linear Dodge
 Opacity – 53%

The weather stripping at the bottom of the door starts with a rectangular piece of the Material layer about 22 pixels high and the width of the door, maybe slightly smaller.

1. Create a new layer and name it **Weather_Stripping**. Make sure that it is under the inner and outer frames, but on top of the door layer.

LOCK AND PLATE

KNOB

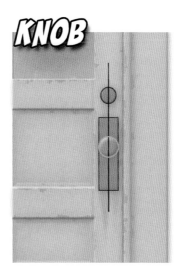

2. Paste the strip of material at the bottom of the door and centered. Nudge it up 3 or 4 pixels.
3. Brighten this strip. Ctrl+U: +20 Brightness.
4. Filter > Noise > Add Noise 2%.
5. Use the Burn Tool and a 13-pixel soft brush to darken the bottom half of this.
6. Use the Burn Tool and a 9-pixel soft brush to further darken the very bottom of the strip.
7. Use the Burn Tool and a 5-pixel soft brush to make a dark line roughly in the middle, leaving a gap between the darkened bottom.
8. Use the Dodge Tool and a 9-pixel soft brush to lighten the gap between the darkened bottom and the line you just made. Also, lighten the very few top pixels of the strip.
9. Add a drop shadow with the default settings and a slight outer glow. You will have to change the mode to Multiply, the opacity to 35%, and the size to 8.

Figure 6-48
The stages of the knob and plate.

10. Finally, I used the 5-pixel hard brush and a medium/dark gray and placed those five dots that look like nails holding the strip on when the texture is reduced and placed in a game. Even though most weather stripping has guide holes, I purposely eyeballed the placement of the nails and staggered them so it would look like someone hammered that on real quick.

All we have left to do is beat this door up some more. We can make it look weathered, dirty, and chipped.

1. Create a new layer on top of everything else and name it **Weathering**.
2. Fill this layer with black.
3. Filter > Render > Fibers > defaults.
4. Filter > Artistic > Colored Pencil > defaults.
5. Set the layer mode to Overlay and play with the Opacity; I like 15%.
6. You can leave it this way, or clean off the window, as glass and wood would weather differently. Go to the Door layer and select the window hole with the magic wand and go back to the weathering layer and delete it.
7. Create a new layer and name it **Chips**.
8. Use the Gradient Tool with black as the foreground. Use the Foreground to Transparent preset. Drag the gradient up from the bottom a little over half the way. Hold Shift!
9. Filter > Noise > Jack it all the way up!
10. Filter > Artistic > Paint Daubs – Brush Size 5, Sharpness 22, Brush Type Dark Rough.
11. Change the Layer Blending Mode to Multiply and the opacity to 27%.
12. Create a new layer and name it **Dirt**. This will be just a general darkening of the areas people come into contact with on the door the most.
13. Change the Layer Blending Mode to Soft Light and the opacity to 35%.
14. Use a big, soft black brush (100 pixels) and hit the areas around the knob and near the bottom, especially by the inner part of the door where it opens.

Sometimes when I am all done with a texture, after I flattened the file, I like to run a filter over the whole thing (usually Dry Brush) and then fade it way down. This can give a texture a more cohesive feeling. The final door is shown in Figure 6-49.

Congratulations! You made all the textures for the urban environment. Here they all are in the warehouse scene (Figure 6-50). You may notice things I didn't address in the scene like the pipes for the rollup door, the switch, and the yellow stripes and pylons by the door. I left these out, because to create them would be redundant. The pipe texture we made. The yellow stripes and pylons are based on the same techniques you learned in the sci-fi chapter creating caution stripes, and the button and switch are created in the same manner as the detail textures from Chapter 5.

Figure 6-49
Final door.

Building It up Using Overlays

In Figure 6-51, you can see a variation made with some overlays and a lowering of light. The cement looks moldy because I took the rough cement from Figure 6-29 and added a layer above it. I set the Blending Mode to overlay and the opacity to 30%. I then rendered clouds on this layer with black as my background color and a very dark and desaturated green as my foreground color. I used the same technique on the other textures. On the walls, I used black and gray for the clouds. The windows use a variation we created earlier in this chapter. I took the glow and light shafts out and replaced it with an illumination map that makes the windows look incredibly dirty with the sunlight barely penetrating.

Tearing It Down for Shaders

The shaders used in this final scene are simple and addressed elsewhere at great length. This chapter specifically dealt with low polygons, low texture budget, and older technology, and shaders are not a big part of that workflow. If you are interested in the windows, refer to the illumination map we looked at earlier in this chapter and the light beams we look at in Chapter 8. The bloom or glow shader effect is described in Chapter 3.

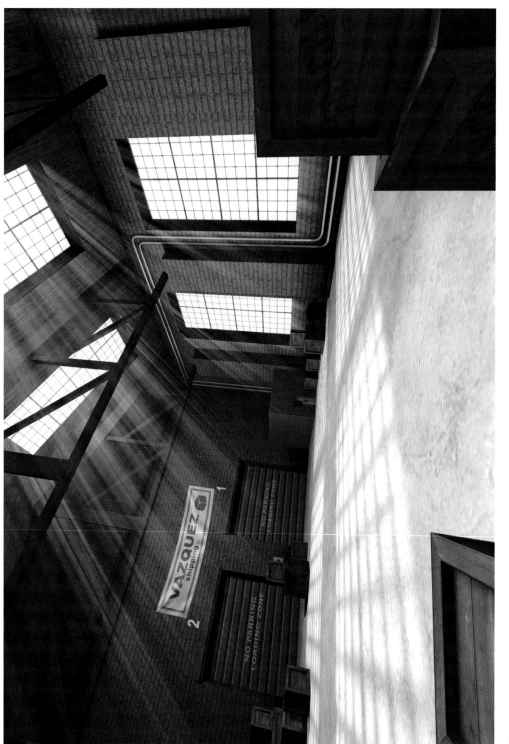

Figure 6-50

Here is the final scene. You may notice the shafts of light streaming from the windows and the shadows of the window frames on the ground. The light shafts are super easy and we will make those in Chapter 8. The frame shadows are simply the alpha channel of the windows projected onto the floor.

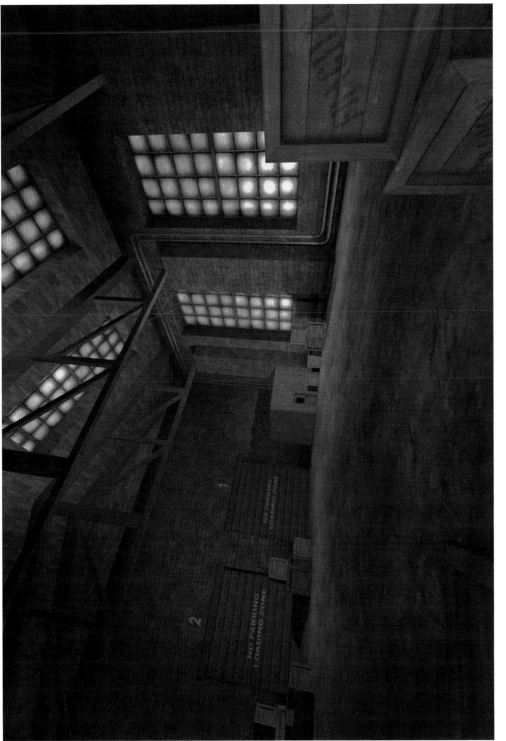

Figure 6-51
Here is a variation of the final scene using overlays and lowering the light levels. I also took the light shafts out of the scene.

Chapter Exercises

1. Practice breaking the materials and details out of a scene. Take 10 or 20 minutes to do this and compare notes with other people in class. Can you identify the base materials that tile and the details?
2. Create your own bricks. Change the pattern, color, and mortar style. Create a set of tiling textures for your bricks that include the top and bottom of the wall.
3. Create a window texture set that includes either an illumination map or alpha map. Make your own frame design.
4. Create textures for a set of crates that have a few variations of stenciling and labels—these can be WWII-style, modern-day, or whatever you want. Use images from a Google search for labels and art and you can get some overlay images as well. Make the wood look stained and worn using images from the Internet.
5. Create a base concrete and a set of overlays for dirt, mold, and fine cracks. Create a set of alpha-channeled details for the floor such as strewn trash, leaves, coins, stains, or whatever you like.
6. Create your own set of signs.
7. Create a door that has variations on color and weathering (stains, dirt, and so on); you can use the overlays that you created for the floor as a base.
8. **Advanced:** Create a door in the same way we created a door here, only use concrete for the sills. How would you alter the size, shape, and proportions of things to make the door look believable? Use the metal we created for heavy hinges and latches. Try creating a sign that would make this door look even more formidable and ominous.

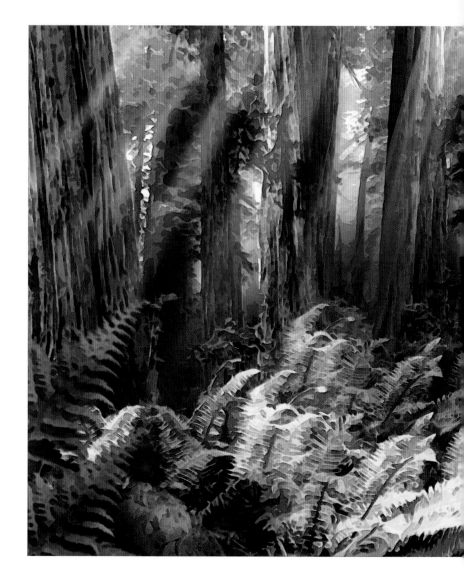

Chapter 7

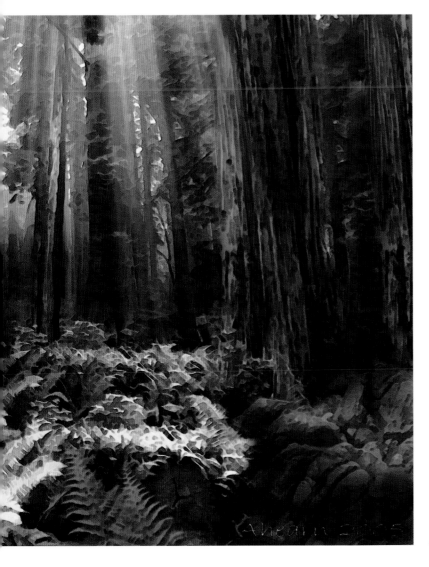

Forest Concept 2005 by Luke Ahearn

The Outdoor Setting

Introduction

In this chapter, we will create a set of textures for a forest that can be altered to look spooky, friendly, or fanciful. Using the basic approach presented here, you can also create a similar simple set of textures for any outdoor environment: jungle, desert, and so on. I will also introduce the use of photo sources in texture creation. I mentioned in the very beginning of the book that the use of a photo source to create textures is not only common, but also preferred. It makes your job faster and easier and gives your textures an extra layer of richness that can take a lot of time to achieve otherwise. I find that using overlays when creating assets for the outdoor environment is particularly useful. The surface of a rock, the bark on a tree, and the veins in a leaf are all challenging to create for most, whether by hand or in Photoshop—or time-consuming at the very least. Using an overlay of a real leaf over a solid leaf shape will create a better texture more quickly than either hand-creating the leaf or trying to manipulate a digital image into a workable asset.

With overlays, you still use the same work flow as in all of the previous chapters. Although working with overlays may take the most time and tweaking, they are generally added later in the creation process, after a good foundation is laid. Using digital imagery will greatly enhance and speed up your work, but you don't want it to be a crutch that you must always lean on. Using a photo source should be looked on primarily as the icing on the cake, not the whole meal.

Texturing a large, foliated outdoor environment can be challenging, but once you break it down to its basic elements, a game environment can be fairly easy to create. The distinction here is that we are building a game environment, not a real environment. A real outdoor environment has many species of trees and plants, all with specific details. All we have to do is make this space look good and believable. In order to do this, we need to understand what should be in a certain environment, and for the game artist the focus is mainly on color and shape. We do need to have some degree of accuracy, which we can obtain from pictures, but ultimately the environment we will create will not stand up to the scrutiny of a botanist.

The Concept Sketch

Creating assets for the outdoor setting can be fun, because it can actually be simpler than creating assets for most other types of game settings and net more impressive results. We are just now beginning to experience truly impressive outdoor environments in games, due to technological advancement. Remember when 3D games were set in confined spaces such as hallways? As computers become more powerful, things will keep opening up and we will continue to see more of the outdoors. Already we are seeing impressive outdoor spaces being built for games, with expansive

terrain and high-poly-count models, and things are only going to get better.

These large, impressive, and elaborate environments can be challenging to create in many ways, but they are also actually easier to create compared to just a few years ago. Partly this is due to the fact that most outdoor environments consist of similar elements (grass, dirt, leaves, bark, and stone), and a good set of assets can go a long way if they are used correctly with newer technology. A relatively small set of textures can be mapped to an equally small set of meshes and then the models placed, rotated, scaled, and arranged to produce an enormous amount of variety. This technology alone gives us the ability to create a more convincing forest or jungle. But the major reason that creating outdoor environments is now easier is that the tools are more powerful, more refined, and more user-friendly. Some game engines allow for the combining of multiple layers of textures on terrain in a manner similar to how Photoshop handles layers. This approach allows the terrain textures to be composed predominantly of one material, and therefore makes them easier to tile. Add to this the fact that we are also able to use much larger textures and you can get some really great-looking outdoor environments.

It used to be that the terrain mesh was tiled with one (smaller) texture and if you wanted something like a road or dirt patch, you had to create various versions of that one texture to place on specific polygons on the terrain where you wanted the road to run or the dirt patch to appear. This was limiting to say the least; roads ran in straight lines and right angles and you had to create a separate texture for any unique terrain detail. Now we can create a few large textures of a specific terrain material (packed dirt, grassy dirt, dried dirt, grass, dead grass) and paint them onto the terrain. You can lay down a base layer of grass on your terrain and paint on darker grass patches, add an organic winding dirt road—you can create any type of terrain you can imagine. Painting and erasing layers on terrain is easy and the results are superior than any previous technique.

The front plate shows a pretty typical forest with towering trees and ferns. In addition to the obvious tree bark and ferns, we also need to create assets for the rocks, branches, the ground, and the end of the log in the lower righthand corner. You can even see the sky, so we will need to create that, too, and that involves a bit more planning and a different technique than typical texture mapping.

I did a few quick color studies of this environment. The goal with the initial concept was to create a neutral location—just a plain forest. These variations are intended to explore the potential of the environment using various color schemes. I would use one of these color studies as a guide when texturing and lighting a scene to recreate the feel of the study. In addition to spooky/dark/desaturated and happy/bright/colorful, I created a bleak, dreary place that is more emotionally disturbing than scary. Altering the concept art was easier than altering all the textures and loading

them into a game editor or 3D application to see the results (Figure 7-1).

Breaking out the Materials in the Scene

This set will contain the following:

- Forest floor
- Tree bark
- Tree branches
- End of log
- Rock
- Ferns

Forest Floor

This concept art is a visual guide for the look and feel the environment should have, but it isn't a game-specific piece of art. Sometimes, as a specific location of a world is being designed, you will start creating assets for it and will have information based only on a piece of art that is a representation of the look and feel of the game. We need to anticipate and create the assets most likely needed for a game world based on a look-and-feel piece. So, although you can't see it, the ground needs to be created, because it is pretty likely that in a game the player will see the ground.

In a dense forest like this, the ground tends to be covered with a dark, moist, matted blanket of rotting vegetation. For this texture, I started with an image of the ground after rain. I added an image of some dead grass on top of this. Even though the grass looks dead and dry in the original image, it worked great because of the contrast. When overlaid, it looks as if the grass occasionally grew, but died and matted down with the rest of the forest floor. In addition, I created a texture that I could use as a path through the trees. A path will be worn, packed dirt, but also needs to blend into the scene in terms of color, contrast, and so on. I created a new image and used a third image of some packed dirt with small rocks in it on top of a copy of the forest floor texture. I blurred the forest floor to get the overall color and general feel of the ground (the subtle pattern of the forest floor remains) (see Figure 7-2). I made this image a bit lighter, because it is dirt in the open and would be drier. You also need a little contrast so that the path stands out (see Figure 7-3).

Tree Bark

Tree bark is actually a bit hard to photograph digitally. It is usually in less than ideal lighting conditions, and it is wrapped around a cylindrical shape. This means that even though you can see about half of the trunk facing you, only a small portion of the bark is actually positioned facing you straight on. I used the Fiber filter, stretched the image vertically, used Liquify to make some fine

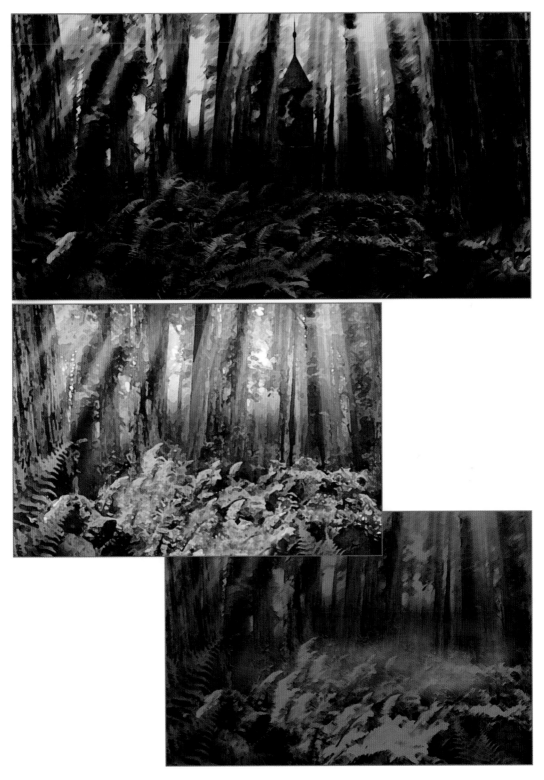

Figure 7-1
A few quick color studies. **Upper image**, a bleak dreary place that is more emotionally disturbing than scary. **Middle**, happy/bright/colorful, and **bottom**, spooky/dark/desaturated.

Figure 7-2
The progression of the forest floor and path texture.

adjustments (like we did with the wood crate in Chapter 6), and colorized the image. See Figures 7-4 and 7-5 for the progression of the tree bark.

Figure 7-3
The beginning of the scene with only the terrain in place.

Tree Branches

For the tree branch, I used a digital photo of a branch with no leaves on it that I was able to capture with only the contrasting blue sky behind it. I used the Extraction Tool (under the Filter menu) and took the background out. I did have to do a little clean-up with the eraser, but not too much, and I colorized the branch. I took another digital image of a close-up of the redwood needles and did the same. I copied and pasted this only a few times. I made an alpha channel by selecting the transparency of the merged branch elements the way we have done previously. See Figures 7-6 and 7-7 for the progression of the branch and the evolving scene.

At this point I started to adjust my color and lighting a bit to more closely match the concept art. I tend to work on the dark side. As you build textures you may find that you have certain pitfalls that you gravitate toward, so be sure to refer to the concept art often to make sure you are on track (Figure 7-8). I also added the tree line backdrop. I used a photo and the same steps as I used to create the branch (Figure 7-9). In order to work, a tree line backdrop must be

Figure 7-4
The progression of the tree bark.

Figure 7-5
The next stage: trees. They are usually added after the branches are on them, but I wanted you to see the stages of the texturing.

Figure 7-6
The progression of the tree branches. **Left**: the original image; **second**: the extracted branch; **third**: the cleaned-up and rotated branch; **far right**: the final branch texture.

where the player can never get to it and usually needs to be desaturated and darkened to emulate the color and luminance that we lose with distance.

Figure 7-7
The evolving scene with the branches added to the trees.

End of Log

To create the end of the log, I used a digital image of—that's right—the end of a log. I enhanced the image with the sketch filter (circles) (see Figure 7-10).

Figure 7-8
The scene with the tree line backdrop added and some color corrections to more closely match the concept art.

Rock

The rock texture was simply a colorized image of some rock. I lowered the contrast and saturation, and I made it tile. Actually, I made it seamless. It technically doesn't tile, because I left the bottom of the texture darker to simulate shadow and moisture, as if the boulders were sitting in the ground a long time. If this texture were tiled across a large surface, you would see the repeating pattern. This texture was made specifically to be wrapped around the boulders (Figure 7-11).

Ferns and the Complete Scene

The ferns were all made from one fern leaf, just like the tree branch (Figure 7-12). I went outside, digitally photographed a fern leaf, extracted it in Photoshop, and created an alpha channel. Figure 7-13 shows the final scene with the ferns in place.

Additional Information: The Sky

A good sky adds a lot to the feeling of depth and atmosphere in a virtual world, even if only glimpsed through trees in a scene like this one, but it's *almost* not worth having one at all if it is poorly

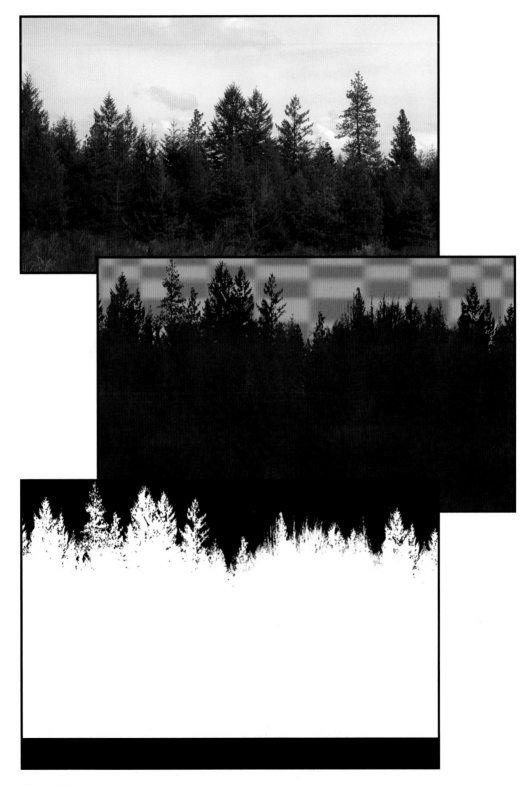

Figure 7-9
The tree line backdrop: a photo, the Extract Tool, and a little bit of work with the eraser.

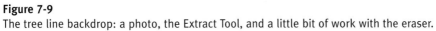

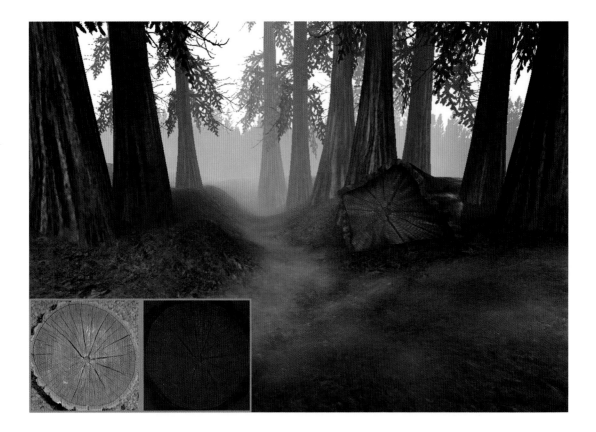

Figure 7-10
The scene with the fallen tree added and the end of log progression inset.

implemented. If there are mistakes in the sky (the player can see seams, for example), the illusion is shattered. Typically, in a game, the sky is handled a few ways:

- Single image
- Sky dome
- Skybox

The single-image technique is used in only a few games (generally older ones) that have a limited view of the world. Most older 3D games and many driving games kept players on a certain path. You were in some form of a 3D world, but your view was restricted to a 2D plane; you could look only left and right, not up and down (you could often walk up and down stairs, but could not tilt the camera to look up at the sky). These games used an equally limited technique for the sky: a single image moved only left to right and up and down as the player moved about the world. I won't step you through this technique, simply because it is rarely used, if at all, in any game of quality. With mobile gaming exploding in popularity, it may well become prevalent again; nevertheless, if you can create one panel of a skybox, then you have the required asset for this technique.

The sky dome technique is simply a fixed model that is part of the game map and is large enough to encase the entire world. This approach is referred to as a sky *dome* because typically a dome

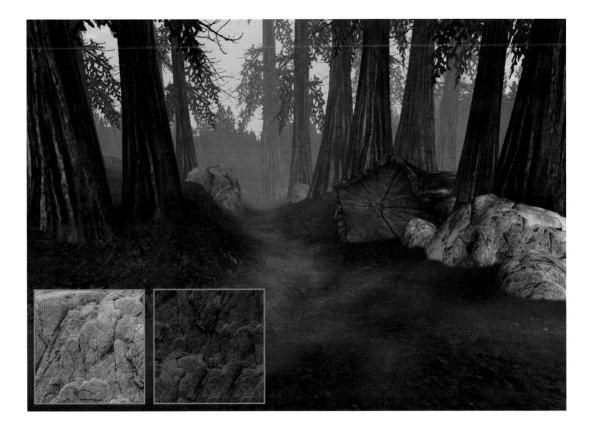

Figure 7-11
The stone texture progression and the scene with boulders in place.

shape looks best using this approach, but you can also use a simple cube (if it works) and save a lot of polygons. Mapping a texture to a dome is easier, whereas a cube requires more tweaking to get things to look right. See Figure 7-14 for an illustration of the sky dome and Figure 7-15 for an example of a skybox with a seam showing. Personally, I don't like this method for several reasons; it's harder to work in the map with the sky in the way, and if I hide the sky dome, the level doesn't look like it will in the game and it's harder to accurately judge the work that I am producing. In the game the dome is also a physical limit, and the player has to be kept away from it. This isn't at all conducive to the larger worlds that we are able/required to create today, especially those worlds on the scale of a present-day/near-future massively multiplayer online (MMO).

The skybox technique is actually a separate area in a map (like a little room) with only the sky elements in it. There is a camera centered in the area that doesn't move but swivels in the same direction the player looks. What this camera sees in the sky box is composited with what the player sees and the result is impressive. I like this method because it is easier to work with, you get better results, and the player can walk forever and never reach it or can view it from an angle where it doesn't look its best. Because the sky moves with the player, you can control precisely how it looks to her. It is easier to get a skybox looking perfect from one angle than

Figure 7-12
The fern texture progression. **Upper left**: the original image; **upper right**: the extracted fern; **lower left**: the cleaned-up fern frond; **lower right**: the final fern texture.

every conceivable angle. See Figure 7-16 for an illustration of how the skybox works.

Additional Information: Terrain

Although it's not texture creation, I wanted to go over a few aspects of outdoor creation that often fall to the artist and do have some overlap or similarities to texture creation. Basic terrain creation and editing are common to most game tools, and there are three general ways to create terrain for games: manually using a 3D application, using tools in a game editor, and using a terrain generator. You usually end up relying on one way and using the others in the course of your work. Because in-game terrain tools are usually tailored to that game/game engine and combine basic terrain-editing features with proprietary features, we will first look at the basics of terrain creation, followed by a brief discussion of terrain-creation software. After you understand the basics of terrain editing, you should be able to quickly pick up almost any terrain in-game editor.

Manual Terrain Creation

Creating terrain manually can be tedious; it's great if you are on a budget or simply don't need an overly large or elaborate piece of terrain. Manual creation involves a few basic operations that can be

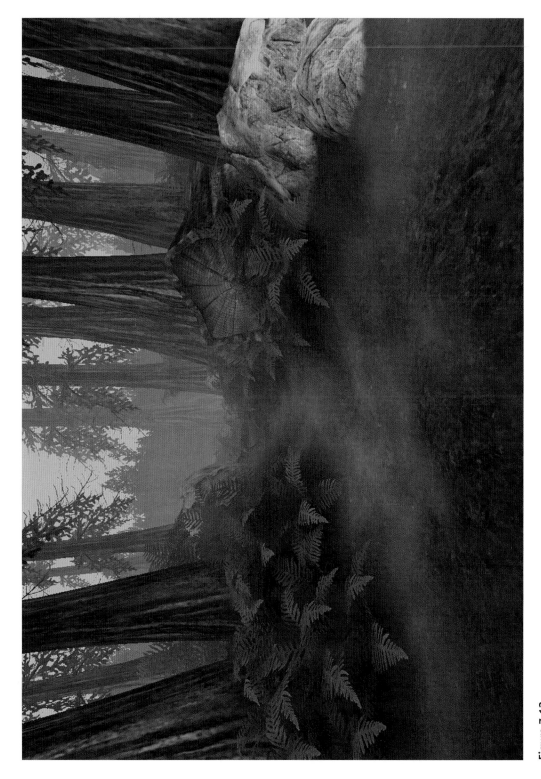

Figure 7-13
The final scene with the ferns in place.

Figure 7-14
The sky dome is a fixed model that is part of the game map and is large enough to encase the entire world. This approach is called a sky "dome" because typically a dome shape looks best with this approach, but you can also use a simple cube (if it works) and save a lot of polygons.

Figure 7-15
The sky dome, using a cube. The seam can often show.

Figure 7-16
Number 1: The camera is in its own location and swivels to look where the player looks, but doesn't move.
Number 2: The view of what the skybox camera sees. **Number 3:** The players' view with no sky. **Number 4:** The sky and players' view composited together.

used alone or in conjunction with each other: forming the terrain mesh using a displacement map, sculpting the mesh by hand, and using application-specific tools to manipulate the mesh. You can also hand-paint the displacement map, but that takes a great deal of time and skill. I believe that you are better off working on the mesh directly. Importing a rough displacement map is useful if you need to build terrain that fits a certain map (Figure 7-17) and work from there.

First, let's look at using a displacement map to distort a mesh. This is a pretty simple concept. Basically, a grayscale map is used to determine the height of any given point on a mesh. This is best understood in illustration—Figure 7-18 shows samples of displacement maps and the effect they would have on a mesh. You can see that the finer the transition is from black to white, the smoother the physical transition on the mesh. What makes hand painting terrain so challenging is that each shift in grayscale is a change in elevation. You can see how the slightest shade difference can cause an ugly artifact in your mesh (Figure 7-19). In this case, the artifacts were caused by extreme image compression.

When you need to hand manipulate terrain in a traditional 3D application such as Max or Maya, there are many tools to help you and each program has different tools sets. Maya has a set of mesh sculpting tools, and Max has features such as soft selection and paint deformation so that you can import a height map (Figure 7-20), manipulate it by hand (Figure 7-21), and apply various modifiers to it as well (Figure 7-22). Modifiers can include noise, ripples, waves, meting, relaxing, and much more. Modifiers tend to affect an entire mesh, but in Max you can use soft selection to apply the modifier to a portion of the mesh and have the effects fade out with the soft selection (Figure 7-23).

Terrain Editing Basics

Like any mesh, terrain is composed of polygons and pixels and has resolution (Figure 7-24). The big difference in this mesh is how the game engine handles it due to its size and intended use. And because it is mesh, you can manipulate the vertices and polygons in much the same way. Note that there is a difference between the resolution of the mesh and the resolution of the height map: both affect the end result of the terrain (Figure 7-25). The mesh is composed of polygons, and the more polygons, the smoother the mesh. The height map is composed of pixels, and the more pixels, the finer the control it has over the mesh. Thus, if one of these is low quality, that will be reflected in the other.

The basic tool for terrain editing is a brush much like the brush in Photoshop. You can determine the overall size of the brush and the hardness of the brush. The softer the brush, the more gradual the slope of the terrain. In Figure 7-26, you can see the effect of various brush settings. This is an important concept to

understand, because so much of terrain manipulation and painting is based on it.

Figure 7-17
Importing a rough height map.

Freeform Terrain Painting

With the brush, you can physically manipulate the terrain to achieve various effects. Most simply, you can raise or lower your terrain, as in the brush example. But there is a lot more that you can do. Keep

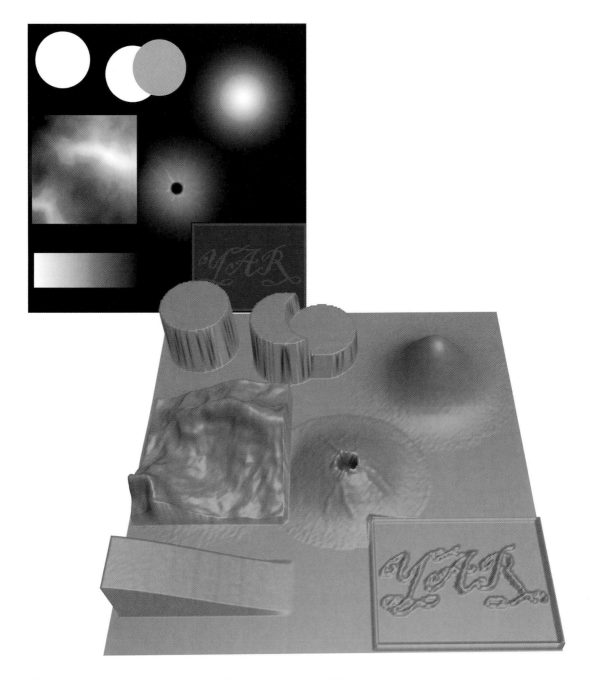

Figure 7-18
Height map.

in mind that we are not talking about textures or any other aspect other than the physical shape of the terrain mesh.

Push/Pull, Lower/Raise

You can set the size and softness of the brush, as well as strength. This allows for the subtle manipulation of the surface or a radical change in the surface (Figure 7-27).

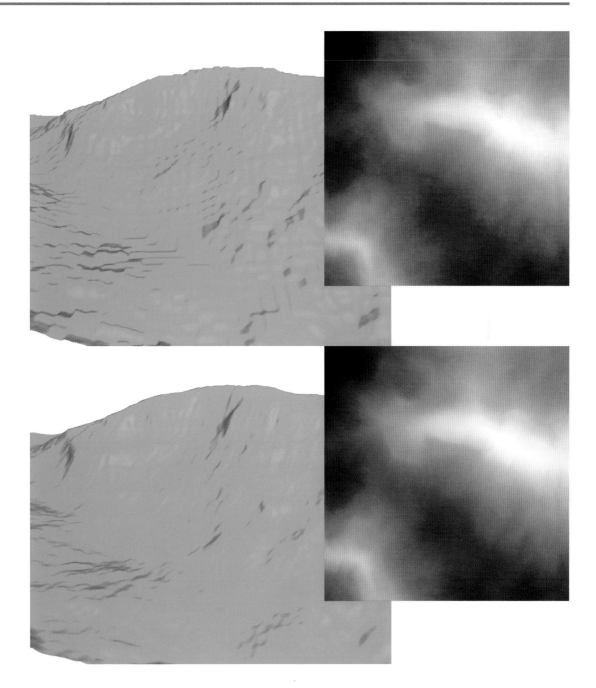

Smoothing/Erosion

Another useful effect is smoothing or erosion. This differs from a simple lowering of the brush in that it smooths the angles between polygons, instead of just lowering them from the center of the brush (Figure 7-28). A good terrain editor will mimic actual erosion, which will look better than a simple smoothing of polygons. The distinction is that the smooth effect occurs mathematically, opening up the angles on the polygons affected, whereas actual

Figure 7-19
Mesh artifact.

Figure 7-20
Importing a height map.

Figure 7-21
Hand manipulation.

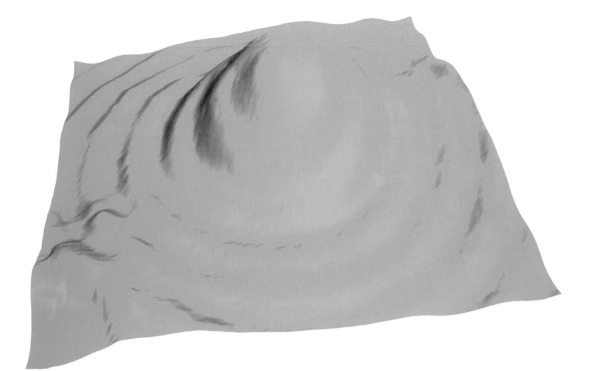

Figure 7-22
Modifiers applied to mesh.

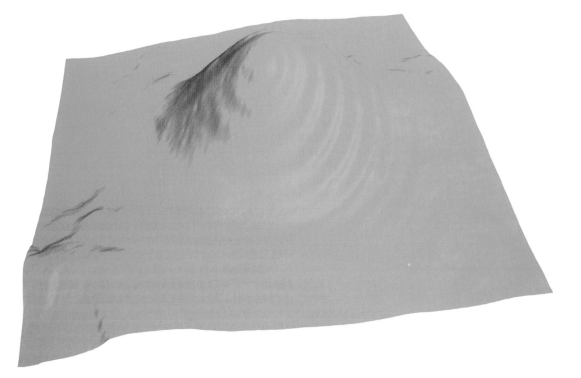

Figure 7-23
Modifiers fading out using soft selection.

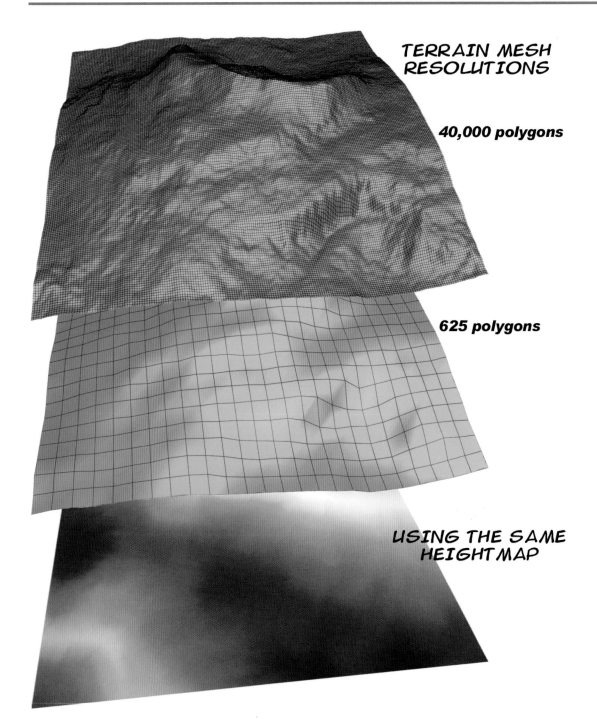

TERRAIN MESH
RESOLUTIONS

40,000 polygons

625 polygons

USING THE SAME
HEIGHT MAP

Figure 7-24
Same height map with terrain of varied resolution.

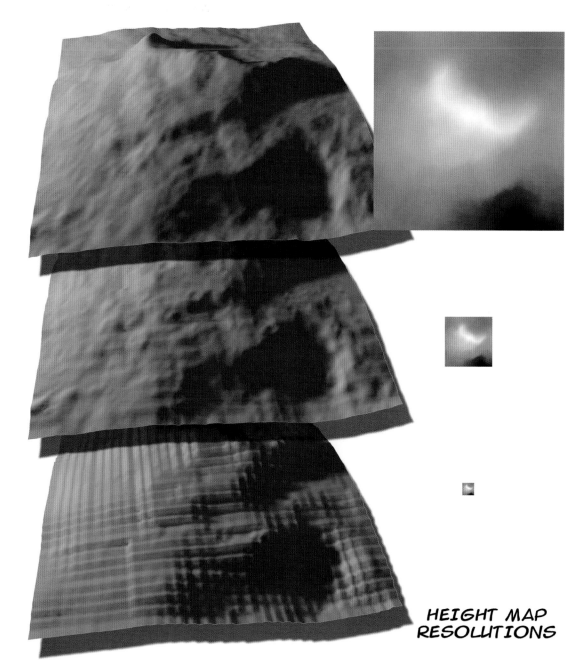

Figure 7-25
Same terrain mesh with height maps of varied resolution.

INSIDE INNER BRUSH
100% EFFECT

OUTSIDE OUTER BRUSH
0% EFFECT

AFFECTED AREA
TRANSITIONS BETWEEN
0% AND 100%

Figure 7-26
The Terrain Brush and various settings. Notice how the brush works: everything inside the inner circle is affected 100%, and everything outside of the larger outer circle is not affected at all. The area between the two is where the terrain-editing effect transitions between 0 and 100 percent.

Figure 7-27
The same brush with different strength settings.

Figure 7-28
Most terrain editors allow for a smoothing or eroding function to help you shape your terrain.

Figure 7-29
Smoothing versus erosion.

cliff face

erosion

smoothing

erosion pulls material down and piles it up below the brush (Figure 7-29).

Noise/Turbulence

Another simple but useful ability is adding random noise or turbulence to your terrain (Figure 7-30). After shaping and smoothing, your terrain may look too smooth and need some random movement along the surface. Of course, there are settings that will determine the area and strength of the effect, and often there is even a choice of which mathematical algorithm to use when calculating the turbulence.

Flatten/Set to Height

Sometimes you may want to establish a part of your terrain as a flat, inorganic space where a building may be located, for example. Terrain editors allow for the flattening of polygons, and you can usually choose to flatten the terrain to a certain height that you

SIMPLE PULL RAISES TERRAIN

NOISE ADDED

enter numerically, or to the height of the first polygon that you
select before you start flattening the terrain (Figure 7-31). For the
jungle river in the illustration, I flattened the terrain along the river
path so that the water table would be clearly visible to me and then
eroded the banks of the riverbed.

Figure 7-30
Adding random movement
along surface.

Other Features

Good terrain editors also allow for the creation of terrain features
such as cliffs and steppes. Most are starting to support tools that
aid in the creation of roads (Figure 7-32).

Terrain Texturing

At its most basic, terrain texturing is done using several tiling
textures of the surfaces most common to the environment you are
creating. The textures are stacked like layers in Photoshop, and
either alpha channeled or combined to make a single large texture.
Many large terrains in a game are using several maps just for the
base level of texture: one large low-resolution color map; a smaller
set of higher-detailed color maps that are chopped into tiles and
loaded and displayed only when the player is on the section of the
terrain that needs it; and a smaller, highly detailed map that is often
a bump or normal map for the area immediately around the player
where such fine detail would be appreciated (Figure 7-33).

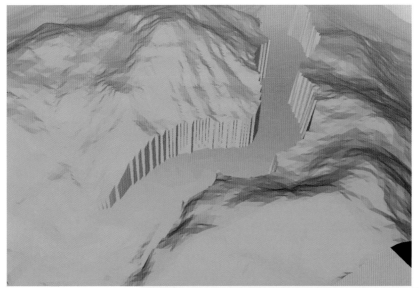

Figure 7-31
Flattening terrain.

The terrain texture can be painted by hand in the terrain editor or generated by the terrain editor. Hand painting terrain is much like working with Photoshop layers.

Terrain Generation Software

There are many programs that can generate terrain for you, and they range in price from very costly to free and differ according to intended use. Some like Bryce 3D and Vue are designed for high-detail renders and not real-time gaming, and use some very complex code that simulates various real-life behaviors. Still others are barely more than mesh manipulators that allow for layered painting

Figure 7-32
Road created in a terrain editing program.

Figure 7-33
Terrain texture map tiles.

on terrain. The reason that game developers are ill served by both of these tools is that the high-end tools do not produce assets easily used in games, and the others generate vast terrains programmatically and generally lack the degree of close-up control the game developer needs. The simplified terrain editors require that every inch of the terrain be hand crafted, or that information from other sources be imported to aid the developers and save them from creating the entire terrain by hand. So, on one hand, there is not enough fine detail control, and on the other, we have all the control and lack tools that can speed up and enhance our work.

L3DT (Large 3D Terrains)

L3DT is a Windows application for generating artificial terrain maps and textures developed by Aaron Torpy, the proprietor of Bundysoft. There is a free standard version and a very reasonably priced professional version. The standard version can do a lot, and it is free to use commercially. L3DT was developed primarily for game developers making large worlds typical of MMO games, but the artist can use this as well to generate terrain for other uses.

I have found that L3DT serves the game developer best. This application can generate a terrain and all associated maps (height, normal, light map) and output the mesh and textures in various formats. And it allows for the up-close editing and control needed by the developer. Even the auto-generation can be controlled to a great degree by the developer, as you will see. The most impressive aspect of this terrain generator is the wizard that walks you through all the steps of terrain generation.

The best thing about L3DT is that it supports several modes of operation. You can set a few general parameters and let the program do all the work, and you can also manually edit your map and use a design map after the fact. The design map is the middle ground between vast uncontrolled terrain generation and tediously pushing every vertex where you want it and painting every pixel. The design map lets you paint the attributes of your terrain in broad strokes. You can determine the shape of the terrain, as well as specify where things like mountains, plateaus, and volcanoes go. You can add or subtract height, place cliffs, increase or decrease erosion, and more. When L3DT generates the terrain, it looks at your design map and generates the fine details from there. There is even a terrain wizard that walks you through the steps of creating your terrain from the design map to the finished texture and everything in between. Quick steps to create a small simple map by just clicking a few buttons are shown in Figure 7-34.

Figure 7-35 shows a map created using the same parameters as in Figure 7-34, but the design map has been changed to include one place where the terrain is higher and more jagged. A larger, more radically altered map is shown in Figure 7-36. Using the design map,

I painted in a lower valley with the temperate climate in the middle of this arctic wasteland.

L3DT also supports the common editing tools discussed previously. You can shape and sculpt your terrain, and use tools like the road builder and erode brush. Figure 7-37 illustrates the tools in action. And when you are finished, you can recalculate the associated maps, including the light, normal, and texture maps. In Figure 7-38 you can see how altering the terrain in various fashions produces a different texture. A flat surface is grassy, a smooth hill is slightly eroded, and at a steeper angle you get exposed rock. Note that I lowered the terrain below the water table; the area is filled with water and the textures reflect it. The shores are sandy and the terrain under the water is darkened and tinted based on the depth of the water.

The ability to control the climate is extensive. You can auto-generate the climate, alter it on the design map, and even create your own climates and save them as presets (like you can most other aspects of the terrain). The climate modeler distributes textures in a realistic fashion; this includes fresh- and saltwater effects. In Figure 7-39, you can see that the same terrain has had its climate changed and rerendered. The water can be automatically and manually designed using the water-flooding aspects of the program or tweaking it all by hand. And this is not a simple water plane that fills the entire world at one level. It is possible to have an island on the sea with a mountain lake on a higher elevation (Figure 7-40).

L3DT was designed to generate very large maps. The free standard version has a cap on the map size, but the professional version allows for maps up to 131,072×131,072 pixels in size for the height map and 2M×2M for the texture. You don't need gigs of RAM for these maps—L3DT includes a automatic paging system that swaps map "tiles" from RAM to the hard disk drive as required. It's called a *mosaic map*, and it usually caps RAM usage in the 100–200 MB range (even for gigabyte- or terabyte-sized maps).

Tutorial: Clouds

It has always bothered me that I couldn't render clouds or a lens flare on a transparent layer. In Photoshop, when you create clouds or a lens flare, you must have a background color. In other words, clouds must be rendered with two colors and can't fade into transparency like a gradient can (Figure 7-41).

For most Photoshop users, the Blending Mode function is the answer for a realistic cloud or lens flare overlay. You can render clouds on a layer above your image and play with Blending Mode until the clouds look the way you want them to (Figure 7-42).

In game development and interactivity, the images created often need to be used in applications that don't have the sophistication and power of Photoshop. We don't have access to blending modes,

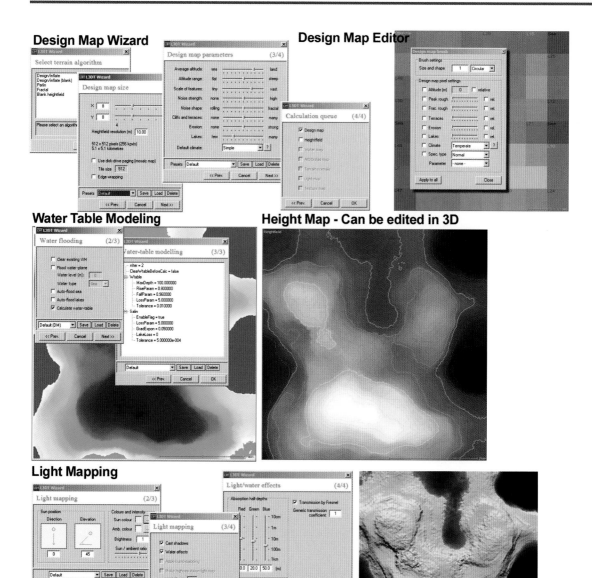

Figure 7-34
Basic L3DT steps.

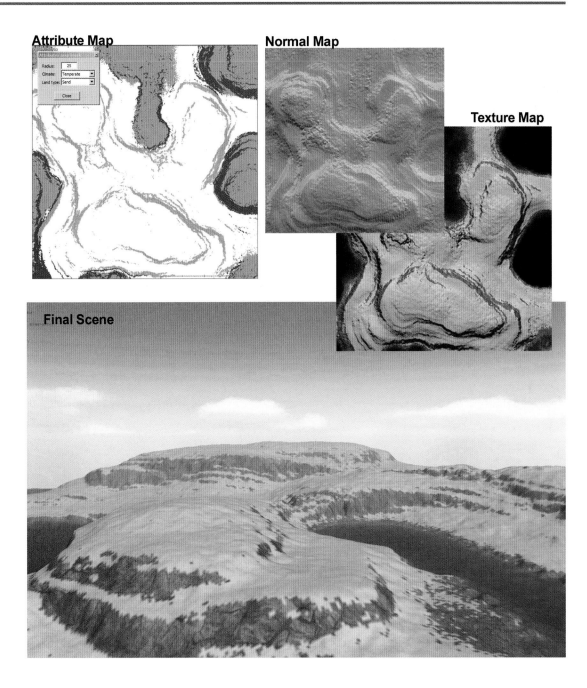

Attribute Map

Normal Map

Texture Map

Final Scene

Figure 7-35
One design map parameter changed.

and the image must come into the application with transparency already in place. As a result, I have developed a quick way of creating a lens flare or clouds on a transparent layer. I will step you through the process using clouds, but this can be applied to lens flares as well.

Open Photoshop and create a canvas of any size. Keep in mind that because of the way that the Clouds filter works, the larger the canvas the finer the clouds will be. I used a 512×512 image size. For standard clouds, select white as the foreground color and black as the background (Figure 7-43).

pos: 137, 615
alt: 1000.0m - flying
fps: 14.2
tex: 4 / 320MB (0 bias-auto)
tri: 33062 / 32768
ver: 3.0m
far: 10240m (1024v)

Figure 7-36
More radically altered map
using the design map.

You might think that a sky blue would be the better choice for a
background color, but that will leave a bluish cast in the image. You
can see in Figure 7-44 that on the left I used an image created with
this tutorial using blue as the background color on the left and
black on the right. The blue tint is not desirable, as it limits the
flexibility of the image and makes accurate color work harder.

Create a new layer by clicking on the Create a New Layer icon and
name this new layer Clouds (Figure 7-45). Filter > Render > Clouds
on this new layer.

Note: You can hold down the Alt key while running this filter to
make your clouds pop more. The default clouds are on the left and
the clouds with more contrast are on the right. These images were
originally 512×512. For this exercise I used the softer clouds on the
left (Figure 7-46).

To create the alpha, or transparency, image for the clouds, simply
duplicate the Clouds layer by dragging it onto the Create New Layer
icon and rename it Alpha. Using a separate image to dictate
transparency is how many applications function (Figure 7-47).

Apply Auto Levels to the image: Image > Adjustments > Auto Levels,
which alters the pixels in the image so that they function better as
an alpha map for games. You can also skip this step. The results are
still good, just different (Figure 7-48).

You can see how an alpha map works in Figure 7-49. The
source image is to the left and the alpha mask in the middle. The

Figure 7-37
Road builder, erode, and other common functions in L3DT. Note that the erosion looks like real-world erosion—the material has slid down to fill the area below. This is not just a smoothing algorithm.

resulting image has a delicate transparency that makes the clouds look real and soft. The second example uses a figure with a more distinct outline. This makes it easier to see how the alpha mask works.

To actually remove the pixels from the layer in Photoshop—creating a layer with transparency and not just a separate alpha image—follow these steps.

1. Select the entire Alpha layer and copy it; Ctrl+A selects all and Ctrl+C copies it. Go to your Channels tab and create a new alpha channel (Figure 7-50).

Figure 7-38
Texture calculated by angle, depth, climate, and other factors. This is all done automatically by L3DT.

Figure 7-39
Same terrain in different
parts of the world:
temperate, desert, and arctic.

2. Paste the copied Alpha layer (Ctrl+V) into the new alpha channel (Figure 7-51).
3. From the menu, Select > Load Selection and check the Invert box. Make sure that you have the Alpha Channel selected (Figure 7-52).
4. Go back to your original Clouds layer and press Delete. You can play with brightness a little if you like, but it shouldn't need much. Here I changed my background color to a sky blue so that you can see the clouds (Figure 7-53).
5. To thin out your clouds, press Delete a couple more times before deselecting (Figure 7-54).

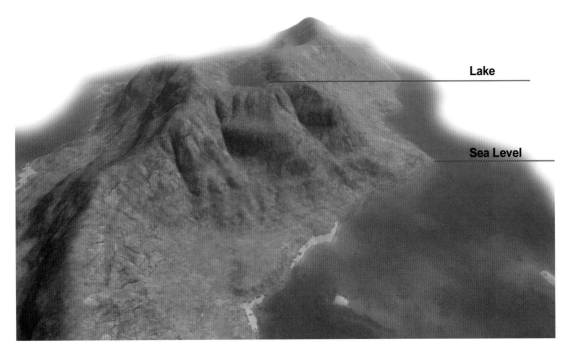

Figure 7-40
Water at multiple elevations.

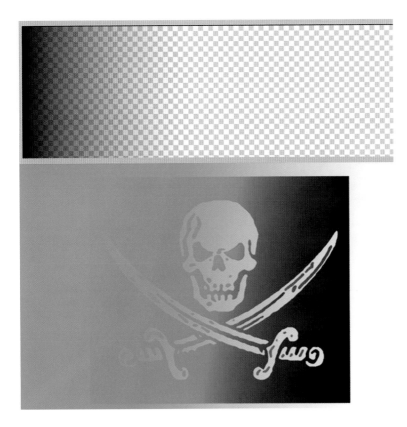

Figure 7-41
Gradient fade.

Figure 7-42
Blending clouds into a still image.

Figure 7-43
Foreground and background
color in black and white.

Figure 7-44
Don't use blue as your
background color for clouds.

Figure 7-45
Create a new layer.

Figure 7-46
Clouds with contrast.

Figure 7-47
Creating the cloud alpha.

Figure 7-48
Adjusting levels.

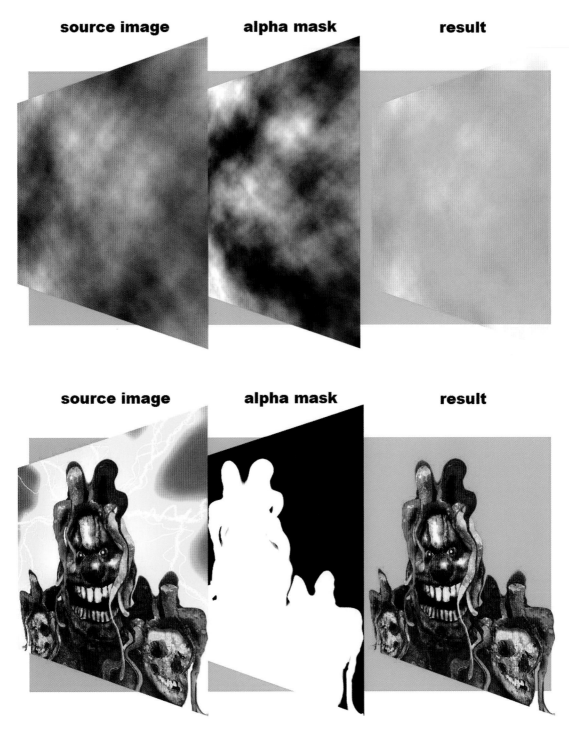

Figure 7-49
How alpha mask works.

Figure 7-50
Create a new alpha channel.

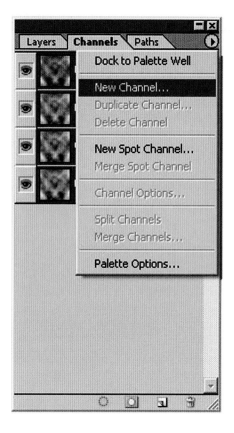

Figure 7-51
Step two in creating an alpha channel.

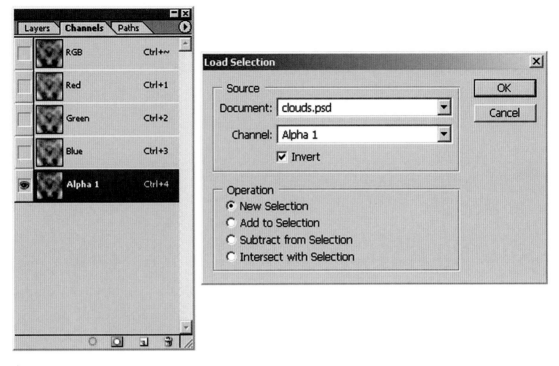

Figure 7-52
Selecting the transparency.

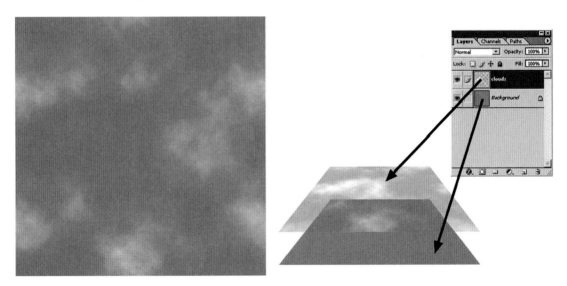

Figure 7-53
Deleting the pixels.

Figure 7-54
Thinner clouds.

Figure 7-55 shows the cloud image in a 3D application using the alpha mask that we created. Note that the clouds tile automatically using this method. Also note that I used two layers of clouds (using the same image), making one layer display the clouds larger and move slower to add more depth.

Single Clouds

If you want a single cloud rather than a tiling sky full of clouds, use the Lasso Tool with a very large feather. I used a 512×512 image and a 45-pixel feather. Simply draw an organic curvy shape and render clouds. You can use a large, very soft eraser to gently sculpt the clouds a bit if you need to (Figure 7-56). Figure 7-57 shows a giant single cloud I created for this 3D scene.

Water

In games, water can be made using a simple flat water plane or shaders that deform the geometry, followed by adding any number of effects with maps such as normal maps, specular maps, and alpha maps, among others. Particle systems even play a part in some water effects for things such as mist. Usually a good-looking water source in a game uses several of these combined. A water plane is a large, flat polygon with a water texture. Sometimes an alpha channel is on this texture. If it is supported, the texture can be multilayered and animated (Figure 7-58). The plane can consist of a large number of polygons and be animated so that the waves have physical depth like the real ocean. Add to this the use of shaders to control the reflection, light effects, and normal mapping for smaller waves, and the water starts to look really good. Top it all off with a mist of spray using particle effects and you get some really convincing water (Figure 7-59).

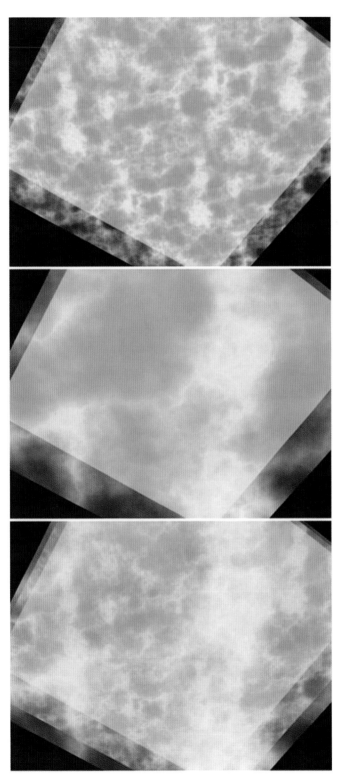

Figure 7-55
Same cloud, multiple layers.

Figure 7-56
Creating a single cloud.

Figure 7-57
Single cloud in scene.

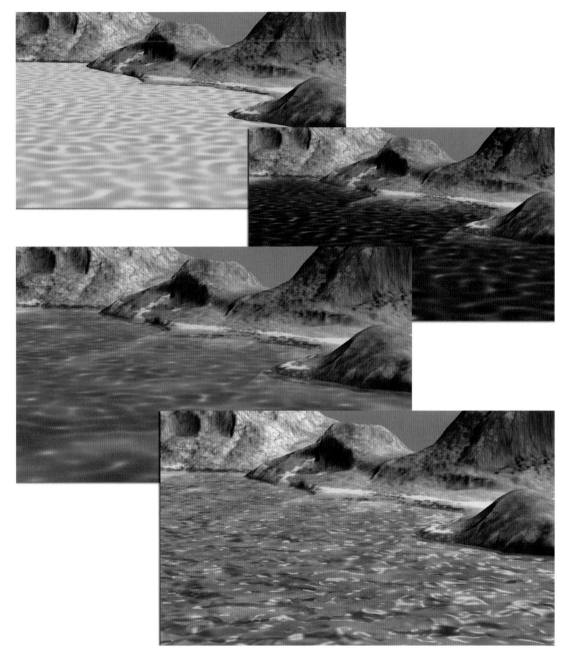

Figure 7-58
Water can be a simple plane or use many complex shaders. **Top,** flat plane; **second,** opaque; **third,** two layers animated; and **bottom,** bump mapping and specular highlights added.

Figure 7-59
Water in games can now look this good, thanks to pixel and vertex shaders.

Figure 7-60
Caustics are the pattern you see when the sun shines through water into a shallow pool or clear ocean.

Caustics Generator

One effect that water causes is called *caustics*. An extremely simple definition of caustics is the pattern you see when the sun shines through water into a shallow pool or clear ocean (Figure 7-60). If you find yourself without access to a high-end 3D program, you can download this free Caustics Generator at http://www.lysator.liu .se/~kand/caustics/.

The subject of caustics is quite complex and involves the process of light converging with light. Caustics are caused by light that is reflected or refracted several times before actually hitting a surface, such as through waves. The more light that is refracted to the same area on a surface, the brighter the area will be lit and, hence, the bright pattern we see. To calculate the effect of light refracting through water requires complex math, but thankfully, because of the Caustics Generator (Figure 7-61), all we have to do is push buttons and look at pictures. The Caustics Generator produces

Figure 7-61
Interface of the Caustics Generator.

rendered frames that are tileable. You can also generate multiframed animations. There is no alpha channel support, but that is a simple thing to create. The Caustics Generator is available in two versions—freeware for everyone and a commercial version intended for professional users.

Chapter 8

Game Effects

Introduction

Games are full of visual effects—probably even more than you realize. These effects are important not just as eye candy, but also for giving the player clues and information about what is happening in the game world. These effects also add a great deal to the level of immersion that a player will experience in a game. For example, in some games you can shoot at wall and nothing will happen—did a bullet come out of your gun? In another you can shoot a wall and a few pixels may fly from the point of impact; how satisfying is that? Shoot a gun at a wall in a recent game of any quality and you will see a hole or abrasion on the wall, a small shower of debris fly from the point of impact, and a puff of dust dissipate into the air. Typically, if you shoot at any surface in a game—wood, metal, concrete, and their variations—you will see and hear a different effect for each surface. Effects also include the glow around a candle, light shafts from a window, even raindrops— and a whole lot more. The assets for these effects are fairly easy to create. Actually, asset creation is the easy part of creating effects in a relative sense. It does take work to create the art and it must look good, but the systems that run the effects can still be complex and challenging to work with. There are generally three types of effects for which you will create assets:

- Static
- Animated
- Particle

Static Effects

Most effects are based on a fairly simple texture and mesh set, and the texture and mesh of the static effect don't move. Effects like the light beams streaming from the windows in the warehouse and fantasy settings and the glow around the candles in the fantasy setting are *static effects*. Some of the most common static effects are the marks left on a wall after the impact of a bullet, like those in the opening image of this chapter. The various impact marks on each of the different surfaces are all created in this chapter. See Figure 8-1 for an illustration of the bullet-hole image (with alpha) mapped to a two-triangle polygon to create the decal, and how it looks when placed in the world. Effects like the bullet holes are called *decals*, because they are displayed like a decal on a surface in the game world. A bullet hole is easy to make; it's the programmers who have the difficult job of getting the decal to appear at the right time, display correctly on the surface, fade away after a certain amount of time, and control of numerous other variables. Some game engines rotate the image, cycle through different images for each bullet hole, and even animate the images on the decal. Though usually simple, these effects add a lot to the game world they appear in.

Animated Effects

Animated effects are based on the texture/mesh arrangement, except that the texture is animated and plays like a mini-movie on the face of the mesh. There can be anywhere from a few to many frames in an animated progression, and the frames can exist as one large image or as separate images. As one large image, the separate frame images are displayed one after the other, and as separate images, the frames are all on one image and the game engine displays the various areas of the image in order. The program flips through these frames and plays the images like a movie.
Animated sequences were usually used as fire in previous games, blinking lights on a console, oozing blood, and many other effects. Fire was created by using a flat plane that always faced the camera and the animated sequence was mapped to it. Animated effects can also be applied to nonmoving models, like the lights of a computer console (Figure 8-2). I put the entire console image in the figure so that you can see the animation in context, but for a game the lights would be a separate image with an alpha channel to save memory. Some current games, and probably all future games, are increasingly using nonanimated particles, because the particle systems and the hardware have evolved enough that a much higher degree of control can be achieved, more particles and emitters can be used, and effects that process in real time make the

Figure 8-1
An illustration of a bullet-hole decal—a simple texture with an alpha channel applied to a two-triangle polygon. **Below**: a row of bullet decals placed on a wall.

Figure 8-2
Animated effects are based on the texture/mesh arrangement, except that the texture plays like a mini-movie. There are several frames in the animated progression, and the frames can exist as one large image or as separate images. The computer console is an example of an animated sequence in context.

particle systems look much better than a static, or prerendered, asset.

Animated effects are still used to animate some decals, such as a weapon blast. Imagine the burst of energy from a blaster hitting a metal wall beside you in a space station. The blast mark is bright from the heat of the blast and the glow fades and shrinks as it quickly cools (see Figure 8-3). This animated sequence was made quickly in Photoshop. Animated images are a little more challenging to work with, and the job of creating a 2D animation for an effect often falls to the artist who may not be used to traditional animation, or have access and the knowledge to use a 3D package. Animated effects are commonly used in the muzzle blast from a gun and are often used for explosions and smoke, so you will most likely see them around a little while longer. You can use ImageReady to create and test animate effects.

Figure 8-3
The creation of an animated particle or decal doesn't always have to be difficult. This laser blast was made quickly in Photoshop.

Particle Effects

A particle system is a system that can display an assigned asset in great numbers (the asset is usually a small polygon—two triangles—with an applied texture that has alpha transparency on it). The system tracks the particles in 3D space using a set of parameters that the artist can change. These parameters typically alter the rate, size, speed, position, and life span of the particle, as well as telling the particle to shrink, fade, or always face the camera (which it usually does). Particles can even physically interact with the game world, colliding and bouncing off surfaces. Figure 8-4 shows the same scene with the same particle system in use with a different texture used in each scene. Actually, the particle used for all of the effects (except the sparks in the upper lefthand corner) is mapped with the same texture; however, in each case the texture has been colorized with a different hue and saturation. The texture itself is simple to create:

Figure 8-4
Particles are used in these scenes to create various effects such as sparks (**upper left**), gaseous flames (**upper right**), volcanic smoke or ash (**middle**), poisonous gas (**lower left**), and steam (**lower right**). These scenes use the same particle system, with a different texture used in each scene. Actually, the particle used for all of the effects (except the sparks) is mapped with the same texture. In each case, the texture has been colorized with a different hue and saturation.

1. Create a 512×512 image, black background.
2. Create a new empty layer.
3. Drag out a circular selection with a 22-pixel feather centered in the image.
4. Render clouds.
5. Select > Load Selection > Load the transparency of the layer.
6. Dodge, Burn, Airbrush, and/or Colorize this image to get the effect you want.

A particle system can be used to simulate a wide variety of effects from smoke to a flock of birds. Traditionally, the use of particle systems with a large number of particles coming from it was too big a drain on a computer, so the effects that game developers were able to achieve were limited. But as software gets more complex and game hardware more powerful, smoke and fire and other impressive effects are being very effectively generated using a much larger number of particles.

Dealing with particle systems can be the most difficult part of effects work. Understanding and effectively using the systems that drive the particles, especially a good system with lots of options, can take a lot of time and patience. But even a complex particle system usually uses the same simple texture and geometry setup for the visual particles. See Figure 8-5 for the progression of a static magical sparkle. Figure 8-6 shows a simple particle system. In the

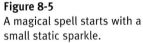

Figure 8-5
A magical spell starts with a small static sparkle.

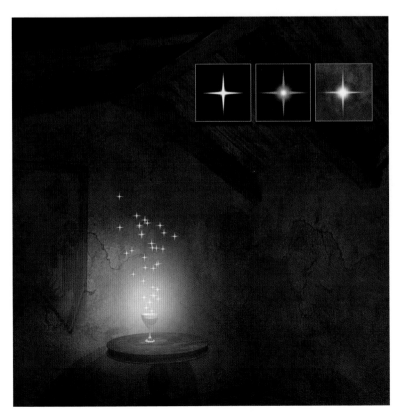

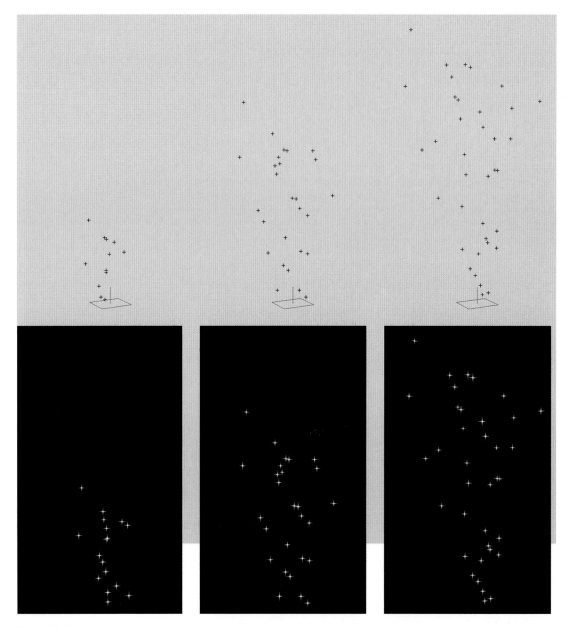

Figure 8-6
This is an illustration of a simple particle system, a magical spell. The **upper** set of images shows the particles represented by crosses, so that you can see what the particle system is actually doing, and the **lower** images are the same as the upper, but with the sparkle image attached to each particle.

upper set of images, the particles are represented by crosses (so that you can see what the particle system is actually doing), and the lower images are the same as the upper but with the sparkle asset attached to each particle.

The point at which the particles are *spawned*, or appear, is called an *emitter*. An emitter can be of any size. A small emitter with lots of

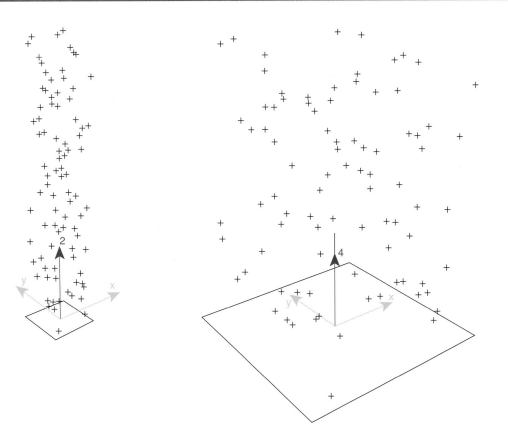

particles coming out in a spray may be what you would use for a garden hose, whereas a very large emitter high in the sky of your game world with a few particles falling from it might be used for rain or snow. See Figure 8-7 for the effect of using different emitter sizes. Often, special particle systems are written for specific uses. Specific particle systems that handle weather effects, for example, are commonly created, because weather systems have a more limited function but cover a larger area than a typical full-featured particle system usually does. These special versions of a particle system allow the developers to make them run more efficiently, which is achieved in part by dropping many of the features a typical particle system has that are not needed for a more specific-use particle system. Emitters are typically represented by some sort of icon in the game editor, but are invisible in the game—you see only the assets spawning at the emitter point being controlled by the particle entity that they are attached to. Usually the game artist, when placing an emitter, makes sure that it looks as if the particles are coming out of something—not just from thin air.

Although a simple particle system may contain only an emitter, a polygon, and a texture, more complex particle systems can contain multiple emitters and multiple textures, and use 3D meshes as particles. An explosion is usually composed of a quick ball of fire and a spray of debris and then smoke that drifts from the blasted area and dissipates into the air. This effect is typically created using a

Figure 8-7
Emitters are where the particles come from and can be of various sizes. The same number of particles is coming out of both emitters in the figure, but the wider emitter has spread the particles out over a larger area.

blast decal and several systems, one for each effect: flash, debris, and smoke. Additionally, particle systems are usually associated with sound events. Sound adds a lot to the effect that a particle system has. What would rain be without the rumble of thunder? How effective would a silent explosion be? When a fire crackles as you get near it, it adds another level of realism and immersion to a game.

We will start with some simple weather effects and then tackle some of the more common effects for a game, such as lighting and weapons effects.

Weather

As complex as nature can be, the particles for the most common weather effects are easy to create. Rain and snow are both tiny simple images. You can see the effect that a few hundred of these tiny particles can have on a scene (see Figure 8-8). Notice that the images are blurred a little. The rain is blurred toward the back of the drop to simulate the blurring of a real raindrop as it falls to the ground.

Lighting

If you understand the math and science of light, then more power to you. But most of us mortals can understand this stuff only on a basic level—it can get really complex. Of course, it helps to understand how light works, but it is absolutely no guarantee that you can create the art that makes a light look good in a game. In fact, an artist is probably better served by observing a variety of light sources in various situations and studying them at a purely visual level than trying to wrap his or her mind around a subject that may have inspired an interest in art in the first place. Fortunately, we are artists and we have to make things look good, not write the code that controls the particle. Several of the more common lighting effects are easy to understand and recreate in a game setting. These effects are accomplished with a simple mesh and texture set. You have already seen a few of these effects in the previous chapters.

Light Shafts

Do you remember the shafts of light that streamed in from the windows in the warehouse and the windows in the fantasy setting? In the real world, light shafts are created when light passes through the atmosphere and reflects off tiny floating particles. Light shafts are prevalent in games because they look cool, but they can also be important visual clues. Light shafts are presently created using the simple mesh/texture set. In the future they will probably be rendered in real time, but for now, see Figure 8-9 for the components of the light shafts as I created them for the scenes in this book.

Figure 8-8
The particles for the most common weather effects are easy to create. Rain and snow are both tiny simple images. You can see the effect that a few hundred of these tiny particles can have on a scene.

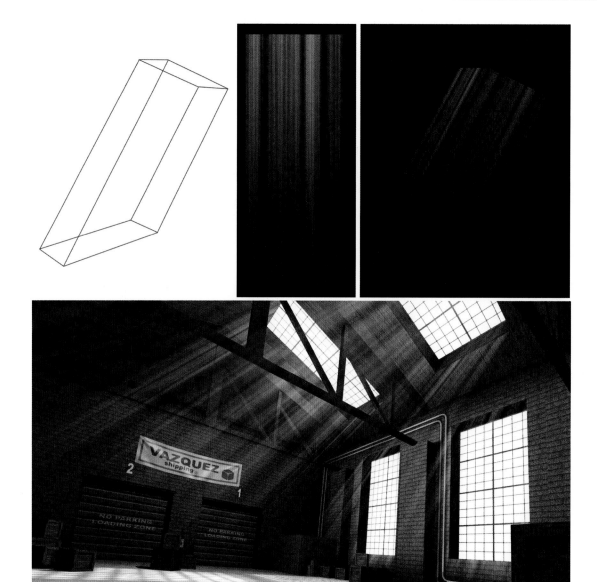

Figure 8-9
The components of the light shaft are a simple mesh and texture.

To produce that texture, I created an image that was 256 pixels wide and 1024 high. I turned on the Fade option in the Shape Dynamics for the brush and drew a few white lines with a soft brush from top to bottom. Then I Motion Blurred it down a few times and Gaussian Blurred it a little, too.

If you are able to use these textures in a 3D application, keep the following points in mind:

• Exclude the geometry from being affected by the light sources in the world so that it doesn't cast a shadow.
• Turn the full-bright (or illumination) on the texture all the way up. When you do this, the texture displays at full brightness and seems to glow. Because light shafts are located near a source of

light that is brighter than the surrounding (relative) darkness, they look great and will never be in a situation where they are bright for no reason (well I guess you can make a door close and the light shafts will remain, but you shouldn't do that).

- Turn Collision off so that your light shafts don't block anything (like real light); the collision process is a processor hit, so it's always a good idea to turn Collision off anything that doesn't need it.

I have seen this effect augmented in some creative ways: with animated textures that make the shafts seem to waver or shift, with particle systems that simulate dust drifting through the light shaft, with a projected shadow like the one I used on the floor of the warehouse so it appears that the light is actually casting a shadow.

Candle Glow/Corona

At night, light sources often seem to have a glow or halo around them. This effect, in the real world, is caused by the light, the atmosphere between the light source and the viewer, and the viewer. As the light hits water droplets in the air, it is broken up into various colors based on the many variables that can exist in the light source (distance, color, brightness), the atmosphere (amount of moisture in the air, pollutants), and even the viewers' eyes. Although a game might have one corona for many light sources, occasionally creating a few special-case coronas for drastically different-colored light sources, in reality each corona you see is unique because of the many variables involved. Fortunately, a game is usually designed around a theme or setting, which allows for the use of a smaller, more focused, set of assets—coronas being one of them.

In the fantasy setting, we had a glow around the candle flame, which is also a corona, but has a different texture made to look like a candle glow rather than an electric light source (see Figure 8-10). The light shafts are static, but a corona needs to move. To simulate a glow around a light source effectively, many games rely on a technique that uses a moving polygon with a simple corona or glow image mapped to it. The corona entity allows the artist to control several parameters that make the corona image shrink, grow, and fade in and out as the player moves toward and away from it.

I actually created two glows for the candles in the fantasy scene: one that was more diffuse and faint for the background candle, and a brighter, more fanciful glow for the candle on the table in the foreground to give the impression that it is magical. See Figure 8-11 for the progression of both glows. The steps are as described here.

Candle Glow, Faint and Diffuse

1. Create a new image, 1024×1024. I work this large so that I can get finer gradation in the glows. You do lose some of that when you resize, but I find that it makes the corona smoother.

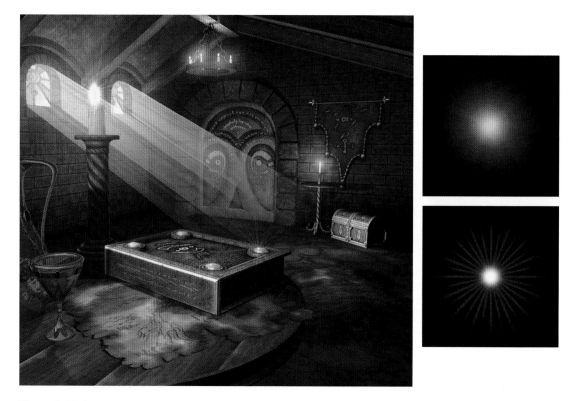

Figure 8-10
The fantasy setting uses a glow around the candle flame, which is also a corona entity with a texture made to look like a candle glow rather than an electric light.

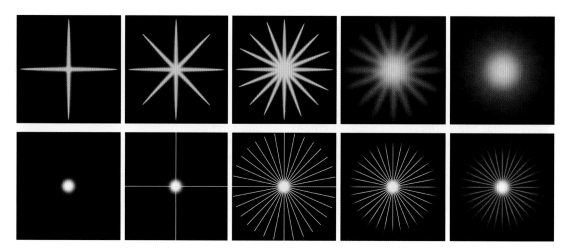

Figure 8-11
The progression of the candle glows.

2. Make a layer named **Center** filled with black and snap two guides to the horizontal and vertical center of the image.
3. Create a new layer named **Lines**.
4. Use a small, soft brush with the Fade option set to about 75 pixels.
5. Draw yellow-orange lines from the center to all four points of the compass. Copy, paste, and rotate this four times.
6. Filter > Blur > Gaussian Blur 20 pixels.
7. Filter > Blur > Radial Blur – Amount 100, Quality Best.
8. Create the alpha channel in the same manner as you did for the candle flame in the fantasy chapter.

Candle Glow, Brighter and More Fanciful

9. Create a new image, 1024×1024.
10. Make a layer named **Center** filled with black and snap two guides to the horizontal and vertical center of the image.
11. Create a new layer named **Lines**.
12. Use a smaller, soft brush and set the foreground color to a very desaturated yellow RGB 255,248,218.
13. Set the foreground color to white, reduce the brush size a few steps, and put a white center in the yellow circle.
14. Create a new layer named **Lines**.
15. Invert your colors and use the desaturated yellow and a small, hard brush, 5 pixels. Draw lines across the canvas until you have a complete circle of tight thin lines. You can draw two lines using the guides and then copy, paste, and rotate them. Merge all the line layers together when you are done.
16. Use an inverted circular selection with a 42 feather to remove the ends of the lines.
17. Gaussian Blur this 4 pixels.
18. Radial Blur this, too. Amount 100, Blur Method Zoom.

Traditional Corona

The traditional corona is a little more involved than a candle glow. You can use the Render > Lens Flare filter to get a variety of effects that are great references when creating a corona, but you can't use the resulting lens flare as a corona texture, because you can't render the effect on an empty layer, which makes the creation of a decent alpha channel a challenge. Also, the lens flare is meant to simulate the flare from a camera lens, not the glow from a light source, so there is a good deal of extra visual information in the effect that would be next to impossible to remove. The steps to create a corona start as the candle glow:

1. Create a new image, 1024×1024.
2. Make a layer filled with black, and snap two guides to the horizontal and vertical center of the image.
3. Create a new layer named **Center**.
4. Use a large, soft brush and set the foreground color to white. Put the center white glow in.

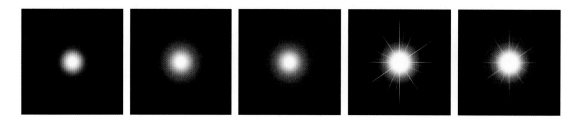

Figure 8-12
The progression of the
traditional corona.

5. Coronas can have many colors in them, but they should be subtle. We will start by creating a faint circle in the background. Create a layer named **Brownish Circle** behind the glow on the center layer. Use a circular marquee with a 22-pixel feather and fill it with a brown: RGB 80,71,59.

6. Create a new layer named **Ring1** under the center layer.

7. Set your foreground color to RGB 40,47,40.

8. Use the circular marquee with the 22-pixel feather still on it and stroke an 8-pixel line outside of the brownish circle.

9. You have the option of adding a circle or two more if you like. Ultimately, the corona's color and intensity will be based on the setting it is in.

10. Either paint or smudge the white lines out from the center. Note that the lines are fewer than the fanciful candle glow and are of varying lengths.

11. Finally, Gaussian Blur this about 4 pixels. See Figure 8-12.

Weapons

Now we are going to tackle weapons effects. These can be the most involved and complex effects to set up, given the number of weapons in a typical game, the number of effects each weapon has associated with it, and the effect that the weapon's projectile might produce when impacting any given surface of the game world. Though these effects are usually complex and involved to set up, the assets they use are fairly easy to create.

Muzzle Blasts

The plume of fire that discharges from the barrel of a weapon is called a *muzzle blast*. In reality, every type of weapon has a distinct muzzle blast, but most people can't distinguish between the muzzle blasts from similar firearms to any great degree. A muzzle blast from a rifle will do the job for most rifles in a game, but a muzzle blast from a rifle used on a handgun might be noticeable. Although the muzzle blast from various weapons will have various patterns and sizes, currently they are all made in the same basic fashion. They are a combination of geometry and texture. First, let's look at the elements of the typical muzzle blast in Figure 8-13 and the complete muzzle blast in front of a backdrop (Figure 8-14).

Here are the steps to create the muzzle blast. See Figure 8-15 for a visual progression of the steps below. To create the circular part of the muzzle blast:

Figure 8-13
The plume of fire that discharges from the barrel of a weapon—a muzzle blast—is created with a combination of geometry and texture. **Upper right,** the muzzle blast texture. **Middle,** the model of a gun with the geometry for the muzzle blast in place. **Bottom,** the muzzle blast with the texture and geometry together.

1. Open a new 512×512 document in Photoshop with a black background.
2. Create a new layer named **Orange**.
3. Set your foreground color to orange RGB 255,150,0.
4. Use a very large soft brush (300 pixels) and put a large orange circle in the middle of the image using a horizontal and vertical guide.
5. Use a smaller, soft brush (200 pixels) and put a white circle in the middle of the orange circle.
6. Use the Smudge Tool (27 pixels, 74%) and smudge out the color from the center of the image.
7. Filter > Distort > Ripple – Amount 75%, Size Large.
8. Filter > Blur > Radial Blur – Amount 10, Blur Method Spin, Quality Good.
9. Filter > Blur > Radial Blur – Amount 25, Blur Method Zoom, Quality Good.

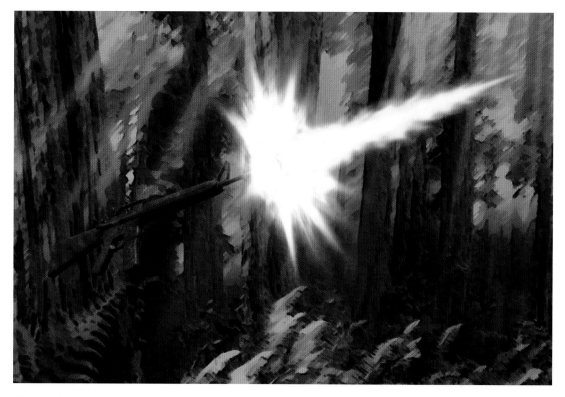

Figure 8-14
Here is the completed muzzle blast in front of a colored backdrop.

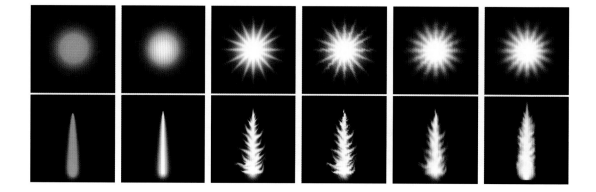

Figure 8-15
The progression of the steps to create the muzzle blast.

To create the elongated part of the muzzle blast:

1. Open a new 512×512 document in Photoshop with a black background.
2. Create a new layer named **Orange**.
3. Set your foreground color to orange RGB 255,150,0,
4. Use a large, soft brush (100 pixels) and set the Shape Dynamics to Fade (25 pixels). Drag a long orange line from the bottom to the top.

5. Use a smaller brush (50 pixels) and set the Shape Dynamics to Fade (55 pixels). Drag a white line from the bottom to the top of the image.
6. Use the Smudge Tool (27 pixels, 74%) and smudge out from the center of the image and upward.
7. Filter > Distort > Ripple – Amount 75%, Size Large.
8. Filter > Blur > Motion Blur – Angle 90, Distance 25 pixels.
9. Filter > Blur > Radial Blur – Amount 25, Blur Method Zoom, Quality Good.
10. I did a little more smudging to strengthen the flames.

Impact Effects: Bullet Holes and Debris

When you fire a gun in a game, the muzzle blast may be notable, but it's the effect the bullet or projectile has on the surface it strikes that is really satisfying. If little to nothing happened when you fired a weapon, you wouldn't feel as immersed or excited by the game. The effect is not only cool, but it also is an important interaction with the game world. In fact, a player is usually made aware of the effect his interaction has on the game world (other players being part of the game world) through visual effects. Impact effects give you important visual clues as to how close you are to hitting the target you are aiming at. It is a particularly tense event in a game to hear the sound of a bullet impact near you and see the hole and debris and realize that you are the target. In a stealth shooter, where you are both hunter and prey, this is an important part of game play. Of course, auditory and even tactile effects (vibrating controller) play an important role, too, but you can more easily play a game without speakers than without a monitor.

This section is entitled "Impact Effects," with the additional phrase "Bullet Holes and Debris" because almost any interaction with a game world is an impact that spawns an effect: weapons effects are just a subset of impact effects. But weapons effects are usually the most commonly needed and complex effects created for a game. I am limiting the examples of impact effects in this chapter to basic weapons effects, because the same principles apply to the creation of virtually all other effects. The bloody hole and red spray from a gunshot wound, the tracks left behind and dust kicked up by a vehicle's tires in the desert, a swarm of insects, and most other effects are all created in the same manner as those effects created in this chapter.

Some effects are relatively simple—you fire a gun and blow dirt from the ground or leave a hole in a metal panel—but some can be pretty dramatic. In some games, you can shoot a window and blow the glass pane into a thousand shards. If you are in the position of creating effects such as these for a game, you will quickly realize that you need a spreadsheet to track the weapon types, ammunition or projectile, world surfaces, and the description and needed assets for each impact effect. This spreadsheet can also include the associated sound files and even special case events like malfunctions and misfires. Here I will walk you through the basics of

creating impact effects for an average bullet on the most common surfaces.

First, we list the most common surfaces in an average game world:

- Cloth
- Concrete (plaster)/brick
- Dirt
- Glass
- Grass
- Metal
- Water
- Wood

For each of these surfaces, we must create a texture that the game engine can display over the surface (like a decal) and look as if a bullet left a mark at the point of impact. We also need to create a particle/debris image for each surface and variations for some of the surfaces. For example, a bullet hitting the thin metal of a tin garden shed might simply put a neat hole right through the metal with little to no debris coming from the point of impact, but the same bullet slamming into the heavy metal of a blast door might dent the metal only slightly but send a shower of debris or even red-hot sparks flying from the point of impact.

Although you can come up with a neat list of the materials in your world, these might all look vastly different in variations of each material. For example, heavy metal can be rusted or freshly painted, wood can be old (desaturated and brownish) or new (brightly painted furniture or highly polished panels). The challenge here is to create a bullet-hole decal for a certain material (wood, for example) that will work equally well in many situations (old wood, painted wood, and so on). I find that a grayscale image with good light, shadow, and alpha treatment works best, as it tends to blend with the material that it is displayed on top of. This method also allows you to focus your efforts on how a given material will react to a bullet impact regardless of the color or condition of the material. For example, wood generally splinters, glass shatters, metal is dented or punctured, and so on. By leaving the color information out, you can create an effect that will adopt the color of the surface it is displayed on and spew the appropriate particles for the material type. The key to creating a good impact and debris set is to consider the physical properties of the material first; how hard, brittle, or squishy is the material, and how will it react to the impact of the specific projectile that will be hitting it? Then focus on the highlight and shadow of the hole and debris. Experiment with the effects in Photoshop and in the game and adjust the alpha channeling to obtain the best results. A deeper hole may be small with an almost solid black center while a shallow dent may be wider and almost transparent with only a hint of light and shadow.

Here are the basic surfaces I usually work within a game. They are listed alphabetically, not by importance.

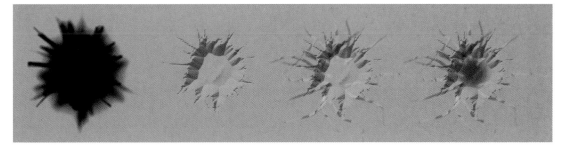

Figure 8-16
The progression of the steps to create the bullet hole for cloth.

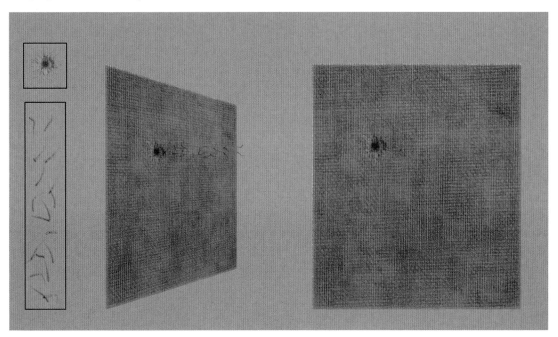

Figure 8-17
The cloth bullet hole, debris, and the effects in context.

Cloth

If you kick in the door of the average crack house and start blazing away with your nine, chances are you will hit a sofa, stained mattress, or some dope shag carpeting. When you are taking down that stained mattress, you want to know it's really dead, so the game artist better give you some good visual feedback.

Cloth tends to rip and tear and leave strings or fibers when it is destroyed. To create the impact and particles for cloth, I started with a simple stringy pattern and applied the Bevel and Emboss layer style and finally added some additional strings and darkened the hole to give it depth. See Figure 8-16 for the progression of the cloth bullet hole and Figure 8-17 for the bullet hole, debris, and the effects in context.

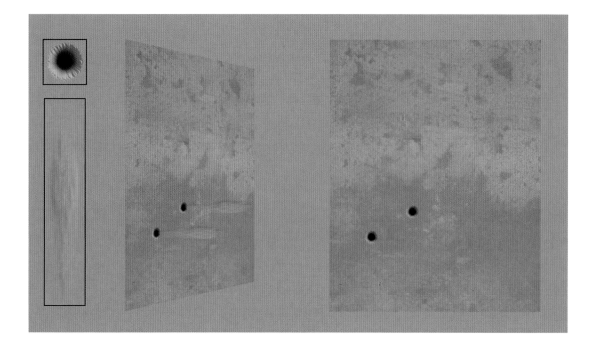

Figure 8-18
The light concrete/plaster effects set and the effects in context.

Concrete (Plaster)/Brick

These three materials are very common in game worlds and similar in their effects. The holes and debris are almost interchangeable, but you may want to differentiate between light concrete, heavy reinforced concrete, and/or bricks and heavy ceramics because of the frequency and wide variety of these types of materials.

Light concrete or plaster will leave a cleaner hole and produce a more wispy puff of debris. See Figure 8-18 for the light concrete/ plaster effects set. This effects set was created as most of the other effects were using various brushes and the Bevel and Emboss Layer Style as a beginning.

For the heavier, reinforced concrete, I made the holes shallower and rougher and the debris essentially the same as the lighter concrete. I also added a puff of dust to the context image. We created the puff earlier in the chapter in the section on Particle Effects, so you could see a more complete example of an effect (Figure 8-19).

For the bricks, I went with a simple circular hole as if the brittle brick were blown out in a large shallow circle. I think the shallow, carved-out look works for most brittle brick and tile surfaces. I made the debris contain some small chunks, as it seemed like the brick would be blasted outward, whereas the concrete would powder under the impact (Figure 8-20).

Figure 8-19
The heavier concrete effects set and the effects in context, with a puff of dust that drifts away after the initial impact. We created the puff earlier in this chapter in the section on particle effects.

Figure 8-20
The brick effects set and the effects in context.

Figure 8-21
The dirt effects set and the
effects in context.

Dirt

Dirt tends to crater when impacted, so I created a wider, shallower, crater-like hole and a longer, wider, spray of dirt grains (see Figure 8-21).

Glass

In general, one of three things can happen when glass is impacted in a game world. In one case the glass remains intact and a decal of a bullet hole is laid on the surface followed by a small amount of debris shooting out from the hole. In the second the glass shatters into pieces and falls out of the frame. The third option is a hybrid of the two; you shoot the glass several times, putting holes in it as you weaken it, and then it shatters out of the frame after several shots.

When glass breaks out of a frame and falls to the floor in pieces, this usually involves the model of the glass pane being removed from the scene on the impact of the projectile and the particle system of falling glass shards spawned at the place the glass pane used to be. This involves less asset creation, as you are making a few tiny shards, and more technical setup as you are coordinating events in a chain reaction:

projectile impact ····⟩
 remove pane mesh ····⟩
 play breaking glass sound effect ····⟩
 spawn falling glass shard particle system ····⟩
 play tinkling glass sound effect ...

For the first option, the hole decal and debris, the effect is technically simpler to set up but involves more asset creation and this is the effect we will create since this is an asset creation book. As stated above, this effect mimics the effect of thick, reinforced, or bulletproof glass being impacted by a projectile but not breaking. When impacted the glass pane remains and a hole appears with spidery cracks emanating from it. A small shower of glass shards are thrown back from the hole. For this effect the hole is simply a black circle with a faint inner glow for some depth and thin white lines emanating out from the center (use the Fade option for this). The glass debris are some simple shapes that I dodged and burned. See Figure 8-22.

Figure 8-22
The glass hole and debris effects set and the effects in context.

Grass

I created the grass effects set based on the techniques used for the cloth and dirt set. The hole created when grass is shot wouldn't be a clear hole, but a dark patch where the grass was displaced, with a few blades overhanging. The debris would be dirt and grass blades. I colored the debris greenish so that it would look like grass blades, but could have left it desaturated if I needed it to be more versatile. See Figure 8-23.

Metal

Metal is another potentially big category. I created three basic scenarios: the light metal with a clean hole, the heavier metal that will get dented inward and punctured when shot, and a dense metal

Figure 8-23
The grass effects set and the effects in context.

that will only dent when impacted. Each hole is a variation on a Bevel and Emboss with some dodging and burning. See Figure 8-24 for the light metal, Figure 8-25 for the heavier metal, and Figure 8-26 for the dense metal.

Water

When water is shot, it sprays upward and outward. Here I show you the simple decal/debris version that we have been working with. Some games make the water splash more complex, resembling the muzzle blast of the gun that we looked at earlier. See Figure 8-27 for the water impact and splash.

Wood

Wood will splinter when shot, so I created a simple hole similar to the grass impact. There is a depression with splinters that overhang the hole. The debris is obviously splinters or chips of wood. See Figure 8-28.

That's a basic rundown of in-game effects. The asset creation is the easy part; it's working with the various systems to get the desired effect that is the real challenge. This chapter has provided you with a basis for creating the assets for any effect that you may be required to create for a game.

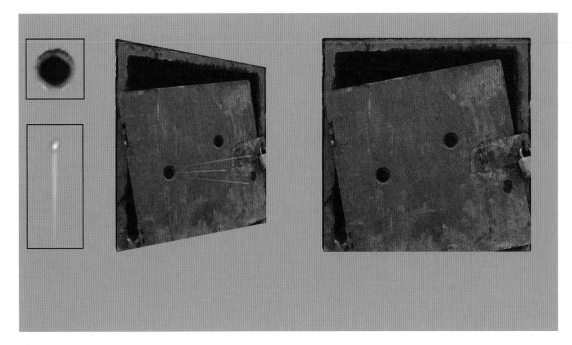

Figure 8-24
The light metal effects set and the effects in context.

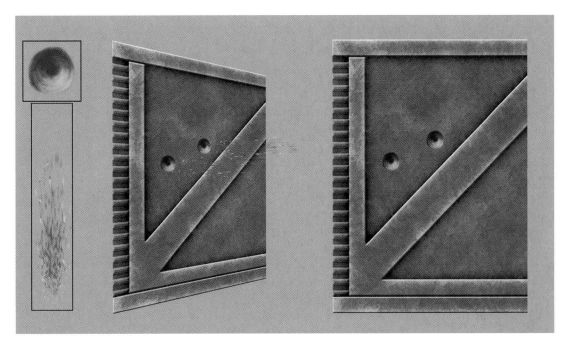

Figure 8-25
The heavier metal effects set and the effects in context.

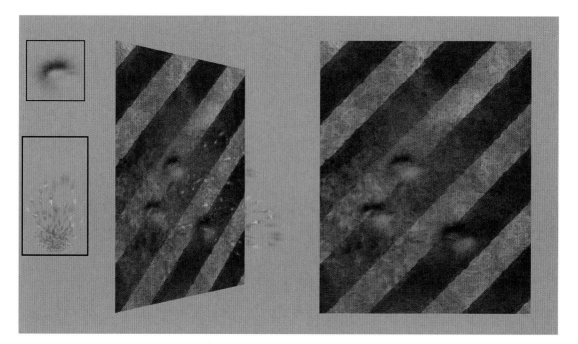

Figure 8-26
The dense metal effects set and the effects in context.

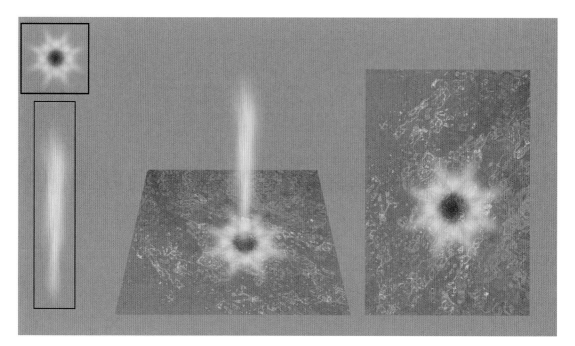

Figure 8-27
The water effects set and the effects in context.

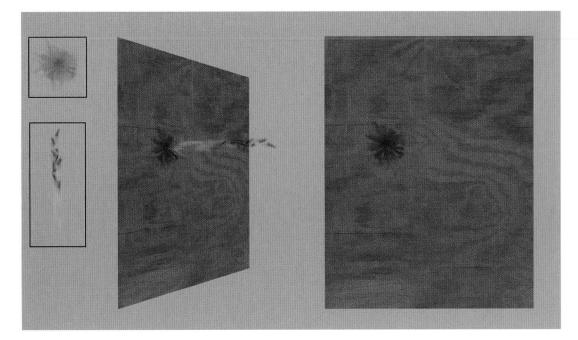

Figure 8-28
The wood effects set and the effects in context.

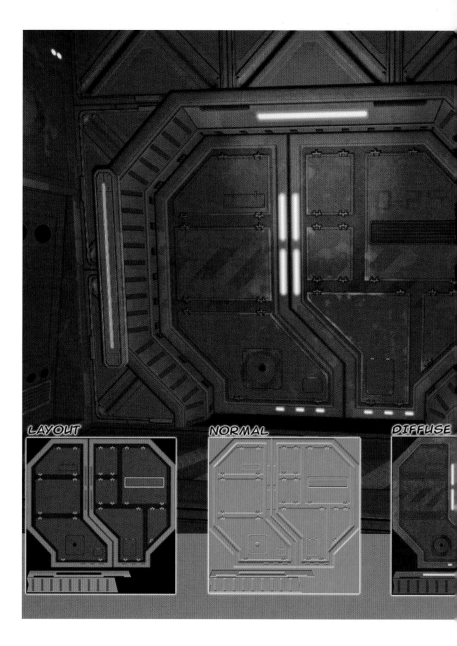

LAYOUT

NORMAL

DIFFUSE

Chapter 9

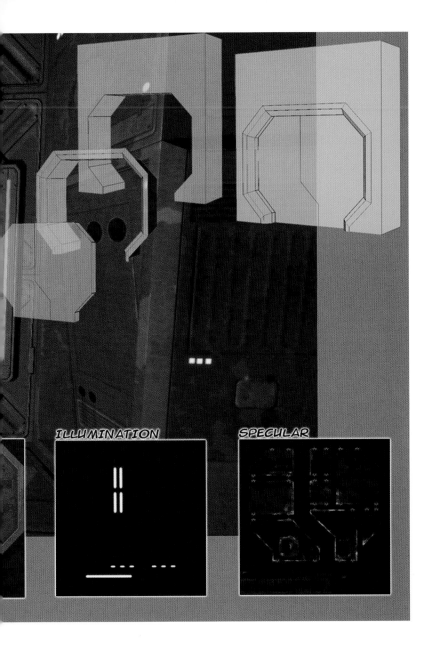

Normal Maps and Multi-Pass Shaders

Introduction

This chapter focuses on normal mapping, specifically on creating normal maps in Photoshop, with a look at creating them using a 3D program, and creating the supporting maps for a typical environment. I will explain how 3D applications are used to do this, but we won't be doing this in this book.

In order to understand what a normal map is, first we will look at what a normal is and how lighting in games generally works. In short, a normal map creates an illusion of depth by recalculating the highlights and shadows on a low polygon surface using the information from a high-polygon model—and does it all in real time. Earlier in the book, we looked at bump and normal map shaders briefly; these add 3D depth to an otherwise flat surface. Although bump maps are grayscale and display the most limited 3D effect, the normal map adds more depth using a color map with lighting information stored in it. A painting can be created that looks like a real scene, but it will look good only from one fixed angle. When you change your viewing angle, you suddenly see that it is a flat 2D image. Imagine if you could create a painting that repainted itself every time you moved it so fast that it seemed as if you were seeing a real 3D scene. That is essentially what a normal map is doing as it calculates light and shadow in real time on an otherwise flat surface. We still need to maintain the silhouette of the model as best we can, meaning that the overall shape of the model will still look the same, even if the flat surface is highly detailed. The good news is that using a normal map allows us to focus more polygons on the silhouette of the model. Currently, a normal map cannot change the silhouette of the model, but there is an even better type of mapping called *parallax mapping* that can actually take into account the fact that items protruding from the surface of an object should occlude objects behind it.

Vertex vs. Per-Pixel Lighting

The science of light is complex, to say the least. Due to the limitations of hardware, programmers have had to grossly oversimplify light calculations in order to calculate light in real time. They are just now able to program some decent lighting in the games, due to recent hardware advances. There are several ways in which lighting can be handled in games, but if it is calculated in real time it is probably either vertex lighting or per-pixel lighting. *Vertex lighting* (generally called *Gouraud shading*) uses a broad brush to determine the lighting of a surface, whereas *per-pixel lighting* uses a very fine brush to do so. Vertex lighting takes the brightness value of each vertex of a polygon and creates a gradient across the polygon face (Figure 9-1). This is not nearly as accurate a lighting model as per-pixel lighting, where the lighting is calculated for every pixel.

So what is a normal and how does it relate to the normal map? The normal is simply which way the face of a polygon is facing. Unlike

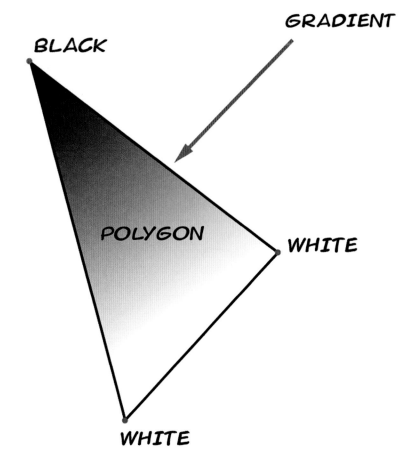

Figure 9-1
Vertex lighting.

the real world, in which a sheet of paper or the sides of a cardboard box have a back and front (and technically, sides) in a 3D world, a polygon is generally visible only when you are facing it. So in a 3D world, if you get inside a cube, from the inside you will be able to see out of it, because you are on the backside of all the polygons and the normals are all facing away from you. In some 3D games you can get your character in a position where you can see inside and through objects. In fact, in some games players can get themselves inside objects where they can see and shoot other players, but those players can't see them or shoot back. Some programs will show you an outline when you are behind the polygon to help you keep track of your objects or give you other tools to work in 3D, but games generally look at the normal "as is" unless specifically told not to. Normals are usually represented as an arrow pointing away from the visible face in a straight perpendicular line. This simple concept is important to understand, because how a normal map functions is based on this bit of information (Figure 9-2).

In vertex lighting, for every normal on the mesh, the angle of the normal and the angle of the lights in the scene are calculated (often

Figure 9-2
The normal map.

with their distances included as well) to determine the brightness of the vertex and the gradient between these points (Figure 9-3):

Brightness = *N* (the normal) ×
 L (the light vector, or the line from the light to the surface)

Now that you know what a normal is, the direction the polygon is facing, understanding what a normal map is will be easier. A normal map is an RGB texture that stores the normal information from a very high-resolution model in the various color channels of the texture (red, green, and blue representing the X, Y, and Z values of the normal vectors). This allows a single polygon to display the light and shadow information from a high-resolution model that has thousands or even millions of polygons. Figure 9-4 shows what a normal map generally looks like.

BRIGHTNESS = **N** (THE NORMAL) *DOT* **L** (THE LIGHT VECTOR)

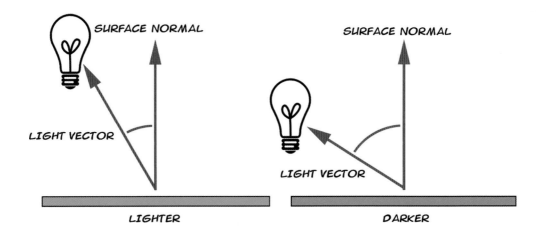

Creating Normal Maps in Photoshop

Figure 9-3
The normal and the N × L calculation.

An easy way to create normal maps is to create a grayscale map in Photoshop and use the NVIDIA plug-in to convert it to a normal map. There are several techniques for building these maps: painting them, creating them from photos (source-based), and using parts of existing normal maps.

Painting Normal Maps

An easy way to create a normal map is to create grayscale height maps and use a filter (freely available from NVIDIA) to convert them into normal maps. In Figure 9-5, you can see the height map, the NVIDIA interface with 3D preview, and the resulting normal map. You can see that using various shades of gray and creating soft or hard edges you can create almost any object you need in a normal map.

Source-Based Normal Maps

A source-based normal map is one that is created from an image— usually a photo. Although this is not always desirable, you can get some good results from a photo. In most cases, when creating environments for a game, the textures that you will be creating won't all be for rounded, injection-molded plastic spaceship interiors. Most textures are for stones, concrete, tree bark, wood, and hard-edged objects—and a lot of other surfaces that are almost impossible to model and shoot normals for. You will often be in a situation where you have to use a photograph, or finished texture, to create a normal map. The steps to do this are as follows:

1. Start with a copy of your image and desaturate it. I often convert the image to 16 bit, as any banding in the image will

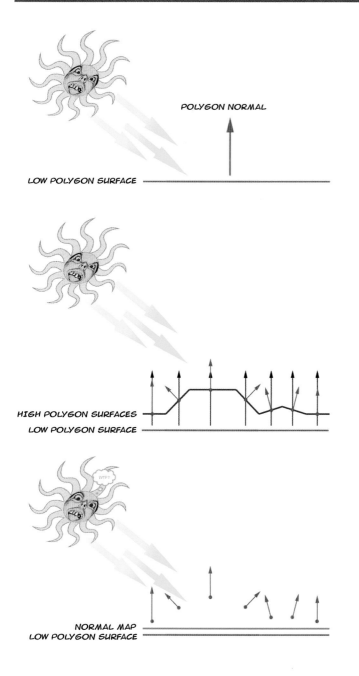

Figure 9-4
A normal map.

show in the normal map. It will look like a topographical map (Figure 9-6).

2. Run the Photocopy filter. You will have to adjust the settings based on the source image, but the goal is to get the lower parts of the image to be black and the higher to be white with little distortion. Figure 9-7 shows this and the following steps.

3. Darken the areas that are supposed to be deeper than the overall surface. In this example, I darkened the area where the bricks

GRAYSCALE MAP

RESULTING NORMAL MAP

POLYGON

NORMAL MAPPED POLYGON

are exposed, as the plaster is on top of the layer of bricks and should be set back in relation to it.

4. I cleaned out a lot of the noise from the overall image, as normal maps are very sensitive and usually an excess of detail on a normal map translates into a noisy and/or puffy result.

5. I took a very small brush and darkened the major cracks in the wall and put a 2-pixel Gaussian Blur on the entire image. This entire process takes only a few minutes and adds a great sense of depth to the image.

Figure 9-5
Normal map creation using varying grayscale values and softer or harder edges.

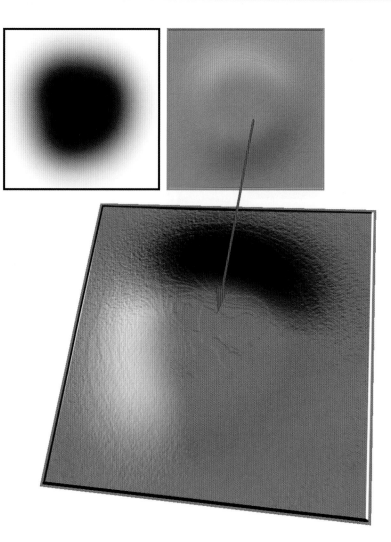

6. You can build up more depth in your normal map by taking the normal map into Photoshop and creating a layer via Copy and setting the Blending Mode to Overlay. This step alone will enhance the detail of the normal map.
7. If you blur this layer a few pixels, that adds more depth. You can repeat this process several times—duplicate the layer and blur it (making sure that the Blending mode is still set on Overlay) and check the results every so often until you like what you see. This extra step is great for more organic textures, as it builds depth in a way that makes the details more rounded. Hard details are still best painted in if you are working in Photoshop.
8. The last thing to do is to renormalize the map by running it through the NVIDIA filter and checking the "Normalize only" option. This step corrects any vector information encoded into the normal map that we might have corrupted during these steps (Figure 9-8).

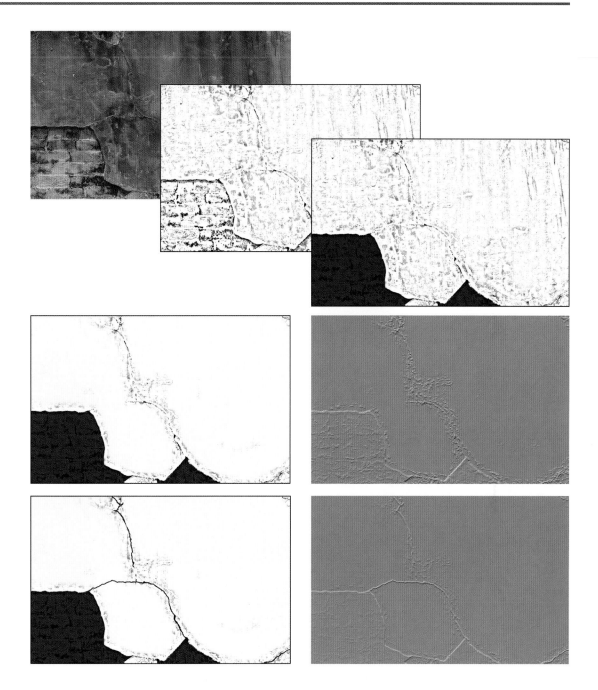

Use Parts of Existing Normal Maps

This method can be used in 2D as well as 3D. In 2D, you are simply cutting and pasting parts of existing normal maps and putting them together; in 3D, you are putting various parts or geometry together to create the normal map. The 2D parts can be moved about to be effective only as parts of a normal map, but the 3D parts can be moved, scaled, rotated, and reused in many more ways.

Figure 9-7
Creating a normal map from a photo.

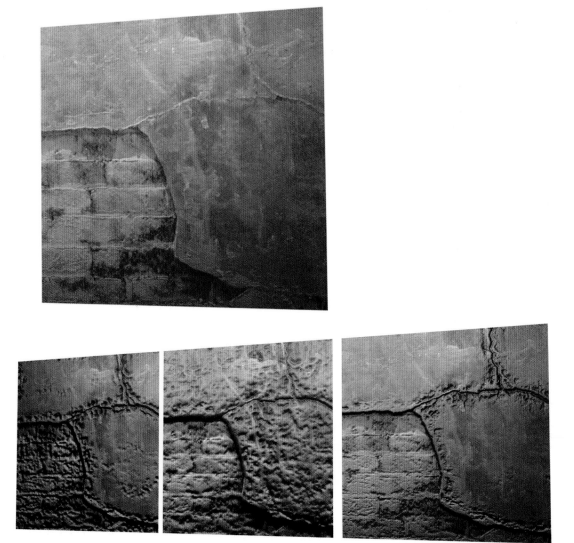

Figure 9-8
Various strengths of the normal map created from the photo.

Creating Normal Maps Using a 3D Program

The process for creating normal maps using a 3D application start with the two models: a high-polygon model (the sky's the limit on detail) and a low-polygon model (needs to run in the game engine you are creating it for). It doesn't matter which one you create first, but there are some pros and cons to both approaches. After the two models are created, the process generally involves arranging the two models so that they are on top of each other and generate the normal map correctly. This step can be the most time-consuming and frustrating. When the application that generates the normal map is run, it is doing the following:

- Mapping an empty texture to the low-polygon model
- Calculating, for each pixel of the empty texture on the low-polygon model, the corresponding normal from the high-polygon model

- Recording that information in the texture map as an RGB value

This method is required for very highly detailed characters and some organic props, but the time and effort spent on this for environmental art (walls, floors, control panels, and so on) are overkill—and often produces inferior results. If you can't achieve your result quickly in 2D and you have access to a 3D application, here is a method for the quick creation of normal maps in 3D. Essentially, you model all of your high-poly details as separate parts so you can arrange them and shoot the normal map once (Figure 9-9). In fact, a simple prop with a few sides can more easily be modeled and normal maps shot by building all the separate faces of the model flat (similar to laying out UVs, only in 3D) and shooting the normal maps and assembling them in Photoshop. I have seen inordinate amounts of time go into normal map creation for things as simple as vents on a wall (I am talking about *days*), when it should have taken under an hour the first time and only moments in the future, as the asset can be reused.

Assets for a Futuristic Interior

The assets for this futuristic interior mostly involve the creation of the textures for the shaders. The models themselves are purposely very simple for this exercise so that you can see clearly the power of the normal maps and other shaders when applied to even the simplest of geometry.

Texture List

- Wall Panel
- Floor Panel
- Light/Ceiling Panel
- Column
- Door
- Monitor
- Pipes and Hoses

Wall Panels

Let's start with a wall panel. As we know we are creating a shader that will involve multiple maps—diffuse (color), specularity, illumination, opacity, and a normal map—we need to set the Photoshop file up so that each map corresponds exactly to each of the other maps. Say you are creating a light panel where the frame protrudes from the surface, the light panel is bright even in darkness as if the light were on, the paint is scratched away, and the exposed metal shines brighter than the remaining paint around it. All the images created for use in the shaders that will produce all those visual effects need to line up exactly. If these images are not created in an organized fashion so they line up perfectly you will get many undesired effects that will shatter the illusion you are trying to create. Misaligned maps will create lit parts of a texture that

HIGH POLY MESH

POLYGON

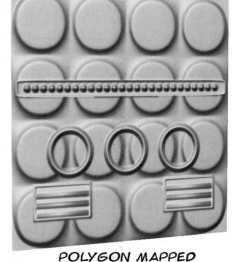

POLYGON MAPPED

Figure 9-9
Creating normal maps in a 3D application: the quick way.

should be dark, normal bumping where things should be flat (picture the image of a nail head in a wall and a few pixels over a bump that looks like a nail head). No map is immune! The specular map needs to line up perfectly with the materials in your texture. Scratches and chipped patches of exposed metal need to shine and the shine needs to stop right where the exposed metal stops and the paint starts. Of course Photoshop layers make this easy. This

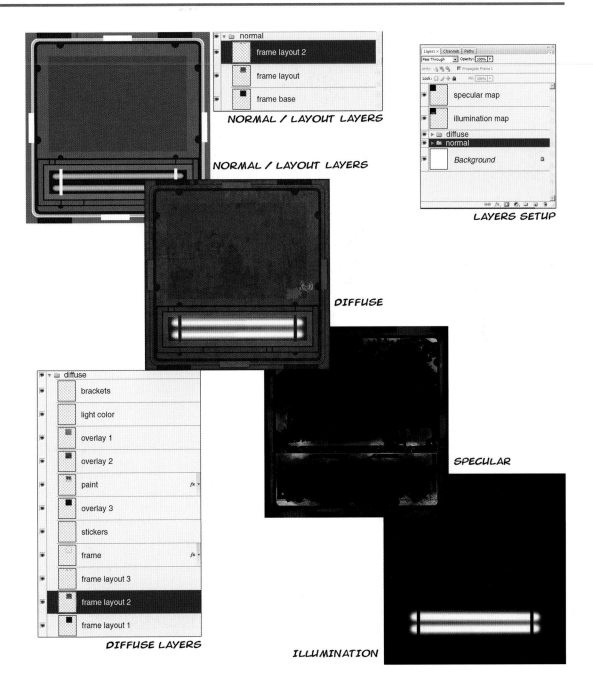

NORMAL / LAYOUT LAYERS

NORMAL / LAYOUT LAYERS

LAYERS SETUP

DIFFUSE

SPECULAR

DIFFUSE LAYERS

ILLUMINATION

approach also allows for the rapid iteration of changes in each of the maps. Setting the file up right will greatly speed up your work, as all the maps created can be produced based on the first few layers you create. I usually start with a simple layout of the texture. For the wall panel, this is a black-and-white layout of the shapes of the panels and parts of the wall panel. You can see in Figure 9-10 the layers that compose the group for the shapes in the panel. From this I usually create the normal map right off to see whether the concept can be achieved in 2D (Figure 9-11).

Figure 9-10
Black-and-white layout of the shapes of the panels.

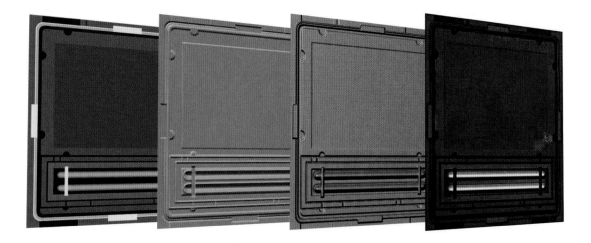

Figure 9-11
Normal map to see whether
the concept can be achieved.

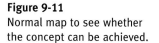

Color

Start with the group that we just created for the layout of the panel, and copy it. Name it **Diffuse** or **Color**. For the diffuse map, the stark black and white of the layout is taken way down (use Fill and not Opacity to do this so that the layer styles are not affected). Having the shapes all on separate layers will make texture creation easier on each map, for various reasons. On the color map, you can use the various layers to apply subtle layer styles—a slight dark outer glow, for instance, to create the look of dirt in the cracks. You can use a color overlay to try out various colors quickly and when you like what you have, you can sample the color to create a paint layer.

To create a great layer of peeling paint, use this common trick that will net you impressive results. Create a new layer on the top of the stack and select the paint bucket. Check the All Layers box, select a nice desaturated color, fill an area, and watch what happens. To get different results, try playing with the tolerance of the tool. You can also try masking off specific areas so that the paint only fills that area; this can be good for trim or panels. You can also use a pattern fill; that is how the caution stripes were done in (Figure 9-22). Create the paint layer last and on top of the stack, but you need to move this layer under all the overlays for it to look right, with the weathering and stains on top of the paint. Try a 1-pixel, very slight bevel on the paint to give it some perceived thickness. Use an equally subtle dark outer glow to help enhance this effect.

Having any parts that need illumination on their own dedicated layers makes it very easy to create the illumination map later on, too. This applies to all the maps—even the specular map is easier when you can quickly isolate a panel using a Ctrl-click on a layer. By creating your overlays for dirt and scratches—and other elements of color, such as stenciled writing or stickers—on separate layers, you can use these layers as a basis for each new texture you create, so that all the surfaces of the space you are creating will have a consistency in the wear and tear and overall look (Figure 9-12).

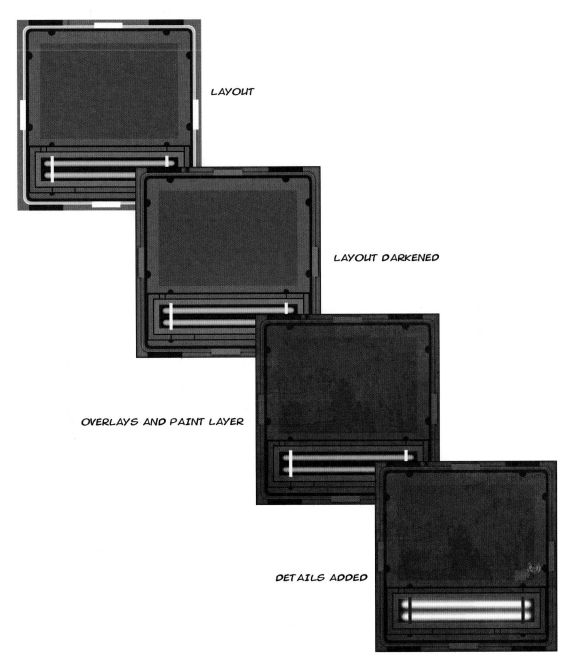

LAYOUT

LAYOUT DARKENED

OVERLAYS AND PAINT LAYER

DETAILS ADDED

Figure 9-12
Overlays for dirt and scratches and other elements such as stenciled writing or stickers. These overlays can be used on each texture you create, so that all the surfaces of the space you are creating will have a consistency in the wear and tear and overall look.

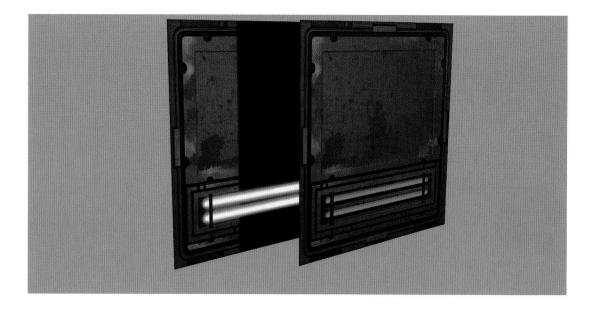

Figure 9-13
The texture with and without
the illumination map present

Illumination

The illumination map is created by making a new layer
filled with black and Ctrl-clicking on the layers with the parts that
will be illuminated—the color of the lights for this panel—and
inverting the black to white on the new illumination layer (Ctrl+I).
In this case, the only lights present are the two fluorescent-type
tubes on the bottom of the panel. In Figure 9-13, you can see the
difference between the texture with and without the illumination
map present.

Spec

The specularity map is a copy of the entire texture that is
darkened; because the various parts of the texture are on layers,
we can Ctrl-click the layers to get precise control over the
specularity of various elements of the surface such as the paint.
The paint is all chipped and peeling; by selecting this layer's
transparency, we can take the brightness up or down to make the
paint uniformly shiny or dull. We can also dodge in scratches and
scrapes. Remember that the white will be shiny and the black dull,
so the edges of panels and around handles will be scratched and
shiny. You can also paint with a white brush on a separate layer if
you want to have more control over the effect and the ability to
redo and fix things more easily later. In Figure 9-14, you can see the
texture with the normal map, the specularity map, and then all three
together in the foreground. Another thing to keep in mind is that
deep cracks and spaces shouldn't have any specular reflection; this
is one of the many reasons many normal maps often look like
molded plastic.

Normal Map

The normal map starts out as a grayscale image, and I do many iterations with the NVIDIA normal mapping filter in Photoshop several times until I get the desired result. There are a few things to keep in mind when creating normal maps in this fashion:

- Watch for banding in the normal map. If this is a problem, work at a higher resolution, take the image mode up to 16 bit, and make sure that the brush you are using is not only soft, but that the "spacing" is set as low as possible under the brush tip shape of the Brushes Palette.
- If you want to create multiple layers of depth, do this by working at multiple levels of grayscale. Two objects crossing each other will look as if they are on the same level and mashing together, rather than on separate levels, if they are using the same values. Make one darker so it seems farther back; Figures 9-15 and 9-16 illustrate the effect of changing the grayscale values.
- Remember that normal maps are very sensitive to value changes. If you want to include dirt on your normal map, the difference in value for the surface it is sitting on should be very subtle. Brighten the surface slightly and the dirt will protrude; darken it and the dirt will look like pits and dents. You may want to consider adding dirt last, after you have tweaked the major height appearances of the normal map. If you need to increase the values of the overall normal map at any stage, that also means that the effect of the dirt protruding from the surface will increase and it will end up looking like huge lumps (Figure 9-17).

Figure 9-14
Rear, the diffuse texture with the normal map applied, middle, the specularity map by itself, and then all three applied to the mesh in the foreground (diffuse, specularity, and normal maps).

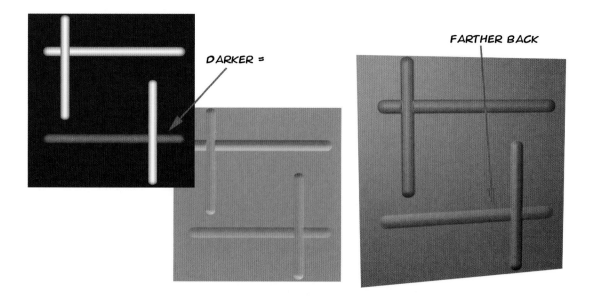

Figure 9-15
Multiple layers of depth.

- Save interesting objects that you build normal maps for and create a library of vents, panels, controls, and so on.

Wall Panel Variations

By creating a copy of the file that you just created, you can make variations on the wall panel—without lights or half-sized or with different panel designs. By using the existing file, you can keep the texture visually consistent (Figure 9-18). In Figure 9-19, you can see more details for the open wall panel. This was constructed in the same manner as the other panels, only there is added detail—more panels and lights. Because there is so much detail in the normal map, I found that as I worked, some parts looked good and others needed more work. I wanted to continue to make some parts more prominent, so I simply saved a copy of the normal map at that stage and kept working. Later, I combined the versions of each normal map and kept the parts I liked best to create the final normal map. In this case, I wanted to make the panels more prominent, but that made the hose connectors too puffy, so I put the final normal map on top of the version with the good hose connectors and erased the connectors from the top layer. Remember to merge and renormalize. This is as complex as the geometry for the walls and floors gets at present (Figure 9-20).

Floor Panels

Creation of the floor panels starts from the wall panels, but being on the floor, these textures can be simpler (Figure 9-21). They feature some diamond plate and caution stripes. I created a half-sized version with the caution stripe on it to be used around the edges of the hall (Figure 9-22).

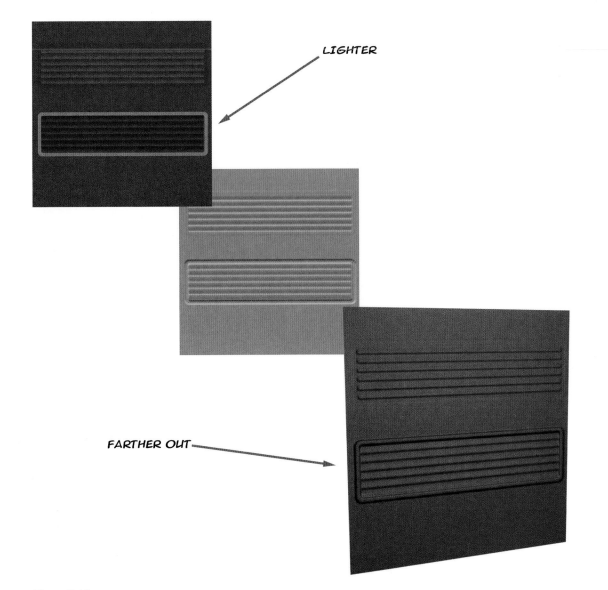

Figure 9-16
Grayscale value changes.

Figure 9-17
Dirt caution.

Column

With the column, we introduce a slightly more complex mesh than the flat polygons of the floor and walls (Figure 9-23).

Light/Ceiling Panel

The light panel (Figure 9-24) has only one unique texture for the grate. The others are wall panels and the lights themselves are from the wall panel with a light. There is also the introduction of the opacity map. Although the illumination map can be a little fuzzy (so it appears that the area around the light is being lit), the opacity map needs to be precise if you want the grill to look clean. If it's fuzzy, there will be a fading of the texture.

Door

On the door texture, I included the frame parts as well (Figure 9-25). The surface behind the door is a wall, so I textured it accordingly.

Monitor

The monitor (Figure 9-26) has a few overlays for the screen, and in addition to the illumination map, there is an actual light source in the scene that helps make it glow. The mesh is simply a line extruded, and the front face beveled.

Figure 9-18
Wall panel variations.

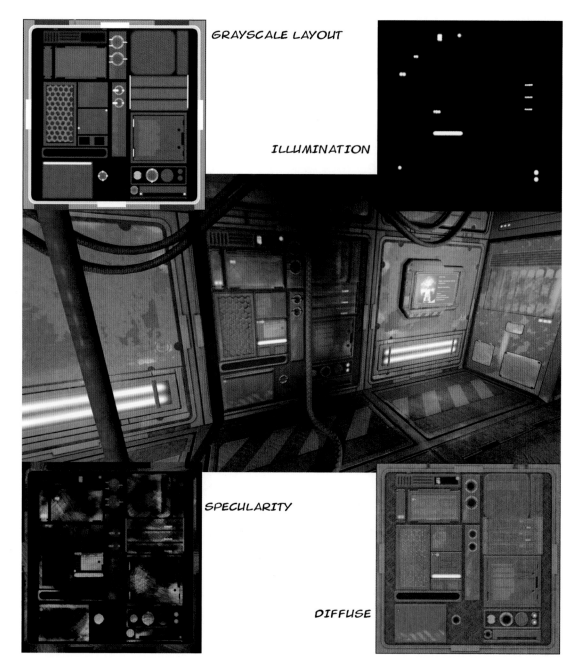

GRAYSCALE LAYOUT

ILLUMINATION

SPECULARITY

DIFFUSE

Figure 9-19
Wall panel open.

Figure 9-20
The geometry of the scene—it's very simple.

Pipes and Hoses

With the ability to add more polygons to our scenes, we are now able to include traditionally high-polygon (relatively speaking) objects such as hoses (Figure 9-27). Hoses are round and can be curvy—round and curvy means polygon-intensive. Start with a horizontally tiling texture for a few hoses and a pipe or two. The fact that we can use a specular and normal map on the hoses allows us to create a really cool texture on the hoses (Figure 9-28). Figure 9-29 shows a render of the final scene with and without the shaders in place.

Figure 9-21
Large floor panel.

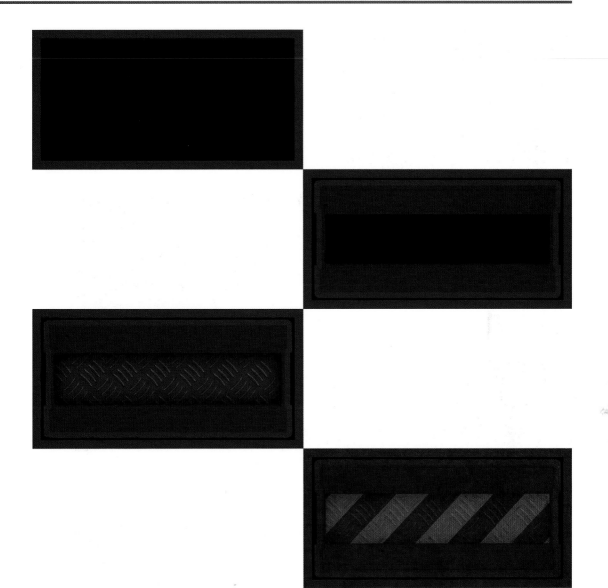

Figure 9-22
Half-sized floor panel.

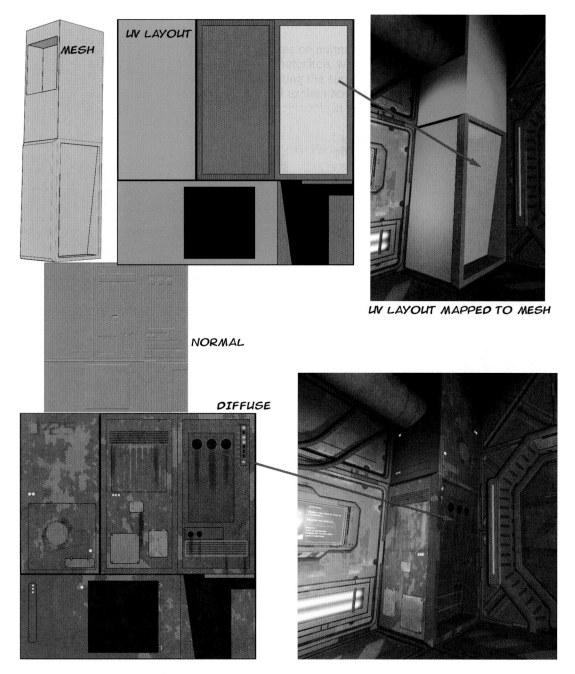

Figure 9-23
Column.

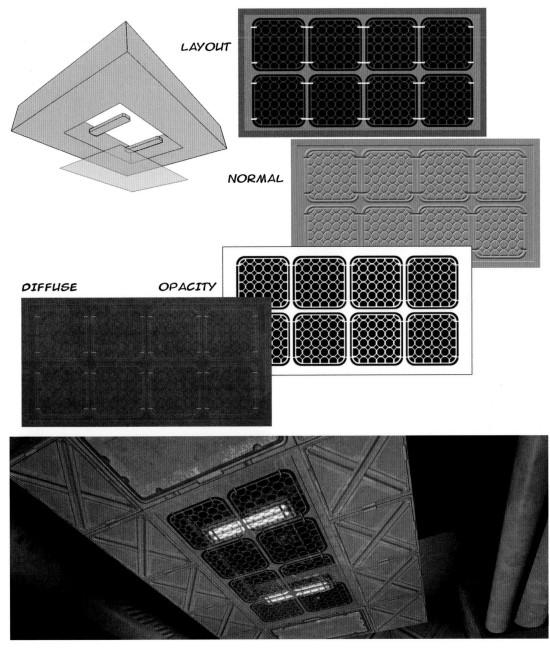

LAYOUT

NORMAL

DIFFUSE OPACITY

Figure 9-24
Light panel.

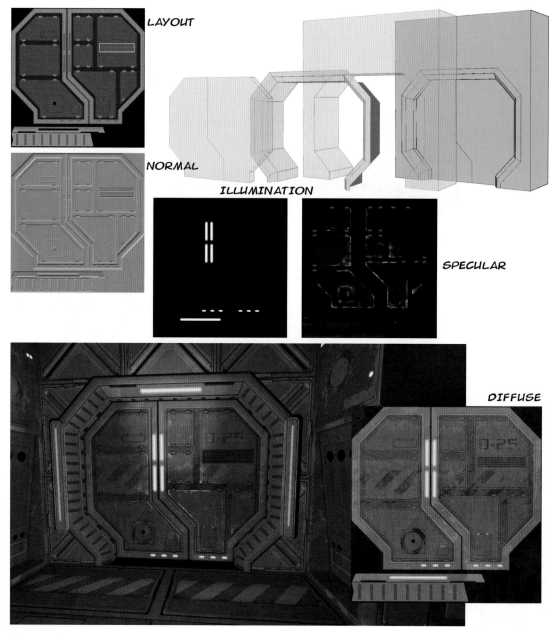

LAYOUT

NORMAL

ILLUMINATION

SPECULAR

DIFFUSE

Figure 9-25
Door.

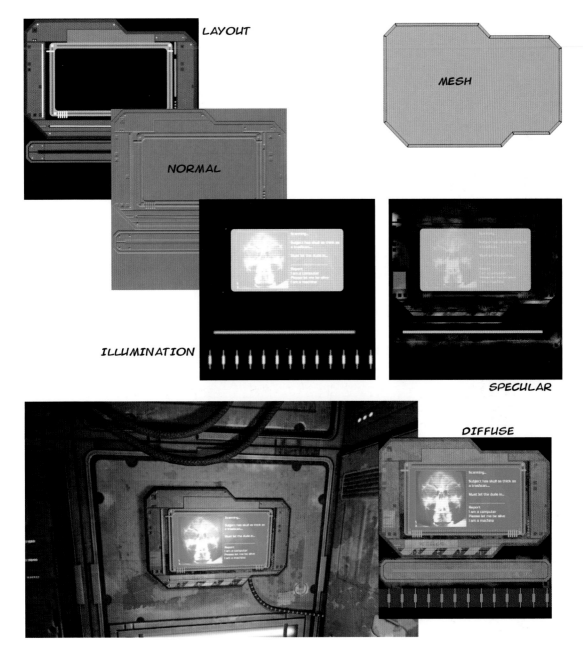

Figure 9-26
Monitor.

Figure 9-27
Pipes and hoses.

Figure 9-28
Hose detail.

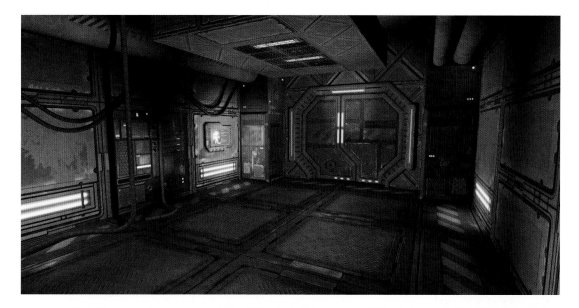

Figure 9-29
Final scene.

Index